THE POLITICS OF THE ARTIFICIAL

THE POLITICS OF THE ARTIFICIAL

Essays on Design and Design Studies

Victor Margolin

The University of Chicago Press

Chicago and London

Victor Margolin is professor of design history
at the University of Illinois at Chicago. He is
the author of *The Struggle for Utopia*, editor of
the journal *Design Issues*, editor of *Design
Discourse*, and coeditor of *Discovering Design*
and *The Idea of Design*.

The University of Chicago Press, Chicago 60637
The University of Chicago Press, Ltd., London
© 2002 by Victor Margolin
All rights reserved. Published 2002
Printed in the United States of America

11 10 09 08 07 06 05 04 03 02 1 2 3 4 5
ISBN: 0-226-50503-0 (cloth) ISBN: 0-226-50504-9 (paper)

Library of Congress Cataloging-in-Publication Data
Margolin, Victor, 1941–
 The politics of the artificial : essays on design and
design studies / Victor Margolin.
 p. cm.
Includes bibliographical references and index.
ISBN 0-226-50503-0 (cloth) — ISBN 0-226-50504-9 (paper)
1. Design—History—20th century. I. Title.
NK1390 .M273 2002
745.4'0973'09045—dc21

 2001003511

♾ The paper used in this publication meets the minimum
requirements of the American National Standard for
Information Sciences—Permanence of Paper for Printed
Library Materials, ANSI Z39.48-1992.

To my wife Sylvia and my daughter Myra. Both have helped broaden and deepen my idea of design.

CONTENTS

I: DESIGN

When I was in my early twenties, I set out to create a cosmology. My intent was to explain the relation between the different forces in the world, from the most noble to the most base. Overwhelmed by the hope and expectation that I, a young dropout with a good undergraduate education, might be the one to accomplish what no philosopher in the past had successfully done, I plunged into the vast sea of knowledge and grasped intuitively at straws that held the promise of unraveling the universe's mysteries.

My reading of esoteric Sufi literature introduced me to the *inshan kamil*, or perfect man. In a cosmic order of seven levels, he was the fifth. Above him were two angelic realms and below him, four realms signifying material, vegetable, animal, and human forces. I wanted to apply this esoteric structure to a wider understanding of the world, one that would, once and for all, explain the underlying principles that link all forms of knowledge no matter how seemingly disparate they were. After extensive reading in the vast and eclectic literature of system building, which is peppered with the attempts of John Bennett, Herbert Spencer, Peter Ouspensky, George Perugio Conger, and Ludwig von Bertalanffy to make order out of chaos, both in cosmic terms and more mundane social ones, I felt sufficiently empowered to begin constructing my own cosmic model.

My method was highly intuitive. It developed from images and spontaneous flashes rather than from logical deduction. I contrived a system of three spheres—the cosmosphere, the biosphere, and the sociosphere. These fit well

together in a triangular diagram. The cosmosphere was the realm of inchoate energy that needed to find a form. This energy was intelligent and embodied an intentionality to guide the construction of a beneficent world. The biosphere was a transformer, which converted cosmic energy into social organization. It contained the biological reality of this world from which the different forms of life emerged. And the sociosphere was the realm of culture through which humans organized themselves and the resources of the Earth. The relation between these realms was dialectical. In the best of all possible worlds, humans in the biosphere transformed energy from the cosmosphere into a humane sociosphere.[1]

I worked hard on a notational system that could function metaphorically as a form of shorthand to help me move complex ideas about, and I filled many legal pads with marks that a few years later I myself would find incomprehensible. The cosmology engaged me for about two years. I tried to pull key words out of the most diverse sources, from biographies of scientists to treatises on international law. On some days I felt the key to understanding all relationships was close at hand. On others, I thought my jottings were as meaningless as three different pieces of fruit on a Las Vegas slot machine. Years later someone I know dubbed this period my Karl Marx phase. He was making an analogy to the time Marx spent in the British Museum working on *Das Kapital*. Yet I produced no such volume, only a thousand pages of formulas and equations full of strange terms, all beginning with cosmo-, bio-, or socio-. Some time afterward, in an act of liberation, I threw the whole lot out, having decided that my goal was unachievable.

However, the impulses that animated me to create a cosmology remained latent and revived when I started my teaching career. Although I began as a design historian, the opportunity to help found and then edit *Design Issues*, a journal of design history, theory, and criticism, drew me into a wider realm of design culture.[2] As I became more engaged with this culture, I did not return to the three spheres, but I did begin to think about design as a vehicle that revealed human intentions for making the world. Thus, I began to look at particular designed objects as evidence of a larger vision of how their designers thought the world was or might be. This way of thinking, as I realized later, resonated with St. Augustine's belief that "by means of corporeal and temporal things we may comprehend the eternal and spiritual."[3] I was not then thinking consciously about how design provided evidence of spirituality or signs of what life in a world beyond might be like, but this did emerge later as a theme of my reflection, although I rarely foregrounded it in my lectures or essays. It did, however, lead me to focus much of my thinking on the effects of design rather than on its formal characteristics. My interest in users, for example, or in ecological issues is evidence of this orientation.

In a lecture I presented at the Milan Congress of the International Council of Societies of Industrial Design (ICSID) in 1983, I explored the concept of a "responsive environment." This was my first attempt to work out a problematic of how design might play a spiritual role in human development. The responsive environment was an image rather than a theory. At its core was the idea that designed products existed collectively as a kind of medium whose contents anticipated and facilitated human activities. In an ideal world in which all projects are life-enhancing, the responsive environment would support productive human activity, both as means of communication (graphic design) and as action (material products). Thus, the responsive environment referred to a characteristic of design that enabled human development rather than manifested the sacred in particular formal terms.

Sustainability is central to the issue of human development and in the early nineties, I took it up as a design issue. "Expansion or Sustainability: Two Models of Development" is one of two essays in this book to address the subject. It originated as a conference paper in London and is a response to the Club of Rome reports that began with *The Limits to Growth* of 1972. I admire the systemic approach that Club of Rome researchers have taken to global problems, but they have been stronger on analysis than on devising plans of action. The global economy keeps on expanding, and the model of consumption that was created in the most highly developed nations remains the goal for even the most impoverished people in third world countries.

To cut through the rhetorical conflict between a sustainable model advocating the necessity of conserving natural resources and an expansion model that disregards long-term environmental consequences, I suggest that design activity, as a demonstrative form of problem solving, might provide new and valid compromise solutions to the current ideological stalemate between proponents of the two models.

The other essay on sustainability, "Design for a Sustainable World," was first written as a paper for the conference "Globalization and Regionalization" in Ulm, Germany. In this essay, I focus on action plans for designers, using as a central text the report of the 1992 Rio summit, *Agenda 21: The Earth Summit Strategy to Save Our Planet*. Had the various design organizations around the world been more attuned to this event, they could have made a contribution to the document, which, nonetheless, is filled with valuable ideas for socially responsible design projects. I make reference in the essay to Curitiba, Brazil, a city where design thinking is evident in many forms of civic action. At the time of the Rio summit, the mayor of Curitiba was Jaime Lerner, an architect whose eco-mindedness put the city on the international map. Curitiba remains an example to other cities of how civic leadership can use design inventively to improve the

quality of life. The process that Lerner initiated also demonstrates what can be accomplished when design is recognized as a social service. The design policy in Curitiba supports my own call to expand the locus of design activity from the market to the realm of concerns that relate to the natural environment as well as to the problems of the social world.

Just as I tried to develop my cosmology intuitively, I have been working similarly on a social philosophy of design, using rhetorical occasions like conferences and symposia to explore specific problems. In pursuing this aim, I have been moving back and forth between design issues at different scales from the global to the individual. This shift is evident in my essay, "The Experience of Products," in which I take up the idea of how design contributes to the situations in which individual human beings gain experience. People depend on products to accomplish certain tasks and goals. Products that invite a fruitful relationship with a user become part of the responsive environment. As Donald Norman and others have pointed out, designers have not always been attuned to how people engage with their products. The more designers and manufacturers take this into account, the more they provide a service to the user. "The Experience of Products" began as a lecture in Helsinki at the conference "Design—Pleasure or Responsibility." As the basis for it, I read John Dewey's *Art as Experience* and related his idea of experience to product use. I was intrigued with Dewey's awareness of how material goods contribute to experience. Toward the end of my essay I take up the question of research policies for design, noting that the relation of products to users is severely underresearched. We need more data on the personal and social consequences of product development. Compared with research on the environment, violence, sexuality, and a myriad of other subjects, research on product use is virtually nonexistent.

"Design at the Crossroads" began as a lecture to the local Chicago chapter of the Industrial Designers Society of America. Considering the organization of design activity, I argue that the various design professions have not yet learned to share knowledge effectively. The essay states a theme that is evident in other of my writings: designers need to think in a more integrated way about how they work, and they need to find better ways to navigate the intersection of domain knowledge and shared knowledge. The skills to maneuver between the two are not taught well in design schools, and consequently, designers are rarely prepared for situations that require cooperation with those whose domain knowledge is different.

Although I espouse an interdisciplinary approach to designing products in complex situations, I also value the lone designer. Such a person is Ken Isaacs, my friend and colleague, who built a long career as a designer and ar-

chitect on a single idea—the matrix. For more than fifty years, Ken has sustained a steadfast commitment to a design concept that serves him as a metaphor for life. The matrix functions as his grain of sand, which on close inspection reveals the fullness of the universe. He has pared his design vocabulary down to a few essential elements and from them has devised a wide range of results.

In the last essay of part 1, "The Politics of the Artificial," which originated as a lecture at the California College of Arts and Crafts, I take up the issue of spirituality as a means to confront the nihilism of postmodern theory and the materialism of posthuman discourse. As I learned more about the Human Genome Project and breakthroughs in bioengineering, it became clear to me that we are on the threshold of a completely new project—the design of ourselves. How will we set the limits of intervention once we script a genetic lexicon that controls particular forms of behavior and biological conditions? Will someone's notion of the social good stimulate us to target people diagnosed as socially undesirable and attempt to "correct" their behavior genetically? While this might seem a fantastic scenario, when faced with difficult personalities such as recidivist sex offenders, the incentive to alter their behavior through genetic engineering increases.

I argue in the essay for a transcendental source of accountability that can inform our judgment about how to set limits for design interventions. Here I use design quite broadly in a polemical sense to reinforce the idea that we are thinking as designers just as much when we contemplate a genetic alteration to produce a particular biological result as when we imagine the form of a new toy for children. The essay title plays polemically on Herbert Simon's "sciences of the artificial," countering Simon's model of seamless rationalism with that of a contentious struggle to determine the limits of design.

Inaugurating the essays in part 1 is my account of the Cooper-Hewitt, National Design Museum's 1992 conference, "The Edge of the Millennium." I use the conference, which was a rhetorical occasion for scholars and designers from several continents to assess the meaning of design at the end of the twentieth century, as a point of departure for my own reflections. Although the event revealed more conflict than consensus, it managed to raise a number of issues and debates that confront us today, particularly concerning the city.

II: DESIGN STUDIES

As a young man fueled by youthful hubris and a passion to understand the universe, I thought that I could do it alone. The thinkers I most admired had also tried to explain the cosmos by themselves. Plowing through the four volumes of John Bennett's *The Dramatic Universe*, I marveled at the author's vast store of 4 . 5

knowledge. But today, his magnum opus has been relegated to the intellectual provinces and is known only as an esoteric footnote to the least respectable corpus of philosophic thought, system building.

Knowledge has increased exponentially several times since Bennett published *The Dramatic Universe* in 1956, and the complexity of contemporary life has fostered strategies of intellectual pursuit based more strongly on communities of researchers than Bennett or his nineteenth-century forbears could have imagined or desired.

The essays in the second part of this book are concerned with issues in the emerging field of design studies, which include the problems and challenges of building a research community. Although my primary domain knowledge is in design history, I also participate in this wider community of researchers and believe strongly in forging connections among its different strands.

The creation of a broad research community, especially an international one, poses design problems of its own. History can be helpful in this process. It is invaluable for tracing the origins of research tendencies and evaluating their results. It is also particularly useful as a mapping tool to show where and when different research initiatives began, and it can help in exploring the reasons why they came together or remained separate.

My essay "Design History in the United States, 1977–2000," originally presented as a paper in Brighton, England, at the Design History Society's tenth anniversary conference in 1987 and then updated for this book, reveals multiple sites of design history research and enables us to see that design history has not developed in a linear way. The investigation of U.S. visual and material culture and their history has a plurality of starting points and continues to occur in different research communities that pose their own questions about the history of design and the divergent criteria for its study. This multiplicity of sites would seem to mitigate against the establishment of a new design history discipline with strict boundaries. Instead, it suggests the greater value of a pluralist realm where research results can be shared among different communities through a more intensive process of communication than now exists.

I stress this point of communication in "Design History and Design Studies," which was first presented at a conference on design history in Milan. The original paper and the article that derived from it were initially entitled "Design History *or* Design Studies," and I am sure that I annoyed some of my British colleagues by proposing that design history merge into a larger research community. In retrospect, I was too harsh in my call for the dissolution of an emerging practice. I now believe that a pluralistic research community can function better as a communications network between various kinds of researchers rather than a as place where different types of research are forced into a comprehensive hi-

erarchy. Yet, I continue to argue that design historians have much to contribute to and learn from the wider community of design research, and I urge their more intensive relation with it.

In "The Two Herberts," I juxtapose Herbert Simon's well-known proposal for a science of design with Herbert Marcuse's idea of history as a tool of critical reflection. I use Marcuse to challenge Simon's implicit assumption that one can devise plans of action without engaging with all the complexities and contradictions of the social world and without a critical reflection on those complexities. While Marcuse is considered in some circles to be an irrelevant figure from the sixties—a "romantic Freudian" as one colleague called him—I continue to be moved by his conviction that history can function as an instrument of human liberation by offering us a vantage point outside the prevailing values of society from which we can see those values more clearly and better formulate our own relation to them.

I return to my mapping activities in "The Multiple Tasks of Design Studies" and attempt to lay out the terrain of a broadly conceived design research community. The essay is based on a paper I presented at a conference on design research in Helsinki. Originally I proposed design studies as a field that would consider design primarily from a cultural perspective. But a diverse international design research community has begun to emerge, and there appears to be a willingness among many researchers to participate in events that are not constrained by strict disciplinary boundaries. It has become clear to me that a pluralistic community that can embrace the widest array of initiatives would serve design best. Since design studies is related to a practical activity— designing—at least part of its accountability should derive from its usefulness to practicing designers of all kinds, not necessarily in the narrow sense of informing technique but also in the larger sense of contributing to the development of consciousness and values.

The challenge in creating such a community is to establish connections between different groups of researchers. To paraphrase anthropologist Clifford Geertz's notion of "thick description," the result could be a kind of "thick discourse," which stems from the recognition that new thinking grows to a high degree from engagement with the thought of others rather than from attempting to invent theories and arguments in isolation from others. There has been little tradition within design discourse for this kind of intertextual engagement, but as more scholars produce new work, it raises the possibility of a community growing out of multiple conversations with and references to the work of its members.

In "Narrative Problems of Graphic Design History," I address a specific issue in one field of design. My principal argument in this essay is that graphic

design, like design history, is not a clearly bounded activity and that the narration of its history needs to account for the multiple strands of practice that have grown up to further particular aims and purposes. Nonetheless, these strands have not continued on discrete parallel paths; rather, they have frequently intersected, and some of them have been amalgamated into new practices. The breakdown of graphic design into specific strands might seem antithetical to my assertion that design can be found in every realm of the artificial, but the two ideas are complimentary. Both acknowledge the social construction rather than the epistemological differentiation of professional practices. The notion of strands represents the specificity of design activity, while the idea that design embraces the entire artificial world refers to an open terrain for new socially constructed practices.

"Micky Wolfson's Cabinet of Wonders" examines the collecting motivations of a man I greatly admire. As a collector of objects myself, I am particularly interested in the reasons why people acquire things. In the case of Wolfson, whose collection is now housed in its own museum, the Wolfsonian, there is both a public purpose, which is explored in the catalog that I review in my essay, and a private one that is yet to be exposed. I include the essay here as an example of how the cultural meaning of a design object expands as the object circulates through different situations from use to museum display.

The interplay between public explanations of the Wolfsonian collection and Micky Wolfson's deep personal reasons for acquiring things is also relevant to what I have tried to present in this introduction. On the one hand, this book of essays is a contribution to design studies literature and represents one example of how a design studies scholar might work. On the other, the range of themes addressed here is part of an ongoing personal quest to understand the world through design.

Beginning with the Cooper-Hewitt symposium that debated the future of design and ending with a call for a new research community, I have tried to demonstrate that design knowledge is produced through a plurality of rhetorical occasions, published research, and community ideals. We are just learning how to better develop these efforts as a community of designers and researchers. I anticipate fruitful results in years to come.

1 Currently, I would call the sociosphere the realm of the artificial and the biosphere, the realm of the natural. However, technological advances, as I indicate in "The Politics of the Artificial," have resulted in more frequent incursions of the artificial into the realm of the natural and have led some thinkers to claim the death of the natural.

2 The decision to found an academic design journal at the University of Illinois, Chicago, was made around 1982 by Martin Hurtig, then head of the university's school of art and design. The team that Hurtig, a painter, brought together to create the journal included Leon Bellin, also a painter, Larry Salomon and Simon Steiner, both industrial designers, and myself. Hurtig and Bellin studied at the Institute of Design (ID) only several years after the death of Moholy-Nagy, its first director, and I would like to think that the impetus to found *Design Issues* was prompted in part by the open relation between art and design at the ID when they were there. Bellin thought of the journal's title. I was the editor for the first three years. Following that, the UIC School of Art and Design continued to publish the journal for six more years. The editorial board was expanded, and its members took turns as coordinating editors. In 1994, the journal moved to the School of Design at Carnegie Mellon University, where it now resides. At the time of the move, the editorial structure was revised and Richard Buchanan, Dennis Doordan, and I, all of whom had previously been on the editorial board, became the coeditors.

3 St. Augustine, *On Christian Doctrine* (Indianapolis: Bobbs-Merrill, 1958), 9. This connection was brought to my attention by my colleague Richard Buchanan.

DESIGN

10

Eduardo Terrazas, a Mexican architect, speaking at the Cooper-Hewitt, National Design Museum symposium, "The Edge of the Millennium."

THINKING ABOUT DESIGN AT THE END OF THE MILLENNIUM

We speak in broad terms today of differences between nineteenth- and twentieth-century thought and experience, but one is hard pressed to find a singular moment when the paradigm of the nineteenth century collapsed and a new one emerged. However, we can detect in the latter decades of the nineteenth century a steady buildup of scientific and artistic projects that literally erupted in the early years of the twentieth century as a radical challenge to what came before—quantum theory, the theory of relativity, the indeterminacy principle, cubism, futurism, suprematism, dada, the stream-of-consciousness novel, twelve-tone music, and the development of totally new media such as film, come to mind. Although it is equally difficult to find in our own recent experience of the late twentieth century a singular sign to characterize life in the twenty-first, we will very likely experience changes in this new century as momentous as those that occurred in the first part of the last one. The stakes of this wager are heightened by the millennial shift, which enhances the drama of a new beginning even more.

Given the portent of this shift, it was therefore appropriate and courageous for the Cooper-Hewitt, America's designated national museum of design, to organize a symposium on the theme of design at the edge of the millennium, which was held in New York at the historic Great Hall of the Cooper Union on January 15–18, 1992.[1] Director Dianne Pilgrim told the audience in her introductory remarks that the Cooper-Hewitt was in transition as it prepared for its centenary in 1997. The museum had started as a repository of drawings, prints,

books, and decorative arts. Under Pilgrim's direction, it began to think about design in wider terms that include, but are not limited to, traditional museum objects. As part of this process, Susan Yelavich, director of education, organized "The Edge of the Millennium" to initiate a dialogue that would ultimately play back into the museum's own reflection on its goals. The fact that the symposium was organized by the National Museum of Design placed it in relation to the museum's possibilities of action, thus giving it a heightened significance as a rhetorical occasion.

The symposium brought together architects, designers, critics, historians, and theorists over an evening and three days to speculate on the current state of design—here embracing architecture, products, and graphics—in the late twentieth century. The intellectual framework of the symposium and the core of its concerns stemmed primarily from the experience and discourse of designers in the developed world. In her introductory remarks, Yelavich made reference to postmodernism, poststructuralism, and deconstruction as important modes of thought that influenced her choice of symposium themes. Robert Campbell, architecture critic for the *Boston Globe,* who served as a key consultant for the event, echoed this postmodern orientation with his references to a world of simulations, a contingent future, and the loss of a clear master narrative. As the symposium progressed, however, the sense of a postmodern moment was not shared by all speakers and was countered particularly by the Italian designer and theorist Andrea Branzi, who made an impressive argument for a "second modernity."

The lack of consensus as to how to characterize the current cultural moment was indicative of a number of competing visions and arguments within the symposium. And that was one of its particular strengths. Yelavich assembled a much greater range of speakers—distinguished by differences in their social, cultural, philosophical, and technological views as well as their rhetorical strategies—than one customarily finds at a design conference. In fact, this event was particularly differentiated from the conferences organized by professional design organizations by its emphasis on culture as a significant framing device for the presentations and discussions. While this emphasis occurs frequently in conferences and symposia on architecture, it happens less often when product design and graphic design are discussed.

Following Campbell on the first evening, political scientist Michael Barkun gave an overview of millenarian thought in the last century and offered his own vision of the next millennium. Barkun took particular note of Francis Fukuyama's "end of history" argument that, he said, suggests a future devoid of conflict but characterized by crashing boredom. He also emphasized the expectations of disaster that have characterized millenarian thinking and spoke as

well of the past faith in the ability of science to produce a rational order.

Barkun made the important point that many people have become disillusioned with technology as a redemptive force. One need only recall, as he did, some of the disasters of recent years—Three Mile Island, Bhopal, Chernobyl, the Exxon Valdez oil spill—to realize that much can go wrong with technological plans. At the end of his talk, he made several compelling prognostications, which included a loss of faith in technology, a renewed attraction to life in small communities, and revived attention to artistic and spiritual values.

These statements recall specific social movements of the 1960s and 1970s, notably the American counterculture and the intermediate technology movement that was inspired by the work of E. F. Schumacher. One might have conveyed a millenarian vision in other ways: in fact, a number of presentations in the following days evidenced a good deal of faith in cities, new technologies, and global interrelations that did not fit comfortably within Barkun's vision.

Fully embracing the notion of the millennium as an apocalyptic ending, graphic designer Tibor Kalman and Karrie Jacobs, a critic for the design magazine *Metropolis,* called for an end to design in their multimedia slide and video show. The rhetorical mode of the conference had shifted from Barkun's scholarly lecture to Kalman and Jacobs's media blitz show-and-tell, a format that characterizes many design conferences. They presented a Black & Decker plastic device that separates coffeemaker filters as the embodiment of all that is trivial and wasteful in product design. This, they said, was unfortunately the level of problems that designers were capable of solving.

One could sense in their presentation a great deal of frustration and dissatisfaction with the prevailing social role of the designer. In earlier forums, Kalman had been quite outspoken about what he saw as the triviality of much design activity and the designer's lack of initiative in shaping a design agenda. He and Jacobs threw down a gauntlet to the symposium with their assertion that design had become an inconsequential practice. There were no direct responses to this challenge from any of the other speakers in the succeeding days, although Branzi spoke about the project of design, *il progetto,* as the Italians call it, as being something extremely significant that was embedded in the deepest notions of who we are.

THE STATE OF ARCHITECTURE The differences in modes of presentation during the symposium made it clear that there was no single design culture in the United States or elsewhere within which connections between views and positions could be easily made. In the past twenty years or so, architecture, which was the topic of the first day, has claimed the high ground among design practices as the one with the greatest intellectual discipline. It is to architecture

that literary theorists and philosophers have flocked and within architecture that debates about practice and meaning have taken on the cast of a Talmudic discourse with all the complexities of interpretation and issues of morality that such discourse entails.

Historian Rosemarie Bletter gave a brief overview of utopian practice in the twentieth century, leading the audience through Frank Lloyd Wright's Broadacre City, the Futurama at the 1939 World's Fair, and the 1964 World's Fair in New York. Little research has been done on the latter event, and Professor Bletter pointed out how few of the projects it anticipated were fulfilled. The technological optimism that characterized that moment, notably the enthusiastic promotion of atomic energy, had, as Professor Barkun noted, been severely tempered. And projects conceived in an era of economic optimism, such as underwater hotels and automated farming, no longer retain their luster. Embedded in Professor Bletter's talk, though not explicitly developed, was the thesis that visionary thought is very much of its historical moment. The "instant cities" of the British architectural group Archigram, the arcologies of Paolo Soleri, and the jerry-rigged domes of Drop City in Colorado, all prominent visions of the 1960s, have been supplanted by other, less comprehensive views of how we might live. In fact, Peter Cook, one of the central figures of Archigram, made a presentation at the symposium with his colleague Christine Hawley on London in which they transmuted Archigram's visionary interventions into more modest ways of working in the interstices of urban life, where only smaller changes seem possible. In some sense, Cook's continued belief in change, even on a reduced scale, supported Bletter's reference to German philosopher Ernest Bloch's definition of utopia as a critique of the present that marks what might be achieved.

In her introduction to the next group of speakers, whose topic was the spiritual essence of cities, Yelavich humanized the city, referring to New York and Berlin as once authentic cities that were pathologically damaged. Some of her imagery and that of several other speakers in this session was drawn from the writing of John Hejduk, dean of the School of Architecture at Cooper Union. Yelavich was the first of several speakers to cite Hejduk's statement that "[i]n order to become well, the city must breathe the thought of the feminine."

The presentation of Alan Balfour, the new director of the Architectural Association in London, made reference to the city as the site of complex negotiations between necessity and desire. On the one hand, he argued, world industry must use the most advanced construction technology to satisfy the pressing demands for housing; on the other, evidence of what he called "authentic desire" could be seen in more diminutive manifestations such as neighborhood shrines and small gardens in Japan. Unlike Barkun, who envisaged a future of

decentralized small communities, Balfour claimed that the city would dominate our imagination in times to come.

Pace University philosopher Peg Birmingham, who acknowledged her limited understanding of architecture, espoused Hejduk's meditative writing as a way of shaping the discourse about cities, particularly in gender-related terms. Her talk was extremely difficult to follow because she used a rhetorical strategy that relied on an alternating sequence of assertions and images, which forced the audience to listen in an unfamiliar way. At the same time, she presented encapsulated accounts of extremely complicated feminist arguments that have been developed and understood among a particular conversation community, but which can be obscure when stated in an abbreviated form to a general audience. Laced through her talk was a series of poignant images that were meant to take on rhetorical value but failed through their intangible relation to her arguments. She recounted quite vividly, for example, strong scenes of street life in Harlem, including a merchant's murder of a boy who stole some jewelry from his store.

My difficulty in grasping Professor Birmingham's arguments began to clarify a much larger issue of how contemporary social discourse is conducted. Particularly in academia, but also in the professions, issues and problems tend to be framed in terms of isolated conversation communities, groups who evolve their own terms, frames of reference, rhetorical strategies, and issues and speak primarily to each other. Clearly, Birmingham was addressing a general audience from within the discourse of a particular conversation community, academic feminism. She found a connection to the community of architects through the work of Hejduk, which similarly served as a bridge for the next speaker, philosopher David Krell.

Professor Krell focused on a project of Hejduk's called the "room for thought," a square silo with seats in the four corners. For Krell, the "room for thought," like Bloch's notion of utopia, is a space of possibilities. At one point, Krell characterized planning as a withdrawal of what wants to be thought about, suggesting the diminution of possibilities inherent in action but in some way arguing more strongly for a sense of loss than a practitioner might (since he is a thinker and not a planner).

Krell's engagement with architecture as a thinker and his positing of a relation between thought and action within which the latter might be viewed as a closing out of possible thought, highlights some of the difficulties that architectural theorists who draw their ideas from literature, philosophy, or psychoanalysis have with the act of building. Such theorists are often extremely impatient with the limitations of planning and strive to define architecture as something apart from building. They see it as a way of keeping open a seemingly wider and 16.17

more profound mode of thought; hence, it is no surprise that Hejduk's writings would have been of such interest to both Birmingham and Krell, since Hejduk locates architecture in a space of possibilities that is unfettered by the presence of the everyday.

Hejduk himself was the final speaker of the morning. A large man, his presence too seemed of a greater scale. He spoke, one might say, with a rhetoric of prophecy, releasing his words slowly with a calming rhythm. Prophets need not analyze, justify, or rationalize. They make assertions with a spiritual force that places them beyond the conventions of critical response.

Hejduk presented his equation of the spirit with slow time through his portrayal of life in the Bronx during the 1930s. This, for him, was a moment filled with what he called "spirit time." The trolley car was the seminal image. It moved slowly through the cityscape, enabling its riders to fully experience the journey. It stopped at places that had a numinous presence. Hejduk described the Bronx of his youth as a frugal place. With its profusion of vacant lots, it had an air of emptiness.

The quality of feeling that Hejduk introduced into the discussion was more palpable than that offered by the previous speakers. Here was an example in which the mixing of rhetorical strategies served a productive end. It also made clear that this symposium was not likely to generate a set of conclusions on the basis of shared discursive conventions. Instead, it would demand more from the audience who would have to both recognize and engage with the extremely different rhetorical strategies of the speakers.

If the morning program could be seen as a reflection on the philosophical and spiritual sources of architectural practice, the four case studies in the afternoon—London, Los Angeles, Mexico City, and Tokyo—were presented as the testing grounds for the loftier premises of architectural thought. London, as described by the architects Peter Cook and Christine Hawley, offered only modest room for thought and little space to act. Cook and Hawley placed great emphasis on informed observation of small sections of the city as a way of experiencing it and, hence, devising strategies of action. For them, London was not characterized by a grand plan; in fact, they lamented the absence of such a plan in the city's near future and instead placed their optimism in small interventions that responded to complex layers of visual stimuli as well as traces of activity.

As a method of observing the activity within a physical space, Hawley suggested a representation of sites through layers of screened images that created a context for action. She and Cook characterized this as an architecture of overlay, rather than one of insertion. Their sense of collage as a metaphor for urban life recalls the bricolage described by Colin Rowe and Fred Koetter in their book *Collage City.* There is a sense of discovery in this method. The archi-

tect must find all the subtle elements, including traces of human activity, that comprise the site in order to make use of them in a project.

By contrast, the architect Eduardo Terrazas, who spoke on Mexico City, described the Mexican capital as a place where large-scale planning was still possible, in fact necessary. Terrazas, the only speaker at the conference from a developing country, nevertheless tried to account for Mexico City in terms of the developed world's cultural discourse. He wanted to characterize the city as postmodern by virtue of its shift from the entry point for modernization in Mexico, represented by a concentration of commerce, education, and goods and services, to something new, yet to be characterized, that results from a reversal of the government's centralizing policies.

Yet Terrazas also seemed ambivalent about decentralization. He spoke of buildings and monuments as educators of the public and urban artifacts as testaments to a national past. As he developed his argument, postmodernism for him seemed to have more to do with elaborate juxtapositions of modernity and tradition, avant-garde culture and native arts, and multiple ethnicities than with a sense of the inauthentic that many postmodern theorists have claimed.

Rather than postmodern, however, the situation Terrazas described could also be characterized as late modern or, in Andrea Branzi's terms, a second modernity, particularly the coexistence of colossal engineering feats, such as the city's gigantic pumping system that brings water into the city from outlying areas, and the low-cost indigenous building schemes conducted by the populace without architects or engineers.

An interesting discussion might have been generated by closely comparing Mexico City with Los Angeles, which was described by John Kaliski, principal architect for the city's Community Redevelopment Agency. Whereas for Mexico City, self-representation, as Terrazas described it, was still seen in terms of national identity and city projects were supported in large part by state funds, Los Angeles is a city that has been developed with sizeable infusions of private capital and multiple independent visions of urban life. To balance the concerns for stable residential neighborhoods with a push for expansion, Kaliski described a network of public boulevards with residential areas behind them.

Even this degree of planning, however, could not be found in Tokyo, as architect and critic Marc Treib depicted it. Tokyo comes closer to Jean Baudrillard's vision of a simulacra-driven world than any of the other cities discussed on the program. Treib characterized Tokyo as an urban process rather than a product, noting its chaotic development. Originally a group of villages, it still does not have many trappings of a metropolis such as a system of street names.

Japan is a nation that had a significant cash surplus in the early 1990s to support an idiosyncratic building program. Treib noted that few architects addressed the city in their buildings, preferring to create extravagant structures that stand out from their surroundings. For many Japanese architects, it seemed, Tokyo is a resource, a place to make new statements rather than discover existing patterns of activity and relate to them. Treib's emphasis on the way some Japanese architects transform building types into icons of other objects strongly invites a reading of Tokyo that is different from what any orthodox modernist could provide.

The descriptions of the four cities were so rich in data that no cursory exchange could have easily extrapolated the connections between them, either in terms of commonalities or differences. In the subsequent panel discussion, moderated by Alan Platus, associate dean of the Yale School of Architecture, an attempt was made but little was concluded. The cities had been well chosen for their differing social, economic, and cultural identities, and a more intense unraveling of these might have helped the audience to achieve a better grasp of the larger concerns about the millennium that framed the symposium.

THE SEMANTICS AND PRAGMATICS OF PRODUCT DESIGN In keeping with the cultural theme of the conference, the lead speaker on the second day was British design journalist and consultant John Thackera, who espoused a concept of "cultural engineering," which he was helping a number of corporations and public institutions to develop. Thackera defined this concept as a way for corporations to become involved with cultural programs and education. Pragmatically it means linking up with institutions that, in an optimistic sense, may help to convey to the public the cultural significance of design; in a pessimistic one, it may simply be another way to promote products.

Although the rest of the day's speakers differed considerably in their concerns, all shared an interest in the relation of industrial products to the human user. Michael McCoy, cochair of the design department at the Cranbrook Academy of Art, spoke about product form. Under McCoy's leadership, the product design program at Cranbrook was emphasizing the semantic value of products as evidenced in the poetic objects that McCoy believed signify cultural myths. Such objects designed by Cranbrook students became the most visible demonstrations of how product semantics, a recent theory that explores product meaning, can effect the development of forms. Located in an art school, McCoy placed more emphasis on the formal aspects of design than on engineering or manufacturing. As sources of product forms, McCoy referred to different examples of popular culture, notably films such as *2001, Blade Runner,* and *Road*

Warrior, but also to vernacular objects. He claimed that a product becomes mythic by serving as a kind of theatrical prop for living, hence his emphasis at Cranbrook on the visual. He mentioned several concepts that served as strategies: prosthesis (the product as an extension of the body), anthropomorphism (the product form anthropomorphized to make it friendlier), and vernacular form (the product form as a reference to earlier products; i.e., an answering machine with an iconic relation to a rural mailbox). At bottom, McCoy's presentation suggested that intuition was a stronger basis for form generation at Cranbrook than theory. As he discussed theory, it was not a set of principles but a series of hypotheses about myth and technology that guided the discovery of forms.

If Hejduk had spoken the previous day with the prophet's voice, Branzi, who followed McCoy, delivered a statesman's address. He presented three theorems for an ecology of the artificial world, which he framed within the cultural context of a second modernity. While Hejduk shared his personal experience of a particular historic moment, the Bronx in the 1930s, presenting it as verification of the value of slow time, Branzi gave the audience an embracing vision of contemporary culture that was made credible by his own immense stature in the field of design. He was initially part of the "radical design" movement in Italy in the late 1960s, then became a formulator of Italian "new design," a participant in the Memphis group, and an educator at the Domus Academy in Milan. His writings and projects have had great influence among designers worldwide for a number of years.

Branzi, who has shifted the locus of his thought from postmodernity to an extended and renewed modernity, is representative of a more philosophical position within Italian design culture. He spoke, as a number of Italian designers do, of the "project of design," an embracing concept that locates design centrally in the process of cultural transformation. I have always found this concept to be an inspiring one that forces the need for continuing cultural analysis. If the design project is as culturally significant as Branzi and other Italian design theorists argue that it is, then one needs to be deeply engaged with large issues of social transformation since these will affect the nature of the project.

Branzi's presentation demonstrated the value of well-informed and sophisticated designers who are capable of stating their own will to design in culturally powerful terms. He acknowledged the complexity of the contemporary condition and stated that the new design must take full account of this. There are limits to the capitalist industrial system, he declared, but he also claimed that the collapse of socialism in Eastern Europe made it difficult to posit an alternative. Nevertheless, he kept the possibility open.

The focus on design, stated Branzi, is not the single object but an ecology of the entire world. He then outlined a series of theorems that had to do with

balancing opposing logics of production—advanced technology and crafts, standardization and diversity, humans and machines. Branzi ended with a statesmanlike summation of where the first modernity has fallen short and what design can contribute to a renewed modernity.

He noted what he called the "violent complexity of the metropolis" and saw this countered in part by virtual space, which he described as a "world of fiction and simulacra." Branzi ended his talk with a presentation of choices rather than a prescription. Designers, he said, have to decide whether to work in the real world or the virtual one. This was not a talk to be dissected as one would a scholarly paper but rather a statesman's vision of the contemporary world and the possibilities it holds for designers.

Unfortunately, Branzi's rhetoric of statesmanship was not recognized by his respondent, Michael McDonough, a young New York architect, who countered Branzi's overarching vision with a rejection of authorities and experts that smacked rhetorically of the 1960s counterculture. McDonough characterized Americans as populists, mistrustful of experts, cynical about reform-oriented design cultures, and believers in change from the bottom up. In McDonough's jingoistic reading, Branzi represented a European high culture that was irrelevant to the American experience.

This was a regrettable interpretation of Branzi's talk, particularly for an audience generally unfamiliar with Italian design discourse, since McDonough attempted to undercut the importance of Branzi's vision as an instrument to empower designers. He called for a resistance to the project of design as Branzi proposed it, preferring instead to espouse the untidy microcosms of American multiculturalism. Needless to say, Branzi had acknowledged and even argued for the very diversity that McDonough celebrated in his response.

The difference between the two, however, was that Branzi, the product of a strong European cultural tradition, formulated issues of design within a long wave of historic time and related current practice to eminent achievements of the past. McDonough, on the other hand, in a way that is American but not typically so, considered practice to be an immediate and existential response to a situation. Whereas Branzi preferred to think in broader terms, McDonough was content to act microcosmically without relating the designer's action to a larger vision of contemporary culture or to the precedents of the past.

VIRTUAL WORLDS AND EXPANSIVE PROBLEMS FOR DESIGNERS The virtual world to which Branzi alluded was brought front and center by the afternoon's first speaker, Bruce Sterling, a bestselling science fiction author and a founder of cyberpunk, a sci-fi genre grounded in an engagement with pop culture and high technology. Sterling presented his thoughts in the form of a con-

versation with product designer Tucker Viemeister. Their exchange was enveloped in a fluid backdrop of slides, video clips, and music. It was intentionally provocative, even to the point of being structured indeterminately as six narrative sections. The order of these sections was decided by the audience, who randomly picked the overhead transparencies that identified each section.

Sterling spoke as a visionary, offering the audience a scenario of future technological possibilities. Central to these was cyberspace, a term introduced by William Gibson in his cyberpunk novel *Neuromancer* to denote the virtual space made possible by communication through computers. In its early protoform, cyberspace was characterized by computer bulletin boards, but Sterling and others later conceived of it as an alternative simulated milieu made ever more tangible by virtual reality (VR) technology.

The subtext for Sterling's optimistic portrayal of cyberspace was a libertarian philosophy that chafes at social restraints and is coupled with a cynical view of government officials and technomanagers who have badly bungled their stewardship of our future. "Escapist" would be too simple a term for Sterling's position. He believes the future can be reinvented in cyberspace and that the mistakes of the corporeal world can be corrected in the virtual one.

The attraction of cyberspace for Sterling is its lawlessness. In true libertarian fashion, he referred to it as the "ultimate designable medium" where possibilities can be realized without undesirable restraints. He called it a frontier, just as Americans in the nineteenth century referred to the Western landscape and as John F. Kennedy at the beginning of the 1960s characterized outer space as the "new frontier."

Sterling's characterization of cyberspace stemmed from a complex mix of anarchy, cynicism, libertarianism, alienation, self-reliance, hedonism, and high-tech fascination. Although cyberspace may become the ultimate fantasy medium in the hands of the Nintendo and Disney corporations, Sterling regarded it as a serious political location that strongly critiques the limitations of contemporary life.

He raised an immense number of issues, but unfortunately there was no format for unpacking them or for bringing his account of an alternative reality into play with what had preceded it in the symposium thus far. His vision of the future could not be farther from Barkun's narrative of small, decentralized communities nor could it differ more from Hejduk's slow time or Branzi's ecology of the artificial. How would Birmingham characterize cyberspace in feminist terms, or Krell, as a place to think what calls to be thought? On what basis might designers generate the forms of virtual objects? Would these objects be considered any less trivial than those decried by Kalman and Jacobs? And did the poetic projects of McCoy's Cranbrook students represent in any way the myths

that underlie cyberspace consciousness?

With the next group of speakers, all of whom emphasized issues related to product users, the symposium returned from virtual to corporeal reality. Donald Norman, a cognitive scientist known in the design community for his book, *The Psychology of Everyday Things,* led off. Norman has earned a considerable reputation for his widely publicized assertion that many, if not most, products are badly designed. At the symposium he took the position of a pragmatist who believes that a product's functional relation to the user is the only question worth addressing. For him, McCoy's concern with myth embodied in form was irrelevant, as is all the "literary deep thought" that confuses the issue of how to design.

Norman could not have been more blatant in his denunciation of inconsequential discourse, and in doing so, he revealed a considerable ignorance of design culture. According to him, most designers didn't know how to make a product that works well. Such a statement could only come from someone unfamiliar with the history and current practice of design. Norman's thesis that many products are badly designed is beyond dispute, but his narrow focus on this issue as the core of design thought was misplaced. It was much more satisfying to hear Branzi's generalized reflection on design in culture than Norman's singular point, which he hammered away at more than was necessary by holding up to the audience examples of badly designed products.

As a participant in the discourse about products, Norman identified a central problem of design while acknowledging little of the larger culture of which design is a part. This paradox is still inherent in current design thinking, which is grappling with ways to integrate pragmatic or operative concerns with semantic or symbolic ones. Norman, however, did not want to recognize this complexity. Instead, he preferred to privilege problems of product function and reject all other concerns. Consequently, his presentation was one of the least successful of the symposium due to his unwillingness to come to terms with the ideas of most of the other speakers.

The talks by the two speakers who followed Norman, John Seely Brown, director of the Xerox Palo Alto Research Center, and John Rheinfrank, a designer with Fitch Richardson Smith, while fuller and more reasoned than Norman's jeremiad, also concentrated on pragmatic issues rather than cultural ones. This separation of pragmatic and cultural problems in product design is in sharp contrast to architecture, where a centuries-long tradition of high cultural status and technological advance, along with a well-developed historical consciousness, has embedded architectural discourse in cultural issues.

The paradox, however, is that immensely interesting work is being done by product designers in spite of the split between pragmatics, cultural theory,

and historical consciousness. The work described by Brown at the Xerox Palo Alto Research Center is a good example. Brown focused on the subject of ubiquitous computing, which he defined as "taking computing out of the box," and the development of networks to establish multiple access to a single program. After an enticing introductory statement that he and his colleagues in Palo Alto were "rethinking the border in product design," he proceeded to recount the particularities of the work underway at his research center as if he were speaking to a meeting of professional colleagues. While of interest, this descriptive rhetoric did not develop further the deeper meaning inherent in rethinking the borders of design, which, if articulated, might have helped to make connections between the presentations of other speakers.

Rheinfrank illustrated a set of general principles about designing with case studies of his own firm's work. These included the redesign of a Xerox copying machine that exemplified the cognitive ergonomics Norman espoused. The presentations by Brown and Rheinfrank were intended as demonstrations of cutting edge design, but their rhetorical strategies were embedded in the discourse of professional meetings of colleagues and clients. The aims of such meetings are usually to solicit client or management support for further activity or to demonstrate possibilities of practice to other practitioners. It is no surprise, therefore, that a number of the questions that followed these two presentations related to professional concerns about how to design products rather than to larger cultural issues of which the work discussed might have been indicative.

BETWEEN MODERNIST PRACTICE AND GLOBAL DIVERSITY The final day's talks on graphic design were somewhat diverse but had in common the concern for a new grounding for practice. The opening speaker, journalist Michael Thomas, was supposed to challenge the myth of the "information age," but his talk was simply a curmudgeon's complaint about the evils of the present. He offered little new information, and even his opinions fell easily within well-recognized conventions.

Lorraine Wild, a professor of graphic design at the California Institute of the Arts, returned the colloquy to problems of designing. Whereas Brown and Rheinfrank, as working designers and design managers, exuded a confidence about the problems and projects in which they were engaged, Wild noted a loss of consensus as to what graphic design was. This loss, she said, resulted from a belief that modernist design philosophy and formal innovation had run their course. Wild had studied with Paul Rand and Bradbury Thompson at Yale and then worked in Massimo Vignelli's office in New York. She was particularly disappointed in the way Vignelli defended his version of modernism by attacking

younger designers such as the publishers of *Emigre* as well as designers who depended heavily on the computer, which she quoted Vignelli as describing as "a tool that gives them license to kill."

Beyond her vision of a moribund modernism, Wild saw a confused design scene where many designers had lost the modernists' sense of social purpose. Instead, they were occupying themselves with self-centered aesthetic and technological exercises. Similar to many artists, architects, and designers who have decried a version of modernism that appears to espouse universal solutions, Wild called for a pluralism of ideas, which she said a study of language theories, in particular, semiotics and rhetoric, could facilitate. She also stated that the development of a personal voice should be high on the agenda of graphic design education.

Speaking out so strongly against a modernism that seemed to her moribund was clearly an emotional experience for Wild. As a leading graphic design educator in midcareer, she was also voicing the feelings of numerous younger designers and students, many of whom are women. Within graphic design, she stated, there was a search for a new direction that would enable designers to combine a sense of honest purpose with new types of formal solutions that are both more personal and appropriate than the limited visual vocabulary they have associated with modernism.

The call for a new sensibility was also central to the stimulating slide lecture on information signs presented by Ellen Lupton and Abbott Miller. They continued Wild's critique of universal graphic solutions by arguing that the presentation of information, particularly in the form of visual icons, is not value-free. Their talk combined criticism of existing signs, such as their exposure of the sexist bias in the U.S. Department of Transportation sign system, with an advocacy that information icons be used more sensitively to denote differences of gender and culture.

Cultural distinctions were exemplified in the two afternoon presentations whose subject matter was graphic design in the former East Germany and Soviet Union. These talks focused on how the socialist experience had shaped design thought. The first presenter was Eric Spiekermann, a founder of Meta Design in Berlin, who had done a lot of work in the city's former eastern sector. He pointed out that the striving for a socialist style of public graphics in East Germany was eventually eroded by increasing knowledge of Western practice. Following him was Constantin Boym, a Russian product and exhibition designer who had relocated from Moscow to New York. Boym told the poignant story of Vladimir Chaika, a graphic designer in Moscow who went to New York to work. Disillusioned with the heavy emphasis on meeting client needs, Chaika returned to Moscow and was trying to make a living as an artist. Was

Directional signage, O'Hare International Airport, Chicago (top) and Sydney Airport (bottom). The sign at O'Hare represents an elevator with three male figures standing inside a square while that from the Sydney airport conveys the same meaning with two female figures and one male. The difference between them indicates the gender politics of using Isotype-derived figures for public signage.

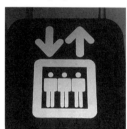

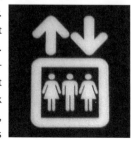

Boym's narrative tale meant to signify a more widespread Russian sensibility caught between the frustration of underdevelopment and the demands of overdevelopment? There was certainly more to explore on this theme of cultural fit.

CONCLUSION With one exception, the members of the closing panel, who were supposed to sum up the symposium, evaded their task and gave their own presentations. These ranged from moderator Michael Sorkin's designation of an ATM machine transaction as a metaphor for the decline of public space, to critic Hugh Aldersey-Williams's argument for recognizing national characteristics in design. Only Kathy McCoy of Cranbrook attempted to draw any conclusions from the proceedings. Her strongest statement was the claim that architecture had spent itself.

It was evident from the symposium that those who participate in the discourse about design and the built environment do not share a common vision of what constitutes our contemporary condition, nor did the symposium make evident any agreement on what design might become in the next millennium. Although the event offered a rich experience of many voices speaking out about architecture and design, conversations among the speakers did not develop. Consequently, the deeper issues embedded in their presentations were not teased out and discussed.

This difficulty in discovering and conversing about common themes remains indicative of our cultural moment. What is lacking among intellectuals is the will to cut through these differences and forge wider conversations around topics that matter. But, more so than at most design conferences, "The Edge of the Millennium" brought together many speakers with differing concerns. The opportunity to hear them as part of a single though multivocal narrative enabled me to better compare their themes and rhetorical strategies. It also reinforced the challenge of creating productive conversation communities. That, in particular, made it worthwhile.

1 The conference papers were published as *The Edge of the Millennium: An International Critique of Architecture, Urban Planning, Product and Communication Design*, ed. Susan Yelavich (New York: Whitney Library of Design, 1993).

Mannequin wearing motorized roller skates designed by Antoni Pirello, c. 1948.
Henry Ford Museum, Dearborn, Michigan.

DESIGN AT THE CROSSROADS

In the university, where much professional design training takes place, the different practices are separated into distinct academic programs that serve to obstruct productive dialogue. This is partly due to the various kinds of knowledge embraced by the practices of design. There is a division between those practices that have historically been recognized as intuitive and aesthetic and, hence, located in schools and departments of art, and those seen as technical and thus found in colleges of engineering and computer science departments. Once divided, practices develop their own directions and discourses, which tend to reinforce their separation from each other.

Along with the division of design training into professional specialties, practitioners in these specialties place differing values on the importance of explaining to themselves and to others what they do. This has contributed to the difficulty of establishing a dialogue among them. Therefore, a strong discourse about design as a broad human activity has been slow to develop. It has been less common for designers to seek a shared understanding among themselves of what they do than it has been for other professionals such as lawyers. In the history of Western law, for example, the debates about legal interpretation have been fierce and ongoing. Many practicing lawyers have also been legal scholars. As well, lawyers have opened up their discourse to thinkers from other disciplines who have engaged in the profession's internal debates.

By contrast, we can take the example of product design and look to history to explain why self-reflection in this particular field is not stronger. Product

design, narrowly defined as a practice of shaping material objects, has its roots in fine art and only gradually adopted a limited body of technical knowledge. Early product designers within the European system of industrial production were artists who simply provided drawings for manufacturers. Nineteenth-century design theory was what some today would call "soft theory." It had more to do with issues of decoration and form, which represented the preoccupation of designers at the time, than with technical expertise.[1]

The situation was not very different in the 1930s in the United States when industrial design became generally recognized as a part of the manufacturing process. Raymond Loewy, Walter Dorwin Teague, Norman Bel Geddes, and Henry Dreyfuss all came to industrial design with backgrounds in either illustration, stage design, or even the design of store windows. What unified them as industrial designers was a strong orientation to how things looked, and in fact, they pioneered a way of designing known as styling, or giving a product a strong visual image.

These designers were opportunists and showmen, both of which talents enabled them to parlay initially modest assignments into large-scale projects. Within six years Loewy went from his first product design—the casing for the Gestetner duplicator, to the design of an automobile, the Hupmobile, and then to an engine for the Pennsylvania Railroad. Loewy was able to make such strides because of several factors: he hired a staff that could provide the technical knowledge he lacked, but he also demonstrated a continuity of method and presentation that gave his clients confidence. Loewy and the other consultant designers did a great deal for industrial design by promoting it as an important part of the manufacturing process. Their success was supported by statistics on product sales as well as other data related to user response. At the same time, these designers were known primarily for their artistic knowledge rather than for their technical expertise. To some degree, Dreyfuss was an exception. He was one of the first industrial designers outside the military to use human factors information in product design.

Despite their construction of multidisciplinary offices as well as their ability to produce successful products, the consultants paid more attention to their public image as businessmen than they did to the cultural or social issues of their profession. As practitioners, they fell somewhere between the engineers whose work was grounded in technical knowledge and the architects who maintained a strong cultural presence. Even though there have been subsequent designers who raised issues about the cultural conditions in which product design—a term that many designers now prefer to "industrial design"—is practiced, these isolated arguments have still not coalesced into a discourse that permeates the entire field and functions as a source of continual

discussion and debate.

Today, architecture still remains at the apex of the design hierarchy. Architects have their own sense of cultural value that usually leads them to set themselves apart from other designers.[2] I emphasize these cultural distinctions because they help to explain why the design professions remain divided within the universities. The issues are not simply epistemological. The different ways of valuing aesthetic and technical knowledge are deeply embedded in the culture at large and have prevented greater communication among designers and design educators. Given the difficulty of overcoming such sharply variant self-perceptions and levels of reflection, we might ask what motivates us at the present time to address this separation of design professionals from each other as a significant topic for discussion.

One answer is that the conventional divisions between design practices are breaking down of their own accord as designers confront problems they are unable to grasp or solve. We could regard this as a crisis but can also consider it as a healthy opportunity to look beyond the existing boundaries of the distinct professional practices. Despite a past history of separating these practices, there is an emerging interest among some design educators in generating new academic programs that cut across departments of engineering, industrial design, and marketing, for example, or in setting up other projects where students from different departments such as architecture and design can work together.[3]

Before considering further the specific problems that face designers, let us consider briefly some of the larger economic, technological, and social forces that have generated them. These include the acceleration of invention and the rapid rise of new aggressive players in the game of commodity production and distribution. Today, inventions such as the microproccessor are not only changing the kinds of products we use but also, through these products, the way we work and communicate. The existence of the computer, for example, created a new field of software design that has brought experts in artificial intelligence, cognitive psychology, and other disciplines into the design process. Rapid advances in robotics technology, including the application of sensors that can detect errors to a high degree, are transforming the manufacturing process, not only by accelerating it but also by making possible a greater range of product variations through batch processing. We now speak of FMS (Flexible Manufacturing Systems) as an alternative to the fixed assembly lines that necessitate large runs and expensive set-up times.

Concurrently, competition for markets has increased among nations and the speed with which a company can bring a product to market is now a decisive factor in that product's success. There has also been a rise in user expectations of product quality and value. A poll undertaken in the United States more

than a decade ago showed almost unanimous agreement among users that the most important design value was a product's ability to function as promised; closely following that were durability and ease of repair. Although attractive design and technological innovation were also seen as important, they were secondary considerations to the basic demand that a product be reliable.[4]

Let us now consider several problems that face designers as a result of the accelerated pace of technological innovation and economic competition as well as of rising user demands for quality products. First is the problem of coordinating different aspects of the design process, as well as the relation of design and manufacturing within a company. Daniel Whitney addressed this in the *Harvard Business Review* as follows:

In many large companies, design has become a bureaucratic tangle, a process confounded by fragmentation, overspecialization, power struggles, and delays. An engineering manager responsible for designing a single part at an automobile company told me that the design process mandates 350 steps—not 350 engineering calculations or experiments but 350 workups requiring 350 signatures.[5]

Whitney identifies numerous problems within the production process as the result of not understanding how or when to involve the various designers—the manufacturing engineers, the repair engineers, or the styling department. When design decisions are not integrated, informed, and balanced, he says, difficulties arise. The solution he promotes is multifunctional teams, which may typically include up to twenty members. Among the names given to this team approach are "simultaneous engineering" and "concurrent design."[6]

The team approach emphasizes the necessity within a large company for an overview of the entire production process. Each person involved needs to have a basic understanding of how their contribution relates to the entire process and must be willing to modify their own recommendations in order to achieve the good of the whole. Whitney quotes an engineer from the Japanese company Nippondenso who calls the factory [in Whitney's words] "a carefully crafted fusion of a strategically designed product and the methods for making it."[7] Whitney looks at design broadly. He argues that strategic product design infuses every aspect of production. "It forces managers, designers, and engineers to cross old organizational boundaries," he claims, "and it reverses some old power relationships."[8]

The problems companies face by not integrating the different participants in the design process are further described by James Dean Jr. and Gerald Susman in another *Harvard Business Review* article, "Organizing for Manufacturable Design."[9] The authors note that a fundamental requirement for changing the design process within a company is changing the *structure* of the or-

ganization. Among the strategies for doing so is the introduction of a person known as "the integrator." This person's role is to work with designers to insure that their designs take into account all the factors of production to which their projects will be subjected. But the authors point out the difficulty of finding integrator types. "Manufacturing and design engineers are the products of separate and distinct degree programs," they write. "There is usually little opportunity to broaden their provincial outlook to include the other groups' concerns."[10] What the above examples make clear is the importance of a common conception of the product within a process of design and manufacturing. This can only result from a greater understanding and collaboration among the different participants in the process. As Dean and Susman indicate, the differences between professionals are instilled within professional education. These differences tend to reinforce the isolation of separate segments of the design process from each other. The results are production time lost through poor communication and money wasted in attempting to overcome misunderstandings.

A second, but related, problem area is the organization of innovation. Don Kash states that innovation includes "not only the discovery and invention phase but also the development, production, and marketing of new products and processes."[11] He argues that the time of the single inventor/entrepreneur in the high-tech area is over and that we now depend on a wider range of information, knowledge, and skills for product innovation than any one person can assimilate. Here again we face the issue of integrating individual professional expertise into team efforts. But Kash, in his definition of innovation, introduces a factor I have not yet discussed: the limitation of a professional formation that does not foster the capacity for invention. Again, when we look at the history of product design, we find that few designers have come up with new products. Most have refined or redesigned existing ones. The separation of design from invention has been a loss to the profession of product design and has contributed to its struggle for relevance within the larger production process. This situation has also resulted in a number of missed opportunities. In 1976, Robert N. Noyce, chairman of the large electronics firm Intel, noted that there were over 25,000 potential applications of semiconductors but "active designs are being pursued in only about 10 per cent of them."[12]

In the way we tend to separate professions, inventing is separate from most forms of design.[13] Invention is prevalent in the artistic forms of design such as fashion where its results are aesthetic. But in more technical areas, it is not considered part of the designer's job. The Japanese inventor Yoshiro Nakamatsu, a man virtually unknown in the pantheon of great product designers, exemplifies the qualities of mind that characterize the process of invention. He holds approximately 2,360 patents, more than twice the number held by

Thomas Edison. Nakamatsu thinks in terms of needs to be met before he concerns himself with product forms. In some cases, such as the floppy disk, the form is the least significant part of the invention. The disk is essentially a storage facility for bits of information. But Nakamatsu is also responsible for such low-tech products as the small plastic siphon-pump that millions of Japanese housewives use to transfer soy sauce from twenty-gallon drums to smaller containers.[14] Nakamatsu's process of invention, like that of most inventors, depends on two basic skills; applying the requisite technical knowledge to bring a product concept to the prototype stage where it can be patented and understanding the needs of users.

The latter is a third major problem area that faces designers. Across the spectrum of different design practices the user comes into the process in a number of different ways. In those practices most closely related to art, such as fashion design, accountability to the user is different from mechanical or electrical engineering or computer science. When a fashion designer creates a dress, a high value is placed on its style. Aside from producing a garment that fits, the designer is primarily accountable to the user's taste. But a software designer must engage the user in a different way. The interaction between the user and the software is a more complex process, and the designer has many more factors to consider. Software is a product in which the user participates and the designer must understand the user's behavior in order to create a satisfying experience. The problems of "interface design" are becoming central to the use of a wide range of smart products whose functions must be activated by the user through the manipulation of a control panel of some sort. As we observe the growing number of smart objects that users must learn to operate in order to get what they need from them, we can see how important the human/machine interface is. Problems of form take a back seat to problems of communication. Ben Schneiderman characterizes the interface designer's task as follows:

Successful designers go beyond the vague notion of "user friendliness" and probe deeper than a checklist of subjective guidelines. They must have a thorough understanding of the diverse community of users and the tasks that must be accomplished. Moreover, they must have a deep commitment to serving the users.[15]

This commitment must also extend beyond the manipulation of the product to the entire system that insures its effective maintenance. Elsewhere I have called this system the "product environment," which is the set of conditions that satisfies all the requirements for a satisfactory "living" relationship with the product. The product environment is essentially an aftermarket aspect of the overall cycle of product development and use. As the previously men-

tioned opinion poll indicated, users place the highest value on product relia-bility. This means that the product must be ready to use when needed. Thus, any peripheral components must be easily obtainable, repairs must also be easily completed, and satisfactory support readily provided. This product en-vironment, which is an essential part of the product-user relationship, must also be designed, and the various difficulties that the user might have with the product need to be anticipated.[16]

I would argue that most designers have not been sufficiently prepared to address the problem areas described above and additional ones whose under-standing would greatly improve their participation in the production process. There are certainly more problems that one might discuss, but those already mentioned suffice to reinforce my argument that a rethinking of design educa-tion and practice is needed.

My comments on the limitations of narrowly defined design specialties and subspecialties are intended to help promote other ways that designers might be educated to address new problems. A designer's assets are knowl-edge, information, sensibility, and skills. We normally think of these as cate-gories that add up to specific professional formations such as product design, graphic design, architecture, or mechanical engineering. But what would hap-pen if we began to identify and separate the knowledge, information, sensibili-ties, and skills that now make up the professional paths we know? We might be able to eliminate some and recombine others into new professional formations that would better prepare designers to address contemporary problems.

We also need to place a greater focus on integrated research in design education. Although we currently lack good research models, a large amount of research is presently scattered across various fields and disciplines and re-mains to be combined within a new framework. The first step in developing a new research agenda is for various designers to initiate dialogues with col-leagues in related fields. If done with the objective of widening the community of discourse, the exchange of experiences could have fruitful results.[17] Design-ers desperately need to learn how to talk with colleagues who do related work. Outsiders have entered different professional fields when they have felt wel-come and when they have sensed they had something to gain through dialogue with a field's practitioners. To the degree that an insufficiently developed pro-fessional mentality prevails in design, such dialogues are unlikely to occur. In terms of priorities, the design professions must first generate meaningful dia-logue among themselves before they can expect others to join them with any sense of commitment.

Creating conversation communities is the necessary first step. Even when we can see epistemological relations between seemingly different areas

of knowledge, there nonetheless remain many obstacles to bringing them together in applied forms. These obstacles, as I have argued, have to do with the self-perceptions of professionals, the maturity of their internal dialogue, the breadth or narrowness of the problems with which they are concerned, and their openness to collaborate with peers outside their disciplines.

Because design's broad role in society has not been sufficiently conceptualized, it still seems a marginal subject to many people. But challenging transformations in the factory, the office, the home, and the global economy make clear that a new approach to design is needed more than ever.

1 By contrast, nineteenth-century engineering education addressed issues of form and technique. See Yves DeForge, "Avatars of Design: Design before Design," in *The Idea of Design: A Design Issues Reader*, eds. Victor Margolin and Richard Buchanan (Cambridge: MIT Press, 1995), 21–28. The article originally appeared in *Design Issues* 6, no. 2 (spring 1990): 43–50.

2 One exception is in Italy where, until recently, almost all the outstanding product designers were architects.

3 Alan Samuels has described an interesting interdisciplinary project at the University of Michigan, which was funded by the National Science Foundation in the late 1980s. Students from the departments of industrial design, mechanical engineering, aerospace engineering, electrical and computer engineering, and industrial operations engineering were divided into interdisciplinary teams that designed three projects during the three years of the study. A series of observations about the design process was generated that included the following: "Designers of various kinds are taught discipline-specific methodologies, tools and skills resulting in specific and biased points of view. These biases often block logical attempts at collaboration. We are taught now not to hear and work with others" (44). See Alan Samuels, "Observations on the Designing of Projects, Processes, and Products," in *Design at the Crossroads: A Conference Report*, eds. Marco Diani and Victor Margolin, CIRA Seminar Monograph Series, no. 2 (Evanston: Northwestern University Center for Interdisciplinary Study in the Arts, 1989), 36–45.

4 "Making It Better," *Time*, November 13, 1989, 80.

5 Daniel E. Whitney. "Manufacturing by Design," *Harvard Business Review* 66, no. 4 (July–August 1988): 83.

6 Ibid., 85.

7 Ibid., 88.

8 Ibid., 5.

9 James W. Dean Jr. and Gerald I. Susman, "Organizing for Manufacturable Design," *Harvard Business Review* 67, no. 1 (January–February 1989): 28–36.

10 Ibid., 29–30.

11 Don E. Kash, *PerPetual Innovation: The New World of Competition* (New York: Basic Books, 1989), 62.

12 Robert N. Noyce, cited in A. A. Perlowski, "The 'Smart' Machine Revolution," in *The

Microprocessor Revolution, ed. Tom Forester (Cambridge: MIT Press, 1981), 122.

13 Peter Whalley offers an excellent account of the independent inventor's difficulties in "The Social Practice of Independent Inventing," *Science, Technology, & Human Values* 16, no. 2 (spring 1991): 208–232.

14 "Dr. NakaMats Has Inventive Knack That He Finds Lacking in Americans," *Chicago Tribune*, October 1, 1989.

15 Ben Schneiderman, "Designing the User Interface," in *Computers in the Human Context*, ed. Tom Forester (Cambridge: MIT Press, 1989), 167.

16 I develop this concept in my article, "Expanding the Boundaries of Design: The Product Environment and the New User," in *The Idea of Design: A Design Issues Reader*, 275–280.

17 Augusto Morello, President of the International Council of Societies of Industrial Design (ICSID) envisions the new designer as one who has the specific ability to work within a wide community of discourse. "The individual contributions of (old) designers will survive," he writes, "if—and only if—they are available for a new kind of profession, that of a meta-designer—or a designer of interfaces between creative bodies, people and computers." Augusto Morello, "The (New) Design Profession," *ICSID News* 3 (June 1999): 3. Helen Rees, former director of the Design Museum in London, spoke earlier at the International Design Congress in Glasgow of a "Renaissance designer," which she references to artists of the Renaissance who "were at the heart of a new movement of intellectual enquiry, which was primarily preoccupied with the rights and responsibilities of the individual in a just society." Helen Rees, "What Makes a Renaissance Designer?" in *Design Renaissance: Selected Papers from the International Design Congress*, ed. Jeremy Myerson (Horsham: Open Eye, 1994), 101–104.

Showroom, AS Tiram Produkter, Karasjok, Norway, 1994. AS Tiram Produkter is a small company that markets outdoor clothing and camping equipment designed by its owner Marit Kemi Solumsmoen.

There is no discipline in the world so severe as the discipline of
experience subjected to the tests of intelligent development and
direction. JOHN DEWEY, *EXPERIENCE AND EDUCATION*

THE
EXPERIENCE
OF
PRODUCTS

INTRODUCTION Questions of how humans give value to products are of in-
creasing concern to manufacturers. Consumers are often bewildered by the
vast, constantly changing array of products in the marketplace, while they are
also more sophisticated than ever before and are putting powerful demands on
manufacturers for product quality. Because competition is so intense, issues of
user satisfaction that manufacturers once ignored can now determine the suc-
cess or failure of a new product.

　　　The current attention to user issues also has implications for those more
involved with the discourse about products than with their design and manu-
facture. It provokes the need for this discourse—which has traditionally fo-
cused on the qualities of things—to include the nature of experience as well.

　　　Things have been the principal topic of design discourse since the early
nineteenth century. Debates developed around the integrity of materials, the
refinements of form, craft versus mass production, and the relation between
form and function.[1] To the degree that the discourse about things has domi-
nated design thinking, insufficient attention has been paid to the relation be-
tween things and the experience of users. Dieter Rams, who spent years as
the chief designer for the appliance company Braun, hinted at this in a lecture
of 1983:

Rigid functionalism of the past has been somewhat discredited in
recent years. Perhaps justly so because the functions a product had
to fulfill were often seen too narrowly and with too much puri- 38 . 39

**tanism. The spectrum of people's needs is often greater than de-
signers are willing, or sometimes able, to admit. Functionalism may
well be a term with a multitude of definitions; however there is no
alternative.²**

While Rams acknowledged the importance of user considerations in de-
signing a product, he did not go far enough in questioning how the product be-
comes part of the user's experience. This question is the subject of a new dis-
course that promises to have important applications for design practice and
design studies in years to come.

THE NATURE OF EXPERIENCE To describe the idea of experience, I will
draw heavily on the work of the American pragmatist philosopher John Dewey.
Experience was a central topic of philosophic reflection for Dewey, who did not
see it simply as a category to be explored abstractly. Instead, he examined it
within a study of institutions and practices that might be changed in order to
improve its quality. In his seminal book *Art as Experience,* which comprises a
cycle of lectures he gave at Harvard University in 1931, Dewey attempted to
bring art closer to the experience of daily life. And in his small book of 1938, *Ex-
perience and Education*, he argued for a type of progressive education that
would be more empowering to students because it raised the issue of how they
could use their prior experience and knowledge in the classroom.³

Most important in Dewey's discussion of experience is his statement that
it is not something that is exclusively internal to the individual but is affected
by the environment. As he writes in *Experience and Education*:

**In a word, we live from birth to death in a world of persons and
things which in large measure is what it is because of what has
been done and transmitted from previous human activities. When
this fact is ignored, experience is treated as if it were something
which goes on exclusively inside an individual's body and mind.⁴**

Dewey cites roads, transportation, tools, furniture, and electric power as exam-
ples of things that contribute to the conditions of experience. Taken further, we
can say that design—the conception and planning of material and immaterial
products—is central to the creation of these conditions.

According to Dewey, persons and things comprise the environment in
which we are situated. This environment is not static but is constantly being
transformed. We engage with the persons and things in it to create experiences.
"The environment, in other words," says Dewey, "is whatever conditions inter-
act with personal needs, desires, purposes, and capacities to create the experi-
ence which is had."⁵ Experiences are personally and socially continuous in that
"every experience both takes up something from those which have gone before

and modifies in some way the quality of those which come after."[6] Thus, experience can become richer and deeper the more that awareness and understanding are brought forward from the past.

Dewey employs the term "interaction" to characterize the relation between the individual and the environment that results in experience. He says that this relation is composed of both objective and internal conditions. The objective conditions are those in the environment, while the internal ones are within the individual. Dewey calls the interplay of these two sets of conditions a situation. We live, he says, in a series of situations. For Dewey, the word "in," as in the phrase "to be *in* a situation," designates a location in relation to the environment. Thus, as he says,

The conceptions of *situation* and of *interaction* are inseparable from each other. An experience is always what it is because of a transaction taking place between an individual and what, at the time, constitutes his environment.[7]

Dewey developed his concept of the situation in the context of a proposal for educational reform that would make schools more attentive to the internal conditions students bring to the learning environment. He spoke, in fact, about the conditions for learning as if they were the results of design. This accords with design critic Ralph Caplan's concept of "situation design," which he says consists of "seizing on a purpose; defining the situation or problem; identifying constraints and organizing materials, people and events in a way that can be modeled and visualized in advance."[8]

Healthy human development, according to Dewey, depends on the individual's capacity to integrate successive experiences with one another. This, in turn, requires situations that make sense to the individual and in which the individual can have a satisfying experience. As Dewey notes: "[A]ttentive care must be devoted to the conditions which give each present experience a worthwhile meaning."[9]

But, says Dewey, not all encounters between the individual and the environment result in an experience. An experience must have a narrative coherence that "carries with it its own individualizing quality and self-sufficiency."[10] For a situation to result in an experience, it must have closure, as well as a unity that gives it a sense of particularity. An experience is not generic. It has a discrete identity with its own qualities. This identity gives the experience meaning. Dewey does not describe an experience as a tangible entity. Instead, he accounts for it in terms of concrete conditions that produce its qualities. These conditions may derive from people or things.[11]

Therefore, a discourse about experience as it relates to design is about the human interaction with products—material or immaterial things that are

conceived and planned. This interaction has two dimensions: *operative* and *reflective*. The operative dimension refers to the way we make use of products for our activities. The reflective dimension addresses the way we think or feel about a product and give it meaning. Of course the two dimensions work together, since we don't use a product without considering what that use means to us.

The cognitive psychologist Donald Norman has addressed the operative dimension of product experience in his book *The Psychology of Everyday Things*, in which he argues that many products are designed without the user in mind.

Why do we put up with the frustrations of everyday objects, with objects that we can't figure out how to use, with those neat plastic-wrapped packages that seem impossible to open, with doors that trap people, with washing machines and dryers that have become too confusing to use, with audio-stereo-television-video-cassette-recorders that claim in their advertisements to do everything, but that make it almost impossible to do anything?[12]

As Norman makes clear, products that frustrate the user add to the stress of life. His focus on the operative dimension of product design highlights the way products that do not create satisfying conditions of use contribute to a negative experience for the user. In Dewey's terms, these products do not contribute to a complete experience.[13]

An unworkable operative interaction with a product is like the unsuccessful forms of didactic pedagogy criticized by Dewey in *Experience and Education*. The knowledge of the student he expected a capable educator to have is similar to the understanding of the user that one would like a successful product designer to possess. Dewey stated that in order to influence a student's education, the educator must create an environment that will "interact with the existing capacities and needs of those taught to create a worth-while [*sic*] experience."[14] Dewey's concept of progressive education shifted the locus of pedagogy from the teacher to the student. Dewey understood that the end goal of education is learning rather than teaching and that the motivations and energies of the student need to be central to the educational process. Therefore, an environment of products that are satisfying to use will contribute to the healthy development of the individual.

And yet, there is often a discrepancy between the user who is envisioned by the designer and manufacturer and the person who actually engages with the product. The designer and educator Bernhard Bürdek has described this discrepancy well in a paper entitled "Design and Miniaturization":

The telephone set in my office has 30 push buttons; the system is so intelligent that I can use just some two or three basic functions. I

**don't want to remember all [the] other[s] and I really don't want to
read the user instruction during a telephone call.**[15]

Experience becomes relevant here in several senses. Professor Bürdek as a user does not have sufficient experiential knowledge to access the full range of functions in his telephone system. The product capabilities have outstripped his experience, and he must then either ignore the added functions or make an effort to learn how to use them, something he is reluctant to do. The action that results from his relation to the telephone system is thus limited to his *experience as knowledge*. However, there is another sense in which experience comes into play and that is the sense of *experience as satisfaction*. Professor Bürdek has the intellectual capacity to learn functions, but this does not promise him any satisfaction so he refuses. As a consequence, he uses the telephone system in a limited way and would do just as well with one that had fewer functions.

The designers of the telephone system had an understanding of mechanical function as well as its relation to possible actions. However, they did not recognize the importance of experience when they anticipated the user's relation to the system. In the above mentioned paper, Professor Bürdek argues that products must become easier to use. Although he does not talk explicitly about experience, the implication of his argument is that designers will improve the relationship between users and products as they better understand how to build on the experience people already have instead of making extravagant demands on them to acquire new knowledge.

Identifying the operative dimension of a product interaction is easier than characterizing its reflective one. In general, the criteria for determining the effective operation of a product can be clearly articulated. They are described in the advertising literature and in the instructions that come with products. When we compare our expectations of product services with our ability to access them, we can give our operative experience with the product a value. This value can also be understood by others who use the same criteria to measure it.

However, we need to be aware that the *operative parameters* of a product differ from its *reflective parameters*. The former are limited by the configuration of the product itself. We cannot do more with the product than this configuration allows. But there is no limit to the parameters for reflection. We can think or have feelings about a product in any way we choose, whether we focus on its operative value, its poetic qualities, or its social significance. These qualities will not be equally important to every individual and will be present in their awareness in varying degrees.

We can see this in the remarks designer Massimo Vignelli made at a panel discussion on the future of museums held in Chicago in 1987. Referring to the chair that Ludwig Mies van der Rohe designed for the Tugendhat House

in Brno, Czechoslovakia, Vignelli celebrated its aesthetic value rather than its functional qualities:

I sit on a Brno chair all day long, not the most comfortable chair. There are a thousand other chairs done by friends that are terrific and much more comfortable, but no one has that class. All the time my mind gets massaged by that class![16]

Experience exists in the individual's consciousness as the result of his or her interaction with a product. Therefore no two individuals will have an identical experience. Each person will bring different internal conditions to a use situation and will thus give their interaction with the product a meaning that belongs only to them.

Vignelli's experience with the Brno chair is one example. I can offer another that is more personal. Some years ago my mother gave me and my wife, Sylvia, a service of Czechoslovakian dinnerware that had belonged to my grandmother. When we use it to serve a meal, we and our guests share a judgment of its operative value. The dinnerware enables us all to eat and drink. We may also share a recognition of the dinnerware's aesthetic value and a common appreciation of its age. Beyond that, Sylvia and I share the experience of having chosen the dinnerware for different social occasions, and we may recall those occasions whenever we use it. Sylvia may also find meaning in using dinnerware that has a long history in my family, while for me the dinnerware represents a connection to my parents and grandparents. This connection will be reinforced for my daughter, Myra, when Sylvia and I pass the dinnerware on to her.

It is evident from this example that an engagement with a product will have different degrees of fullness, depending on how an individual's interaction with it resonates with his or her own sensibilities and past experience.

THE PRODUCT MILIEU To pursue the question of how products contribute
to human experience, it is necessary to consider the larger social sphere in
which they exist. I have coined the term *product milieu* to characterize the ag-
gregate of material and immaterial products, including objects, images, sys-
tems, and services, that fill the lifeworld.[17] This milieu is vast and diffuse, fluid
rather than fixed. It is always physically and psychically present and consists of
all the resources that individuals make use of in order to live their lives. The
products in the lifeworld each have their own history. Their lives span different
lengths since transformations in the milieu take place at varying rates in differ-
ent product fields. These changes move faster in the software field, for exam-
ple, than in the field of domestic furniture, where older pieces are frequently
valued more highly than new ones. We therefore engage simultaneously with
products developed at different historical moments. They embody different de-
grees of operational simplicity or complexity as well as the potential for differ-
ent kinds of satisfaction.

As a concept, the product milieu is most useful in reinforcing the fact
that engagement with products is a central part of human development. And
questions of how products enter the milieu, how they find their way to users,
and what users do with them are much more closely linked to psychology, soci-
ology, and anthropology—disciplines that study human development—than we
have previously recognized.

The product milieu does not itself constitute a structured set of condi-
tions to which individuals adapt. Instead, products within the milieu are drawn
together in situations through human action. Consider, for example, the way a
bank designs the totality of its services. These range from ATM machines on
the streets to the creation of financial products for its customers and the organ-
ization of electronic systems to keep track of accounts. Frequently such serv-
ices are designed without any vision of an end-user's well-being, and conse-
quently they can be easily seen as hostile or even inhuman.

Even when the dominant interaction in a situation is with human beings,
it is products such as automobiles, airplanes, telephones, or computers that
have made people accessible, and it is frequently products that constitute the
basis for the interaction with them. Situations vary as we change the products
with which we interact, but our experience with them is continuous. We shift
from one situation to another, one product to another, as we are motivated by
our personal projects.

I have divided the product milieu into three separate but related spheres:
civic and state projects, the market, and the sphere of independent design,
which embraces those products that people make for themselves. Our experi-
ence with products is connected to each of these spheres. In them we have 44 . 45

varying degrees of control over what products we will engage with and how we will do it. We may buy a car of our preference but work in a building we don't like and follow a set of work rules or protocols that bother us. We can only alter some products, such as buildings, with difficulty and expense, or not at all, but others such as appliances can be easily exchanged for better ones.

The idea I want to introduce here is that we have an ongoing engagement with products of many types. Each day we are in numerous situations with products, and these situations result in experiences of varying satisfaction. The larger the scale of a product, such as an office building, the less chance we have to modify it. We have the most control over products we acquire in the marketplace or make ourselves.[18] Once obtained or made, the product then becomes part of our personal portfolio, or product web, which may include several hundred different items ranging from material goods such as clothing and appliances to immaterial ones such as telephone networks.

We have become the managers of large product webs that require knowledge, energy, and finances to operate and support. This necessitates our familiarity with warranty agreements, service centers, and retail outlets for fax paper, batteries, printer cartridges, floppy disks, and answering machine tapes. Maintenance, for the most part, must be handled by professional repair services. The considerable time we spend on the management of our product webs thus becomes an ever larger part of our experience with products. We therefore need to account for this management activity when we assess the contribution of products to the quality of experience.[19]

THE PRODUCT CYCLE Products enter the product milieu and make their way through it in a series of stages that I call the *product cycle*. Every product goes through a process of development and use that begins with its conception, planning, and manufacturing, moves to its acquisition and use, and ends with its disassembly or disposal.[20] For some products the cycle is extremely short, while for others, such as my grandmother's dinnerware, it can endure for generations. While this cycle maps most easily onto the circulation of products in the market, it also makes reference to products that people create for themselves, frequently with materials obtained through the market.

In recent years, designers have sought to incorporate more knowledge about the product cycle into the process of conception and planning. This has been prompted by the considerable demands that new smart products make on the user as well as by growing environmental concerns. As designers have to consider additional aspects of a product, the act of design becomes a more complex activity. Thus, product design is now frequently done by teams of professionals that include, along with designers and engineers, social scientists who

are trained to study the characteristics and qualities of human experience.[21]

The quality of experience that a product is likely to offer is anticipated by users for whom its discovery and acquisition is the first stage of their engagement with it. The product may be new, and the user may see it in a retail outlet or learn about it through an advertisement.[22] Or a used product may turn up at a yard sale, a secondhand store, a flea market, or on one of the growing number of Web sites such as eBay where goods are bought and sold.[23] Before the act of discovery culminates in an acquisition, there is also a stage of assessment during which the prospective user makes a judgment about the potential value of the product to him or her. The individual's anticipation of the experience a product may provide is a powerful factor in his or her motivation to acquire and use it. Anticipation is not only prompted by advertising and promotion but also by prior experience. Someone who has had a satisfying interaction with a product may strive for a continuity of experience by acquiring a new version or model of it as in the purchase of a software update.[24]

In our relations with products, we need to understand them before we can access their services. We do this initially through an *interface*, which I define here more broadly than the interface on a control panel or a computer screen. The interface in this broader sense is the set of characteristics that define a product for us. In a simple product like a cup, for example, the interface is its shape. From experience with previous cups, we know the cup interface well enough to recognize it even in an extreme variation. Because the cup is a common object that has changed little over time, we can rely on prior cultural knowledge rather than special learning to establish an operative relation with it.

In Dewey's terms, the shape of a cup constitutes the objective condition of a situation in which we encounter it, but the internal condition we bring to the situation may change the use we make of it. Depending on our past experience with cups and objects that are cuplike, we may use the cup for drinking, for transferring a substance from one container to another, or even for holding pens and pencils. In the first two instances, we use the handle for lifting the cup, while in the last instance, we ignore the handle and treat the cup as if it were a simple cylindrical container.

A simple interface can be just a shape, but as interfaces become more complex, the relation between our initial perceptual encounter with them and the knowledge of how to make them work requires specific learning above and beyond our prior cultural experience. Let's compare the cup shape with the keyboard of an early typewriter. When typewriters were first introduced in the United States and Europe, cultural experience was not sufficient for individuals to operate them without training, so new courses had to be organized to teach people how to type. Such courses became part of the public school curriculum

and were offered as well in special private schools. In fact, a subindustry to teach typing, including the creation of books and course materials, developed. While learning to type was and is an experience in itself, it was preliminary to accessing the typewriter's service, which was imprinting letters on a blank page. For many people, the skill of typing then formed part of the cultural knowledge that later enabled them to quickly learn to use an expanded computer keyboard.

With products that require less knowledge for their operation, learning usually occurs by following cues within the interface. These are known in the psychological literature as "affordances." As Norman has pointed out, products often fail because their interfaces provide no affordances that make reference to a user's prior cultural knowledge. After learning to manipulate knobs and dials on radios, people could then figure out newer interfaces on televisions. But the numerous functions on a VCR interface or the plethora of buttons on a typical television remote control device have outstripped the average person's cultural knowledge and demand specialized learning that many individuals refuse to undertake. These are examples where the interface's affordances are poor.

By the 1980s, it became evident to manufacturers and designers that more complexity was not necessarily better. They learned that product use should depend as much as possible on prior experience rather than on special learning processes. This has been proven by the widespread appeal of iconic computer interfaces. Eliminating a document by dragging it to a trash can was an attempt to replicate visually a cultural activity that we are already familiar with. Actually, the use of familiar icons in interface design accords with the tenets of progressive education that Dewey espoused by creating situations in which the student can bring more of his or her prior experience to the learning process.

Where the product interface does not provide sufficient affordances for a pragmatic engagement, we have to depend on some type of instruction to show us how to access the product's services.[25] Manuals, handbooks, or software program help documents teach us to use the product. A complex interface such as that in an automobile will not only include knobs and buttons but may also embody instruments such as gearshifts, keyboards, remote control devices, and steering mechanisms that we must learn to manipulate. This requires the coordination of cognitive and physical skills.

When we are able to access a product's service, we have established a successful relation with it and this results in a satisfying experience. Satisfaction comes from our ability to make the product work, which then enables us to carry out actions that are important to us. Products thus provide the conditions for us to grow as human beings by helping us to transform our projects into actions. They also affirm our competency to master the devices we require for this purpose. When products don't do this, as Norman argues, they prevent us from act-

ing as we wish, while also sending a message that may challenge our sense of competency.[26]

The final part of the product cycle to which we have given little thought until recent years is disposal. As long as products are available for use, we can say that they are in circulation. To dispose of a product means to take it out of circulation. Unlike the "throw-away aesthetic" espoused by Rayner Banham and Pop design theorists in the 1950s and 1960s, longevity is now a desired value of products, and some designers and manufacturers are devoting much thought to the question of how to extend product cycles so that products can remain in circulation for longer periods of time.[27] Actually, longevity occurs in many ways. The designation of a product as an antique or collectible keeps it circulating because it has become a token of cultural capital. Other products intended for reuse circulate through secondary and tertiary markets such as yard sales, junk dealers, and wholesalers of secondhand goods. In countries in which new products are either not available or are too expensive, older ones are kept functioning through extensive repair networks. American automobiles made in the 1930s and 1940s that are still on the roads throughout Cuba are a good example of this.

In addition to these activities, however, there is a new consciousness regarding product recycling and reuse. The terms *ecodesign* and *sustainable design* now characterize products that embody a design strategy that is consistent with the values of minimizing waste, using less energy, and reducing the amount of material we relegate to landfills. Tony Fry, director of the EcoDesign Foundation in Sydney, Australia, writes in the introduction to the catalog for *Green Desires,* an exhibition of products designed with ecological concerns, that

[t]he desire of Green Desires is for a desire for life. A desire for on-going well being . . . If it is to become a means to power change,

which it can, this desire has to be turned into things we see and want. It has to be directed toward production, products and lifestyles.[28]

Implicit in Fry's call for ecologically sound products is a concern for keeping products and their components in circulation. Thinking ecologically has deepened our experience with products by relating their use and maintenance to the task of sustaining the planet. It has provided a fresh look at the product cycle and posed new arguments for extending product life.

USER EXPERIENCE AND VALUES For designers and design researchers, Dewey's theory of experience opens up a rich new space for reflection. Once we acknowledge the inextricable relation between the quality of products and the way we experience the world, we realize how much there is to learn about the way products influence our lives. In most instances, product innovation, whether a new material object or a company voice mail system, occurs with insufficient awareness of how it affects the experience of users. There is, on the one hand, an extremely liberating aspect to the wide availability of goods and services in the global product milieu. But at the same time, there is a technological determinism that closes out choices for users and frequently obliges them to interact with inhospitable systems of service delivery or product access. The rapid increase of the learning curve for mastering new products may sit well with young people but becomes taxing for those who are older and more accustomed to easier access to the products they need. Thus, many people in technologically advanced societies feel progressively alienated from systems on whose procedures and devices they depend but which they find increasingly difficult to use.

What is problematic about the current pace of innovation is that there is little discussion of the end-user's well-being. Technological innovation frequently makes more work for the end-user rather than less. No one is more efficient than a human telephone operator who can connect a caller to anyone within a company in a matter of seconds. Mechanical answering systems, which have largely replaced these operators, save money for the companies but create more work for the callers who must wade through extensive menus of options before getting to the person they need to speak with. Often there are long delays for which no one is accountable.

The shift from human exchange to mechanical and electronic exchange may increase efficiency, but it also operationalizes social life in a new way. Those with no time for socializing welcome the most direct route to obtaining goods and services. Amazon.com may have every book a buyer wants, but it precludes an agreeable conversation with a knowledgeable bookseller even though Amazon may provide reviews and connections to other readers of the

book one is seeking to purchase.

Unfortunately, we have no norms for attaching shared values to user experience. While people with no spare time may welcome on-line shopping, others who prefer a neighborhood store lose this opportunity because the larger service providers gobble up or shut out the small ones. In an open society, it is difficult to legislate lifestyles, but increased public discussion and debate about the quality of experience might at least make some people more conscious of how their own lives are being affected by the rapid-fire creation of new products, services, and environments that surround them.

We also need to think more about how designers can gain additional knowledge of users. First, designers are users themselves and can draw on their own satisfaction or frustration with existing products to create new ones. They must therefore learn to reflect more critically on their own experience so they can make better use of it as a resource for ameliorating the experience of others. Second, designers and users sometimes form close communities that we can call product cultures. Two examples can be seen in the fields of software development and cycling. In both cases, designers and users share a great deal of experience as knowledge and experience as satisfaction. They have an understanding that enables extensive feedback from users to modify and debug new products quickly. Software developers recognize the value of this common interest by creating electronic bulletin boards where users can share their experiences with new products. In the bicycle culture, some of the outstanding designers of new bicycles and cycling equipment are themselves cyclists who draw consciously from their user experience to create new products such as the titanium bicycle produced by Merlin Metalworks in Boston. Third, designers employ market research about user motives and behavior. This ranges from surveys and focus groups, which produce responses according to prescribed patterns of questioning, to ethnographic techniques that generate data on how people relate to products.

While the development of new research methods has certainly been helpful in improving product quality, it produces a different kind of knowledge than that derived from direct experience. The value of direct experience, for example, is evident in George Sturt's book *The Wheelwright's Shop,* where Sturt describes the community of craftsmen who made farm wagons in England at the turn of the nineteenth century and in the early part of the twentieth. These craftsmen, as Sturt describes them, did not have clearly articulated methods. Their expertise came directly from personal knowledge and was never codified. It included not only the craft of making wagons but also a knowledge of how to satisfy a customer's needs for wagons that functioned on specific terrains.[29]

I am suggesting here that product development is a combination of 50.51

experience and technique rather than technique alone. One of the important challenges, then, as we continue to talk about designer-user relations, is how to recognize the value of user *and* designer experience for the development of new products, not only those designed within the socially constructed professional design culture, but others as well.

I have already identified users as social actors who consider a product in relation to their own plans and activities. Many people prefer to maintain established patterns of product use while others continually seek the latest devices and fashions. These differences in lifestyle have been well documented by market researchers. At the same time, everyone accumulates experience that is available for the evaluation of existing products and the invention of new ones.

THE CULTURE OF PRODUCT DEVELOPMENT There is clearly a need for a new theoretical model that can help us use the power of our collective experience to create more satisfying products. The development of such a model is no easy task because it requires much more information about people and products than we now have. Unfortunately, social scientists have paid little attention to the product milieu. Sociologists and anthropologists have concerned themselves with issues of consumption rather than with issues of use.[30] We have no theory of social action that incorporates a relation to products, nor do we have many studies of how people acquire and organize the aggregates of products with which they live their lives. When we consider how thoroughly documented other types of activity such as political or sexual behavior are, we can see how marginal the subject of product use still is.[31] Likewise, philosophers have examined themes of human happiness such as the love of beauty, justice, or goodness without linking these to the world of material and immaterial products.[32] Dewey is an exception. In *Experience and Education,* he strongly emphasized the contribution of material things to the construction of experience.

We understand best those aspects of human culture that have been heavily researched and debated because they are seen as being important to our collective self-understanding and well-being. Social polices in education, health care, and now the environmental domain are based on thousands of research studies that are essential to profile a problem and suggest solutions. But comparable research has not been done on product use, and consequently designers do not have sufficient information to go on when developing new products. Exceptions, of course, are the studies done by large companies such as Sony and Philips, but these are always carried out with corporate self-interest as the principal motivating factor.

The lack of research on product use has resulted in a number of significant consequences:

1 We don't know enough about the relation between products and how people construct ideals of human happiness. Technological innovation and market forces drive much new product development, while advertising offers models of the good life. These activities are moving at such a rapid pace that they outstrip our ability to assess their social, psychological, and spiritual value before the next wave of innovation occurs.

2 Poorly researched products that fail in the marketplace waste valuable financial resources, frequently acquired from lending institutions and investors who might have put their money into something more productive and socially valuable.

3 We have too few studies of technology innovation on which to base proposals for social policies or legislation that would link human well-being to the presence or absence of particular products. One value that has been extensively researched is safety, and various kinds of legislation have been passed to prevent unsafe products from reaching the marketplace. The requirements for seat belts and airbags in automobiles are one result of this process. Now we await further legislation to address the problem of limiting the public sale of handguns and assault weapons.

4 We have no systematic way of developing a social needs inventory to stimulate the invention of beneficial new products.

5 There is no pool of studies that cultural researchers in related fields can use to better understand the role of products in human society.

An obvious task then, if we seek to understand better the essential relation between designers, products, and users, is to encourage large-scale research on the subject of product use.[33] This would require multiple efforts in all parts of the world. We also have to encourage and stimulate lay people to participate more actively in creating the product milieu. One way to do this is through open competitions for new products on set themes. Product invention could become much more of a public activity and could generate a public debate about how products contribute to human happiness. Such activities might be organized by design centers, municipalities, and museums.[34] A more widespread involvement in product design could also generate new opportunities for small businesses.[35]

Besides the creation of such opportunities, we also need better ways to support struggling designers who have unusual ideas and who work on a small scale. Design culture needs to open itself up to recognize the value of such efforts. I can offer one example here. In the summer of 1994, I traveled with my wife and daughter in Scandinavia. When we were in Lapland we wanted to meet some Sami people and learn about their culture. In Karasjok, Norway, the site of the Sami Parliament and a center of Sami life, we found a small shop run by a

woman named Marìt Kemì Solumsmoen. She is a self-taught designer who makes an interesting variety of hiking, camping, and hunting equipment as well as winter garments that draw on Sami motifs. She has used her experience as a Sami and her skill at making things to develop her own line of products. They are highly competitive with those of larger manufacturers in terms of inventiveness, quality of materials, price, and use value. One of her hunting knapsacks, for example, has a foldout seat and fold-in bullet cartridges, while another backpack can be converted into a camp stool. These are modest inventions, but in their small way they improve the quality of hunting and camping gear. Such enterprises, if better supported, could bring in additional revenue to this tourist area, employ more people, and serve as an example to other Sami people of how
they might convert their unique cultural knowledge into products for the market. Yet, despite these possibilities, Solumsmoen was struggling along with no public recognition or easy access to resources for expansion.

Another example, though one that has resulted in greater success, is the invention of the mountain bicycle about twenty-five years ago. It was devised by a California bicycle racer named Gary Fisher who got the idea while biking with some friends in the hills outside San Francisco. His friends were pushing old fat-tired one-speed bicycles up the hills and then riding them down at high speed. Dissatisfied with the effort of pushing the bike up the hill instead of riding it, Fisher patched together parts from various bicycles to combine the ruggedness of the fat-tired bike with the slick gears of the racing bike. The mountain bike that resulted from his effort was only the first step in a subsequent series of refinements that have since involved the major bicycle companies. Today, mountain bikes account for 60–70 percent of all bicycles sold in the United States, and interest in the product has spawned a host of new manufacturers such as Trek, Giant, and Specialized.[36] The invention of this new product has not only created a mini-industry with thousands of new jobs, but it has also helped to promote mountain biking as a sport and serves as a good example of how the initial experience of a bicycle racer was converted through invention and marketing into a new product. Around this product has developed an entire subculture of races, rallies, and excursions, including the introduction of mountain biking as a competitive sport for the first time at the 1996 Olympic Games in Atlanta, Georgia. The mountain bike has also been the impetus for the development of related gear such as special helmets and shoes and has made its impact on tourism in mountainous regions such as Colorado.[37]

Unemployment is a major problem worldwide, and design could be an instrument to create jobs. I have often thought about the tragedy of highly skilled

workers in the American auto industry who were laid off a few years ago. These workers might have adapted their mechanical skills to the design of new products in metal and other materials of which they were knowledgeable. Instead, many remained unemployed, some retrained for technical jobs in other industries such as computers, and others had to work at low-level service jobs.

What is lacking, at least as I see it in the United States, is a knowledge of how to help people use their own experience as a source for valuable new products. Little is known, as well, about how to provide them with sufficient skills and marketing support to introduce these products to the public. Because the product milieu is so vast, there are always interstices where satisfying new products can be offered to the public. We see this particularly in the food industry where upstart companies have gained large market shares with new ice creams, yogurts, and condiments, for example. The food industry is teeming with small entrepreneurs whose inventions have greatly enriched our global culinary culture. Food, however, is only one kind of product that carries cultural values. We can also consider music, clothing, tools, and other cultural artifacts. The experience with the products of a different culture is an excellent way to appreciate the people of that culture, and there are numerous possibilities for the international distribution of goods that increase our awareness of this multicultural planet.

One of the ways that we cultivate ourselves is through the discovery of new products. The product milieu can thus be vastly enriched by the greater involvement of more people in the product development process. Making the connection between products and experience can help to discern the qualities that result in satisfying use and can provide motivation to develop products that contribute to the attainment of these qualities. And for the general public, a greater awareness of how products contribute to personal experience will help everyone act more consciously and decisively within the product milieu as we seek to improve the quality of our lives.

1 An excellent example of the discourse about things is the debate that took place at the Deutscher Werkbund exhibition in Cologne in 1914. The main positions were taken by Herman Muthesius, who promoted the standardization of product types, and Henry van de Velde, who argued for greater artistic freedom in the design of goods. The principal texts of the debate appear in *Documents: A Collection of Source Materials on the Modern Movement*, ed. Charlotte Benton (Milton Keynes: Open University Press, 1975), 5–11.

2 Dieter Rams, "Omit the Unimportant," in *Design Discourse: History Theory Criticism*, ed. Victor Margolin (Chicago: University of Chicago Press, 1989), 111. This essay

first appeared in *Design Issues* 1, no. 1 (spring 1984): 24–26.

3 John Dewey, *Art as Experience* (1934; reprint, New York: Perigree Books, 1980) and *Experience and Education.* Dewey's first major publication on the subject of experience was *Experience and Nature* (New York: Dover Publications, 1958), a book based on his 1925 Carus Lectures.

4 Dewey, *Experience and Education,* 40.

5 Ibid., 44.

6 Ibid., 35.

7 Ibid., 44.

8 Ralph Caplan, *By Design: Why There Are No Locks on the Bathroom Doors in the Hotel Louis XIV and Other Object Lessons* (New York: McGraw-Hill, 1982), 182.

9 Dewey, *Experience and Education,* 49.

10 Dewey, *Art as Experience,* 35.

11 An excellent account of how people give meaning to their lives through the relationships they establish with things is Mihaly Csikszentmihalyi and Eugene Rochberg-Halton, *The Meaning of Things: Domestic Symbols and the Self* (Cambridge: Cambridge University Press, 1981). See also Csikszentmihalyi's *Flow: The Psychology of Optimal Experience* (New York: Harper & Row, 1990).

12 Donald A. Norman, *The Psychology of Everyday Things* (New York: Doubleday, 1989), 1. The paperback edition is entitled *The Design of Everyday Things.*

13 For a collection of witty vignettes that includes several accounts of an intelligent user's frustrations with contemporary products and their use, see Umberto Eco, *How to Travel with a Salmon & Other Essays* (New York: Harcourt Brace, 1994). Among the products Eco criticizes are the fax machine, the cellular phone, and "the coffee pot from hell." However, he is equally frustrated with bureaucratic procedures, which are also products of design. See, in particular, his essay "How to Replace a Driver's License." More serious case studies of how poorly designed products resulted in tragedies for users can be found in Steven Casey, *Set Phasers on Stun and Other True Tales of Design, Technology, and Human Errors,* 2d ed. (Santa Barbara: Aegean Publishing Company, 1998).

14 Dewey, *Experience and Education,* 45.

15 Bernhard E. Bürdek, "Design and Miniaturization: Some Consequences for Designers" (unpublished paper, 1994).

16 Massimo Vignelli, speaking at a panel discussion, "Architecture and Design in American Museums circa 2000," held at the Graham Foundation in Chicago on June 10, 1987. The edited proceedings were published in *Design Issues* 5, no. 1 (fall 1988): 71–81. Vignelli's comment is on p. 80.

17 I introduced this term in my essay "The Product Milieu and Social Action" in *Discovering Design: Explorations in Design Studies,* ed. Richard Buchanan and Victor Margolin (Chicago and London: University of Chicago Press, 1995), 121–145.

18 For a discussion of how users adapt products to their own purposes, see Tufan Orel, "Designing Self-Diagnostic, Self-Cure, Self-Enhancing, and Self-Fashioning Devices," in Buchanan and Margolin, *Discovering Design: Explorations in Design Studies,* 77–104.

19 The late French sociologist Abraham Moles examined this experience in terms of his theory of micropsychology, which enabled him to measure the costs of small actions

that are involved in product use and repair. See Abraham Moles, "The Comprehensive Guarantee: A New Consumer Value," in Margolin, *Design Discourse*, 77–90. The article originally appeared in *Design Issues* 2, no. 1 (spring 1985): 53–64.

20 On "design for disassembly," see Bruce Nussbaum and John Templeman, "Built to Last—Until It's Time to Take It Apart," *Business Week*, September 17, 1990, 102–103, 106.

21 See, for example, Rick Robinson, "What to Do with a Human Factor: A Manifesto of Sorts," *American Center for Design Journal* 7, no. 1 (1993): 62–74.

22 An extensive literature on the experience of buying and selling is developing, particularly in the interdisciplinary field of consumer research. Anthropologist John F. Sherry Jr. has coined the term "servicescape" to characterize the place where selling and buying occurs. See his "Understanding Markets as Places: An Introduction to Servicescapes," in *Servicescapes: The Concept of Place in Contemporary Markets*, ed. John F. Sherry Jr. (Lincolnwood, Ill.: NTC Business Books, 1998), 1–24. In the same book, Sherry does a brilliant ethnographic study of Chicago's Nike Town. See John F. Sherry Jr., "The Soul of the Company Store: Nike Town Chicago and the Emplaced Brandscape," 109–146.

23 Sherry has also studied flea markets as an ethnographer. See John F. Sherry Jr., "A Sociocultural Analysis of a Midwestern Fleamarket," *Journal of Consumer Research* 17, no. 1 (June 1990): 13–30. The author sees flea markets as part of a "retail ecology" that includes other sites where goods are sold.

24 There is an active field of research on how people buy products, much of it centered on the interdisciplinary *Journal for Consumer Research* and other publications of the Association for Consumer Research. See, for example, Russell W. Belk, Melanie Wallendorf, and John F. Sherry Jr., "The Sacred and the Profane in Consumer Behavior: Theodicy on the Odyssey," *Journal of Consumer Research* 16, no. 1 (June 1989): 1–38. For a discussion of the variety of methods in the field, see Richard J. Lutz, "Positivism, Naturalism, and Pluralism in Consumer Research: Paradigms in Paradise," in *Advances in Consumer Research*, vol. 16, ed. Thomas K. Srull (Provo, Utah: Association for Consumer Research, 1989), 1–7; and John F. Sherry Jr., "Postmodern Alternatives: The Interpretive Turn in Consumer Research," in *Handbook of Consumer Behavior*, eds. Thomas S. Robertson and Harold H. Kassarjian (Englewood Cliffs: Prentice-Hall, 1991), 548–591.

25 We not only learn how to use products from guides and handbooks but also how to maintain them.

26 The experience we have with products today is different from that of our parents and grandparents. In my parents' and grandparents' generations, fewer people were adept at using machines. My wife's grandmother, who emigrated to the United States from a small town in Austria at the beginning of the twentieth century, never learned to dial a telephone. And in my parents' generation, many women, including my mother and my wife's mother, never learned to drive a car. Each generation faces an array of technology that demands new skills to operate.

27 The opposite is true in the computer field where upgrades in hardware and software appear in rapid-fire succession and make older models of both obsolete at an alarming rate.

28 See Tony Fry, introduction to *Green Desires: Ecology, Design, Products* (Sydney:

Eco-Design Foundation: 1992), 13.

29 George Sturt, *The Wheelwright's Shop* (1923; reprint, Cambridge: Cambridge University Press, 1993).

30 See, for example, Daniel Miller's review essay, "Consumption and Commodities," *Annual Review of Anthropology* (1995): 141–161. Miller, whose essay includes an extensive bibliography, has done valuable work in focusing anthropologists on consumption, but neither he nor others in the discipline have attended enough to questions of how people make use of products, except in the symbolic sense. This is a fruitful area of investigation that has the potential to contribute to the field of design research.

31 As excellent, if rare, examples of studies related to product use, I can cite the work of Willard Kempton and his colleagues at the Center for Energy and Environmental Studies at Princeton University. See Willard Kempton, "Two Theories of Home Heat Control," in *Cultural Models in Language and Thought,* eds. Dorothy Holland and Naomi Quinn (Cambridge and New York: Cambridge University Press, 1987): 222–242; Willett Kempton, Daniel Feuermann, and Arthur E. McGarity, "Air Conditioner User Behavior in a Master-Metered Apartment Building" (paper presented at the Symposium on Improving Building Energy Efficiency in Hot and Humid Climates, Houston, September 1987); and Willard Kempton, "Folk Models of Air Conditioning and Heating Systems" (paper presented at the AAAS session "Cognitive Ethnography of Industrial Society, Boston, February 1988).

32 It would be interesting to write a paper on product design and theories of justice that would discuss the general relation between just expectations for a decent life and the way that products enhance or impede these. Specifically, issues of justice have been the basis of the move toward safety measures in products as well as that of universal design, which was based on the injustice of people with disabilities not having access to public facilities.

33 See the section "User/Consumer," in *Arttu* 5–6 (1998): 27–38. Finnish economist Mika Pantzar, coeditor of the section, has published extensively on the consumer's relation to products, and his work is a useful model for others. See Mika Pantzar, "Domestication of Everyday Life Technology: Dynamic Views of the Social Histories of Artifacts," *Design Issues* 13, no. 3 (fall 1997): 52–65.

34 A good example of such a competition in the United States is the National Science Teachers Association's Young Inventors Awards, which began in 1997. Sponsored by Sears, Roebuck & Co., the event provides student inventors with both cash and recognition. See David Heinzmann, "Young Inventors Prove Age Holds No Patent on Imagination," *Chicago Tribune*, September 26, 1999. Another event for young inventors is the annual National Collegiate Inventors and Innovators Alliance (NCIIA) Conference. At the 1999 meeting, student projects were showcased at the Smithsonian's National Museum of American History.

35 A useful precedent can be found in the scientific disciplines where hundreds of science fairs for junior high and high school students provide encouragement for future scientists. Similar fairs could be held for future designers.

36 On the invention of the mountain bike, see "Pedaling New Ideas: Innovators Are Taking Bicycles Down Unexplored Paths," *Chicago Tribune*, July 4, 1993. The impact of the mountain bike on the bicycle market is discussed in "Pump, Pump, Pump at

Schwinn," *Business Week*, August 23, 1993, 79.

37 There is also another side to this story. Some people believe that excessive mountain biking in the Swiss Alps is ruining the terrain.

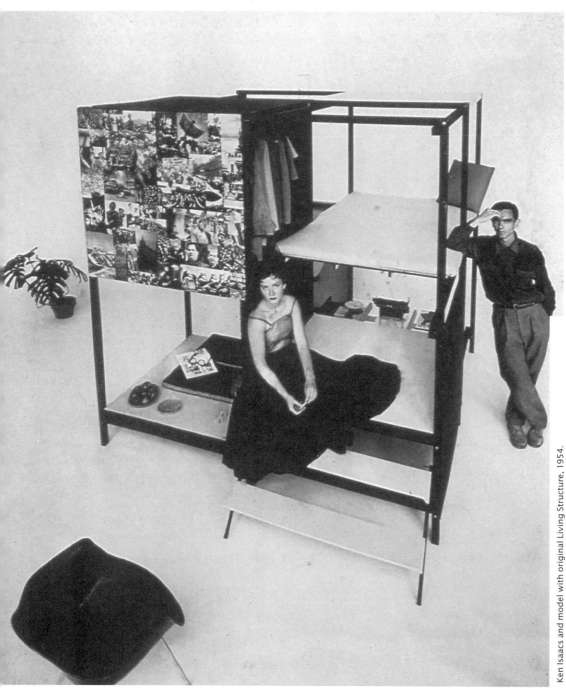

Ken Isaacs and model with original Living Structure, 1954.

We had dreamed of freedom and invented the thirty-year mortgage.

KEN ISAACS, "ALPHA CHAMBERS"

KEN ISAACS: MATRIX DESIGNER

My friend Ken Isaacs's Living Structure, a three-dimensional frame that united spaces for sleeping, working, and socializing in a single object, first came to public attention in a *Life* magazine article, published in October 1954.[1] Among the photographs in the article is one of Ken seated at a work table within the frame while his wife of the time, Jo, rests on the bed above. The frame is neatly divided into eight cubes which, when joined together, function as a combined bedroom, storage area, work space, and a place for intimate socializing. Later versions of the Living Structure were to incorporate space for dining and additional storage.

At a time when the American public was preoccupied with the dream of a house and yard, a new car, and a kitchenful of appliances, the Living Structure, by contrast, presented a more radical argument for how people might live.[2] As Ken later wrote, "The changes indicated that the mythic significance of the status symbol might eventually give way to the conception of the object as a useful tool with which to achieve a personal experiential result."[3] His emphasis on action recalls the rhetoric of the Russian avant-garde designer Alexander Rodchenko, who conceived of multipurpose furniture in the 1920s in a similar vein. But what is different about Ken's work is that it quickly found a place in the American cultural mainstream rather than ending up in the realm of speculative avant-garde projects. As presented in *Life,* the Living Structure was a means to liberate much-coveted space in a one-room urban apartment and transform it into the equivalent of what Ken called "a kind of two-story house."

What further rooted the Living Structure in the mainstream was the fact that it could be easily constructed by anyone with the most basic carpentry skills.

Throughout his career, Ken has worked with a single core idea, the matrix, a three-dimensional grid that he has used to organize all his projects. The matrix has served him as a powerful vehicle for order and economy while also functioning as an equally strong device for the invention of projects. What underlies Ken's work is a commitment to productive living, which is manifested in his design of what Ivan Illich has called "convivial tools."[4]

Ken grew up in rural southern Illinois, where his father held a variety of jobs including a sojourn as a tenant farmer. Early in life he became comfortable with tools, and throughout his career he has maintained a belief in the value of building things one's self. When Ken was sixteen, his father arranged an engineering apprenticeship for him with R. G. LeTourneau, then the leading designer of large-scale earth moving equipment. This was followed by another apprenticeship with H. Fredrick Lange, who designed the first American distillery for scotch whiskey. From these experiences, Ken learned a great deal about mechanical construction, which would be central to his subsequent work as a designer.

Recognizing the need to continue his education in a more formal setting, Ken entered Bradley University in Peoria, Illinois. While an undergraduate at Bradley in the late 1940s, he crystallized his initial ideas for the Living Structure as well as for its architectural version, the Microhouse. At Bradley, he studied with a sculptor named Roy Gussow, who had come from Chicago's Institute of Design, where he had most likely been a student of László Moholy-Nagy. Ken also took a course with Moholy-Nagy's widow Sybil, who had started a new career as a professor of architectural history after the death of her husband. Gussow proposed to Ken that he design an information kiosk for the university as an independent study along the lines of the kiosks Herbert Bayer designed while a student at the Bauhaus. However, Ken's greatest influence at Bradley was Dan Crowley, an anthropologist who turned him on to modern architecture and design as well as to many other things. As one example, Crowley drew Ken's attention to Japanese architecture and from this exposure, Ken conceived the idea that a house could be built like a cabinet or armoire.

Ken first began to work with the matrix idea and to make rigorous use of the grid while he was at Bradley. One of his earliest drawings, entitled *First Good House* from 1948 was inspired by the prospect of doing something with the used bricks he noticed lying around vacant lots after buildings had been torn down. Similar to what Le Corbusier did in his open plan houses such as Villa Savoye, Ken drew a series of vertical pipes to support the nearly flat roof of the house. His first drawings illustrate his interest in the idea of a unitary space

that could be subdivided for specific needs. In the drawing for the *First Good House* he created, underneath a raised walkway, a cave that he envisioned as a counterpoint to the more public open space. The drawing shows his fascination with the use of floating planes in a linear frame. The horizontal plane on the right-hand side of the drawing is his first experimentation with the integration of a horizontal surface supported by vertical poles. This would become a standard element in much of his subsequent work.

Once Ken began to work with the idea of a unitary space, he addressed additional problems. In his project *Vault House* of 1949, he created the first separation of the interior structure from the weatherproofing. The structure still remains somewhat cumbersome, however, and the drawing derives its greatest importance in Ken's development not from the elegance of the interior frame itself but from its articulation as a distinct object that would be compressed and refined over the next few years.

In another drawing from 1949, Ken depicted his first aggregated furniture unit that floats in a room, unlike George Nelson's Storage Wall that was published in *Life* magazine the same year, and contains facilities for cooking behind the sleeping and sitting area. This was Ken's earliest attempt to create a complex unit that combined multiple furniture functions. Unlike other designers of the period such as Nelson and Charles and Ray Eames, his ambition was to aggregate all living requirements into a single structure. The word that provides a key to his design principles and that he would use over and over is "autonomy." His aim, which he developed and refined in numerous subsequent projects, was for a self-contained, economical unit replete with resources to satisfy all one's needs. Reflecting in 1967 on the radical nature of this proposition, Ken expressed his hope "that the new person would be active on a larger scale which would shift emphasis to the extrinsic values of artifacts and away from whatever intrinsic values might be grafted onto them by the high priests of culture."[5]

A drawing of 1949 for his first aggregated furniture unit is similar to the earliest freestanding Living Structure that he built while at Bradley University. In part, the idea for the structure, which was intended to fit in a two-car garage, had been generated by his independent project for an information kiosk with Gussow, where he saw the possibilities of building frames with 1 1/2" x 1 1/2" timbers. This structure contained the seeds of much of Ken's subsequent work—the use of a cubic frame or container, the raised sleeping area to liberate floor space, and the suspended planar surfaces for eating, working, and storage. As the matrix idea developed, the structures became more complex.

After Bradley, Ken received a Saint Dunstan's Fellowship from the Cranbrook Academy of Art, where he studied for a master's degree between 1952 and 1954. By the time Ken arrived at Cranbrook, Eliel Saarinen, the Finnish architect who was the first director of the school and its most powerful influence, had died, and the era that produced such giants of architecture and design as Charles and Ray Eames, Eero Saarinen, Harry Bertoia, and Florence Schust Knoll had ended. Ken was encouraged at Cranbrook by Robert Snyder, the new head of the architecture department, who introduced him to issues of town planning and ecology, and by Ted Luderowski, an architect then heading the design department at the school.

While a graduate student, Ken expanded his interest in the Living Structure into a broadly conceived program that he was later to call the Matrix Research Project. Its essence was a three-dimensional modular frame that was used for varied human activities. The frame could be scaled down to a single chair, developed as a large multifunctional structure, or turned into a small dwelling. For his diploma project, Ken built a full-scale Living Structure. Luderowski had obtained a grant from the school to enable Ken to construct this project, which he completed with the help of some fellow students and then exhibited in the 1954 graduate thesis show. Luderowski's support turned out to be providential. Most likely someone from 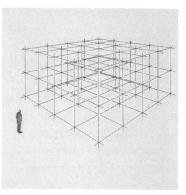 Life's Detroit bureau saw the Living Structure in the thesis show and brought it to the attention of the magazine's editors. Its subsequent publication in Life marked the beginning of a public interest in Ken's work that was to grow in the years to come.

The presentation of the Cranbrook project in Life is significant on several counts. First, it created a public discourse about Ken's projects that would continue over the years in mass-circulation publications such as Life, Time, Look, and the New York Times, as well as on network television. What is particularly intriguing about this reception is the way it differed from more limited reception of avant-garde or experimental furniture and architecture in Europe in the 1920s and 1930s.

In the case of the Life article, the "cube," as the magazine called the compact matrix structure, offered a low-cost solution to furnishing a small urban apartment. Providing space for sleeping, working, and relaxing, it could be assembled within two hours and would release space in a room for other activities. As presented in Life, the Living Structure was a sophisticated design object that one might expect to find in the best home furnishing or department stores. For Ken, however, it was to take on greater significance as what he called a "culture breaker." In architectural terms, it was antibourgeois, economical instead

of extravagant, and simple instead of ornate.

Despite *Life's* publication of his project, Ken's ideas were nonetheless way ahead of what furniture manufacturers were willing to produce in the 1950s. In 1954, he submitted two designs to the Herman Miller Company, a leading manufacturer of modern furniture. One was a Living Structure for adults, and the other was for children. The company expressed no interest in these, although a few years later they did float an experimental project that used a similar concept. Actually, Herman Miller, with George Nelson as its design director, was the furniture company whose ideas were closest to some of Ken's concerns, particularly their interest in modularity and interchangeability. But the move from single pieces of furniture to a complete environment was more than any furniture company was willing to make at the time.

After Ken graduated from Cranbrook, he designed exhibitions for the Department of the Army, worked briefly for Boeing in Wichita, and started a design practice in New York City. In 1956, he was called back to the school to become head of the design department. By this time he had added some theoretical underpinnings to his intuitive designs. This was evident in the Matrix Study Course that he created and required of all Cranbrook design students. The intent of the course was to invent what Ken called "a processing environment" that would prepare students to translate information about the world around them into new objects to enhance creative living. The course was based on a series of problems that began with a statement about the self and moved on to an engagement with issues related to information processing.

To break down conventional habits of thought, Ken devised the Matrix Drum, an 18' circular space in which students sat. Inside, they were bombarded by three slide projectors that cast images around the 360° wall. The purpose of this activity was to give the students an experience that would reinforce the idea that "product solutions be made in terms of the total environment."[6]

The Matrix course was described in the 1957–1958 Cranbrook catalog as "an exploration into the nature of the environment providing opportunities to structuralize previous experiences into meaningful patterns." Initially, the course included a series of what Ken called "translations," whereby the students would create a sequence of material representations, first of themselves, then of a friend, and finally of a social situation. The point of these "translations" was to show the students that the matrix was not just a physical object; it was a metaphor for the world. In one project, Ken told the students to modify a solid block of wood by making any cuts they wanted (one student reduced the block to sawdust). After they did this, he asked them to construct something with the parts. As an aspect of the Matrix course, Ken also introduced his students to Norbert Wiener's *The Human Use of Human Beings,* an atypical book for design

students in the 1950s, which referenced the act of designing to Wiener's work on cybernetics at MIT. Students, in fact, had to create material objects that embodied Wiener's ideas.

The Matrix Study Course was a boot camp for future designers. As a result of it, Ken's students rejected product styling, then the most widespread American approach to design, in favor of more inventive and comprehensive objects such as a low-cost helicopter, a small car, a collapsible folding tent structure, and a cylindrical kitchen unit. The student who built the helicopter had an engineering background and intended the machine to fly. The point of the kitchen unit was to break with the conventions of the traditional kitchen and put all cooking and washing up facilities together in a single compact object that was also freestanding like the Living Structure.

As a teacher, Ken conceived projects on a grand and radical scale and then involved large numbers of students in their completion. The Matrix Drum was the first of a number of such projects at various schools. I want to reference the work on the Matrix Drum to the construction of Russian artist Vladimir Tatlin's *Monument to the Third International* in 1919–1920. Both objects involved a teacher and his students in the creation of models for extremely idealistic structures that were intended to communicate new social ideas to the public.[7] Unfortunately, the radical nature of Ken's thinking brought him into conflict with Cranbrook's director Zoltan Sepeshy, an academic painter who had taught at the school since 1931, and Ken left in 1957.

While teaching at Cranbrook, Ken had also kept an apartment in New York and commuted between the two locations regularly in his second year. In New York he developed his design office, which he maintained until 1972. His apartment on East 38th Street, whose interior he designed in accord with his matrix principles, was photographed and published in *Industrial Design* magazine. In this case, unlike the *Life* article, the apartment was presented to an audience of designers as a design invention with a slightly avant-garde edge.

After his departure from Cranbrook, Ken concentrated on building his design practice in New York. The diverse array of projects on which he worked ranged from interiors and product designs to a sequence of projected images for a Broadway play about the accused spies Julius and Ethel Rosenberg. One project from around 1958 was the interior of a restaurant in New York's theater district. This provided an opportunity for Ken to experiment with a number of different concepts that interested him. He used large color areas to define the interior space as Theo van Doesburg had done in his project for Strasbourg's Aubette Dance Hall and Cinema in the 1920s. As a variation on van Doesburg's use of color to define space, Ken covered the entire back wall of the restaurant with one of his photographic murals, which a journalist for *Look* magazine had

dubbed *pholages*. He also designed a freestanding enclosed kitchen so that the entire serving area could be opened up. The counters were attached to compression vertical poles that lined the restaurant while the lights were suspended from horizontal rods. All the furniture was custom-made and Ken even gave the restaurant its name, Act 4.

Ken worked as well on experimental furniture during this period. His T-Cube, which functioned simultaneously as a seat and a storage unit, could be stacked with the metal backrests in the shape of a T. The back support could be rotated as the cubes were being piled on one another so as not to impede the stacking. When asked why he preferred the T-Cube to a folding chair, Ken stressed the multiple uses of the object, notably its capacity to function as shelving as well as seating. He also highlighted its superior appearance.

Although Ken had a busy practice in New York, teaching continued to attract him because it offered opportunities to work in community that were noticeably absent in the commercial world. In 1961, he taught for a semester at the Rhode Island School of Design (RISD) where his principal project was Torus I, a larger and more elaborate version of the Matrix Drum from Cranbrook. The Torus was to be a circular corridor with film and slide projectors flashing images into it at points along the way. The students built a section in model form and then a full-scale cross-sectional mockup.

In 1961, Jay Doblin, a product designer who had worked in the Raymond Loewy office in New York before becoming director of the Institute of Design at the Illinois Institute of Technology (IIT), invited Ken to come to the school as a visiting lecturer. Doblin may have known of Ken's work from its publication in *Life* or *Industrial Design,* which had done an article on Ken's Matrix course at Cranbrook in addition to its feature on his New York apartment.[8] Doblin not only gave Ken the freedom to create a series of innovative studios where students became involved in constructing major projects, but he also found the resources to realize these.

By the time Ken arrived at the Institute of Design, he had become disillusioned with the traditional methods of devising design projects for students and professionals and was firmly committed to the idea of "total design," which meant for him a breakdown of barriers between the conventional design disciplines. The project at the Institute of Design for which he will be best remembered was a perfect example of this approach. Dubbed the "Knowledge Box" by a *Chicago Tribune* journalist, Clay Gowran, it was a combination of Ken's initial Matrix grid and the visual stimulation of his earlier Matrix Drum.[9] The box was a 12' square wood, masonite, and steel cube with twenty-four projectors, including four underneath it, which cast images simultaneously onto the six surfaces that surrounded people who moved freely inside it. A group of students

worked with Ken on the project for approximately eighteen months. When completed, the Knowledge Box brought Ken again to the attention of *Life* magazine, which published an article on it in September 1962.[10]

For its first demonstration, the Knowledge Box was erected in IIT's Crown Hall over a weekend and was widely shown after that. Many of the images were taken from *Life*. They were enlarged in scale and programmed in cycles that were designed to expose new relationships between them. Special lenses were required to project the 6' x 6' images on the box's interior surfaces.

For Ken, the purpose of being in the Knowledge Box was no less than the transformation of consciousness. His aim was to use people's experience in the structure to break through the crust that he believed prevented them from seeing the world at a deeper level. He wanted to inject a social awareness in the viewer through a blitz of images. This approach was representative of his belief at the time that true learning comes from a total immersion in experience. As Paul Welch wrote in his *Life* article:

And you recoil at a grim-visaged Latin American–looking peasant glowering down at you. He vanished. A sixth sense—or whatever instinct it is that makes you feel someone staring at your back—turns you around and there are four images of the same peasant looking through you from another wall. Then he's all over the place, even underfoot. You squirm a little at his message of dislike and wish he would go away.[11]

Besides projecting images aimed to induce an emotional transformation in the viewer, Ken also wanted to display various global social and economic trends in diagrammatic form. Using United Nations reports and other social data, he designed charts with colors representing the different continents. The comparative scale of each continent showed proportional relationships between population and manufacturing, for example. Multiplied by 24 in order to fill the box, these charts provided visualizations of extremely complex relationships. Ken's sequential display of data patterns was similar to a project that R. Buckminster Fuller promoted several years later as part of the World Design Science Decade at Southern Illinois University. The Knowledge Box also had an intriguing precedent in the late nineteenth-century Outlook Tower, created by the Scottish environmentalist and city planner, Patrick Geddes.[12] Widely publicized in *Life, Industrial Design,* and elsewhere, the Knowledge Box fit into an optimistic discourse about technology in the early 1960s.

The next project Ken undertook with a group of students at the Institute of Design was the further development of the RISD Torus. Called Torus II, it was to be portable like Fuller's geodesic domes. Its skin was to be made of hy-

polon—nylon reinforced with neoprene—and it would be lifted into an exoskeleton that supported 8 mm projectors for showing images through the skin. This project was only realized, however, in the form of several models rather than as a full-scale sectional mockup.

Although Ken's thinking about the importance of experience, the value of building, the deleterious effects of overconsumption, and the significance of community easily intersected with the counterculture discourse of the 1960s and early 1970s, its roots were instead in the communitarian aspirations of the nineteenth century and the rationalist impulses of the European avant-garde. In the 1960s, he shared with Ivan Illich a suspicion of schools as socializing institutions, expressing the hope that schools "might eventually be replaced by large matrix environments acting as life analogs."[13] This was evident in the Space University, a gargantuan structure that looked something like a cross between a geodesic dome and a jungle gym, which was the focus of one of his Institute of Design studios. As Ken put it, one would enter the Space University with a backpack and come out when he or she was educated. Ken envisioned the pedagogical function of the matrix environments as follows:

The student would explore these labyrinthine constructions as man used to explore the unknown earth, every human a discoverer on his own.[14]

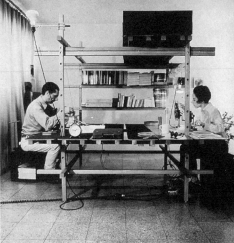

On a more modest scale, the apparatus Ken designed for his Chicago apartment at the time represented a further development of the Living Structure. It was a 6' x 6' wooden frame whose pieces were bolted together at the corners. On the frame were placed horizontal panels that could be shifted around or added and subtracted according to individual needs. The structure was light and portable and could fit into a 1' x 1' x 72" crate for moving.

This matrix was soon to develop into a new phase of Ken's projects. While working as a designer in New York in the late 1950s, he had maintained an interest in the architectural potential of the matrix. In 1954, he built his first Microhouse, a 6' x 6' plywood cube with a plexiglass dome, at Groveland, a property in central Illinois near Peoria that was owned by his family. Eight years later in 1962, he was named an Architectural Fellow by Chicago's Graham Foundation for Advanced Studies in the Fine Arts. The foundation was headed at the time by John Entenza, who had championed Charles Eames's use of industrial materials for housing in California in the late 1940s while editor of *Art and Architecture*. The Graham grant provided Ken with funds to build three Microhouses at Groveland. He left the Institute of Design around the time he received the grant and began to commute between New York, where he returned to his design practice, and Groveland,

where he spearheaded the design and construction of an experimental community, working with some of his students from the Institute of Design.

From the early 1960s to the early 1970s, a period of intense social change in the United States, Ken developed a number of full-scale Microhouse prototypes using the matrix grid. His first project was the Shoebox House, later known as the Old Microhouse, which became the living space for him and his family when they were at Groveland. The Shoebox House was a huge space frame of galvanized iron pipes within which were inserted two large plywood cubic volumes, one on top of the other. These filled half the space, the rest being used for plywood platforms that functioned as decks.

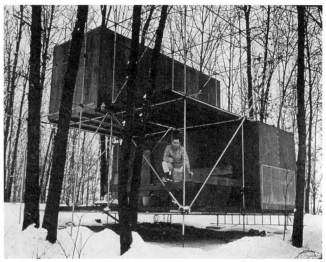

One of the projects on which Ken worked at Groveland in the early 1960s was an 8' x 8' prototype of the Microhouse that could be transported easily on a small trailer and erected quickly. Another project, undertaken for the General Tire and Rubber Company, was concerned with using royalex, a plastic material with which the company manufactured the hoods of transport trucks. Ken also developed a proposal for his largest structure to date, an 18' x 18' square Microhouse that would be constructed of eight sections bolted together. When not assembled, the sections would stack one inside the other.

For almost a decade beginning in 1963, Ken shuttled back and forth between his high-profile design practice in New York and Groveland where he pursued his experiments with variations of the Microhouse. In New York, the Living Structure continued to capture public attention and was even featured by Johnny Carson on the *Tonight Show*. In 1968, *Look* presented it in an article entitled "The Basic Pad."[15] As with the *Life* article fourteen years earlier, the qualities of the Living Structure emphasized by *Look* were the liberation of

space and money for creative living. By 1968, however, the accent was on "mobile Americans, who are more comfortable with streamlined disposibles [*sic*] than dusty antiques."[16]

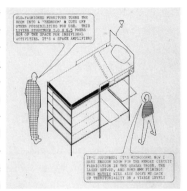

The publicity from the *Tonight Show* was most likely one factor that encouraged Ken to start his own furniture factory and showroom in 1967. Initially he concentrated on three projects, the Microdorm, the Superchair, and the Fun House. The Microdorm was a variation of the Living Structure for a single individual. More compact in plan, it occupied the same floor space as a single bed with the difference being that the sleeping area was on top of the structure, while the lower part was dedicated to space for studying and relaxing. The Superchair, which Ken referred to as a "Reading Environment," had a comfortable cushioned seat and back which were set in a frame that included shelves for books and a reading light on top. The back was attached to the frame with leather straps and could drop down to convert the chair into a bed. Ken had first conceived the Superchair in the mid-1950s as an entry to a competition sponsored by the American Cotton Association for objects that made use of cotton cloth. In one of his early sketches, he envisioned the chair as a small house to which additional modular units could be attached. The third product marketed by Ken Isaacs Ltd. was the Fun House, also called the Beach Matrix. It was actually a Living Structure frame with an enclosed plywood section as in the Shoebox House. Easy to erect, the Fun House was promoted as a vacation structure for use either at the beach or in a wooded area. At his own retail outlet, Ken sold knockdown kits for these three products, which were designed either for permanent or temporary construction. Among the other retail outlets that sold the kits were the Federated Department Stores in Los Angeles and the New York department store Abraham and Straus, which put on an exhibition of Ken's work in 1969. However, few of the Living Structures were sold in

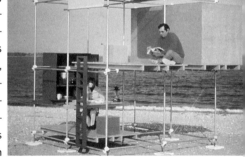

their assembled form and that particular marketing approach was soon dropped. As a result of the wide publicity, Ken's projects were extremely influential for other designers, particularly in the 1960s when there was a strong emphasis on shell-like living environments. Craig Hodgetts, Dennis Holloway, and Michael Hollander were among the young American architects working in this mode at the time.

In early 1968, Ken was invited by *Popular Science,* a magazine that featured do-it-yourself projects, to become a consulting editor. His involvement with the magazine exposed a populist aspect of his matrix concept. Over a period of five years, he created a series of objects that people could make

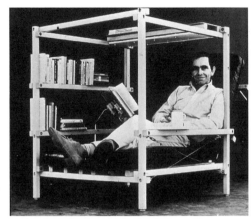

themselves. Publicized in *Popular Science* articles, their construction involved few materials, and they were easy to assemble. Through *Popular Science*, Ken literally gave his projects to the public. "Until recently," he wrote in one article, "my Superchair design sold through authorized outlets for $800. You can *build* it, however, for a fraction of what a conventional upholstered chair would cost."[17] This democratization of his own designs reinforced his basic strategy as a designer, which has been to empower people to live creatively, not just by using innovative furniture, but by building it as well.

Ken presented his *Popular Science* projects as part of a larger "Matrix Idea in design." He compared this concept with traditional design, which he argued "is concerned with fragmented solutions to one aspect of a problem at a time," while "the Matrix Idea is an attack on the whole problem at once."[18] For the magazine's readers, Ken presented the Fun House as "an ideal base camp for hiking, hunting, and fishing, or just witnessing the wonders of nature."[19] Positioned somewhere between a trailer and a tent, it provided sleeping and storage space as well as a place to eat and dry out wet clothes. Ken's article about it featured its multiple uses and emphasized its easy assembly. The Fun House could be easily transported for a vacation and then disassembled afterward. Ken sold it as a kit but, as an alternative, it was possible to simply buy the special joint fittings, which could be used with galvanized piping and plywood obtained from local sources.

For an article in the October 1969 issue of *Popular Science*, Ken presented a dining room table and chairs. The cube chair was a variant of his earlier T-Cube chair, and the "I" table had adjustable legs so that it could be used either for dining or as a coffee table. The themes of flexibility and the liberation of space were by this time recurrent in his designs. Another piece of furniture he created for *Popular Science* was the Delta Desk, which he characterized as a small-scale form that grew out of his work on the larger Matrix Idea and Living Structures. He continued the theme of adaptability to changing needs with the

Channel Modules, which were featured in the April 1970 issue of the magazine. They could be used as room dividers, as shelving, or as island units.

With the Meditator, a low-cost microcosmic version of the Knowledge Box that had photographs pasted on the interior walls, Ken introduced a space for contemplative withdrawal. He referenced the Meditator to Lewis Mumford's book *The Conduct of Life* in which Mumford encouraged his readers to slow down and make meditation a part of their regular routine. The editors of *Popular Science* traced the Meditator's lineage back to the Knowledge Box at the Institute of Design, but its source was actually a solitary Thinking Box that Ken had sketched in 1962 while working on the larger project.

In 1970, a small New York publisher, MSS Educational Publishing, brought out Ken's' first book *Culture Breakers: Alternatives & Other Numbers,* a photographic record of his drawings and projects that extended back to 1949. The brief texts that accompanied the images were preceded by a short introduction, which exposed the underlying radical nature of the Matrix project. Following a critique of runaway technological expansion, Ken argued for a critical analysis of culture "so that only those elements which contribute to evolutionary change may be retained and used as parts of a new formation."[20]

By the end of the 1960s, Ken had garnered considerable publicity for his projects, in particular, his furniture and information structures. His experimental work on Microhouse prototypes at Groveland had strengthened his interest in architecture, and in 1970, following a lecture he gave on his work at the School of the Art Institute in Chicago, he was invited to join the architecture faculty at the University of Illinois at Chicago Circle, now the University of Illinois at Chicago.

Initially, Ken developed a series of large-scale studio projects while also involving his students in the matrix houses at Groveland. One of these projects was the Liberating Cube, which required students to construct cubic wooden matrix frames for working or relaxing. The cubes were designed to be aggregated into a larger structure. A version of this cube, which was constructed at Groveland, became a precursor of the 8' x 8' Microhouse. This house for one or two people was inexpensive, easily and quickly erected, and temporary—the ideal shelter for a vacation or sojourn in a natural setting. Constructed from plywood panels, the boxlike structure was braced by four tetrahedral legs made of electrical conduit piping. The Microhouse project, which was featured in Ken's last article for *Popular Science* in July 1972, demonstrated an incredible economy of space. Inside, it maintained his characteristic raised sleeping area with space for study and eating below.

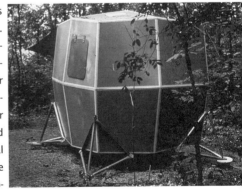

Whereas the Fun House had been marketed by Ken's New York company called Groveland 2, Microhouse kits were now being sold by a new company, Groveland 3, which was located at Groveland itself. Ken would bring groups of students from the university down to Groveland to work with him. In fact, his notion of community at the time was predicated on a group of Microhouses "loosely ringing a community space or 'village square.'"[21] This concept reinforced his long-time interest in relating privacy and community. Unlike the utopian socialists of the nineteenth century such as Fourier and Godin who envisioned huge singular structures to house their followers, Ken's community of Microhouses preserved a strong sense of autonomy, which he has always felt to be essential for a creative life. The circular arrangement of these structures thus represented an opportunity to live with others while still maintaining spaces that were intensely private.

Other furniture forms that Ken developed between 1971 and 1973 were derived from the Panel Matrix. These included a set of stackable cubes and chairs constructed from plywood panels with tetrahedral supports made of electrical conduit piping, similar to the supports on the 8' x 8' Microhouse. A set of furniture that Ken designed for the office of a film producer in New York City had been proposed to *Popular Science* and rejected. The editors said that Ken worked with nothing but cubes, and they requested him to do something that more closely approximated conventional furniture. That, according to Ken, ended his relationship with the magazine.

The Blue House, another University of Illinois studio project from 1973, was a different version of the 8' x 8' Microhouse. It consisted of eight 4' x 4' cubes that were built by the students. These were put together and skinned as a single structure. Ken's thrust at this time was to continue increasing the scale of the Microhouse so that it more closely approximated a home rather than a vacation dwelling. Another offshoot of the 8' x 8' structure was a

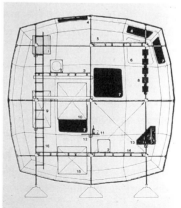

Drawing of large Microhouse.

multilevel building that Ken called the Tall House. It was a vertical version of the basic Microhouse, which was designed on the stacking principle that characterized Ken's T-Cube chairs and Panel Matrix storage units. The original concept went back to his thinking of the mid-1960s, although a prototype was not constructed at Groveland until 1974.

The 18' x 18' Microhouse was the biggest structure that Ken designed. The first model was built in 1957, but its scale was larger than the one with which he normally worked. It contained an eight-cell matrix with sleeping and study levels on top and incorporated a cooking cabinet, portable toilet, eating area, and a sunken wooden bath. A partial full-scale model of it was built in a studio class that

Ken taught at the University of Illinois in 1974. This project was to be his last before he directed his energies toward more established architectural pedagogy.

It was also the final project in his book, *How to Build Your Own Living Structures,* published by Crown Books in 1974. This publication, which featured detailed plans for various furniture pieces and Microhouses, brought Ken's matrix work again to wide public attention in a form that encouraged people to build the objects themselves at a very low cost. With its multiplicity of matrix projects, the book summed up what Ken had accomplished in the domains of furniture and architecture since his graduate work at Cranbrook. It was also a demonstration of his fundamental belief that building is an empowering activity. With its explicit directions for constructing his many projects, the book was Ken's way of bringing his work to the people. It was very much in the spirit of *The Whole Earth Catalog* of several years earlier, although it provided plans for things to make rather than information on things to buy.

Teaching in a school of architecture rather than in one of design opened up new possibilities for Ken to engage with the traditions of that profession for the first time. Gradually moving away from matrix design for a time, he continued his interest in craftsmanship, clarity, and simplicity, which engendered in him a high regard for classicism, as well as strong feelings about the role of craft, particularly drawing, in architectural design. His interest in classicism is evident in the house he designed for himself and his wife Sara in 1994 at Seaside, the innovative community in northern Florida that is based on the new urbanism, a theory of small town layout developed by Andres Duany and Elizabeth Plater-Zyberk. Despite its spare classical references, the Seaside house is nevertheless similar to the Microhouses in spirit. A comparison with the Shoebox House, for example, shows the same concern for simple volumes and linear frames.

While the Seaside House was an opportunity for Ken to engage fully with the conventions of architecture, it did not lead to an abandonment of the matrix system. Using Le Corbusier's dictum that architecture is a patient search, Ken returned several years later to the matrix as a guiding principle for a small urban transport vehicle. The idea of a microcar had interested him as early as his graduate student years, when he became fascinated with the cycle cars of the Edwardian era, which had bicycle wheels and motorcycle engines. Ken's intent in designing a new vehicle was to produce something that could transport individuals or goods on a neighborhood scale. He conceived of a motorized frame that could function with or without a detachable matrix top that would shelter the driver and his or her cargo. Although this project was not taken to the prototype stage, it nonetheless signaled for Ken that his original matrix concept was still a valuable generator of design projects.

The microcar, which brought Ken full circle back to his point of origin, leads me to a set of reflections on the legacy of his life in design. It is not the matrix structure itself that is the core of Ken's work but rather the matrix as an example of focused design thinking. Ken himself has stated that his aim was never to propose the matrix as the best solution for all design projects. Instead, it serves as evidence of how one designer has confronted the world for more than fifty years.

Ken's career shows us the possibility of generating a lifelong design philosophy from a single core idea. We can see something of a parallel in R. Fuller's Dymaxion philosophy, which resulted not only in geodesic domes at all scales and in all materials, but in other projects such as maps as well. Another aspect of Ken's legacy is the positive value of working at a small scale. Concentrating on smaller objects has enabled him to attend to the details of each one. These details, he believes, are essential to our experience of the material world. Designing artifacts as frames for the experience of one or two people also represents Ken's belief that an autonomous space for the cultivation of individuality is essential to the creation of a productive community. The process of invention behind Ken's work reveals his interest in thinking that is nonhierarchical and flexible. By remaining within a more limited range of objects, he has been able to fine-tune his inventive capacities. Though modernist in his design vocabulary, he has never followed the dictum that the same design philosophy should operate at all scales. Ken's projects do not move from a spoon to a town, as the Italian architect Ernesto Rogers once envisioned, but rather from a spoon to a spoon as Andrea Branzi once remarked.[22]

Ken's matrix objects, which are economical and ecological, result from thought that is spare. With their many dimensions, they serve as rich cultural metaphors that demonstrate how a lifetime of reflection can be embodied in deceptively simple forms.

1 "Home in a Cube," *Life*, October 11, 1954, 91–92.

2 "Living Structure" was a term Ken used for the matrix designs that he began to create around 1949.

3 Ken Isaacs, "Alpha Chambers," *Dot Zero* 4 (summer 1967): 39.

4 For a discussion of this term, see Ivan Illich, *Tools for Convivality* (Berkeley: Heyday Books, 1973), 10–16.

5 Isaacs, "Alpha Chambers," 39.

6 Ken Isaacs, quoted in James S. Ward, "Matrix at Cranbrook: An Experimental Design Course Shakes Student Preconceptions," *Industrial Design* (March 1958): 76.

7 When I first met Ken in 1982, one of our initial topics of conversation was Tatlin's

Tower. Ken was particularly fascinated by the fact that a scale model of the tower was drawn in a cart by horses through the streets of Leningrad as part of a parade to celebrate the Russian Revolution.

8 See note 6.

9 Clay Gowran, "The Incredible Knowledge Box," *Chicago Tribune Magazine*, July 29, 1962, 8–10. Before and after Gowran's epithet appeared in print, Ken was referring to this structure and its precursors as "alpha chambers."

10 Paul Welch, "The Knowledge Box," *Life*, September 14, 1962, 109–112. *Life* may have learned of the "Knowledge Box" from Clay Gowran's feature in the *Chicago Tribune* magazine. Other articles on the project include one by Ken, "Think Box," *Industrial Design* (November 1962): 48–51; and Kildare Dobbs, "Inside the Knowledge Box," in Toronto's *Star Weekly Magazine*, December 29, 1962, 1–3. The Knowledge Box was later discussed by architecture critic C. Ray Smith in his book *Supermannerism: New Attitudes in Post Modern Architecture* (New York: Dutton, 1977), 299–300. Smith's inclusion of Ken's work in a book on postmodernism shows how loosely the term was applied to designers and architects by Ray and other critics such as Charles Jencks.

11 Welch, "The Knowledge Box," 112.

12 See *Patrick Geddes: Spokesman for Man and the Environment. A Selection,* edited and with an introduction by Marshall Stalley (New Brunswick: Rutgers University Press, 1972). The volume includes a lecture by Geddes on the representation of interdisciplinary data about cities, "The Population Map and Its Meaning," 123–133.

13 Isaacs, "Alpha Chambers," 42.

14 Ibid.

15 "The Basic Pad," *Look,* May 14, 1968, M21–M23.

16 Ibid., M21.

17 Ken Isaacs, "Build the Superchair," *Popular Science* (March 1968): 164.

18 Ibid., 161.

19 Ken Isaacs, "Way-Out Fun House for Your Vacant Lot," *Popular Science* (July 1969): 134.

20 Ken Isaacs, *Culture Breakers: Alternatives & Other Numbers* (New York: MSS Educational Publishing, 1970), n.p.

21 Ken Isaacs, "Instant Housing for Your Country Site: Build a Vacation Cluster," *Popular Science* (July 1972): 88. In this article, Ken referred to the Microhouse as a Microhut.

22 Branzi paraphrased Rogers in a panel discussion on Italian design strategies at the 1983 Milan Congress of the International Council of Societies of Industrial Design (ICSID).

Coffee vendor in East Jerusalem.

EXPANSION OR SUSTAIN- ABILITY: TWO MODELS OF DEVELOP- MENT

In spring 1992, Richard Buchanan published an article in *Design Issues* entitled "Wicked Problems in Design Thinking." Using the work of mathematician and designer Horst Rittel as a starting point, Buchanan went on to relate the indeterminacy and messiness of design problems as Rittel defined them to an expanded scope of design practice that constituted four areas or domains of design. These domains moved from symbolic and visual communications to material objects, and then to activities and organized services, and finally to complex systems or environments for living, working, playing, and learning. Central to Buchanan's argument for a widened design practice is his conviction that design is a new liberal art of technological culture that has the capacity "to connect and integrate useful knowledge from the arts and sciences alike, but in ways that are suited to the problems and purposes of the present."[1]

Buchanan's systematic formulation of design activity has its precedents in earlier claims for design's wider relevance. In 1946, László Moholy-Nagy argued at a conference on the future of industrial design as a profession, sponsored by the Museum of Modern Art in New York, that design "is an attitude which everyone should have; namely the attitude of the planner—whether it is a matter of family relationships or labor relationships or the producing of an object of utilitarian character or of free art work, or whatever it may be. This is planning, organizing, designing."[2] John Chris Jones subsequently made a related claim in his influential book *Design Methods:*

Perhaps the most obvious sign that we need better methods of

designing and planning is the existence, in industrial countries, of massive unsolved problems that have been created by the use of man-made things, e.g., traffic congestion, parking problems, road accidents, airport congestion, airport noise, urban decay and chronic shortages of such services as medical treatment, mass education and crime detection.[3]

Yet, despite the advocacy for design's more engaged role in social life by Moholy-Nagy, Jones, Buchanan, and others, this vision of design has gained little credence until recently. It was easily resisted in the past because the professional apparatuses that codify different forms of practice, such as graphic design, industrial design, architecture, or urban planning, corresponded to aggregates of problems that appeared relatively coherent and distinct. I noted in a prior essay, however, that the boundaries around these problem areas have begun to collapse due to the influence of technology, management strategies, social forces, and new intellectual currents. As a result, the old divisions of design practice now appear increasingly inadequate and ineffectual. This situation has caused an intense rethinking of the designer's role by users of design services.[4]

The upheaval in design is a response to a world situation that itself is in turmoil. It can be characterized according to Rittel's definition of a "wicked problem" as a "class of social system problems which are ill-formulated, where the information is confusing, where there are many clients and decision makers with conflicting values, and where the ramifications in the whole system are thoroughly confusing."[5] If designers are to participate in sorting out these problems and inventing productive courses of action, they will have to move from second domain design, where product design has been located since the nineteenth century, to fourth domain design where, in Buchanan's words, they will be "more and more concerned with exploring the role of design in sustaining, developing, and integrating human beings into broader ecological and cultural environments, shaping these environments when desirable and possible or adapting to them when necessary."[6] This does not mean abandoning product design. It means connecting it to a larger situation of production and use.

In a 1996 article published in *Design Issues* as a response to Buchanan's "Wicked Problems" paper, the Australian design consultant Tony Golsby-Smith demonstrated through personal case studies how Buchanan's four domains of design activity can be developed within an organizational culture as one moves from the design of products to the planning processes that generate those products, to the ways in which an organization itself operates.[7] This is a fruitful line of development, but it only partially recognizes the scope of the problems that need to be addressed within a new vision of design practice. What it does

not account for are the ways that fourth domain design can respond to the world situation in its largest sense. This means marshaling all four domains of design practice in order to deal with problems whose definitions, not to mention resolutions, have thus far eluded everyone.

The first step in this process is to construct a model of the world situation in order to identify problem areas. Such a project is extremely difficult and in itself constitutes a significant design problem. Nineteenth-century world models, exemplified by the work of the sociologist Herbert Spencer, were based on metaphors, notably the human body. These earlier models were intended to represent a global wholeness, but they were static and located different geographic regions within a hierarchy of greater and lesser importance. They reinforced colonial relationships and did little to account for the movement of people and goods from one region to another.

It was only after World War II that general systems theory and mathematical modeling provided new tools for a significant advance in representing the world situation. A major effort was initiated by the Club of Rome, which was formed in 1968 at the instigation of Italian industrialist Dr. Aurelio Peccei. As an outcome of its initial meetings, the Club of Rome undertook an exceptionally ambitious project "to examine the complex of problems troubling men of all nations: poverty in the midst of plenty; degradation of the environment; loss of faith in institutions; uncontrolled urban spread; insecurity of employment; alienation of youth; rejection of traditional values; and inflation and other monetary and economic disruptions."[8] The premise for approaching this project was to view the world as a system and analyze it as a whole. Professor Jay Forrester of the Massachusetts Institute of Technology devised a mathematical model that permitted the identification of many components of the problem and suggested a way to study the behavior and relationships of the most important ones. The result was a report, *The Limits to Growth,* first published in 1972, which argued vigorously for the need to achieve a global equilibrium based on limits to population growth, the economic development of less developed countries, and a new attentiveness to environmental problems. *The Limits to Growth* sold more than ten million copies worldwide and generated considerable controversy. It defined for the first time what the authors called a *problematique,* or problem statement, which could be changed and developed over time to incorporate new data. The work of the Forrester group was a good example of fourth domain design although it was restricted to an analysis of the world situation without devising plans for intervention. Since the publication of *The Limits to Growth,* the Club of Rome has undertaken other studies itself, including *The First Global Revolution,* which appeared in 1991, and *Taking Nature into Account,* which was published in 1995.[9]

In the years since the publication of *The Limits to Growth,* considerable changes, both positive and negative, have taken place in the world. On the positive side, there has been an increase in the awareness of situations that threaten the Earth. This has resulted in large-scale international actions such as the European antinuclear initiative led by E. P. Thompson and others a few years ago and the worldwide ecological movement that has fought on many fronts from restoring the South American rain forests to reducing the global emission of carbon dioxide. Conversely, a wanton disregard for ecological citizenship has continued. This has led to the present critical moment where we are doing permanent damage to the planet.

The efforts of the Club of Rome, along with the studies of other international commissions such as the World Commission on Environment and Development, headed by former Norwegian Prime Minister Gro Harlem Brundtland, which produced the United Nations–sponsored report *Our Common Future* in 1987, have resulted in the promulgation of what I will call a *sustainability model* of the world.[10] The premise of this model is that the world is a system of ecological checks and balances that consists of finite resources. If the elements of this system are damaged or thrown out of balance or if essential resources are depleted, the system will suffer severe damage and will possibly collapse. In recent years, the sustainability model has gained wide support as an ideal to strive for. It has motivated the formation and activities of the various Green parties in Europe and North America, informed the agendas of liberal parties in many countries, and underlain a series of United Nations conferences on the environment, population, and women's rights.[11] Yet, the inability of this model to accommodate the dynamic growth of production and trade that is driving the development of an emerging global economy has caused many in the business community as well as large segments of the public in industrialized countries to either pay lip service to it or ignore it altogether.

In opposition to the sustainability model, most businesses and many consumers operate in relation to what I will call an *expansion model* of the world. According to this model, the world consists of markets in which products function first and foremost as tokens of economic exchange. They attract capital which is either recycled back into more production or becomes part of the accumulation of private or corporate wealth. Until recently the global market was centered on what Kenichi Ohmae and others have called the Triad, that is, the economically developed countries of North America, Europe, and Japan.[12] This developed trading area has now been enlarged to include China, the newly industrialized countries of Southeast Asia, and a few countries such as Brazil in other regions of the world.

The two agendas for social development that are central to the sustain-

ability model and the expansion model are not only in conflict, they are on a collision course that has already led to considerable fallout. This is evident in the widening gaps between rich and poor in both global and local terms, the development of an information infrastructure that privileges some and excludes others, and an array of precarious environmental situations that are beginning to permanently damage the planet. The tension between these two models is extreme and must be addressed if we are to overcome the unattractive aspects of both.

The sustainability model is the more sensible of the two, but it requires a reigning in of consumption that poses a direct challenge to the expansion model. As the authors of *The First Global Revolution* argue,

The sustainable society would never arise within a world economy which relied *exclusively* on the operation of the market forces, important as these may be, for the maintenance of vitality and creative innovation. . . . In seeking a normative approach to future world development at this moment of turbulence and change, it is vital to discover whether the present levels of material prosperity in the rich industrialized countries are compatible with global sustainability or, better perhaps, whether a world economy driven by stimulated consumer demand can continue for long.[13]

The extremity of this position is echoed in design discourse by Ezio Manzini, who stated in a *Design Issues* article of 1994 that "what is taking place today is actually a structural crisis, and that the global model of development is the true issue under discussion."[14] Calling for a "new radicalism," Manzini argued that the redesign of existing products was insufficient and that a drastic change in consumption patterns was required. He proposed three consumption scenarios. In the first, designers would need to develop products that could survive as technical and cultural artifacts for a longer period of time than that demonstrated by the lifespans of previous products. The user or consumer in this scenario would have to develop a different relationship to his or her products, foregoing novelty and change for attachment and care. In the second scenario, Manzini saw a shift from the acquisition of products to the utilization of services such as one might envision in the leasing or sharing of power tools and automobiles rather than in their purchase.[15] The third scenario was the most drastic—the engagement with fewer objects through decreased consumption.

There is, however, opposition on many fronts to the reduced manufacture of goods that Manzini believes is necessary and that is implicit in the Club of Rome's critique of consumption. This opposition can be addressed in economic, political, and personal terms. Those who operate according to the expansion model believe that product development and innovation are the

engines that drive the global economy. Such thinking is not without its references to the sustainability model, as we see in the attempts to adapt principles of sustainability to the design of new products or the redesign of existing ones.[16]

However, the expansion model is dominated by a belief in the power of technological innovation to enhance human experience, a relation predicated on the claim that the satisfaction material goods can provide is without limits. Furthermore, materialism has become so integral to notions of happiness that product development is now almost inextricably bound to the striving for human betterment.

This situation has major consequences. First, there are no restraints on the quest for product refinements, nor is there any consensus on what constitutes sufficient product quality. The situation is perpetuated by manufacturers who constantly bring to wider public attention the exceptional characteristics of products that are made for advanced specialized markets. This is particularly evident in the sectors of equipment for leisure activities such as running, bicycling, boating, and tennis.[17] It is evident as well in the American stereo market where some companies have adapted advanced telecommunications technology to home sound systems. In 1992, for example, Apogee Acoustics introduced a speaker system for sixty thousand dollars, while Madrigal Audio Laboratories in Connecticut sold a digital processor for almost fourteen thousand dollars.[18] Although comparatively few people buy this expensive equipment, a trickle-down effect occurs once the high end of a market is defined and standards are set. This effect becomes manifest in differing levels of quality that result in an extraordinary range of products for the consumer, who can then measure the value of his or her own acquisition against the highest standards in the market and perhaps even aspire to upgrade to a better quality when circumstances allow. Frequently the quality of a product is well beyond what is required by the user's needs, but the purchase is made because the product represents the best there is and that constitutes a symbolic statement. The refinement of products today is much more sophisticated than Thorstein Veblen posited with his notion of "conspicuous consumption" just over a century ago.[19] New products today do not simply constitute wasteful and unnecessary versions of existing ones. They frequently embody genuine improvements that alter human experience in the fullest sense.

Another way the expansion model operates is through the creation of markets for new products where none had previously existed. Today, the number of objects with which people in the industrialized countries live is growing rather than declining because actions that people once performed themselves

or had no need to perform are now being done by products, particularly smart ones. Take the beeper and the cell phone, for example. The impetus to be readily accessible and able to access others has made it imperative or desirable for many people to carry telephones or beepers with them at all times.

The beeper, once reserved for physicians or other professionals who had to be reached in an emergency, is today even carried by teenagers who expect to contact each other whenever they are inclined. Not only has this created an enormous market for beepers and cell phones, it has also channeled vast amounts of money to the telephone companies who provide the transmission service.[20] Manufacturers are now pushing video terminals into the state of ubiquity as evidenced by some airlines that have introduced terminals that deliver films and video games to passengers in their seats.

The development and widened use of all these new technological objects is part of a process to stimulate user expectations in order to create new product demands. And there is no end in sight. Even an activity like gardening, which never required fancy equipment, has now become the impetus for the sale of expensive gear that includes kid gloves, special pants, kneepads, expensive Swiss pruners, high-priced watering cans for hard to reach places, and a silver trowel costing two thousand dollars.[21] The rate of product innovation, particularly in electronics, continues to accelerate, and users are conditioned to participate in the process through regular upgrading of existing products and the acquisition of new ones.

Refinement of operation is one of the promises of the new wave of smart products that range from electronic lawnmowers, whose computer-controlled monitoring systems kick in extra power according to the thickness of the grass, to the smart house featuring a control system that will do everything from turn on the coffeemaker to manage the sprinkler system.[22] These and other innovations are entering the market at such a rapid pace that we can only wonder what there will be left to do one hundred years from now.

While lawnmowers and smart houses still remain the option of the consumer, plans for a national network of smart highways in the U.S.A. for which the U.S. Department of Transportation has provided two hundred million dollars in research funds over a seven-year period, present a different situation. Should this smart highway system develop to the point of implementation, it will become what Ivan Illich called a "radical monopoly," which leaves people no choice but to use it.[23] Drivers will be forced to upgrade to smart cars, which will be equipped for such highways, while everyone will shoulder the costs of converting to a smart highway system by paying higher taxes.[24] To fit out the entire national highway system of the U.S.A. for smart vehicles will cost billions of dollars, which could be better spent instead on drastically needed social services.

It is easy to continue with stories of product research and development that are justified within this expansionist discourse by the promise of a better life. However, changing the terms of the discourse is not easy. The political scientist Langdon Winner has pointed out the difficulties of democratically shaping public policy on technology innovation. He believes that moral philosophy tends to confront technology-related issues in an intellectual and social vacuum.

For the trouble is not that we lack good arguments and theories, but rather that modern politics simply does not provide appropriate roles and institutions in which the goal of defining the common good in technology policy is a legitimate project.[25]

Winner thinks the solution to this problem is in new forms of democratic citizenship, which are particularly difficult to institute if they clash too severely with notions of happiness held by the majority of citizens. So long as the costs and benefits of projects like the smart highway are not measured against what is needed to address the global economic and environmental problems that continue to plague us, they will continue to gain support from manufacturers eager to create new products and markets at all costs and from politicians who see in such projects the opportunity to bring jobs to their districts.

Perhaps the most serious defense of the expansion model against policies that lead to global sustainability is the equation of market participation with political power. The rise of Japan to its current position of political influence is a result of its extraordinary drive in the postwar years to become a major player in the global economy. Japan's success was not lost on its neighbors, who today are rivaling each other to develop sophisticated infrastructures in order to attract foreign investment and manufacturing. Once the lessons of how to run a factory were learned, South Korea, Hong Kong, Singapore, Thailand, Malaysia, and their neighbors were eager to build their own factories, start manufacturing, and begin exporting. Foreign partners were quick to seize an opportunity, and their eagerness to expand their own operations has accelerated the economic progress of these newly developing countries. If there is such a close link between economic participation and political power, what argument can we then expect to marshal in order to shift some of the energy in these countries toward sustainable development rather than toward market expansion?

Given the powerful capacity of the expansion model to stimulate human aspirations for a life of comfort and pleasure and the political stakes that underlie the drive for economic power, the likelihood of achieving widespread consumer abstinence in significant numbers is low.[26] To do so in any other way than on an individual voluntary basis would require a restructuring of the entire

world economy and would raise serious questions about how an adequate or better standard of living can be maintained by as many people as now have one because of their participation in the global expansion model. It would also mean turning back a prevalent assumption in advanced economies that a comfortable standard of living with sufficient resources to develop one's self as one likes is a possible goal for everyone. What makes the shift to a sustainability model yet more difficult is that it can only be achieved through the repayment of the debt that businesses and governments operating within the expansion model have run up by ignoring the rules of good ecological citizenship. The costs of purifying polluted rivers, cleaning up bad air, and replenishing depleted soil are astronomical and must be faced if we are to restore the planet to its proper ecological state.

As part of its strategy to systematically identify global problems, the Club of Rome has also developed an analytical method of response that is described in *The First Global Revolution.*

Our task is also to encourage social and human innovation which, when compared to its cousin, technological innovation, is definitely a poor member of the family. We would like to emphasize once again that with the term *resolutique,* we are not suggesting a method to attack all the elements of the *problematique* in all its diversity at the same time. . . . Our proposal is rather a simultaneous attack on its main elements with, for each case, a careful consideration of reciprocal impacts from each of the others.[27]

However, the *resolutique* of the Club of Rome does not recognize the degree to which the forces of the expansion model run counter to the aims of sustainable development. Instead, the Club proposes to work through new and existing public sector institutions without acknowledging the difficulty of restructuring the relation between the sustainability and expansion models. It relies instead on new "collective values" that are sketchily emerging as a moral code for action and behavior, but this constitutes a hope rather than a strategy.

The question of global values has been addressed by the eminent German theologian Hans Küng in his book *Global Responsibility: In Search of a New World Ethic.* Küng calls for an "ethics of responsibility" that is oriented to the consequences of decisions and actions as they are manifest in concrete situations. This ethic he sees as a compliment to an ethic of disposition, which propounds idealistic virtues without concern for the process and effects of their adoption. "Without a dispositional ethics," he writes, "the ethics of responsibility would decline into an ethics of success regardless of disposition, for which the end justifies the means. Without an ethics of responsibility, dispositional ethics would decline into the fostering of self-righteous inwardness."[28]

Küng is aware of the dangers that can ensue from "a vacuum of meaning, values, and norms." He notes that "the free democratic state must be neutral in its world-view, but it needs a minimal basic consensus in respect of particular values, norms and attitudes, because without this basic moral consensus a society worth living in is impossible."[29] Such a consensus has been particularly difficult to achieve on a global scale because there has been no attempt at negotiation between the sustainability and expansion models of the world situation. Proponents of each operate in ways that diminish or marginalize the power of the other while deferring their respective promises of utopia to some point in the future where strategies of accomplishment do not have to be tested against the complaints of their critics. Some supporters of sustainability call unrealistically for a radical reduction of consumption while expansionists consistently minimize the precarious ecological state of the planet and the political dangers of increasing the difference in income levels between rich and poor. As a result, we are involved in a massive denial of the need to bring into relation the conflicting values of these two models.

How then, do we proceed? We have no political mechanism to create the necessary debate between proponents of the respective models. While the United Nations conferences have generated weighty reports full of useful ideas, the U.N. has not had the authority to enforce these recommendations nor has it been able to negotiate respective roles for the developed and developing countries with regard to limiting population, taking ecological measures, and curtailing manufacturing. To counter this stagnant situation, a number of corporate executives have recognized the dangers of unlimited manufacturing and have sought solutions that attend more closely to the needs of a sustainable economy. But these activities have not occurred on a sufficient scale to make a noticeable impact on the expansion model.

There is a vacuum in the development of ways to reconcile these two models that a rethinking of design practice may help to address. As an art of conception and planning, design occupies a strategic position between the sphere of dispositional ethics and the sphere of social change.[30] This is its power. Design is the activity that generates plans, projects, and products. It produces tangible results that can serve as demonstrations of or arguments for how we might live. Design is continuously inventing its subject matter, so it is not limited by outworn categories of products. The world expects new things from designers. That is the nature of design.[31]

Design incorporates methodological techniques for sorting out wicked problems and devising productive courses of action in response. Good designers possess honed skills of observation, analysis, invention, shaping or giving form, and communication. By regarding design as a practice that ranges from

visual communication to macroenvironments, we can endow the profession with more flexibility as well as with additional authority to engage with a wide range of problems. Working with four domains, the designer or design team can locate a particular project in a context that may even change the project itself. When design is not limited to material products, designers can intervene within organizations and situations in a greater number of ways. Keeping in mind Buchanan's designation of design as an integrative discipline, educators and practitioners can take up his challenge in seeking "to gain a deeper understanding of design thinking so that more cooperation and mutual benefit is possible between those who apply design thinking to remarkably different problems and subject matters."[32]

Given the extreme difficulty of reconciling differences between supporters of sustainability or expansion at the discursive level of ethics and values, a strategy which the United Nations and groups like the Club of Rome continue to pursue, it is possible to move forward more fruitfully through projects and products that demonstrate new values in action. These may prove more inviting to the public than would an argument that remains propositional rather than demonstrative

The question we face is how to widen design's traditional sphere of action from serving manufacturers to a more proactive involvement with the *problematique* of the Club of Rome and other groups who are concerned with the world situation. By following this course, designers can seek through the art of demonstration to reconcile the best aspects of the sustainability and expansion models and thereby make an important contribution to the fruitful continuance of life on Planet Earth.

1 Richard Buchanan, "Wicked Problems in Design Thinking," in *The Idea of Design: A Design Issues Reader*, eds. Victor Margolin and Richard Buchanan (Cambridge: MIT Press, 1995), 4. The article originally appeared in *Design Issues* 8, no. 2 (spring 1992): 5–21.

2 Transcript, "Conference on Industrial Design: A New Profession," New York City, 1946, Museum of Modern Art Library, 213.

3 John Chris Jones, *Design Methods,* 2d ed., cited in C. Thomas Mitchell, *Redefining Designing: From Form to Experience* (New York: Van Nostrand Reinhold, 1993), 39–40.

4 For an account of contemporary changes in design for corporate clients, see *Business Week*, June 5, 1995, 88–91. The expanded role for design includes research, technological innovation, and new product planning.

5 Rittel's notion of a wicked problem is quoted by Buchanan from an article by C. West Churchman. See Buchanan, "Wicked Problems in Design Thinking," 14.

6 Ibid., 8.

7 Tony Golsby-Smith, "Fourth Order Design: A Practical Perspective," *Design Issues* 12, no. 1 (spring 1996): 5–25.

8 Donella H. Meadows, Dennis L. Meadows, Jørgen Randers, and William W. Behrens III, *The Limits to Growth: A Report for the Club of Rome's Project on the Predicament of Mankind*, 2d rev. ed. (New York: New American Library, 1974), x.

9 Alexander King and Bertrand Schneider, *The First Global Revolution: A Report by the Council of the Club of Rome* (New York: Pantheon, 1991); and Wouter Van Dieren, ed., *Taking Nature into Account: A Report to the Club of Rome: Towards a Sustainable National Income* (Secaucus, N.J.: Springer, 1995).

10 In the first version of this essay, "Global Expansion or Global Equilibrium? Two Models of Development," I used the term "equilibrium model" instead of the current "sustainability model." I decided to make the change in order to represent more precisely the characteristics of this model and to enable the inclusion of chaos theory in the deliberations on models of development.

11 See *Our Common Future* (Oxford and New York: Oxford University Press, 1987). Other reports in recent years that have addressed the issue of sustainable development include *The Global 2000 Report to the President of the U.S.: Entering the 21st Century*, 2 vols. (New York: Pergamon Press, 1980); Herman E. Daly and John B. Cobb Jr., *For the Common Good: Redirecting the Economy Toward Community, the Environment, and a Sustainable Future*, with contributions by Clifford W. Cobb (Boston: Beacon Press, 1989), and the document that was adopted by nations participating in the United Nations Earth Summit in Rio de Janeiro, June 1992, *Agenda 21: The Earth Summit Strategy to Save Our Planet*, ed. Daniel Sitarz (Boulder: Earthpress, 1993).

12 See Kenichi Ohmae, *Triad Power* (New York: Free Press, 1985). The Triad as a marketing region was a central theme at the 1985 ICSID congress in Washington, D.C. See my article, which criticized the Congress, "Corporate Interests Dominate Worldesign '85 Congress in D.C.," *New Art Examiner* (March 1986): 32–35.

13 King and Schneider, *The First Global Revolution*, 49.

14 Ezio Manzini, "Design, Environment and Social Quality: From "existenzminimum" to "quality maximum," *Design Issues* 10, no. 1 (spring 1994): 38. The German term *existenzminimum* originated in the 1920s, when it denoted the minimal spatial requirements of an individual or family within a rationally planned large-scale housing development such as the Neue Frankfurt.

15 Advocacy for this approach is particularly strong in Germany. A leading supporter of product-sharing there has been the Wuppertal Institut für Klima, Umwelt, Energie.

16 See Nigel Whiteley's chapters "Green Design" and "Responsible Design for Ethical Consuming" in his book *Design for Society* (London: Reaktion Books, 1993), 47–133. See also John Elkington Associates, *The Green Designer* (London: Design Council, 1986); and Tony Fry, *Green Desires: Ecology, Design, Products* (Sydney: Ecodesign Foundation, 1992).

17 On the American predilection for high-end sports gear, see John Skow, "Geared to the Max," *Time*, September 6, 1993, 48–50.

18 "This Sonic Boom Is Made in America," *Business Week*, May 4, 1992, 140.

19 See Thorstein Veblen, *Theory of the Leisure Class* (1899; reprint, New York: New American Library, 1953).

20 The principal product in this case is phone service rather than cell phones or beep-ers. It is almost worthwhile for telephone companies to give phones and beepers away or provide them at low cost in order to attract more customers for their real services, the supply of communications channels. Related issues are addressed in Peter Coy and Neil Gross, "The Technology Paradox," *Business Week*, March 6, 1995, 76–81, 84.

21 "Power Gardening," *Time*, June 10, 1995, 52–57.

22 See Philip Elmer-DeWitt, "Tools with Intelligence," *Time*, December 23, 1991, 80; and Heather Millar, "Smart Houses: Getting Switched On," *Business Week*, June 28, 1993, 128–129.

23 Ivan Illich, *Tools for Conviviality* (1973; reprint, Berkeley: Heyday Books, n.d.), 51–57.

24 On smart cars and smart highways, see Kathleen Kerwin, "The Smart Cars Ahead," *Business Week*, May 1, 1995, 158-E-6; and Christina Del Valle, "Smart Highways, Fool-ish Choices?" *Business Week*, November 28, 1994, 143–144.

25 Langdon Winner, "Citizen Virtues in a Technological Order," *Inquiry* 35, nos. 3–4 (Sep-tember–December 1992): 355.

26 Paul Hawken has sought a middle ground between the sustainability and expansion models by arguing for a corporate role in moving toward sustainability. See his book *The Ecology of Commerce: A Declaration of Sustainability* (New York: Harper Collins, 1993). As one solution, Hawken calls attention to the proposal by consultant Hardin Tibbs for an "industrial ecology," which is based on the idea that it makes economic sense for corporations to adopt environmentally sound policies.

27 King and Schneider, *The First Global Revolution*, 135.

28 Hans Küng, *Global Responsibility: In Search of a New World Ethic* (New York: Cross-road, 1991), 30.

29 Ibid., 39.

30 On the relation between ethics and design, see Carl Mitchum, "Ethics into Design," in *Discovering Design: Explorations in Design Studies*, eds. Richard Buchanan and Vic-tor Margolin (Chicago : University of Chicago Press, 1995), 173–189.

31 Otl Aicher, one of the founders of the Hochschule für Gestaltung Ulm, is a design the-orist who understands how design contributes to culture as an act of making. He writes that "design is the creation of a world . . . human culture can no longer be re-duced to thinking and doing. design intervenes as a methodological discipline in its own right, the emergence of something that does not already exist, in either theory or practice. in design both emerge as fundamentals. design transcends theory and practice and not only opens up a new reality, but new insights." Otl Aicher, "the world as design," in Otl Aicher, *the world as design* (Berlin: Ernst & Sohn, 1991), 189.

32 Buchanan, "Wicked Problems in Design Thinking," 6.

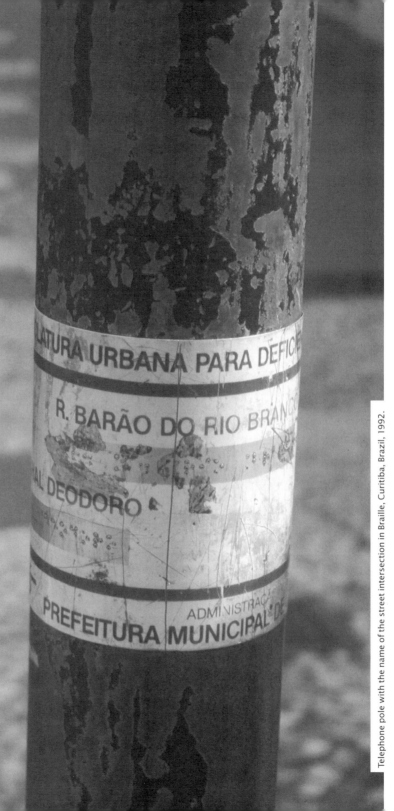

Telephone pole with the name of the street intersection in Braille, Curitiba, Brazil, 1992.

The prospect of inevitable global environmental disaster or world-wide social upheaval must not be the legacy which we leave our children.

AGENDA 21: THE EARTH SUMMIT STRATEGY TO SAVE OUR PLANET

DESIGN FOR A SUSTAINABLE WORLD

Since design's beginning, when it was conceived as an art of giving form to products for mass production, it has been firmly embedded in consumer culture. Design's first promoters in the nineteenth and early twentieth centuries, such as Henry Cole in England and Herman Muthesius in Germany, saw it exclusively in relation to the manufacture of products for the market. This was equally true when a new practice of consultant design emerged in the United States in the 1930s. In the postwar years, American consultant practice became a model for industrial designers throughout the world as they sought to create a place for themselves in their respective national economies. This model continues to be influential in the emerging global economy.

While the process of establishing design as an essential component of global economic competitiveness has progressed in an almost seamless manner, occasional critics have attempted to redirect design practice to other tasks. Perhaps the harshest castigation of industrial design came from the late architect-designer Victor Papanek who wrote the following in his seminal book of 1972, *Design for the Real World:*

Today, industrial design has put murder on a mass-production basis. By designing criminally unsafe automobiles that kill or maim nearly one million people around the world each year, by creating whole new species of permanent garbage to clutter up the landscape, and by choosing materials and processes that pollute the air we breath, designers have become a dangerous breed.[1]

Vernacular kerosene burners, Rio de Janeiro, 1992.

Papanek's diatribe struck a sympathetic chord with many practicing designers and students around the world who were looking for some alternative to designing more products for the consumer culture. Among the new practices Papanek proposed were working with people in developing countries to create products using low technology, designing for the disabled, and creating new goods to counter growing environmental problems. *Design for the Real World* came hard on the heels of the student movement of the 1960s and embodied the simultaneous rage and hope of that period. Papanek's claim that design contributed to the deterioration of the environment introduced a new element into design discourse, though his position remained marginal and made no significant impact on the industrial design profession.

Years earlier, the engineer R. Buckminster Fuller had considered the limitations of industrial design differently. Beginning in the 1920s, he began to propose new products to challenge the traditional practices of the American building industry as well as the constraints of Detroit automakers. His early project for prefabricated tower blocks, which could be dropped by helicopter into a foundation and then connected to water, electricity, and gas, posed a strong challenge to what he saw as the antiquated building trades with their hierarchies of carpenters, bricklayers, and masons. He continued the theme of prefabrication in his subsequent Dymaxion House and his Dymaxion Bathroom. Unconventional thinking was also evident in his Dymaxion Car, a three-wheeled vehicle designed on aerodynamic principles with wheels that could turn on a 90° angle so the car could move horizontally into a narrow parking space.

Suffice it to say that none of these inventions were adopted by American industry. Fuller did, however, eventually achieve worldwide success with his geodesic domes, whose economy of materials as well as their durability, flexibility, and ease of construction were quickly recognized by the United States Marine Corps and then widely adopted by industry. The broad range of objects, both successful and unsuccessful, that Fuller had proposed by the end of World War II, provided isolated examples of his systematic rethinking of design. Fuller,

whose thoughts on design began evolving in the late 1920s, envisioned a "comprehensive anticipatory design science" as a human practice that would align men and women with the evolutionary forces of the universe.[2] Despite some proposals that could never be realized, he demonstrated time and again the practical applications of his vision. Unlike Papanek, who based his early thinking in part on the low-tech design wisdom of indigenous peoples such as the Balinese and the Inuit, Fuller sought the most advanced levels of technology to realize his projects. He also thought in terms of systems as well as in terms of single objects.[3]

In the early 1960s, Fuller was invited to serve as university professor at Southern Illinois University in Carbondale, Illinois. While there, he participated in the launching of the World Design Science Decade, a program intended to demonstrate between 1965 and 1975 how design in the comprehensive sense could play a central role in addressing major world problems. Many goals found in the documentation of that initiative parallel those called for today by the leading advocates of sustainable development. These include

- review and analysis of world energy resources;
- definition of more efficient uses of natural resources such as metals; and
- integration of machine tools into efficient systems of industrial production.[4]

As part of the World Design Science Decade, Fuller and his colleagues conceived an electronic display that would provide a continual update of resource availability and use on a global scale.[5] Fuller's ideas and his development of the World Game, a simulated planning process for allocating resources, engaged students around the world but never penetrated industrial design practice, which continued to embed itself more deeply in the expanding global manufacturing activities of corporate culture during the 1960s and 1970s.

Since the 1970s, the critiques and visions of Fuller and Papanek, as well as of others such as Tomás Maldonado, John Chris Jones, and Gui Bonsiepe, have continued to ripple through design schools and conferences but have never strongly threatened the underlying premise of design practice that the role of the designer is to provide services to his or her clients within the system of consumer culture. This impasse has left many designers frustrated, particularly in light of the growing pressures for sustainable development. Modest efforts to create green products have certainly been valuable, but such products function only as compromise measures in comparison to what is needed.

By the time of the Earth Summit held in Rio de Janeiro in June 1992, global environmental problems had already reached critical proportions. They were amply described, as were hundreds of proposed solutions, in the conference report *Agenda 21: The Earth Summit Strategy to Save Our Planet*. The

report, based on a number of accords adopted and signed by most of the world's national leaders, was a remarkable achievement. For the first time, the world had a document that pulled no punches in mandating extreme measures to counter the harmful environmental effects of the expansion model. However, the Rio accords contained no measures for mandatory enforcement, and subsequent implementation efforts have fallen far short of what was originally called for. On the positive side, the Earth Summit, which included a parallel meeting of hundreds of citizens' groups, has resulted in an emergent *culture of sustainability.* Individuals and groups around the world now have a set of principles to work with and a basis on which to develop strategies for change that might be effective despite the powerful grip that the expansion model still has on world economics and trade policies.[6]

Evelyn Grumach, logo for Rio '92 Earth Summit. Reproduced by permission of Evelyn Grumach. The logo represents the ubiquitous presence of mountains and water in Rio's landscape. The small peak at the top is Sugarloaf Mountain, a Rio icon. The designer also placed Rio symbolically at the top of the world to connote the significance of the Earth Summit's agenda.

Given the growing force of this new culture of sustainability, the question arises as to what role the design professions will play in it. Until now they have done little. With the exception of Papanek, Fuller, and a few other visionaries and critics, designers have not been able to imagine a professional practice outside mainstream consumer culture.[7] Isolated initiatives have occurred including special design projects within the United Nations Development Program, the sponsorship of the International Council of Societies of Industrial Design (ICSID) of the conference "Design for Need" held in London in 1976, and ICSID's Humane Village congress in Toronto in 1997, but most product designers have been locked into the aims and arguments of their business clients, believing themselves unable to take any initiatives of their own.[8] There is a history of calls for a new ethics of design, but these are mostly reactive rather than generative.[9] They arise as urges to resist unsatisfactory situations rather than as impulses to create new and more satisfying ones. The result is a lack of empowerment. In those areas in which designers do have the autonomy for free discussion, notably conferences, journals, and in the college or university classroom, the proposals for change have been all too modest and have rarely come out strongly against the expansion model of economic growth, which is still considered to provide the designer's bread and butter.[10] Hence, designers settle for small victories that are ultimately dependent on the willingness of manufacturers to undertake some form of good work such as a green product.

The primary question for the design professions thus becomes how to reinvent design culture so that worthwhile projects are more clearly identified and likely to be realized. Just as other professionals are finding ways to earn their living in the culture of sustainability, so too will designers have to do the same in order to create new forms of practice. The first step is to recognize that design has historically been a contingent practice rather than one based on ne-

cessity. Designers make choices in response to *particular* circumstances and situations and ignore other possibilities. Today new choices present themselves, and designers need not be bound by what they have done in the past. In years to come, design for consumer culture may be recognized as only one form of practice among many rather than continue to play the dominant role that it does today. As design theorist Clive Dilnot has noted, **Movement towards a "post-product" society, i.e., to one distinguished by a more explicit social management of man-environment relations, is likely to bring back this historic sense of design's significance [as planning]. Design becomes once again a means of ordering the world rather than merely of shaping commodities.**[11]

Once design has been uncoupled from the dominant paradigm of giving form to objects, it is necessary to clarify exactly what designers contribute to a project. To the degree that design has been historically recognized as an art of giving shape to commodities, insufficient attention has been paid to the types of knowledge that would enable designers to work with other professionals in engineering, the natural sciences, and the social sciences. As a result, most design students are exposed to a limited range of situations in which design could be an intervention. This type of socialization, which begins in school and continues in the design magazines and at professional conferences, reinforces a narrow image of product design. It privileges an awareness of consumer culture and its situations rather than the realm of local and global problems that are being addressed by those in the culture of sustainability.

Nonetheless, there is a shift developing in mainstream design thinking. Kenji Ekuan, a Japanese product designer, former Buddhist monk, and longtime ICSID activist, wrote in a 1997 article, published in the *ICSID News,* that **design gives the impression of being in a state of stagnation in terms of both ideology and activities. One gets the impression that design has drawn apart to simply keep watch while the world grapples with numerous serious problems including the environment, welfare, natural disasters and traffic. And if things are left in this state, the times will simply pass by with nothing at all taking place. In order to make a commitment to the main flow of the times and succeed in playing an important role, it appears that the necessity has arisen for design to redefine its purposes and devise a new organizational structure for itself.**[12]

In an earlier article, which appeared in the same publication, Ekuan envisioned a new task for the designer. He argued that "what design can and must do is the proposal of a new life image and lifestyle that is compatible with the environment in daily life, home life, global life and life in the workplace."[13]

Ekuan took a necessary first step by recognizing that the historic model of industrial design practice is inadequate, and he sought to uncouple design from the dominance of its past identity. For him, the solution is in "interdisciplinary and international collaboration in all fields of design."[14] His call for a new purpose is significant and forms part of an emerging dialogue among some designers. However, the terms of this dialogue are not yet well enough defined to lead to viable strategies of practice.

As another voice in this new dialogue, the product designer Alexander Manu believes that responsible design must be shaped by an ideal. He found this ideal in the Humane Village, the theme he proposed for the 1997 ICSID congress in Toronto. "The Humane Village," wrote Manu, "will help us to instill some moral passion and a sense of purpose. We will make idealism legitimate once again. Perhaps the social responsibility that the Village implies will bring about our ability to put balance back in our lives. It will make us human."[15] While Manu's call to action is admirable, it is nonetheless only a first step and must be followed by a process of critical reflection that leads to a program of strategic intervention. A profession cannot be grounded in the expectation that all of its practitioners will share the same moral vision, and it must therefore focus on the concrete issues of practical work in order to define its social identity.[16]

Ekuan and Manu feel strongly that design must change. Ekuan hopes that interdisciplinarity will make a difference, and Manu believes that the vision of a humane village will draw designers toward work that is beneficial to humankind.[17] Both of these visions precede the hard work of mapping a terrain of situations and tasks that will expose the conditions of a new practice.

To move forward with a new agenda for design we can make use of the broad framework proposed by Fuller, which can help us explore the possible relations of design to a number of proposals and actions that are currently emerging within the culture of sustainability. The challenge of creating a sustainable world has moved from the realm of idealism to that of necessity. The understanding of sustainability as an essential value will result from a coming to consciousness in the field of design similar to that which many social groups have gone through since the mid-1960s. We can note the new relations between men and women that feminists have fought for, the respect for all the world's cultures that multiculturalists believe in, and the recognition of different sexual orientations that gays and lesbians have insisted upon.

In all cases, social forces were at work that demanded a rethinking of current attitudes, which has resulted in real differences in behavior. Little by little, such social changes have moved from citizens' initiatives to codification in official documents such as United Nations reports, accords, conventions, and charters. This is happening now with the culture of sustainability, which has

continued to grow and solidify its relations with the United Nations since 1992. Currently on the World Wide Web is the Earth Charter, which is intended to codify many of the values of the sustainability movement.[18]

Design will change as its practitioners develop a new consciousness. Broad proposals and visions are a stimulus to this process but cannot replace the hard, sustained work of rethinking one's identity as a professional. What makes this process so essential right now is the clear evidence that older models of practice are not working. Many new concepts are responses to this situation, but most of these are aimed at reforming consumer culture rather than at contributing to a new vision of professional practice.[19] Design must disengage itself from consumer culture as the primary shaper of its identity and find a terrain where it can begin to rethink its role in the world. The result of this activity, if successful, will be a new power for the designer to participate in projects for the welfare of humankind both inside and outside the market economy.

There are several obstacles to initiating this process. First is a *crisis of will*. Until a designer honestly confronts the reality of his or her work in order to determine whether and how it contributes to the sustainability of the planet, there is little incentive to change. Until now, design discourse has too often supported a rhetoric of idealism that is at odds with the reality of daily practice.

Second is a *crisis of imagination.* Too few examples of projects that are socially directed serve to stimulate or inspire designers. While such projects do exist, they are, for the most part, closed out of academic design courses and professional publications.[20] The belief that product design is a way to cultivate artistic sensibilities and make a lot of money is still quite strong within design culture. To counter this conviction, I want to make reference to two projects that suggest successful alternatives.

One is located in Curitiba, Brazil, where the former mayor, Jaime Lerner, an architect, established an Institute for Research in Urban Planning to identify problems within the city that could be addressed by designers, whatever their field of expertise. The case of Curitiba shows what can happen when a designer gains political power. Lerner's broad mandate enabled Curitiba's design staff to invent projects in response to discovered needs.[21] Many different concerns were addressed—from adding street signs in Braille text to creating innovative bus shelters that offered protection against inclement weather while also speeding up the boarding process. A special system of bus routes was worked out so that color-coded express buses could take riders to distant destinations while local buses circulated within the city center.

Recyling was a high priority for Curitiba, and the planning institute initiated a number of efforts from using recycled plastic containers for

urban structures to starting a factory that converted used plastic materials into toys for Curitiba's schoolchildren. Old buses were transformed into information kiosks and downtown daycare centers where people could leave their children while they shopped. Wooden carts were provided for scavengers to go around the city and gather materials which they could sell, and special mobile stalls were created for vendors in the city's various marketplaces. Underlying these

projects was the idea of integrated service. The designs arose from an investigation of needs and were implemented in such a way as to locate individual projects within a larger vision of urban planning.

Another approach to design is that of Nancy and John Todd, who began their work in 1969 at the New Alchemy Institute, located on Cape Cod in the United States.[22] What distinguishes the Todds' rethinking of design from that in Curitiba is their stress on integrating urban life with biological processes. Recycling is the primary ecological practice in Curitiba, but the Todds envision completely new living environments that incorporate "principles inherent in the natural world in order to sustain human populations over a long span of time."[23] The Todds' method is characterized by their design of "living machines" consisting of algae, bacteria, fish, and other organisms. "Living machines," they suggest, "can be designed to produce food or fuels, treat wastes, purify air, regulate climates, or even to do all of these simultaneously. They are designed along the principles evolved by the natural world in building and regulating its great ecologies of forests, lakes, prairies, and estuaries."[24] The Todds base their design thinking on an understanding of how natural systems function and are thereby able to propose highly original solutions to human problems. Among the projects they have envisioned are neighborhood sewage treatment facilities, drum composters for urban waste, rooftop gardens, and bioshelters that can support urban farming.

None of these projects are typical of those that socialize design or architecture students into their professions. In most cases, design training is driven by the act of giving form to materials, and design is rarely brought into relation with the natural or social sciences. As Dilnot noted in a quote cited above, de-

sign thinking—the art of conception and planning—has to be separated from its historical focus on shaping objects, particularly those for the market.

Designers have the ability to envision and give form to material and immaterial products that can address human problems on a broad scale and contribute to social well-being. This goes far beyond green design or ecodesign, which until now have represented designers' attempts to introduce ecological principles to the market economy. Pauline Madge has identified a transition from green design, a term popular a decade ago, through ecodesign to sustainable design, which she says, "represents a steady broadening of scope in theory and practice, and to a certain extent, an increasingly critical perspective on ecology and design."[25] Several thinkers cited by Madge see the difference between green design and sustainable design as that between a focus on single products and a larger systems approach to human problems.

In support of this broader approach, *Agenda 21,* the report of the Rio Earth Summit, identifies many problem areas that can engage designers although some of these fall outside the traditional sphere of design activity. The report is extremely direct in its presentation of the challenge facing humankind.

Achieving a sustainable standard of living for all people requires a bold new approach—an environmentally responsible global approach to confront these problems. A large variety of techniques can be used to accomplish this goal. Greater efficiency in the use of the Earth's limited resources, minimization of waste and fundamental changes in production processes are some methods that can be employed.[26]

This broad mandate is then divided into six themes: quality of life, efficient use of natural resources, protecting the global commons, managing human settlements, the use of chemicals and the management of human and industrial waste, and fostering sustainable economic growth on a global scale. Within each theme is an extensive list of tasks to be accomplished. Those that have a particular relevance to design as we still know it today include research and development efforts for new and reusable sources of energy, recycling waste products into the world's ecosystems, altering wasteful patterns of consumption, reducing excessive product packaging, developing affordable health care technology for rural settings, designing environmentally safe mass transit systems, creating a new aesthetic for products made of recycled materials, inventing technology to reduce the production of industrial waste, expanding eco- and cultural tourism as new forms of consumption, making more efficient use of forest products, finding alternatives to products that burn fossil fuels, creating better environmental impact statements for new products, inventing new mechanisms to monitor global resource use, 100 . 101

improve methods of recycling waste materials into new products, and assisting indigenous peoples to become entrepreneurs.

While some of these challenges are being addressed by designers within the existing framework of the emerging global economy, many are not since they do not fall within the objectives of the designer's traditional clientele. Because there has been no fundamental reinvention of design practice in order to play an active role in the *culture of sustainability,* clear paths to new forms of practice do not exist. Designers must rethink their practice both individually and collectively in order to find ways of engaging with the massive problems that confront humankind. One of the greatest of these is the accelerating growth of cities, particularly in the developing countries where urban populations are expected to double in the next twenty-five years. This will create inordinate demands for housing, waste management, water purification, food supply, and health care.[27] However, it is not only essential to confront the problems of a future population, we must also face the enormous cleanup operation that is required in order to rectify the mistakes of the past.

Man sharpening knives in a public square, Florianopolis, Brazil, 1992.

The final chapter of *Agenda 21,* which addresses the question of implementation, names various groups whose participation is deemed crucial for achieving sustainable development. These include women, youth, indigenous people, farmers, and labor unions. Nowhere are designers mentioned. Once again design remains invisible because the design professions have not done an adequate job of explaining to themselves and others the powerful contribution they could make to the process of creating a sustainable world.[28] The world's design needs are evident, but the plan for reinventing the design professions is not. The development of such a plan will require an aggressive move by design professionals to seek out colleagues already immersed in the task of creating a sustainable world—biologists, forestry experts, agronomists, urban planners, waste management engineers, and many others.

The necessary shift of purpose for designers is a more complex process than envisioned by Victor Papanek or called for by R. Buckminster Fuller, with his unequivocal faith in advanced technology. It will entail looking at economic and social development from a global perspective and addressing the gross inequities of consumption between people in the industrialized countries and those in the developing world. It will necessitate confronting the full force of the current ecological crisis in order to help return Planet Earth to a condition of sustainability. If the will exists among designers, it will surely be possible to reinvent design. If it doesn't, designers will simply remain part of the problem whose solution other professions will need to invent.

1 Victor Papanek, *Design for the Real World: Human Ecology and Social Change*, 2d rev. ed. (1972; reprint, Chicago: Academy Editions, 1985), ix. Papanek may have taken some of his points from an earlier diatribe on a similar theme by the journalist Vance Packard in his book *The Waste Makers* (New York: D. McKay, 1960).

2 R. Buckminster Fuller, "A Comprehensive Anticipatory Design Science," in Fuller, *No More Secondhand God and Other Writings* (Carbondale and Edwardsville: Southern Illinois University Press/London and Amsterdam: Feffer & Simons, 1963), 84–117. See also his essay "comprehensive designing," *trans/formation: arts, communication, environment* 1, no. 1 (1950): 18–19, 22–23. Here, Fuller anticipated many of the current concerns about resource depletion, though he predicted optimistically that everyone in the world could achieve an advanced standard of living.

3 See Fuller's account of his research in "The Fuller Research Foundation, 1946–1951," Fuller, *No More Secondhand God and Other Writings*, 65–74.

4 "The Five Two-Year Increment Phases of the Ten-Year World Facilities Redesign" in *World Design Science Decade, 1965–1975: Phase I (1964), Document 2: The Design Initiative* (Carbondale: World Resources Inventory, 1963), 107–108.

5 A bill to construct a facility for this display was submitted in the U.S. House of Representatives, but nothing came of it.

6 For a series of case studies of implementation projects, see Leyla Alvanak and Adrienne Cruz, eds., *Implementing Agenda 21: NGO Experiences from around the World* (Geneva: UN Non-Governmental Liaison Services, 1997). Victoria Tauli-Corpuz's essay in this volume, "The Implementation of Agenda 21 and Indigenous Peoples," points out that some indigenous peoples were dissatisfied with the *Agenda 21* document.

7 An excellent example of such a practice is the work of Luiz Eduardo Cid Guimarães, a Brazilian design educator in Paraiba who has been developing ways to help improve the goods that are produced by microenterprises and consumed by poor people in less developed economies. See Luiz E. C. Guimarães, "Terra Incognita: The Uncharted Realm of Low-Budget Design," *Innovation* (fall 1998): 24–26, and "Product Design and Social Needs: The Case of Northeast Brazil," *International Journal of Technology Management: Special Issue on Access to Technological and Financial Resources for SME Innovation* 12, nos. 7–8 (1996): 849–864. A somewhat different design approach is exemplified by the Connecting Foundation, a project initiated by Peik Suyling and Gerda Hahn, designers in Amsterdam, who have been working with craftsmen in India and Morocco "to create a new design process which enables the cultural memory present in traditional craft techniques to be activated into a new industrial context." See the booklet *Cabinets of Cultures: Connecting* (Amsterdam: Netherlands Design Institute, n.d). One can also mention Archeworks, an alternative design school in Chicago directed by Stanley Tigerman and Eva L. Maddox. Their students design products and service in response to requests by Chicago community organizations and social service agencies.

8 See Julian Bicknell and Liz McQuiston, eds., *Design for Need: The Social Contribution of Design* (Oxford: Pergamon Press, 1977).

9 I have taken the distinction between reactive and generative design from my colleague Wolfgang Jonas.

10 In recent years, a few design manifestos have been published, some as statements

created in conjunction with design conferences. See Antonio Barrese, Angelo Cortesi, Gillo Dorfles, and Jonathan De Pas, "Scientific Program on the Themes of the 1983 ICSID Congress," *Design Issues* 1, no. 1 (spring 1984): 64–78; Angelo Cortesi, Martin Kelm, Tapio Periänen, Yuri Soloviev, and Frederik Wildhagen, "The Guzzini Memorandum: From the Ethic of Projects to the Project of Ethics," *Design Issues* 5, no. 1 (fall 1988): 87–92; Giovanni Anceschi et al., "Charter on Graphic Design: Proposal for a Debate on Visual Communication Design," *Design Issues* 8, no. 1 (fall 1991): 67–73; Dieter Rams et al., "The Munich Design Charter," *Design Issues* 8, no. 1 (fall 1991): 74–77; Jens Bernsen et al., "A Scandinavian Design Council Manifesto on Nature, Ecology, and Human Needs for the Future," *Design Issues* 8, no. 1 (fall 1991): 78–79; "Declaration of the Central European Design Conference," *Design Issues* 8, no. 1 (fall 1991): 86–88; and Jonathan Barnbrook et al., "First Things First 2000: A Design Manifesto," *Adbusters* 7, no. 3 (fall 1999): 52–57.

11 Clive Dilnot, "Design as a Socially Significant Activity: An Introduction," *Design Studies* 3, no. 2 (1982): 144.

12 Kenji Ekuan, "Organizational Creativity at a Turning Point in Time," *ICSID News* 3 (June 1997): 7.

13 Kenji Ekuan, "A New Age, New Design Values" *ICSID News* 2 (April 1997): 4.

14 Ibid.

15 Alexander Manu, "Chasing Butterflies: Thoughts on the Big Idea of Design, Redefinitions and Responsibilities," *Humane Village Journal* 2, no. 1 (1995): 23.

16 On July 23, 1998, Design for the World, the organization that Ekuan and ICSID had been promoting for several years, was established in Barcelona. Its founding members include the major international design organizations, and its intentions are to work with organizations such as the World Health Organization and the Red Cross "to promote design solutions for problems that are beyond the scope of a single field of design." Both Ekuan and Manu are involved. See Kenji Ekuan, "Design for the World," *ICSID News* 3 (June 1999): 8.

17 Manu conceived the Humane Village as a compliment to and amplification of Marshall McLuhan's global village, which lacked the spirit of his own concept. Personal communication with the author, 1997.

18 More information on the Earth Charter Campaign can be found on the charter Web site, www.earthcharter.org/draft/charter.htm. Although I use sustainable development as my frame of reference for designers, I should also note that it is only one among many ways to think about the environment. Some, like ecofeminism, are more radical while others, like green design, are more conservative. For a gamut of environmental philosophies, see Carolyn Merchant, *Radical Ecology: The Search for a Livable World* (New York and London: Routledge, 1992).

19 One of the strongest reform tendencies is the Factor 10 movement, which advocates reducing the amount of material in products by a factor of 10. Research has been concentrated primarily at the Wuppertal Institute für Klima, Umwelt, Energie. Factor 10 ideas have been most widely disseminated in Friedrich Schmidt-Bleek, *Wieviel Umwelt Braucht der Mensch? Faktor 10—das Mass für Ökologisches Wirtschaften* (München: Deutschen Taschenbuch, 1997). See also Friedrich Schmidt-Bleek, Thomas Merten, and Ursula Tischner, eds., *Ökointelligentes Produzieren und Konsumieren: Ein Workshop im Rahmen des Verbundprojektes Technologiebedarf im 21.*

Jahrhundert des Wissenschaftszentrums Nordrhein-Westfalen (Berlin, Basel, and Boston: Birkhäuser, 1997); Friedrich Schmidt-Bleek and Ursula Tischner, *Produktentwicklung: Nutzen Gestalten—Natur Schonen* (Vienna: WIFI Österreich, 1997); and *The International Factor 10 Club's Statement to Government and Business Leaders* (Carnoules: Factor 10 Club, 1997).

20 A number of such projects have been inspired by the Appropriate Technology movement. See, for example, John Kurien, "Case Study 12: Kerala Fishing Boat Project, South India," and Monica Opole, "Case Study 14: Improved Charcoal Stoves Programme, Kenya," in *The Greening of Aid: Sustainable Livelihoods in Practice*, ed. Czech Conroy and Miles Litvinoff (London: Earthscan Publications, 1988), 108–112, 118–123. For an overview of appropriate technology, see Witold Rybczynski, *Paper Heroes: A Review of Appropriate Technology* (Garden City, N.Y.: Anchor Books, 1980).

21 After serving as mayor of Curitiba for three terms, Jaime Lerner became the governor of the state of Paraná where he was influential in creating a major auto-manufacturing hub. He also worked with investors to establish a leather industry in the state and has supported the development of clothing and textile industries in towns such as Apucarana, which began by simply producing cotton. See "Building the Detroit of Latin America," *Business Week*, September 15, 1997, 27.

22 See Nancy Jack Todd and John Todd, *From Eco-Cities to Living Machines: Principles of Ecological Design* (Berkeley, Calif.: North Atlantic Books, 1994). The book is a revised version of an earlier edition that was published as *Bioshelters, Ocean Arks, City Farming: Ecology as the Basis of Design* (San Francisco: Sierra Club Books, 1984). Its reissue was in large part a response to the Rio Earth Summit in 1992.

23 Todd and Todd, *From Eco-Cities to Living Machines*, 1.

24 Ibid., 167.

25 Pauline Madge, "Ecological Design: A New Critique," *Design Issues* 13, no. 2 (summer 1997): 44.

26 *Agenda 21: The Earth Summit Strategy to Save Our Planet,* ed. Daniel Sitarz, with an introduction by Senator Paul Simon (Boulder: Earthpress, 1993), 31–32.

27 See Richard Rogers, *Cities for a Small Planet,* ed. Philip Gumuchdjian (London: Faber and Faber, 1997).

28 According to Maurice Strong, the initiator of the Earth Summit, no designers' groups came forward during the planning process to contribute ideas for the event. Strong made this statement during a press conference at the ICSID Humane Village Congress, August 24, 1977.

THE POLITICS OF THE ARTIFICIAL

INTRODUCTION If we consider design to be the conception and planning of the artificial, then its scope and boundaries are intimately entwined with our understanding of the artificial's limits. That is to say, in extending the domain within which we conceive and plan, we are extending the boundaries of design practice. To the degree that design makes incursions into realms that were once considered as belonging to nature rather than to culture, so does its conceptual scope widen.

Until recent years, the distinction between nature and culture seemed to be clear, with design, of course, belonging to the realm of culture. The concept of design, as it was initially developed by early theorists such as Henry Cole, one of the chief promoters of Britain's Crystal Palace Exhibition of 1851, was a static one that was inextricably bound to the object. Cole thought the purpose of design was to improve the appearance of products, and he hoped to confront the confusion and profusion of historical styles that were being loaded onto Victorian objects from furniture to steam engines by promoting a closer collaboration of artists and industry.

With Cole begins a discourse about objects, particularly about how they should look, that continues well into the twenty-first century. It is echoed in Charles Eastlake's exhortations for simple forms and honest representations of materials, Herman Muthesius's call for a rational language of industrial forms, and Adolf Loos's antagonism to ornament. Closer to home, we can see it at work in the streamlined products of the American consultant designers of the

1930s and in the resistance to those products by the design staff at New York's Museum of Modern Art.

Although the modernist belief in simplicity was turned on its head by the expressive furniture of such groups as Studio Alchymia and Memphis in the late 1970s and early 1980s, the terms of the discourse were still focused on objects. It was this emphasis that gave rise to the profession of industrial design we have known until recently. But various theorists such as Herbert Simon and John Chris Jones have argued that a process of design underlies everything in our culture, both material and immaterial. Simon has gone so far as to consider design to be a new "science of the artificial."[1]

Where Simon and Jones proposed a broadening of design's subject matter to embrace all that we might call the artificial, other theorists have questioned design's meaning. In the discourse of the modernists, the locus of meaning was twofold: form and function, for which we might substitute the theoretical terms "aesthetics" and "pragmatics." Early modernist designers believed that meaning was embedded in the object rather than negotiated in the relation between the object and a user. Objects were considered to be signs of value with uncontested referents such as clarity, beauty, integrity, simplicity, economy of means, and function. The reductive slogan "form follows function" assumed that use was an explicit, unambiguous term. Thus, the meaning of objects was to be found in their relation to a value that was grounded in belief. Poststructuralism challenged the idea of grounded belief as well as our right to appropriate "meaning" as if it were a term that itself did not raise questions about the possible conditions of its use.

Besides the slippery subject matter of design and the questions regarding the conditions under which we can talk about its meaning, we must also confront a more difficult problem at the heart of the politics of the artificial, and that is the nature of reality. For the "first modernity"—and here I will use Andrea Branzi's distinction between two modernities—reality was an uncontested term.[2] It was the stable ground for the attribution of meaning to objects, images, and acts. Today, this is no longer the case, and any mention of "reality" must be qualified by conditions, just as the use of the term "meaning" must be; hence we are unclear as to how or whether boundaries can be drawn around the real or authentic as a basis of meaning.

When Simon called for a new "science of the artificial" in 1969, he designated nature as the ground of meaning against which such a science or a broadly conceived practice of design would be defined. "Natural science," he wrote, "is knowledge about natural objects and phenomena."[3] The artificial, on the other hand, was about objects and phenomena invented by humans. The difference between the two was clear to Simon, although his implicit pos-

itivist construction of the natural was also the model for his explicit methodology of design.

The critique of scientific discourse mounted by Paul Feyerabend, Donna Haraway, Stanley Aronowitz, and others has since called into question the way we claim to know nature as real. This critique has at least succeeded in contesting the easy equation of the natural with the real and has thus problematized unqualified references to nature. By focusing on scientific thought as a linguistic construct, critics have attempted to challenge a previous faith in scientific truth. Hence, we have two contested terms, "meaning" and "reality," that severely undermine the certainties on which a theory and practice of design was built in the first modernity. Since we can no longer talk about design as if these terms were not in question, a new discourse is needed, although the way this discourse will develop as a reflection on design practice is not yet clear. However, I believe the central theme to be addressed in this discourse is the artificial and its boundaries.

THE BOUNDARY PROBLEM In the first of his Compton Lectures, "The Sciences of the Artificial," delivered at the Massachusetts Institute of Technology in 1969, Simon characterized natural science as descriptive, as concerned with how things are, while he defined a science of the artificial as "normative" in its engagement with human goals and questions of how things ought to be.[4] The two sciences were differentiated by the term "should," which marked the task of humans to invent the artificial world in order to achieve their own goals while honoring the parallel purpose of the natural world.

Simon proposed four indicia to distinguish the artificial from the natural. Three define the artificial as the result of human agency. He said that artificial things result from an act of making, which he called "synthesis," while the act of observing, "analysis," is the way humans relate to nature. Furthermore, he characterized the artificial by "functions, goals, adaptation" and discussed it "in terms of imperatives as well as descriptives."[5]

When Simon compared the artificial to the natural, he posited the natural as an uncontested term, arguing that the artificial "may imitate appearances in natural things while lacking, in one or many respects, the reality of the latter."[6] However, the equation of the natural with the real has been heavily contested in recent years, most notably by poststructuralists and deconstructionists. Roland Barthes's and Michel Foucault's challenge to authorial intentions in literature and art, Jean Baudrillard's claim that simulacra are signs without referents, and Jean-François Lyotard's refusal to acknowledge any metanarratives or "grands récits" that shape social values all exemplify this tendency, as does Haraway's discourse on cyborg culture.

While these attacks on the real legitimately challenged implicit assumptions of positivist thought that closed out many of the voices that now constitute our cultural community, they also strove to abolish any presence, whether we call it nature, God, or spirit, that might exist beyond the frame of a socially constructed discourse. Hence, Haraway, in her 1985 essay "A Manifesto for Cyborgs," could argue for the cyborg, a hybrid of human and machine, as "a fiction mapping our social and bodily reality,"[7] and Gianni Vattimo, the Italian philosopher who has postulated "il pensiero debole," or "weak thought," as the appropriate philosophy for the postmodern era, can claim that "only where there is no terminal or interrupting instance of the highest value (God) to block the process may values be displayed in their true nature, namely as possessing the capacity for convertibility and an indefinite transformability or processuality."[8] Vattimo concludes from his readings of Nietzsche and Heidegger that "[n]ihilism is thus the reduction of Being to exchange-value."[9] He does not mean this in the mercantile sense of selling the self but in terms of the self's convertibility without a ground such as nature or God against which it can be defined.

We also find evidence of a convertible self in William Gibson's cyberpunk novel *Neuromancer,* in which the artificial is unbounded by any presence outside it. Gibson's characters have no grounding in the real; they are constructed of motives and impulses that are facilitated by the manipulation of artificial products. While some characters are more human than others, none possess any inherent resistance to the incursion of the artificial in their bodies or their lives, and some, like the AI Wintermute (an artificial intelligence [AI] that intervenes in social life), are totally artificial. Part of the fascination with *Neuromancer* outside the cyberpunk milieu is Gibson's portrayal of a world in which the artificial is dominant and where the ability to manipulate it is the most potent human activity.[10]

Neuromancer offers us a scenario of design triumphant in a world in which the real is no longer a point of reference. Simon's postulation of the artificial as an imitation of the natural carries no weight in this context. In the world portrayed by Gibson, being is convertible into infinite forms, and values of identity are constituted primarily through the manipulation of technology. The materials that constitute the substance of design have already gone through so many transformations that their locus in nature is no longer evident.

If design in *Neuromancer* is triumphant at the expense of reality, how do we reflect on the issue of meaning in Gibson's world? We first need to question what meaning is in a world in which reality no longer constitutes the ground on which values are formed. Meaning then becomes a strategic concept that exists pragmatically at the interface of design and use. Its value is determined by operational rather than semantic concerns. The characters in *Neuromancer* have

even designed themselves but without an external ethical imperative or an inner sense of self to guide them.

Neuromancer is a fictional portrayal of Jean Baudrillard's world of the simulacrum. As in Gibson's novel, the real for Baudrillard is "nothing more than operational."[11] The simulacrum, according to Baudrillard, is a sign for the real that substitutes for the real itself. The result is what he calls the "hyperreal." Baudrillard believes there can be no representation since "simulation envelops the whole edifice of representation as itself a simulacrum."[12]

The world of *Neuromancer* is a reflection of Baudrillard's own nihilism. He sees the West as having lost what he calls the "wager on representation." This wager was based on the belief that signs could exchange for depths of meaning and that something external to the exchange—he mentions God— could guarantee it. However, Baudrillard himself expresses no faith in God or in any metanarrative of equivalent power. He expresses his doubt as follows:

But what if God himself can be simulated, that is to say, reduced to the signs which attest his existence? Then the whole system becomes weightless, it is no longer anything but a gigantic simulacrum—not unreal, but a simulacrum, never again exchanging for what is real, but exchanging in itself, in an uninterrupted circuit without reference or circumference.[13]

Although Baudrillard is a prophet of doom, his ability to explore the implications of a world without the presence of the real is useful. As in Gibson's *Neuromancer,* meaning only exists for Baudrillard in the operation of exchange rather than in a reality outside it. In his book *Simulations,* he discusses the difficulty of finding meaning in a world without a metanarrative, a term Jean-François Lyotard defines as any large idea or presence that exists as an uncontested phenomenon outside the realm of human social action. And yet postmodern theorists, led by Lyotard, have insisted that metanarratives are no longer possible. As Lyotard states in *The Postmodern Condition,* "I define *postmodern* as incredulity toward metanarratives."[14] He believes that knowledge may be accepted as legitimate for reasons other than its inherent truth, and he wants to guard against the dominance of knowledge that, in his perception, may be illegitimate. I use qualifiers to account for Lyotard's interpretation of legitimate and illegitimate knowledge to ensure that I relate his thought to his own perception of truth rather than to anything that is or isn't inherently truthful.

Lyotard's skepticism has usefully stimulated a critical analysis of how social discourses are constructed, but it has also reinforced the belief that social life has no ground of meaning. The disbelief in metanarratives, particularly among prominent cultural theorists, is an essential factor in the argu-

ment that the postmodern is a rupture with the modern. Although metanarratives of the modern have been variously defined, the belief in progress animated by instrumental reason is a central one, as is the credence in universals rather than differences.

EXPANDING THE DISCOURSE The collapse of a particular modernist paradigm has opened the space of social discourse to many voices that were formerly marginalized or suppressed. But the recognition of difference has also led to a widespread refusal to postulate the world in terms of shared values. Lyotard refers to the situation of difference as "a pragmatics of language particles."[15] However, many people, including myself, are unhappy with the postmodern condition as Lyotard and other scholars, critics, and artists have defined and elaborated it. But this does not mean that it has to be countered by sustaining a modernist position that is no longer valid. In the most profound sense, the specter of instrumental reason, with its increasing technological power, let loose on what remains of nature without any moral or ethical imperative to govern it, is terrifying.

Mark Sagoff has described the potential impact of advances in biotechnology on the environment:

The goal of biotechnology is to improve upon nature, to replace natural organisms and processes with artificial ones, in order to increase overall social efficiency and profit. . . . That is why we spend more to produce economically valuable engineered species than to protect economically useless endangered ones. And that is also why we continually turn whatever natural and wild ecological systems we may have—from rain forests to savannas to estuaries—into carefully managed and engineered (and therefore predictable and profitable) bioindustrial productive systems.[16]

The issues raised here are similar to those previously referred to in *Neuromancer* and thus justify the critic Peter Fitting's reading of Gibson's world as "not so much an image of the future, but the metaphorical evocation of life in the present."[17] The technical possibilities of biotechnology, as described by Sagoff, have already blurred the boundaries between the artificial and the real. Rather than an imitation of nature, the managed biosystem becomes a replacement of it.

These biosystems still maintain the appearance of the natural in that they draw their energy from the Earth, but their transformation from natural to managed systems may disengage them from a larger ecological balance of which their managers are either unaware or do not wish to take into account. Such managed biosystems might be simulacra of nature without our even

knowing it. Instrumental reason continues to alter species and biosystems for human use, particularly for economic profit. This is design, but, as in *Neuromancer,* it flourishes only at the expense of the natural.

The confusion between the artificial and the natural engendered by the capabilities of biotechnology exists because both realms have been reduced to exchange-value. When they are seen as interchangeable, as biotech managers prefer to do, one can be substituted for the other without any sense of loss. The only way to distinguish between them is to identify one with a value that is missing in the other.

Extreme views of biotechnologists and ecologists who collapse the distinction between the artificial and the natural can be contrasted with another set of views that regard nature as sacred. According to James Lovelock's Gaia principle, the Earth is a living being with whom we must cooperate. Ecofeminists, who have adopted the triadic values of feminism, ecology, and spirituality, also share the belief that the Earth is alive. As Paula Gunn Allen writes,

The planet, our mother, Grandmother Earth, is *physical* and therefore a spiritual, mental, and emotional being. Planets are alive, as are all their by-products or expressions, such as animals, vegetables, minerals, climatic and meteorological phenomena.[18]

Both the Gaia metaphor and the Goddess narrative, which is at the core of ecofeminist spiritual belief, have generated a strong critique of instrumental reason, which the ecofeminists identify with patriarchy. Carol Christ, also an ecofeminist, believes that

the preservation of the Earth requires a profound shift in consciousness: a recovery of more ancient and traditional views that revere the profound connection of all beings in the web of life and a rethinking of the relation of both humanity and divinity to nature.[19]

For ecofeminists the narrative of Goddess spirituality has been a powerful impetus to political action. They have led and participated in demonstrations against acid rain, the destruction of the rain forests, the depletion of the ozone layer, and the proliferation of nuclear weapons and have, as well, been involved with numerous other causes promoting a healthy environment. Their aim, as Starhawk, another ecofeminist, says, is not simply to oppose patriarchal power but "to transform the structure of power itself."[20] The accomplishments of ecofeminists on two fronts—opposing groups that damage the Earth's ecology and creating actions that draw women together to collaborate positively with the life forces of the Earth—signify the power of a narrative in changing human action. From the position of ecofeminism, the postmodern philosophy of Vattimo and Lyotard has little to offer those who wish to act together constructively. It can only acknowledge an absence of meaning.

Ecofeminism has also made a valuable contribution to the understanding of discourse formation through its resistance to a patriarchal narrative that has closed out historical matriarchal cultures in which women maintained roles of authority. Starting from a marginalized location, the ecofeminists have, through cooperative intellectual activity, created a place for themselves within contemporary cultural discourse. They have simply begun from a different position than either positivists or nihilistic poststructuralists, with a project that could be consistently and cooperatively pursued within the framework of a new narrative. Ecofeminists have also demonstrated the power of spiritual conviction and experience in generating positive action. Where they have been less effective is in establishing a rhetorical stance from which to engage postmodern theories in both a critical and an affirmative way. They have, however, implicitly challenged Lyotard's dismissal of metanarratives by producing a narrative of their own that is clearly empowering. While it might be seen by some as marginal because so few people embrace it, the Goddess narrative can nonetheless form part of a more inclusive metanarrative of spirituality within which difference can be asserted just as the postmodernists argue it must be done socially.

Spirituality as a metanarrative—and I interpret spirituality here as a connection to the Divine—can serve as a basis for addressing the problems of meaning and reality that have arisen from an embrace of the artificial. If a broad discourse on the spirit can become as compelling for other social groups as the Goddess narrative has been for ecofeminists, then it has the capacity to empower large numbers of people to find meaning and fulfillment in action directed to the well-being and life enhancement of themselves and others. It is difficult to say what form this action would take, particularly as regards design, but it would certainly be characterized by the quest for meaning and unity in relations with others.

A recognition of the Divine as neither exclusively matriarchal nor patriarchal can overcome the breach between the modern and the postmodern in several ways. It can acknowledge the value of a social narrative in modernist thought while recognizing the limitations of the first modernity's faith in universal categories and instrumental reason. It can also recognize the significance of the many incisive critiques of contemporary culture, which have directed attention to the problem of the artificial.

There is much that design and technology have to gain from a metanarrative of divinely inspired spirituality, particularly as a ground of meaning that testifies to the limits of the artificial. While I trace spirituality to a transcendent source, I refer to it here as it is manifested in human action. What characterizes the spiritual is both its immanence and its transcendence, its capacity to ani-

mate humans from within while also existing as a presence outside them.

SIMULACRA AND THE REAL Spirituality, whether we link it to God, the Goddess, or some other transcendent source, is one of the most contested terms in our contemporary vocabulary, but we have had little chance to explore its meaning because it has been suppressed by a powerful intellectual discourse of materialism. Hence, Donna Haraway states in "A Manifesto for Cyborgs" that

late twentieth-century machines have made thoroughly ambiguous the difference between natural and artificial, mind and body, self-developing and externally designed, and many other distinctions that used to apply to organisms and machines.[21]

Haraway claims that we are moving to a "polymorphous information system" in which "any objects or persons can be reasonably thought of in terms of disassembly and reassembly; no 'natural' architectures constrain system design."[22] Whereas *Neuromancer* is a dystopic narrative of self-interest and power played out through design and the control of technology, Haraway views this new polymorphous flexibility as a vehicle for positive social change. However, the lack of a metanarrative that can serve as a source of normative values compels her to emphasize power and economics as primary in determining the boundaries of the artificial and the real. Such an absence also makes resistance to technology more difficult. A principal theme of technological discourse is that innovative devices will enable us to do things we have not done before. We are told that new experiences made possible by technology will be expansive. Measured against a reductive understanding of "natural" experience, this certainly appears true. But the power of lived spirituality can enlarge the experience of being and thus provide a stronger position from which to support or resist new technologies.

Let's take virtual reality (VR) research as an example.[23] Brenda Laurel has described the many experiences that VR will make possible, as has Jaron Lanier, one of the medium's founders and early spokespersons. In a 1989 interview, Lanier spoke euphorically about the new possibilities of VR:

The computer that's running the Virtual Reality will use your body's movements to control whatever body you choose to have in Virtual Reality, which might be human or might be something quite different. You might very well be a mountain range or a galaxy or a pebble on the floor. Or a piano . . . I've considered being a piano. I'm interested in being musical instruments quite a lot.[24]

Needless to say, neither Lanier nor others involved in VR research privilege personal fantasy as the primary justification for what they do, but it is

certainly a strong element and one that promises extensive economic payoff. Surely, virtual reality, which has already become a site for virtual sex, will continue to develop into a powerful entertainment medium.

While it promises numerous advantages as a simulation device for training surgeons or pilots or for manipulating machines electronically at a distance, the primary issue raised by virtual reality technology relates to whether we experience simulation as a mark or a mask. This distinction was made by Dennis Doordan in an article on simulation techniques in museum exhibits.[25] When the designer marks the edge of a simulation, it is distinguished as a second-order experience whose referent is more authentic. If the edge is masked, the simulation becomes a simulacrum, as Baudrillard has pointed out, with no reference to an experience outside itself. Thus the boundary between the simulated and the real collapses and the simulated becomes the new real.

The counterbalance of perceived constraints in corporeal society and the envisioned freedom of an electronic self raise questions about the value of physical reality in relation to its virtual counterpart. Virtual reality enthusiasts sometimes speak of VR as an alternative to the physical world, a place in which constraints can be overcome and new freedoms can be discovered. On one level, this is classic technorhetoric. New technology always promises more. For some, virtual reality suggests that electronic identity offers something greater or more fulfilling than bodily existence. Recall the comment of Case, Gibson's antihero in *Neuromancer*: "The body is meat."

For Case, jacking into cyberspace is a life-enhancing experience that is more meaningful than being in his body. In cyberspace, Case, a marginal figure in real life, displays a shrewd intelligence in breaking through barriers to crack information codes, and he shows considerable courage in maneuvering his way through nets of electronic opposition. In a world of collapsed boundaries between the artificial and the real, the symbolic world of the Net becomes for Case a more intense and expansive reality than his corporeal one.

Bruce Sterling, the cyberpunk writer, takes the libertarian view that cyberspace is a political frontier where the world can be invented anew without constraints. But the expectation that this new symbolic territory will be immune to the same tendencies to regulate life that characterize the corporeal world is unrealistic. Lawyers are already at work on cases in which electronic events have threatened or violated constitutional rights and have resulted in psychological or even physical harm to individuals. However, legal codes will not be applied to virtual action without great difficulty. As attorney Ann Branscomb states,

The case with which electronic impulses can be manipulated, modified and erased is hostile to a deliberate legal system that arose in

an era of tangible things and relies on documentary evidence to val-
idate transactions, incriminate miscreants and affirm contractual
relations.[26]

We know from the many accounts of hacker behavior and from novels such as
Neuromancer that psychic engagement with electronic communication can be
intense. What is possible, as virtual reality research makes the visualization of
electronic identities more palpable, is that the potential for the increased blur-
ring of boundaries between corporeal and virtual identities will increase. In Bau-
drillard's sense, electronic identity for some may no longer be a representation
of a self; instead, it may become the self against which life in the body is poor
psychic competition.

Cynicism about the constructive possibilities of the American political
system leaves a vacuum of meaning in civil society that offers little or no resist-
ance to the artificial. In fact, the artificial as entertainment, from video games to
interactive VR environments, may become even more engaging for some than
corporeal life.[27] It may also become such a powerful diversion that incursions
into the natural by aggressive biotech corporations will go unnoticed.

The images of becoming as explorations of fantasy are a far cry from the
discourses about human development embodied in the different strands of the
spiritual metanarrative. Within this metanarrative, becoming is part of a conti-
nuity of development that results in a self that understands its purpose within a
larger framework of spiritual evolution. For those who hold this belief, spiritual
evolution is the ground of reality against which the values of the artificial must
be assessed.

The late Jesuit theologian and scientist Pierre Teilhard de Chardin re-
lated the motivation to embrace spiritual evolution to the force with which it is
experienced:

In any morality of movement, on the contrary, which is only defined
by relation to a state or object to be reached, it is imperative that the
goal shall shine with enough light to be desired and held in view.[28]

For Teilhard the Jesuit priest, it is the love of the Divine that animates human
beings to strive together toward a higher unity. Yet as a paleontologist, he re-
alized that humans need to think about spirituality in a new way that does not
oppose the realm of the spirit to that of science. As he wrote in an unpub-
lished text of 1937, "What we are all more or less lacking at this moment is a
new definition of holiness."[29]

SPIRITUALITY AND THE FUTURE OF DESIGN We are now challenged to
take up Teilhard de Chardin's question at a moment when the capabilities of
technology are outstripping our understanding of what it means to be human.[30] 116.117

As artificial beings like cyborgs or replicants more closely represent what we have always thought a human is, we are hard pressed to define the difference between us and them. This is the problem that Donna Haraway addressed with her myth of the cyborg, which draws humans into a closer relation with machines. "No objects, spaces, or bodies are sacred in themselves," she argued in "A Manifesto for Cyborgs"; "any component can be interfaced with any other if the proper standard, the proper code, can be constructed for processing signals in a common language."[31] The film *Blade Runner* plays with this idea of interchangeability, leaving ambiguous the relation of the bounty hunter to the female replicant, whose feeling for him may or may not be the equivalent of human love.

To move toward a self that is more differentiated from rather than similar to artificial constructs, we need to understand the connection to the Divine as a force of evolution that is not in opposition to technology but at the same time offers some of the equivalent fulfillment we currently seek in the realm of the artificial.[32] We are living in a moment that Teilhard de Chardin could not have conceived in 1937, a moment where the real cannot be taken for granted but must be wrested from the artificial. This is not an easy task, but it is one in which we need to engage if we are not to be engulfed by simulacra. It means finding a way of talking about the spiritual that does not present it in opposition to the artificial but instead recognizes particular forms of the artificial as fruitful manifestations of spiritual energy. The task is difficult because of the plurality of human experience and the lack of a discourse that can accommodate the presence of spirituality even for those who resist it or marginalize it.

The first step, however, is to reintroduce the concept of spirituality into the current philosophic debates from which it has been excluded. As a rhetorical move, spirituality must be brought from the margins of contemporary thought to a more central position. By considering its place in our reflections on the artificial, we can raise questions about design and technology that would otherwise go unasked. For example, we would have to wrestle with questions of whether particular forms of artificiality—a genetic mutant, an artificial-life environment, or an expert AI system, for example—were appropriate replacements for equivalent phenomena we have designated as natural. In short, we would have to manage the boundaries between the artificial, which is human-made, and the natural, which exists independently of human design.

While this distinction is more problematic than it may have appeared to Herbert Simon in 1969, it nonetheless empowers us to stake out a different territory for design, one that does not attempt to completely replace the natural but moves instead to complement it. This view is in opposition to the thrust of technorhetoric, which always argues for the superiority of the artificial.

Design theorist Tony Fry addressed this problem in a lecture on eco-design given at University of Notre Dame in 1993. Although Fry was referring to the effects of too much design on the natural environment, I find his words germane to the larger issue of boundaries for the artificial:

Designers have to become more informed about the environmental impact of what they do; they have to be more critical, more responsible. They/I have to fully recognize, that whatever they/I design goes on designing. It/I/they also have to discover how to stop designing, which implies learning how to let essential systems be, or designing mechanisms of artificial support that render future design action redundant. [33]

A metanarrative of spirituality can help designers resist technorhetoric that sanctions the continuous colonization of the natural. It can provide instead a more profound and conscious reflection on the artificial as a subject that has yet to be explored with any depth by designers and technologists. Such reflection can resist the reduction of the artificial to simulacra, on the one hand, or to violations of nature, on the other.

To the degree that a metanarrative of spirituality is articulated as a discourse on human purpose, it can enable technologists and designers to make decisions about what research directions to pursue and what to design. [34] I don't want to make grandiose claims for spirituality as the source of an entirely new design paradigm when, in fact, many products already fully satisfy human needs. But I do want to suggest that the more a designer or an engineer can conceive of a user as a person of depth and worth, the more likely he or she is to design a valuable product. [35]

Design, understood in a deeper sense, is a human service. It generates the products that we require for productive living. To the degree that our activities are enabled by the presence of useful products, spirituality can be a source for cultivating a sense of what is worthwhile. As manifested in product design and technological devices, spirituality is the attention to human welfare and life enhancement seen in relation both to the individual self and to humanity as a whole. As designers and technologists develop a more caring feeling for how people live, they may also generate new products that respond to previously unimagined human activities.

A greater attentiveness to questions of human welfare and purpose can also help us weigh the merits of new technologies as well as the possibilities they offer for the design of products. Bruce Sterling has characterized virtual reality as the "ultimate designable medium," one that can absorb infinite amounts of human ingenuity. [36] The design of cyberspace, for example, runs the danger of becoming a parallel economy in which electronic analogs of corporeal

experience are bought and sold. This activity has the potential to absorb vast amounts of capital and concentrate it in the hands of a few corporations that control the technology to make it happen. We need to ask ourselves whether the construction of such analogs is where designers can most usefully concentrate their talent and the economy its capital. I think not.

A metanarrative of spirituality can empower designers and technologists to better understand design as a form of action that contributes to social well-being. It can link design to a process of social improvement that becomes the material counterpart of spiritual development. Here a sense of continuity with the modern period can reinvigorate the idea of a larger project for design that needs to be fashioned anew in relation to contemporary conditions. Most importantly, a spiritual metanarrative can empower individuals to act confidently and forcefully in the face of a widespread cultural nihilism. This metanarrative can also reunite design with the two contested terms—"meaning" and "reality"—in a way that resists their collapse. There is clearly a need to understand the meaning of products within a larger set of issues about the artificial, but no theory has thus far addressed this problem.

To consider the question of the artificial in the way we need to, I want to return to Simon's 1969 Compton Lectures. But I don't want to accept his assumption that either "nature" or "science" hold uncontested claims to truth. What I believe is important in Simon's argument, particularly in terms of my own call for a new metanarrative, is his delineation of the natural and the artificial as distinct realms. Although the natural can be transformed into the artificial through human action, and Simon acknowledges that "the world we live in today is much more a man-made, or artificial, world than it is a natural world,"[37] the natural, in ontological terms, is not interchangeable with the artificial.

Today we recognize that the artificial is a much more complex phenomenon than postulated by Simon in 1969. We therefore need to problematize it in a new way. The various critiques of positivism and patriarchy, the deconstruction of scientific discourse, and the multiple new voices that now fill the space of social debate are all part of a different situation within which the artificial must be rethought. Among those heavily invested in the artificial as a replacement for the natural, resistance to this challenge is strong. And yet, as the artificial's incursion into the natural domain of our lives advances, we may lose part of our humanity. In the face of such a prospect, there is no choice but to fight back.

1 See Herbert Simon, *The Sciences of the Artificial,* 3d. ed (Cambridge: MIT Press, 1996); and John Chris Jones, *designing design* (London: Architecture and Technology Press, 1991).

2 Branzi has devised the term "second modernity," which I referred to in "Thinking about Design at the End of the Millennium" to characterize our present moment. "What I mean by this term," he states, "is an acceptance of Modernity as an artificial cultural system based neither on the principle of necessity nor on the principle of identity but on a set of conventional cultural and linguistic values that somehow make it possible for us to go on making choices and designing." For Branzi, the principles of necessity and identity may refer to the modern movement's concern with function and its faith in objects that could embody a sense of absolute value. He characterizes the second modernity in terms of a set of theorems that differentiate the conditions of design from the prior period. This term enables him to continue talking about a "project for design," as did the designers of the first modernity, without having to ignore either postmodernism's critical responses to modernism or the cultural complexities of the present that postmodernism has recognized. See Andrea Branzi, "An Ecology of the Artificial" and "Towards a Second Modernity," in Branzi, *Learning from Milan* (Cambridge: MIT Press, 1988). See also his essay "Three Theorems for an Ecology of the Artificial World," in *La Quarta Metropoli: Design e Cultura Ambientale* (Milan: Domus Academy Edizioni, 1990).

3 Simon, "Understanding the Natural and Artificial Worlds," in *The Sciences of the Artificial,* 3.

4 Ibid., 4–5.

5 Ibid., 5.

6 Ibid.

7 Donna Haraway, "A Manifesto for Cyborgs: Science, Technology, and Socialist Feminism in the 1980s," *Socialist Review* 80 (March–April 1985): 66. Haraway reflected on her essay in several subsequent interviews. See Constance Penley and Andrew Ross, "Cyborg at Large: Interview with Donna Haraway," in *Technoculture*, Cultural Politics, vol. 3, ed. Constance Penley and Andrew Ross (Minneapolis: University of Minnesota Press, 1991), 1–20; followed in the same volume by Donna Haraway, "The Actors Are Cyborg, Nature Is Coyote, and the Geography Is Elsewhere: Postscript to 'Cyborg at Large,'" 21–26. See also Marcy Darnovsky, "Overhauling the Meaning Machines: An Interview with Donna Haraway," *Socialist Review* 21, no. 2 (April–June 1991): 65–84.

8 Gianni Vattimo, "An Apology for Nihilism," in Vattimo, *The End of Modernity: Nihilism and Hermeneutics in Postmodern Culture,* translated and with an introduction by Jon R. Snyder (Baltimore: Johns Hopkins University Press, 1988), 21.

9 Ibid.

10 William Gibson, *Neuromancer* (New York: Ace Books, 1984). For a reflection on the relation of Gibson's novels to central issues of postmodernism, see Peter Fitting, "The Lessons of Cyberpunk," in Penley and Ross, *Technoculture,* 295–316.

11 Jean Baudrillard, "The Precession of Simulacra," in Baudrillard, *Simulations* (New York: Semiotext[e], 1983), 3.

12 Ibid., 11.

13 Ibid., 10.

14 Jean-François Lyotard, *The Postmodern Condition: A Report on Knowledge,* translated Geoff Bennington and Brian Massumi (Minneapolis: University of Minnesota Press, 1984), xxiv.

15 Ibid.

16 Mark Sagoff, "On Making Nature Safe for Biotechnology," in *Assessing Ecological Risks of Technology,* ed. Lev Ginzburg (Stoneham, Mass.: Butterworth-Heinemann, 1991), 345. There has been a backlash in Europe and Japan against genetically engineered foods coming from the United States, and this may presage future resistance to biotechnology in the future. See "Furor over 'Frankenfood,'" *Business Week,* October 18, 1999, 50–51.

17 Fitting, "The Lessons of Cyberpunk," 299.

18 Paula Gunn Allen, "The Woman I Love Is a Planet; The Planet I Love Is a Tree," in *Remaking the World: The Emergence of Ecofeminism,* eds. Irene Diamond and Gloria Feman Orenstein (San Francisco: Sierra Club Books, 1990), 52.

19 Carol P. Christ, "Rethinking Theology and Nature," in Diamond and Orenstein, *Remaking the World,* 76.

20 Starhawk, "Power, Authority, and Mystery," in Diamond and Orenstein, *Remaking the World,* 76.

21 Haraway, "A Manifesto for Cyborgs," 69.

22 Ibid., 81.

23 For an extensive survey of virtual reality research, see Howard Rheingold, *Virtual Reality* (London: Secker & Warburg, 1991).

24 "An Interview with Jaron Lanier," *Whole Earth Review* (fall 1989): 108–119.

25 Dennis Doordan, "Nature on Display," *Design Quarterly* 155 (spring 1992): 36.

26 Ann Branscomb, "Common Law for the Electronic Frontier," *Scientific American* 265, no. 3 (September 1991): 112.

27 This theme is particularly significant in light of the current emergence of right-wing, xenophobic, and fundamentalist groups around the world whose messianic militancy has posed a severe challenge to liberal democracy. The survival of democratic institutions and the struggle for social justice now require significant attention and action by many who may find it more tempting to ignore this call and devote their primary attention to the electronic realm.

28 Pierre Teilhard de Chardin, "The Phenomenon of Spirituality," in Teilhard de Chardin, *Human Energy* (London: Collins, 1969), 109.

29 Ibid., 110.

30 An exhibition catalog by Jeffrey Deitch and the late Dan Friedman is entitled *Post-Human* (New York: J. Deitch, 1992). The Australian performance artist Stelarc has created a performance that deconstructs the idea of the human through an intensive relation of biology and technology. See Stelarc, "Da strategie a cyberstrategie: Prostetica, robotica ed esistenza remota," in Pier Luigi Capucci, ed., *Il Corpo Technologico: La Influenze delle Technologie sul Corpo e sulle Sue Facolta* (Bologna: Baskerville, 1994), 61–76; and Howard Caygill, "Stelarc and the Chimera: Kant's Critique of Prosthetic Judgment," *Art Journal* 56, no. 1 (spring 1997): 46–51. Similar themes are addressed in *Incorporations,* a special issue of *Zone* edited by Jonathan Crary and Sanford Kwinter (New York: Zone, 1992).

31 Haraway, "A Manifesto for Cyborgs," 82.

32 Hans Moravec takes the opposite course in his search for congruencies between humans and machines. See Hans Moravec, *Mind Children: The Future of Robot and Machine Intelligence* (Cambridge: Harvard University Press, 1988).

33 Tony Fry, "Crisis, Design, Ethics," paper presented at Notre Dame University, Febru-

ary 1993.

34 The work of the Japanese industrial designer Kenji Ekuan is a good example of how spiritual values can be self-consciously brought into design practice. Trained as a Buddhist priest before becoming a designer, Ekuan views products as more than functional objects. See Kenji Ekuan, "Smallness as an Idea," in *Design and Industry*, ed. Richard Langdon, Proceedings of the Design and Industry Section of an International Conference on Design Policy, 2 (London: Design Council, 1984), 140–143. In this paper, Ekuan makes special reference to the *butsudan*, a small portable Buddhist altar that can be installed in the home. He writes that "the *butsudan* represents the essence of man's life in a condensed form." It is "a portable device that helps the Japanese people communicate with their ancestors and, above all, with themselves." I cite his characterization of the *butsudan* as indicative of his aim to embody spiritual values in material products.

35 Martin Buber has addressed the question of depth in human relationships in his seminal book *I and Thou*, translated with a prologue and notes by Walter Kaufmann (New York: Scribner's, 1970). I discussed Buber's writing as the basis for a new design ethics in my article "Community and the Graphic Designer," *Icographic* 2, no. 4 (March 1984): 2–3.

36 Sterling made these comments as part of a presentation at the Cooper-Hewitt, National Design Museum conference "The Edge of the Millennium," which I discuss in "Thinking about Design at the End of the Millennium" above.

37 Simon, "Understanding the Natural and Artificial Worlds," 2.

DESIGN STUDIES

2

NINTH

Cincinnati

Industrial

OPENS, SEPT. 7TH CLOSES OCT. 8TH

1881

EXPOSITION

THE NATIONAL EXHIBITION

OF ART AND INDUSTRY.

Graduate Studies

History of Design

University of Cincinnati

DESIGN HISTORY IN THE UNITED STATES, 1977–2000

INTRODUCTION The first version of this essay was written in 1987 to coincide with the tenth anniversary of the Design History Society (DHS).[1] My intention at the time was to summarize research in design history and related fields conducted in the United States during the span of the DHS's first decade. Although I did include some events that occurred prior to that time, it was only to establish precedents for later activity. One might have gone back to look at early American scholarship in the decorative arts, material culture, the history of technology, printing history, and related fields published well before the 1970s, but that was not the intention of the original essay, nor was a survey of that scope necessary for my purpose. In this version, which is considerably enlarged to include much that has happened since 1987, I have not introduced any earlier material than that which I had in the previous version.

Design history is as difficult to define today as it was when I wrote the first version of this essay. We are still grappling with what it encompasses and when it begins. There is no consensus on the former, and some on the latter. Regarding the scope of design history, one group of scholars believes that everything, including services and other immaterial products, is design; another is somewhat catholic in its definition of design but limits it to material artifacts; while a third includes only those artifacts that have resulted from the mass production and mass communication process, leaving out, for example, crafts and vernacular graphics.

The problem of chronology is more difficult for design historians than it is in the history of art, the beginnings of which are generally acknowledged in the field to be in prehistoric times. While the history of design starts for some historians with the onset of mass production in the eighteenth century, others consider design to be evident in the earliest manifestations of culture.

Besides issues of subject matter and chronology, design's inherent multi-disciplinarity has made it hard for a single research community to lay claim to its investigation. There are art historians who would consider design to be part of the history of art because they include it in a wider definition of visual culture, while historians of technology can just as easily focus on design's technical aspects and minimize the visual. Hence, historical research on design has arisen in a number of places and focused on different aspects of the subject. This dispersal of sites has, in fact, had some positive results. It has certainly kept the research agenda wide open, thereby producing a rich mosaic of articles, books, and exhibitions that are ungoverned by any single set of disciplinary values.

Not only have scholars in different disciplines engaged in historical research that involves design, but designers, as well, have been active in this process. The result of this dual involvement is a corpus of books and articles written by and for designers along with research that is addressed more directly to the academic community. What is particularly noteworthy about the American situation is the absence of a hierarchy between scholars and other authors interested in the history of design. Designers, in fact, frequently bring insights and passions to their research that may be absent in the work of their scholar counterparts who are trained in methods of historical investigation rather than in the actual practice of design.

I don't want to argue, however, that this situation is entirely satisfactory. What it lacks, as I have noted earlier in this volume, is an arena for discussion and debate where all involved participate in a discursive process that can produce the most meaningful narratives of design's history. As a result, we have much excellent research but no consensual methods to advance design history as a shared enterprise.

Many graphic designers speak of a field called graphic design history, while scholars of material culture, who have a strong interest in household objects, have, until recently, rarely ventured into the twentieth century. Likewise, decorative arts scholars do not normally research objects such as televisions or other artifacts that have been designed for mass production. Such segmentation perpetuates partial views of design in society and makes it difficult to establish a place where the questions and issues raised by all the separate efforts of research and discussion can be brought together and recognized as common

concerns. Until that happens, we will continue to generate fragments of research but will be unable to use them to address larger questions about design's history. To counter this, however, there is some overlap in subject matter and even some borrowing of methods between the different communities of researchers. As this continues, it will eventually reduce the distinctions between different approaches and lead toward more hybrid activities.

DESIGN HISTORY Until just two or three years ago, design history had been spreading slowly, even furtively, within the American academy. In the late 1980s, only a few art schools or universities had full-time design historians, and only one university offered a degree in design history at the graduate level. In recent years, the demand for design historians has begun to grow, and young scholars are emerging from departments of art history and American studies, in particular.[2] The call for design history courses has come almost exclusively from design faculties, concerned by their students' lack of design literacy and historical awareness.

Before any trained historians began to teach design history, a number of designers such as James Alexander at the University of Cincinnati, Arthur Pulos at Syracuse University, and Keith Godard and Lou Danziger at the California Institute of the Arts (CalArts) developed courses in the history of industrial design or graphic design. As Danziger, who taught the history of graphic design for a number of years at CalArts, stated:

My teaching graphic design history as a formal course begins in the early 70s, about 1972 I believe. Keith Godard and I were then both teaching at CalArts. We would often sit in the cafeteria and complain to each other about how difficult it was to teach design to students who thought that Moholy-Nagy was something you eat with a spoon or fork.[3]

One of the early design history courses was developed and taught by design journalist and editor Ann Ferebee, first at Pratt Institute in New York between 1965 and 1969 and then at the Parsons School of Design in 1968–1969. As an outgrowth of that course, which focused on the history of modern design, Ferebee published a small illustrated book in 1970 entitled *A History of Design from the Victorian Era to the Present.*[4] Her course, unlike those given by most of the designers, attempted a broad survey of architecture, interior design, industrial design, graphic design, and photography. Looking through the sequence of the chapters in her book, one suspects the strong influence of Nikolaus Pevsner's modernist teleology, yet Ferebee was prescient in her inclusion of early trademarks, American automobile styling, and corporate logos. While the book placed a heavy emphasis on the development of styles, it is still

noteworthy as an early attempt to fuse Pevsner's European modernism with a recognition of American design contributions, both high style and vernacular. The book also remains the only design history text that brings together all aspects of design in one narrative. Even though its focus is on the traditional styles and movements, it stands as an argument for a single design history, rather than a group of fragmented histories divided along professional lines.

Another early design history course, focusing on graphic design, was developed at Virginia Commonwealth University by Philip Meggs, who initially taught the subject informally in 1968 and gave his first course in 1974.[5] Meggs began his narrative with the earliest attempts at writing and continued through to the most contemporary work. This sweep is evident in his textbook, *A History of Graphic Design,* which was first published in 1983 and is now in its third edition.[6] Meggs was the first to combine printing history, a subject on which many books had already been published, with information about graphic design and designers. His textbook has been widely used for teaching purposes, largely because it provides a sequence of basic information that links illuminated manuscripts, Bodoni type, Lester Beall, Polish posters, Swiss functional typography, and new wave graphics.

No doubt there were additional design history courses taught in the 1970s or earlier by designers and perhaps art historians as well, but these were all individual efforts and there was no means, either through a professional association or a publication, to exchange information. In 1980, planning for a master of arts in design history began at the University of Cincinnati with support from the National Endowment for the Humanities. Lloyd Engelbrecht, who received an interdisciplinary doctorate from the Committee on History of Culture at the University of Chicago, was selected to develop and coordinate the program, which was to be housed in the art history department. Engelbrecht had written his dissertation on Chicago's Arts and Industries Association, a group of businessmen who supported the foundation of the New Bauhaus as part of an effort to improve design in Midwest industry.[7] He taught art history before going to Cincinnati where he was the first professor in the United States to be appointed to a full-time post in the history of design. The plan for the design history MA was to build on separate history courses that were already taught within the studio programs for fashion, graphic, industrial, and interior design. In 1987, the program brochure listed, in addition to these courses, a three-part design history sequence from ancient to contemporary times, as well as special period seminars. There were also courses in the history of books and textiles, along with a series of issue-oriented seminars.[8] But as Engelbrecht pointed out shortly after the program began, it initially attracted only a small number of degree students, mainly because the University of Cincinnati did not

offer a doctorate in art history and students would have had to go elsewhere to prepare for a teaching career.

After Engelbrecht, I was probably the next design historian to be given a full-time appointment. In 1982 I began to teach design history in the Department of Art History at the University of Illinois at Chicago (UIC), where I have been since. I obtained my doctorate in design history, the first in the United States, at the Union Institute, an accredited PhD program that allows students to design their own course of study. I combined independent reading with an internship in making artists' books and the writing of a dissertation on the graphic design of Alexander Rodchenko, El Lissitzky, and László Moholy-Nagy.[9] With no doctoral programs in design history offered in the United States when I began, a route such as the one I took was the only means of obtaining a PhD in design history without going abroad.

Design history was added to the UIC curriculum in response to demands from the design studio faculty, who teach a large number of students in both graphic and industrial design. Although most students in my yearlong design history survey are from the School of Art and Design, there are some from other areas as well, including art history. In autumn 1988, the Department of Art History inaugurated an MA program, although to date few students in the program have given much emphasis to design history. In fall 2000, however, the department began to offer a PhD in art history with one of its two specializations in the history of architecture and design.

Besides the courses developed by Engelbrecht and myself, historians at other institutions were beginning to offer design history courses during the early 1980s, and some initial communication started to occur. At the impetus of Engelbrecht and Herb Gottfried of Iowa State University, a Caucus on Design History was held at the 1983 annual meeting of the College Art Association (CAA) in Philadelphia.[10] About sixty people attended the session, which was moderated by Engelbrecht and included brief presentations by Barbara Young, Gottfried, myself, and Ann Morgan, an art historian who was editing the reference book *Contemporary Designers* at the time. An enthusiastic discussion followed the presentations, and this led to a meeting the next morning, attended by about a dozen people, where a strong need was expressed to build lines of communication between those teaching in the field. The group decided to form an organization, which it called the Design History Forum.[11] Subsequently a newsletter was published, but it only appeared sporadically after the first issue.[12]

For several years after its founding, the Design History Forum held a caucus session at each CAA meeting, and at the 1987 meeting in Boston a second session for papers was added. Prior to Boston, papers were either read at the

caucus session, as was the case in Toronto in 1984 and Los Angeles in 1985, or in sessions organized at other locations, as in New York in 1986 where the forum met at the Fashion Institute of Technology. The papers at these meetings were not directed to a specific topic but instead reflected personal research interests. For the Boston meeting, the theme Design in Industry, was designated for the paper session, but the topic was so broad and time so short that it was not possible to extrapolate related points and issues from the papers. Also in conjunction with this meeting, the forum organized an afternoon of presentations at Harvard's Carpenter Center for the Visual Arts. Among those who attended these early events, besides the people already mentioned, were Clayton Lee, Ward Stanley, and John Montague.

In the late 1980s, the Design History Forum was a loose umbrella for about seventy-five people whose main objective was to organize annual sessions at the CAA. During the business meeting in Boston, concern was expressed that the forum was not evolving into a dynamic organization that could give adequate leadership to the expansion of design history as a field, and it was recognized that those attending the CAA meetings did not reflect a full cross-section of people concerned with the subject. The group therefore decided to change its name to the Design Forum in order to include theory and criticism and thus expand the base of those who might be interested in its activities.

For a number of years after the Boston meeting, several active forum members such as Joe Ansell and the late Richard Martin kept the Design Forum going. In an effort to broaden its appeal, the forum organized a symposium entitled "After Modernism: Art, Architecture, Design and the Crafts" at the Museum of Fine Arts during the Houston meeting in 1988. However, despite such efforts, interest in the Design Forum eventually waned. Few forum members were engaged in ongoing design history research and, great enthusiasm notwithstanding, they were unable to create a community that could shape the issues in the field. At the same time, the Design Forum, as an affiliated society attached to the CAA, did not receive any particular largesse or attention from the parent organization in terms of promotion or recognition, nor did it attract the interest of many other CAA conference participants, most of whom are artists and art historians with a primary allegiance to their respective fields. In short, it was just another affiliated group within the larger organization and was not recognized as a force to broaden the discipline of art history.

Recently, however, the forum has been revived by Carma Gorman, a young design historian from Southern Illinois University. There are plans for an organizational meeting at the CAA's annual conference in 2002 and a proposal for a forum-sponsored panel in 2003. The energy behind this initiative could signal the beginning of a new role for the forum within the CAA.

Despite the inability of design history to take hold at the CAA, there were other vehicles for its development. One was the appearance in 1984 of the journal *Design Issues*. Besides publishing articles and reviews by American design historians, it sought out and has continued to publish articles by scholars and theorists from abroad.[13] It has taken a rather liberal approach to the subject matter of design and has continually expanded its scope with historical articles on the design of computer technology, multimedia, aquariums, display windows, and war gaming rooms.[14] While the history of design has been an important component of *Design Issues,* the journal has in addition brought theory and criticism into the same arena of debate in the belief that questions that arise in one area of design thinking are also important to others. One of the authors who has written for the journal, Ellen Mazur Thomson, an independent scholar, subsequently published an excellent book on graphic design's beginnings in the United States, which featured some material she had previously published in *Design Issues*. Her book did not focus on artifacts but instead on how practices of visual reproduction emerged with the mechanization of printing and new reproduction technology.[15]

In the spring 1995 number of *Design Issues,* dedicated to design history, the editors invited a group of art and design historians from the United States, Canada, and Great Britain to debate the question of whether design history might best develop as a subject in its own right or as part of a larger field of design studies. The starting point was my essay, "Design History or Design Studies: Subject Matter and Methods," published in a revised version in this volume, and the strong response to it from British architectural and design historian Adrian Forty.[16] Distinct positions were taken, particularly by British design historian Jonathan Woodham, who saw the proposal to include design history within a broader research field as an attempt to "colonize design history under the imperial umbrella of design studies."[17] American studies historian Jeffrey Meikle was less sanguine about defining design history as a distinct field when he noted:

Given an inflationary culture of material and immaterial manifestations, all of them designed in one way or another; expanding to encompass just about everything; it is hardly surprising that few cultural historians can escape an involvement with design. Nor is it surprising that a coherent discipline or field of design history proves to be an elusive goal.[18]

The issue provided a rich mix of positions that ranged from design's place in a larger sphere of visual culture, as Barbara Stafford advocated to its contribution to our understanding of being human, as Dennis Doordan argued when he stated, "In projecting the concerns of the present onto the past, history shapes

more than design; it shapes consciousness itself."[19] Nigel Whiteley recognized the value of cultural studies as a way of broadening the history of design to include more than a study of objects, while Alain Findeli wrote about a possible *Design-Wissenschaft* that would include history along with "design epistemology, theory, esthetics, and ethics."[20] There was much in the issue that might have led to other responses as would surely have happened if design history or design studies had been as well developed a field as, say, English literature. But there has been little follow-up thus far on the issues raised and therefore their further development awaits a moment when the academic study of design is more advanced.

The special issue was prompted by a small seminar on the state of design history which I was invited to organize at the Center for Advanced Study in the Visual Arts (CASVA) at the National Gallery in Washington in May 1993. The aim of the seminar was to "examine issues related to the history of the teaching and study of design and its place(s) within the university, museum, or professional school."[21] Among the questions proposed for discussion was whether there was any practical or intellectual advantage to locating design history within a broader discipline of design studies.

Participants included scholars from design history, design education, the history of technology, and art history. Among them were *Design Issues* editors, Richard Buchanan, Dennis Doordan, and myself; art historians Nancy Troy and Barbara Stafford, design historians and theorists Alain Findeli, Clive Dilnot, Ellen Lupton, and scholars from technology studies—Joan Rothschild, Kathryn Henderson, and Peter Whalley. Four design historians from England also attended: Jeremy Aynsley, Chris Bailey, Tim Putnam, and Jonathan Woodham.

The discussions ranged over numerous topics, but the results were inconclusive although a number of important themes surfaced: the relation of high design to the vernacular, the distinction between visual and text-based cultural products, the connection between design history and the practice of design, the relation of design history to a larger field of design knowledge, and the methodologies appropriate for the study of artifacts as historical evidence. What was perhaps most productive about the day was the exchange among scholars with different backgrounds. As a result, design history was addressed less as a sectarian discipline and more as a point of departure for connections to other types of research.[22]

The first PhD in design history at an American institution was launched in 1998 at the Bard Graduate Center for Studies in the Decorative Arts.[23] Located in New York City and affiliated with Bard College, the Graduate Center, which opened in 1993, was founded by Susan Soros, a decorative arts historian, with $20 million of her husband George Soros's resources. Initially, the

graduate center offered an MA in decorative arts but in preparation for the PhD program, Soros hired Pat Kirkham, a well-known design historian from Britain, and Ken Ames, a prominent material culture scholar. A third position was offered to American studies scholar Jeffrey Meikle, but for personal reasons he chose to remain at the University of Texas in Austin.

Although the Bard program at both the MA and PhD levels is still strongly oriented toward the decorative arts, the presence of Kirkham and Ames has resulted in a widening of its subject matter and methodologies to include those from design history and material culture. The 1999 catalog makes reference in fact to a "doctoral program in the history of the decorative arts, design, and culture." Courses include Women Designers in America, 1900–2000, History of Modern Advertising, Postmodernism and Design, Graphic Design in Europe, 1890–1940, and Issues in Design History.[24] The emphasis in the program, as expressed by Susan Soros in 1996, is on the historical context of objects, notably what they tell us about the times when they were used.[25] This focus is derived from theories in art history and material culture and thus differs from the traditional connoisseurship approach of decorative arts scholars. Although the latter is still evident in the catalog, there is an impetus in the Bard program to change the way the decorative arts are studied by allying them more closely with the history of design and other forms of material culture. One way this will come about is through an interest in topics and themes such as women designers that transcend the boundaries of particular research communities. Pat Kirkham has completed a large exhibition and catalog on this subject, drawing on documentation that cuts across a number of different fields.[26] The exhibition, *Women Designers in the USA, 1900–2000: Diversity and Difference*, opened at the Graduate Center in fall 2000.

DESIGN HISTORY AND THE DESIGN PROFESSIONS In the early 1980s, several associations of design professionals, notably the Society of Typographic Arts (STA) in Chicago and the American Institute of Graphic Arts in New York, took a strong interest in design history, specifically, in the history of graphic design.[27] In 1980, the Society of Typographic Arts, whose president at the time was Robert Vogele, initiated a program called Design Chicago, which was intended to promote Chicago as a significant center of graphic design. As part of this program, the society planned to explore the history of the city's graphic design activity in a series of public forums. On the first of two evenings of public lectures, art historian Franz Schulze talked about the arrival of Ludwig Mies van der Rohe in Chicago, Joe Hutchcroft discussed the history of the design program at the Container Corporation of America, and I spoke about broad trends in Chicago graphic design before 1937. On the second evening, the

program was devoted to Unimark, the international design firm that started in Chicago in 1965.[28] Following these events, the STA, with sponsorship from the National Endowment for the Humanities, organized a symposium entitled "Images and Realities: Discovering the History of Graphic Design in Chicago," which was held on June 26 and 27, 1981.[29] At the time, few people were doing research on Chicago design, but the symposium organizers identified for the presentations a small group of historians, most of whom had a prior interest in Chicago history. While a number of the talks were of interest, the audience was left in the end with a series of fragments rather than a coherent discussion of Chicago graphic design. Several hundred people attended the symposium, which, despite its shortcomings, was still an ambitious pioneering attempt to confront the subject.

In April 1983, the Rochester Institute of Technology (RIT) sponsored the first of two symposia on the history of graphic design. Organized by Roger Remington and Barbara Hodik, who taught graphic design and design history, respectively, the first symposium, entitled "Coming of Age," brought together designers, teachers, students, and a few historians with a wide range of interests in design history.[30] Although little substantial research was presented, the symposium was most valuable in its affirmation of design history as an important subject of study. In his keynote address, the designer Massimo Vignelli declared:

THE FIRST SYMPOSIUM ON THE HISTORY OF GRAPHIC DESIGN

COMING OF AGE

April 20-21 1983

Rochester Institute of Technology

It seems to me that the most important thing that we have to do is improve the state of education in our schools. We've got to insert some level of culture, some level of history, some level of philosophy. Without that, we will have just a continuous stream of little designers and craftspersons, or paste-up people at best. We need to provide a cultural structure to our profession.[31]

Vignelli also signaled the need for theory and criticism, and his concerns were echoed to some degree by a session on graphic design criticism, as well as in several theoretical papers by designers. In addition, there was a plenary session on teaching graphic design history. Overall, the first symposium was successful in providing a forum where designers and educators could affirm the significance of graphic design history and begin to make plans for expanding its teaching, research, and documentation.

The second symposium, held in April 1985, was more ambitious in its agenda, specifically, in its attempt to provide a platform for a series of scholarly papers on issues of design history and theory. But the theoretical level of these presentations by Clive Dilnot, who gave the keynote address, Frances Butler, and Hanno Ehses, was beyond the kinds of design discussions many of the par-

ticipants were accustomed to.[32] Although the symposium began to produce the theoretical discourse Vignelli had called for two years earlier, some of the lectures struck many participants as difficult to follow and of questionable value. The disjuncture between these attempts at theory, which should have confirmed the need to elevate the level of design discourse, and the presentations on history, teaching, and documentation caused a lot of frustration and resulted in the end of that particular symposium format, at least for some time.

However, before the year was out, Steven Heller, editor of the *AIGA Journal of Graphic Design*, published by the American Institute of Graphic Arts, heralded that organization's growing interest in graphic design history by devoting almost an entire issue of the journal to the subject. In his introduction, Heller acknowledged that raiding the past for solutions to current design problems was hardly admirable but declared that it might have the salutary value of provoking curiosity and leading to a more meaningful approach to history. Continuing this theme, he stated:

Indeed, the various stylistic revivals of the past thirty five years have not only resulted in some interesting reappropriations, but have also caused more historians, collectors and "buffs" to surface. And these are the people, individually and collectively, who are laying the foundations for a substantive graphic design history today.[33]

Heller continued by calling for a clearly written history of graphic design that would "avoid the pitfalls of 'clubism' fostered by inaccessible jargon"[34] while he also pointed out the "Herculean task" of documenting the field. In other publications, notably *Print* and *Eye,* Heller has proven himself over the years to be an avid researcher, publishing informative articles on the French typographic firm Deberny & Peignot, Fortunato Depero, Lucian Bernhard, Eric Nitsche, Robert Leslie's Composing Room, and other topics.[35] In addition, Heller has published numerous books on the history of graphic design including *Graphic Style: From Victorian to Postmodern, Design Literacy, Design Literacy Continued,* and *Typology: Type Design from the Victorian Era to the Digital Age.*[36] In addition, he coedited *Looking Closer 3: Classic Writings on Graphic Design* with Michael Bierut, Jessica Helfand, and Rick Poynor.[37]

Heller has also been an organizer of exhibitions such as *The Malik Verlag, 1916–1947,* arranged with James Fraser, and *Typographic Treasures: The Work of W. A. Dwiggins,* planned with Dorothy Abbe and his wife, Louise Fili.[38] And he spearheaded as well an important series of nine annual symposia, "Modernism and Eclecticism: The History of American Graphic Design," which were held, beginning

in 1987, in conjunction with the School of Visual Arts. In the announcement for the first symposium, Heller stated:

Though hosted in an academic setting, these discussions are not aimed at a scholarly audience alone, but rather will open a window on a living, accessible past, to inform, inspire and influence all those in and out of the field who are interested in the roots and routes of this visible art form.[39]

The symposia played an important role in bringing speakers from various academic disciplines together with designers, journalists, collecting buffs, and others interested in the history of graphic design. Among the scholars and critics who spoke at these events over the years, besides Heller, were Roland Marchand, Donald Bush, Stuart Ewen, Thomas Hine, Rick Poynor, Ralph Caplan, Teal Triggs, and myself. Design educators and designers included Philip Meggs, Lorraine Wild, Rob Roy Kelly, Ellen Lupton, J. Abbott Miller, Ivan Chermayeff, Milton Glaser, Lou Danziger, George Lois, Massimo Vignelli, Henry Wolf, Paul Rand, Lou Dorfsman, Saul Bass, Gene Federico, Marc Treib, Matthew Carter, Victor Moscoso, Rudy Vanderlans, Roy Kuhlman, and Frances Butler. What was particularly valuable about the "Modernism and Eclecticism" events was the mix of researched talks with presentations by and interviews with some of the older designers such as Paul Rand, Saul Bass, and George Lois, among others. For the scholar, these events provided invaluable information and gave one the feel of the designer's personality, something impossible to obtain when working from documents alone.

One of the most provocative talks at the "Modernism and Eclecticism" symposia was the late designer Tibor Kalman's "Good History/Bad History," which was presented in February 1990.[40] Here Kalman called for a history of design that would be "a history of ideas and therefore of culture." A good history, he claimed, "uses the work of designers not just as bright spots on the page but as examples of the social, political, and economic climate of a given time and place."[41] The talk presented a powerful argument for what a graphic designer might want from design history. The desired result was definitely not a history of styles but rather a "history of design as a medium and as a multiplicity of languages speaking to a multiplicity of people."[42]

Though Philip Meggs was one of the authors critiqued by Kalman for presenting a history of graphic design that was too narrow, Megg's activities as an author for *Print* and other publications, along with the work of Heller and other graphic designers, have thus far played a valuable role in advancing graphic design history in the United States.[43] Designers and design educators such as Meggs bring a great deal of seriousness to their work and have uncovered and publicized much new material. The appreciation of graphic design from the past

as exemplary of high standards of professional quality should not be lost on professional historians who may bring other methodological concerns to the same material. Among many design historians, particularly in Britain, there is a bias against the "great designer and his or her work" as opposed to an approach that is closer to social history. But it is specifically the great designers who have thus far been the focus of much graphic design history pursued by the professional design community, and this trend will continue, because professionals want to use their legacy in current practice, one aspect of which is establishing standards of quality based on past experience and identifying role models for young designers. These objectives have contributed to a number of books on individual graphic designers and typographers produced by designers and design educators in recent years including Roger Remington and Barbara J. Hodik's *Nine Pioneers in American Graphic Design,* Martha Scotford's *Cipe Pineles: A Life in Design,* Steven Heller's *Paul Rand,* and Remington's *Lester Beall.*[44]

It is precisely the desire to create a professional identity for graphic designers that has fueled the enthusiastic interest in the history of graphic design and the outburst of courses in the subject around the country. For example, Lou Danziger, who taught a summer course in graphic design history at Harvard's Carpenter Center for the Visual Arts for many years beginning in 1978, was invited to lecture at many schools, and some people who studied with him at Harvard, such as Doug Scott, subsequently developed their own courses.[45] Scott has taught graphic design history at the Rhode Island School of Design and at Yale University, which had on its faculty for many years pioneer designers such as Rand, Bradbury Thompson, Herbert Matter, and Armin Hofmann. Perhaps this led Alvin Eisenman, who directed the program for many years, to be more aware of design history. In 1987 he co-organized, along with three other Connecticut colleges, a series of four lectures and exhibits on American graphic design covering four decades from the 1930s to the 1960s.[46]

Although Kalman's lecture at the 1990 "Modernism and Eclecticism" symposium had raised a number of issues in a provocative polemical vein about how design history is written, the most intellectually ambitious attempt to deal with the question was the three issues of *Visible Language* devoted to critical histories of graphic design, which were guest edited by graphic design educator Andrew Blauvelt.[47] A major point of Blauvelt's project was that graphic design history had been resistant to theory. He therefore sought both in his own writing and in the articles he solicited for the three issues to demonstrate how theory could help to reveal a richer and more complex history of graphic design. Like Kalman, Blauvelt called for a move away from a preoccupation with the canon of graphic design history toward greater attention to graphic design's social context.

**Graphic design history has yet to undertake the task of under-
standing its social context, understood as a range of effects: from
the reproduction of cultural values through the work of graphic de-
sign to the shifting nature of consumption and reception, both con-
spicuous and symbolic, by audiences.[48]**

As authors, Blauvelt called on designers, theorists, historians, and design edu-
cators, including Frances Butler, Jack Williamson, Steve Baker, Ann Bush, Ellen
Lupton and J. Abbott Miller, Jan van Toorn, Martha Scotford, Susan Sellers,
Gérard Mermoz, and myself.[49] The essays accomplished a number of purposes:
they raised issues about how graphic design history is written; made links be-
tween design history, theory, and criticism; and provided case studies to
demonstrate how a more theoretical design history might be produced. How-
ever, there was no context to absorb these arguments that could generate fur-
ther discussion and debate. Yet the issues continue to circulate and are likely to
be cited and discussed in the future as more scholars take up related concerns.

Among industrial designers, by comparison, interest in design history
has not developed in an equally intensive way. The greater interest of graphic
designers in their history may be explained in part by the long tradition of re-
search in the history of printing and typography that has formed the basis for a
broader history of graphic design.[50] Arthur Pulos, one of the first industrial de-
signers to take an interest in design history, began to incorporate material on
the history of American industrial design in his professional practices course at
Syracuse University as early as 1955. He published his first article on American
design in 1962 and began working with the Syracuse University Library to col-
lect the papers of first- and second-generation industrial designers such as John
Vassos, Walter Dorwin Teague, Lurelle Guild, Russel Wright, Egmont Arens, and
Dave Chapman.[51] In 1983, Pulos published *American Design Ethic: A History of
Industrial Design to 1940,* the first of a two-volume work. The second volume,
American Design Adventure, which covers the period from 1940 to 1975, ap-
peared in 1988.[52] *American Design Ethic* was intended as a book with a thesis
about design and the American character rather than as a textbook survey. As
such, it was criticized for its lack of methodology,[53] but it is still the first history
of American industrial design and, along with its companion volume, remains a
book against which others will be written. Both *American Design Ethic* and
American Design Adventure contain material that derives from the late author's
long involvement with the field, not only as an educator but as an active mem-
ber and president of ICSID, which gave him an international perspective and
provided personal contact with many leading American and foreign designers.

Despite Pulos's research activity over more than thirty years, other in-
dustrial design professionals have been slow to take an interest in their his-

tory.[54] *ID,* once the trade magazine of industrial designers but now broader in scope, occasionally publishes short articles on historical topics,[55] but the legacy of American, as well as European, product design and furniture has thus far received more attention from museum curators and decorative arts specialists than from designers, although architects have shown an interest in the history of furniture and household objects.[56] Recently, however, an excellent article on the origins of the industrial design program at the Carnegie Institute of Technology (now Carnegie Mellon University) was published by Jim Lesko, who taught in the program for several years.[57]

At their national conference in Evanston, Illinois, in August 1986, the Industrial Designers Society of America (IDSA) included a panel entitled "Why Design History?" Initiated by the late Donald Bush, who then taught design history at Arizona State University, the panel featured Bush, Engelbrecht, and myself. We presented our approaches to teaching design history and attempted to convey the value of the subject for the industrial design profession. There was a lively discussion following our presentations, although no immediate follow-up occurred.

In 1988, however, the IDSA formed a History and Archives Committee, which remained a separate entity until 1999 when it was disbanded and its responsibilities were distributed to the organization's planning committee.[58] The committee's objectives included locating existing collections and repositories of materials, establishing a network of participating institutions, developing documentation strategies, and promoting interest in design history.[59] Toward accomplishing these ends, a meeting was held at the Hagley Museum and Library in Wilmington in 1991. At that meeting, the committee chair, Eric Schneider, reported that when polled, a number of IDSA members responded positively to donating archival material to an institutional collection. The aim of the IDSA, he said, was to serve as a broker between members who wished to donate materials and institutions that wished to receive them, but it is not clear how much of this activity occurred after the 1991 meeting.

By 1995, interest in design history had grown within the professional associations. That year the Chicago-based American Center for Design (ACD) sponsored a symposium entitled "Making History (in Design)," with art historian Barbara Stafford being invited to give the keynote address.[60] Stafford was selected because the ACD was interested in scholars who might help to locate design history within the changes created by digital media in the design professions. Bringing her research on visuality to a design audience for the first time, Stafford called for interdisciplinary research on images that would "go beyond art, architectural, or design history."[61] She, in fact, proposed a model of a transdisciplinary expert, a "new imagist," who could "help anticipate, illuminate, and

interconnect unsuspected visualization issues arising across the spectrum and accompanying the global pictorialization of knowledge."[62] Other presenters at the conference—John Heskett, Jeffrey Meikle, and myself—made presentations that were more closely related to issues of design history and how they might relate to education and professional practice.[63] In the afternoon, excitement was sparked by curator Paola Antonelli's interview with Massimo Vignelli, who had become quite outspoken about the loss of a modern ethic and aesthetic in graphic design. This interview provoked intense fireworks and put Vignelli in a rather different position, that of a resister of change, than he had been in a few years earlier at the first Rochester design history symposium when he called for a more intellectual grounding for graphic designers.

As heartening as design professionals' enthusiasm has been to assimilate their own history, however, such efforts will not themselves lead to the establishment of design history as a scholarly field. For this to occur, a partnership must be formed with academic scholars who have an interest in issues of methodology and questions about design history as a whole, particularly the way design functions within the larger cultural fabric.

DESIGN HISTORY IN THE ACADEMY: A DIVERSITY OF APPROACHES
Although design history is far from being recognized as a distinct area of study in the American academy, there is, nonetheless, a great deal of research being done in no fewer than seven or eight different fields. If called by a name other than American studies, material culture, or the history of technology, this research would constitute an impressive body of design history scholarship. **Art History, Architecture History, and the Decorative Arts**. While the history of art was once considered the bête noire of design history, it is no longer dominated by connoisseurship and the celebration of monuments and, in fact, has a lot to offer the design historian.[64] For the past twenty years or so, art history has incorporated new interpretive theories from literature, psychoanalysis, and other disciplines.[65] When art historians first began to consider design, however, they tended to follow the modernist canon laid out by Nikolaus Pevsner and advanced by the Museum of Modern Art. For the most part, the first doctoral dissertations in design-related areas focused on art nouveau, the Bauhaus, or other European movements and styles. A notable exception was Donald Bush's study of American industrial design of the 1930s, which was written as an art history doctoral dissertation and published in book form in 1975 as *The Streamlined Decade*.[66] Unusual among historians of design, Bush obtained degrees in electrical engineering and industrial design before getting his doctorate in art history. Explaining how he came to design history, Bush stated:

Choosing the history of American design as a dissertation topic was a calculated risk, as I knew of very few art historians who could claim that title and knew of no job listings in the field . . . I had no interest in digging up the bones of a long dead painter or sculptor and wanted to write a dissertation that would not be buried in a university library.[67]

Although few art historians followed Bush's lead in researching industrial design topics, his work paved the way for scholars in related fields such as Jeffrey Meikle and Richard Guy Wilson.

Women's work in the home was the subject of Dolores Hayden's book, *The Grand Domestic Revolution: A History of Feminist Designs for American Homes, Neighborhoods, and Cities,* which appeared in 1981.[68] Hayden, an architectural historian, traced the history of feminist thinking about altering the design of living spaces to both rationalize and collectivize household chores. Portions of the book appeared first in the feminist journal *Signs* and in the *Radical History Review,* thus inserting a design topic into current historical debates.

Illustration and poster art have sometimes been subjects of research for art historians in part because of their traditional relation to the decorative arts. In 1980, Brad Collins completed his dissertation, "Jules Chéret and the Nineteenth-Century Poster," at Yale under Robert Herbert.[69] Working within the discipline of art history, Collins emphasized a number of issues missed by historians of graphic design, notably Chéret's concern to raise the poster to the level of fine art and the attendant cultural politics around this issue.

In *Artists, Advertising, and the Borders of Art,* art historian Michele Bogart addressed the relation between art and advertising, particularly in the 1920s and 1930s. Among the themes she discussed was the role of the art director, as well as the relation between posters, billboards, and magazine advertisements.[70] Frederic Schwartz's *The Werkbund: Design Theory & Mass Culture before the First World War,* like Bogart's study, also profits from the openness in art history to mass culture and popular culture topics that resulted from the momentous changes of the 1960s.[71] Unlike Joan Campbell, a historian who also wrote an important book on the Werkbund, Schwartz does not concentrate on organizational issues but rather on the art and design theory that informed the practices of Werkbund artists. He also makes use of the writing of the Frankfurt School as well as more contemporary theories of consumption and commodity signs.

A review of recent dissertations listed in *Dissertation Abstracts* that have some aspect of design history as their subject turns up a significant number of examples on a wide range of topics. Not all, but many, were written in art history departments and go well beyond the narrower focus of the first dissertations on

design-related themes. Those most blatantly representative of design history's purview are Amy Ogata's "Cottages and Crafts in Fin-de-Siècle Belgium: Artisans, Antimodernism, and Art Nouveau, 1880–1910," completed at Princeton University, Rebecca Houze's "Fashion, Disguise, and Transformation: Origins of the Modern Art Movement in Vienna, 1897–1914," done at the University of Chicago, Russell Flinchum's "Henry Dreyfuss and American Industrial Design," done at the City University of New York, and Michael Darling's "Ambient Modernism: The Domestic Furniture Designs of the George Nelson Office, 1944–1963." Darling's advisor at the University of California at Santa Barbara was Edson Armi, an art historian who had previously published a book on the history of automobile design.[72] A related industrial design topic is Shelley Nickles's "Object Lessons: Household Appliance Design and the American Middle Class, 1920–1960," which was completed at the University of Virginia. The dissertation draws on social history and material culture studies to deal with issues of consumption such as the relation of style to the construction of social identity.

A number of doctoral researchers came to design through an interest in topics such as exhibitions and fairs. Becky Conekin wrote the first scholarly study on the 1951 Festival of Britain, "The Autobiography of a Nation: The 1951 Festival of Britain, Representing Britain in the Post-War Era," at the University of Michigan. Elise Moentmann's dissertation from the University of Illinois at Urbana-Champaign addressed issues related to artisans and the decorative arts in "Conservative Modernism at the 1937 International Exposition in Paris," while Suzanne Tise, who completed her doctoral work at the University of Pittsburgh, looked at a broader time span of design reform in her dissertation "Between Art and Industry: Design Reform in France, 1851–1939." Wallis Miller, whose advisor at Princeton's School of Architecture was Alan Colquhoun, continued to mine the literature on fairs and exhibitions in "Tangible Ideas: Architecture and the Public at the 1931 German Building Exhibition in Berlin." One of the issues at the exhibition was the blurring of distinctions between public and private space, which Miller addressed through the contribution of Lilly Reich, Mies van der Rohe's collaborator. Reich, who worked primarily as an interior designer, has also been a subject of interest to other scholars interested in women who have worked in the design professions.[73] Additional dissertations that address the interior design of the home are Jennifer Strayer-Jones's "No Place Like Home: Domestic Models in Chicago's Public Places, 1919–1938," done at the University of Iowa, and Reginald Twiggs's "Domesticating American Identities: The Rhetorical Dimensions of the Nineteenth-Century Decorative Arts," completed at the University of Utah. Twiggs draws on hegemony theory to argue that cultural transformations such as the arrangement of the domestic interior are forms of persuasion transmitted through texts and practices. Another dissertation on the

subject of design for the home is Carma Gorman's "An Acquired Taste: Women's Visual Education and Industrial Design in the United States, 1925–1940." Gorman received her doctorate at the University of California, Berkeley.

Following the work of historian Roland Marchand, who studied the visual rhetoric of American advertisements in the 1920s, Cynthia Henthorn examined World War II advertising and commercial propaganda in her dissertation at the City University of New York, "Commercial Fallout: The Image of Progress, the Culture of War, and the Feminine Consumer, 1939–1959." Issues of consumption as related to women were also considered by Nancy Owen in her dissertation from Northwestern University, "Women, Culture and Commerce: Rookwood Pottery, 1880–1913," while women and ceramics formed the basis of another Northwestern dissertation, Karen Kettering's "Natalia Dan'ko and the Lomonosov State Porcelain Factory, 1917–1942." Consumption is central as well to Regina Blaszczyk's "Imagining Consumers: Manufacturers and Markets in Ceramics and Glass, 1865–1965," which she completed at the University of Delaware, while the art pottery movement in the United States, pivotal to Nancy Owen's dissertation, is also the subject of Janette Knowles's "Out of the Hands of Orators: Mary Louise McLaughlin, Adelaide Alsop Robineau, the American Art Pottery Movement, and the Art Education of Women," done at Ohio State University. In Knowles's dissertation, however, the focus is on the social issue of how an education in the ceramic arts could enable women in the late nineteenth and early twentieth century to engage in a respectable livelihood.

Of all the dissertations surveyed, only one deals with graphic design, Ronald Labuz's "Toward a New Practice: Culture, History and Printed Communication in the United States, 1831–1888," done at Syracuse University. In his abstract, Labuz cites cultural and social history as his methodological sources while noting that the move toward cultural history enabled him to deal with vernacular design, something that Kalman had called for earlier in his "Modernism and Eclecticism" presentation.

Several issues of significance arise from this survey of dissertations. First, many of the subjects relate to women, both as producers and consumers of design. This suggests the importance of previous work by feminist historians as an impetus to use design or the decorative arts in order to address social issues that concern women. Second, cultural and social history are cited frequently as methodological sources. Although several of the dissertations are monographs on individual designers, most consider design or the crafts within a social context and come to the artifacts through an initial concern with social issues related to labor, education, propaganda, or identity. Though all of these dissertations may not have been done in art history departments, each considers the visual as an important component of its thesis.

Some of the dissertations concentrate on the decorative arts, traditionally a part of art history, where research has expanded to include modern and contemporary design.[74] This follows to a degree the growing museum and private collecting interests in that area. For example, Karen Davies, while a graduate student in art history at Yale, organized an exhibition at the Yale University Art Gallery in 1983 entitled *At Home in Manhattan: Modern Decorative Arts, 1925 to the Depression.*[75] Even though the exhibition had examples of industrial products as well as objects that were made in limited runs by craftsmen, there was still a strong emphasis in the catalog on their formal characteristics, an approach that one continues to associate with traditional decorative arts scholarship, despite the broadening interest of decorative arts historians in methods from other fields.

In 1974, the Decorative Arts Society was organized as a special chapter of the Society of Architectural Historians (SAH). Its aim was to provide a forum for museum curators, scholars, collectors, and dealers in the decorative arts. One of its accomplishments was bringing together specialists in European and American decorative arts who might otherwise not have sought contact with each other. The society publishes a newsletter and organizes programs for presenting research, both at meetings of the SAH and elsewhere.[76]

In 1982, the Cooper-Hewitt and the Parsons School of Design in New York began to offer a two-year master of arts program in the history of decorative arts. According to one of the early program announcements, the emphasis was to be a traditional one—European decorative arts from the Renaissance to the present, although courses were subsequently given as well in Asian and American decorative arts. Currently the program offers two options: European and American decorative arts. Students taking the first option study at the Cooper-Hewitt in New York, while those in the second are based at the Smithsonian Institution in Washington. The intention of the program is to prepare graduates for jobs at "museums, auction houses, publishing firms, and academic institutions."[77] The current literature notes that the program seeks to go beyond connoisseurship and include coursework on historical and cultural issues as well.

However, despite the diversity of current methodologies in art history, ranging from Marxism and structuralism to semiotics and poststructuralism, and the move by progressive art historians and critics away from the canon, little of this spilled over into the study of design or the decorative arts until recent years, most noticeably at the previously mentioned Bard Graduate Center for Studies in the Decorative Arts, where one finds in the description of current courses occasional references to race, class, and gender as part of a course's content.

In 1993, when the Bard Graduate Center opened, it began to publish a biannual scholarly journal, *Studies in the Decorative Arts,* which has become a leading forum for new research in this field. As early as the first issue, the book review section included reviews of books that would otherwise be considered design history or cultural history such as Jeffrey Meikle's *American Plastic: A Cultural History* and David Crowley's *National Style and Nation-State: Design in Poland from the Vernacular Revival to the International Style.* While most of the journal's subject matter falls within the conventional decorative arts canon, it has also published articles by art and design historians. Nancy Owens's "Marketing Rookwood Pottery: Culture and Consumption, 1883–1913" focuses on issues of consumption, which have entered the decorative arts from the social sciences, particularly anthropology, by way of design history, while Marianne Lamonaca's "Tradition as Transformation: Gio Ponti's Program for the Modern Italian Home" discusses the work of the Italian architect-designer. Either of these articles could have appeared in the *Journal of Design History* or possibly *Design Issues,* as could many of the reviews by design historians Penny Sparke, Pat Kirkham, David Crowley, and Dennis Doordan. The strategy taken by *Studies in the Decorative Arts,* to open up the boundaries of decorative arts scholarship brings the enterprise into closer relation with other fields such as material culture and design history itself where similar topics are being discussed and reviewed. In conjunction with the Bard Graduate Center's exhibition on women designers, mentioned earlier in the essay, *Studies in the Decorative Arts* published a special issue on women designers in the United States during the twentieth century.[78] The journal's crossover approach to article selection is also perpetuated by the appointment to the journal's editorial board of John Heskett, Christopher Wilk, and Jeffrey Meikle, all authors of design history texts.

What may ultimately open up once and for all the relations between the different approaches to the visual is the concept of "visual culture." According to art historian Marcia Pointon, "every 'man-made' structure and artifact, from furniture and ceramics to buildings and paintings, from photography and book illustration to textiles and teapots, comes within the province of the art historian."[79] The boundaries between different categories of objects are breaking down, whether or not one wants to go so far as Pointon. Referring to the diverse range of topics in the aforementioned list of dissertations, looking at the publishing strategies of journals like *Design Issues* and *Decorative Arts,* and reviewing the range of presentations at CAA conferences in recent years, indicate that art historians are no longer bound by a strict canon. Due to the rise of interest in popular culture, ethnicity studies, and the democratization of art, many art historians have crossed once-forbidden boundaries without anyone batting an eye. **Printing History.** Although 108 doctoral dissertations on top-

ics related to printing history were completed between 1970 and 1984,[80] it is not a developed discipline like art history, but rather an area of interest that has attracted scholars, librarians, book collectors, and printing buffs. The American Printing History Association was formed in 1974, and by the time it began to publish a journal, *Printing History*, in 1979, it had grown to over one thousand members. Among its main activities, besides publishing the semiannual journal, are holding regular conferences and producing a newsletter.

While cognizant of and interested in contemporary printing techniques, the association is also strongly concerned with preservation. As Susan Otis Thompson, the first editor of *Printing History* stated in her introductory editorial:

The more sweeping the take-over of computers and photolithography, the greater urgency there is to prevent the old metal types and the old presses from disappearing. The artifacts must be preserved, as well as knowledge of how they were used, of the people by whom they were used, of the purposes for which they were used.[81]

Thompson then went on to offer potential contributors wide latitude in their choice of subjects. She declared that the journal was "open to scholarly work on all aspects of graphic communication, from cave paintings to holography, from Texas to Timbuctoo."[82] Despite this grand vision, however, much of the journal's fare has been traditional printing history, which occasionally includes articles on modern themes.[83]

In 1987, when G. Thomas Tanselle received the American Printing History Association Award, he used the occasion to call for a more serious approach to the field. Among his proposals was that more scholars concentrate on the nineteenth century, rather than the seventeenth or eighteenth. This is a period of considerable importance to design historians as it coincides with the intensive development of machine production and the factory system. Tanselle recognized that work on nineteenth-century printing would "entail a greater knowledge of the history of technology than has generally been possessed by those investigating earlier printing history," and further, he identified a missing factor in printing history research, noting that "studies that treat the social, cultural, economic, and technological aspects of a printing shop with equal sophistication—and thus with an informed awareness of their interconnections—still scarcely exist."[84]

Tanselle's call for more work on the social context of printing practice, including the design of typefaces and printed materials such as books, preceded but parallels Susan Soros's more social approach to the decorative arts and suggests that as methodologies within the different research communities become more similar, it will be easier to use studies from these communities to

build a larger picture of how the visual and material cultures of the last two centuries have developed.

Besides the American Printing History Association, clubs of bibliophiles such as the Grolier Club in New York and the Caxton Club in Chicago also contribute to the broad culture of design history in the United States. The Caxton Club, for example, has a long tradition of members who are Chicago graphic designers and typographers. In 1985 the Caxtonians published a memorial to one of their distinguished typographer members, Robert Hunter Middleton, who designed typefaces for the Ludlow Company in Chicago and was active in all the city's organizations that had anything to do with design, printing, or books: the Newberry Library, the Society of Typographic Arts, and the Caxton Club, to name the major ones.[85] Most recently, the club mounted an exhibition in the Art Institute of Chicago's Ryerson Library of American dust jackets from the 1920s to the 1950s, which was accompanied by a small catalog.[86]

American Studies. Since American studies first began to evolve as an academic field in the 1930s, it has undergone a series of "paradigm dramas" that have radically shaken its initial assumptions and left scholars doubting, at least for the present, the possibility of a single vision of American culture.[87] The first generation of American studies scholars sought to understand the nature of a large synthetic construct they called the "American mind." Although it was supposed to be present in all Americans, it was nonetheless most coherently exemplified in "high culture," notably in literary statements.[88] But hopes for pursuing such an elusive ideal were dashed in the 1960s with the assertion that American culture was really a congeries of subcultures, each with its own identity and concerns. Today, American studies scholars acknowledge a pluralistic approach, as well as a shift from overarching abstractions toward a study of more specific topics, which can also be understood through material artifacts, as well as, or instead of, written or printed documents.

Despite a growing interest in the physical environment, however, scholars in this field have paid little attention to design. One exception, Jeffrey Meikle, who received his doctorate from the American studies program at the University of Texas in Austin, was probably the first person in the field to write a dissertation on a design subject. This was subsequently published as *Twentieth Century Limited: Industrial Design in America, 1925–1939*, a book that has become a model for research on American industrial design.[89] Meikle, who came upon his subject following a chance suggestion from his dissertation supervisor to have a look at the Norman Bel Geddes papers in the University of Texas library, evaluated his research as follows:

In retrospect, I consider my dissertation (and book) as an exercise in the intellectual history of design, advertising, and business, and

in the literary analysis of trade journal articles. Analysis of designed artifacts and environments was a bit ad hoc and imprecise when compared with the analysis of what designers said or wrote about their design intentions.[90]

This reflection indicates Meikle's reliance at the time on his training in the analysis of written texts rather than the emerging methods of analyzing artifacts, which have been discussed within material culture studies in recent years.[91] His subsequent book *American Plastics: A Cultural History* includes material on design in plastic but goes well beyond that to consider the larger impact of this synthetic material on American culture.[92] Nonetheless, Meikle remains involved in design history communities on both sides of the Atlantic and is recognized as an important figure in the field. He was, in fact, invited to address the Design History Society's twentieth anniversary conference in Brighton, England, in September 1997 and subsequently to give the Eleventh Reyner Banham Memorial Lecture in 1999.[93]

By the time Meikle completed *Twentieth Century Limited,* other scholars in American studies were independently beginning to write about design. In 1986, Eileen Boris published *Art and Labor: Ruskin, Morris, and the Craftsman Ideal in America,* which was based on her dissertation. The book emphasized the labor process behind the crafts revival in the late nineteenth century, the role women played in it, and the place of that revival within the emerging capitalist culture.[94] Boris was a doctoral student in Brown University's interdisciplinary History of American Civilization program. At Brown, she writes, "I developed my interest in the social meaning of art and my quest after a history that would include gender, along with class and race, as a fundamental category of analysis. Later I became concerned with the nature of work."[95]

The books by Meikle and Boris are among the few by American studies scholars to address topics belonging to the conventional narrative of design history. Besides several works that demonstrate methods of placing designed objects—whether railway cars, pottery, or advertisements—in a cultural framework, American studies research has been concerned as well with defining the nature of that framework. Eventually design historians will have to address this question more thoroughly, and they will likely turn to some of the books and articles from American studies such as Alan Trachtenberg's *The Incorporation of America: Culture and Society in the Gilded Age,* which is concerned with the multifarious factors that contributed to the shaping of America as an industrial nation in the latter part of the nineteenth century. Cathy Gudis, one of the recent graduates from the American studies program at Yale, where Trachtenberg teaches, wrote her dissertation on a design-related topic, "The Road to Consumption: Outdoor Advertising and the American Cultural Landscape,

1917–1965," while Christina Cogdell, working with Jeffrey Meikle at the University of Texas at Austin, wrote a revisionist history of American streamlining entitled "Reconsidering the Streamline Style: Evolutionary Thought, Eugenics, and U.S. Industrial Design, 1925–1940." Scholars have also taken up the question of American modernism, looking at it in a larger perspective than have art historians and literary critics, who focus on its manifestation in specific art forms.[96]

For the 1987 meeting of the American Studies Association, I organized a session entitled "American Design Culture: A Diversity of Approaches," where I sought to compare different ways of studying artifacts. Speakers, each of whom spoke about his or her own experience, included Ken Ames, representing material culture; Patricia Kane, speaking for the decorative arts; Donald Bush, discussing design history; and Renée Weber, questioning whether printing history was a discipline. In his summary comments, Meikle could find no basis for a common discipline. He also noted that a focus on the design process would implicate only a relatively narrow number of people who produced designs. What would interest a cultural historian more, he said, is the larger loop in which the design and production of products links with their consumption and use. He concluded optimistically:

Although today's speakers have indeed suggested a "diversity of approaches," they have hardly begun to exhaust the possible ways of considering design.[97]

Meikle's recognition of the many ways that design might be studied ended the session with an acceptance of the scholarly pluralism that continues to characterize the study of design in American culture.

But American studies is limited in its significance for the design historian because of its national focus, even though the questions posed by scholars in the field and the research methods they have developed are extremely important. This focus determines the kinds of questions that are asked of research material and excludes lines of inquiry that would help us to understand design as a practice outside a specific national context. Even though the study of American design remains a neglected area compared with research on European modernism, design historians must still look at their subject in a global framework to fully understand the meaning of design policies, practices, techniques, and values. **Material Culture.** The term "material culture" does not denote an academic field with distinct subject boundaries; rather, it designates a category of subject matter that is defined variously by scholars as "things," "objects," or "artifacts." While these terms are seen to have distinct meanings, most scholars agree that the definition of material culture implies "a strong interrelation between physical objects and human behavior."[98] Historically, the field of material culture has been closely linked to American studies, and until

recent years research was largely focused on American artifacts.[99] However, material culture is more progressive than traditional decorative arts research has been in its concern with the artifacts of all social groups within the culture, not just those of the wealthy. There is, for example, a sizeable group of material culture scholars whose primary interests are in folklore and vernacular culture.[100]

Several degree programs in material culture studies are offered by the University of Delaware, in cooperation with the Henry Francis du Pont Winterthur Museum. The MA in early American culture emphasizes the study of American decorative arts in a material culture context. Students interested in a doctorate can prepare for a degree in art history with a specialization in American decorative arts or apply for the doctoral program in the history of American civilization, which combines material culture study with American social and cultural history.

Both master's and doctoral students take a number of their courses at the Winterthur Museum, which introduces material culture methodology, and they write a thesis or dissertation on an appropriate topic.[101] To coordinate its educational programs, Winterthur has an Office of Advanced Studies, which was once headed by Ken Ames, now a professor at the Bard Graduate Center for Studies in the Decorative Arts.[102] Students in the University of Delaware–Winterthur doctoral program encounter a systematic exposition of issues related to technological innovation and the production of domestic objects. As a result, graduates like Michael Ettema have been able to articulate a set of issues about the production of American domestic objects that remain models for future scholars of American design.[103]

The primary journal in the field is the *Winterthur Portfolio,* which is published by the Winterthur Museum and serves as a useful barometer of the state of material culture studies in the United States. Its primary focus was historically on domestic objects and interiors of the seventeenth to nineteenth centuries, but in recent years the journal has been making a concerted effort to find twentieth-century material. In fact, an issue of 1995 included an article on the space suit as an artifact of material culture.[104]

In the past decade, there have been significant changes in material culture studies besides the attention to material of more recent times. This is evident in the papers that were presented at a 1993 Winterthur conference, the first on the state of material culture studies since 1975.[105] As the editors of the conference volume, Ann Smart Martin and J. Ritchie Garrison, note:

Two general trends have emerged: first, a greater variety of scholars, regardless of their scholarly background, have accepted the notion that material objects function as a kind of text, and second, most scholars emphasize the necessity of a contextual understanding of human behavior.[106]

Before these changes began to occur, articles in the journal tended to be closer in orientation to the traditional decorative arts than to a more contextually oriented approach. However, in recent years, the *Winterthur Portfolio* has begun to publish a number of articles and special issues on consumption as well as gender.[107]

In the mid-1990s, the Winterthur Museum organized a conference on gender and material culture. The scholars whose papers were published in the conference volume represented an even more diverse academic group than those in the 1993 book. Among the contributors were sociologists, professors of business administration and marketing, historians, professors of English and art history, and anthropologists.[108] And in 1997 the museum held a conference entitled "Race and Ethnicity in American Material Life." In an essay related to the conference that John Michael Vlach published in the *Winterthur Portfolio,* he noted that "art and art history studies have been the primary vehicles for the exploration of African American topics over much of the last half century."[109] Vlach went on to say that although the majority of papers at the conference continued to show the influence of art history, one-third of them were grounded in anthropology and "pointed to what I see as evidence of a shift to an alternate direction in African American studies—one that grows out of the archeological investigation of African American communities, particularly at the sites of former antebellum plantations."[110]

A broader survey of material culture research than that found at the Winterthur Museum was undertaken by the Smithsonian Institution in 1989 when it organized a conference for about fifty scholars from many disciplines—art history, cultural geography, archeology, anthropology, folklore studies, and the history of technology among them. Following the range of the Smithsonian's geographic interests, these scholars worked in time across the centuries and in space across the world. They shared an attention to artifacts as evidence of historical thought or activity. The importance of this conference, entitled "History from Things," is that it brought together scholars from more disciplines than tend to participate in the Winterthur events. At stake was the question of whether a new field of study that transcended particular subject boundaries might develop. As Steven Lubar and W. David Kingery state in their introduction to the volume of conference papers:

The essays in this volume not only penetrate the boundaries between fields that use material evidence to understand history but also push the boundaries of the field of material culture further than before, in new and interesting directions.[111]

A subsequent conference at the Smithsonian, "Learning from Things," focused more intently on specific problems of material culture researchers in art history,

the history of technology, archeology, and materials science.[112] These two conferences were important to the field for their focus on methodological issues, which also included more technical problems deriving from archeology. In neither conference volume, however, was there any mention of design.

Material culture studies can offer a great deal to design historians in terms of its methodological debates, but the emphasis on American topics and the general lack of interest in mass-produced artifacts excludes much that is important to their interests. As design history develops in the United States, material culture research will likely play a role similar to the one it has played in American studies—that of demonstrating ways of examining artifacts in a social context and of clarifying the debates about how this is most effectively done.

Popular Culture. According to one definition of popular culture as "cultural artifacts which reach and are recognized by a significant percentage of the population,"[113] designed objects fall well within the purview of the field; yet design as a subject of study scarcely exists for popular culture scholars. A survey of the *Journal of Popular Culture,* the official publication of the Popular Culture Association, reveals only the rare article on a design-related topic. Leaders in the field have shown some interest in selected objects like the Coca-Cola bottle and the automobile as icons—highly charged symbols of cultural values—but more attention has been paid to their reception than to the conditions of their design or to questions of why they took the particular forms they did.[114]

Although the study of popular culture is not confined to American subjects, most of the articles in the *Journal of Popular Culture* are devoted to American themes. This is not surprising since interest in popular culture grew out of the American studies movement. It matured in the 1960s as a response to antielitist sentiment and through a concern with more broadly based cultural products.[115] Besides the Popular Culture Association, founded in 1967 by Ray Browne, there is also the American Culture Association, established in 1978 by Browne to gain more academic credibility for popular culture studies.[116] In the latter organization's *Journal of American Culture,* more attention has been paid to everyday artifacts and to methods of their interpretation than in the related popular culture literature.[117]

Curiously enough, most popular culture scholars, who pioneered in the analysis of film, television, and other cultural phenomena, simply take design for granted. Occasional studies of objects as icons do not, unfortunately, lead to questions about the design process. Objects are more than symbols that evoke emotions. They testify to tangible realities of economics, production, labor relations, and consumer use. The investigation of these realities has thus far been obscured by those in popular culture studies who, when they consider designed objects as icons, do so the way traditional literary scholars consider texts, as

being simply there to provide a springboard for interpretation.[118] However, several articles in the *Journal of Popular Culture* in recent years have explored the iconography of magazine illustration and advertising and this direction may provide closer links to design history.[119] **History of Technology.** Since its founding in 1958, the Society for the History of Technology (SHOT), through its conferences and its journal *Technology and Culture,* has been the primary vehicle for the development of this field in the United States.[120] While much of the material published in the journal and in the research literature generally is well outside the design historian's interest—studies of the Jet Propulsion Laboratory, metallurgy, or particular inventions such as chain mail or rockets, for example—there is also research that is central to design history's concerns.[121]

A major topic of debate within the field some years ago was the nature of the American System of Manufacture which, according to one scholar, may possibly "prove to have the attractiveness as an organizing concept for [the] American history of technology that the concept of the Industrial Revolution has had for the British."[122] Besides various articles on that subject in *Technology and Culture,*[123] an exemplary case study of problems arising from attempts to implement the American system is Merritt Roe Smith's *Harper's Ferry Armory and the New Technology: The Challenge of Change,* which emphasizes the resistance of the armory craftsmen, who produced guns for the U.S. War Department, to the new machines and processes for mass production.[124]

Another topic of central interest to design historians, which has been debated in *Technology and Culture,* is the relation of new household technology to women's changing role in the home. This topic was first introduced to the journal by Ruth Schwartz Cowan who, among other objectives, wanted her article, "The 'Industrial Revolution' in the Home: Household Technology and Social Change in the Twentieth Century," to open up an awareness of different sites of technological innovation besides factories and the wilderness where railroad tracks were laid. "These grand visions," wrote Cowan, "have blinded us to an important and rather peculiar technological revolution which has been going on right under our noses: the technological revolution in the home."[125] It is noteworthy that Cowan introduced her discussion of how machines changed the nature of women's work at home in a journal devoted to the history of technology rather than one dedicated to social history. When her article appeared in 1976, it stood as an isolated argument among many unrelated articles in *Technology and Culture,* but two years later it was followed by Joan Vanek's "Household Technology and Social Status: Rising Living Standards and Status and Residence Differences in Housework" and by subsequent articles since then.[126] Cowan is a historian, but others who have joined the debate on housework and technology are from sociology, economics, social management, and American

studies. That this debate was carried out in a journal devoted to the history of technology suggests the fluidity of field boundaries and the way the definition of a problem can induce scholars to cross these boundaries to address it.

But despite the publication of a few articles on technology in the home, John Staudenmaier, the primary chronicler and theorist of the history of technology in the United States, stated in a 1983 paper that, even with the formation of the group Women in Technological History (WITH), *Technology and Culture* was still biased toward male authors and masculine values. Among other weaknesses in the history of technology, an absence of critiques of capitalism, attention to non-Western technologies, and discussions of the worker's perspective on technology were noted by Staudenmaier.[127]

More recently, the relation of technology to gender studies has been addressed within SHOT. In January 1997, three guest editors, Nina Lerman, Arwen Palmer Mohum, and Ruth Oldenziel, produced a special issue on the subject for *Technology and Culture,* "Gender Analysis and the History of Technology." In their introduction, the editors addressed several themes that are relevant to design historians. They gave particular attention to new ways of studying artifacts:

Most studies of technology have focused on a particular technology: refrigerators, steam engines, sewing machines. The increasing recognition of questions not only about what men and women do but also about how masculinity and femininity can be used symbolically has begun to inform examinations of modern technologies from automobiles to nuclear weapons.[128]

They also argued for a comprehensive view of how technology arises within culture, one that can "emphasize the connectedness of all phases of technological development as relevant to questions of technological change."[129] These scholars see studies that emphasize only invention or use as limiting, and they argue instead that "[i]ntegrating examination of design, manufacture, marketing, purchase, and use, on the other hand, allows a range of social and cultural factors, including gender, to become more apparent."[130] This broad approach makes possible a closer relation between design history and the history of technology than we have seen up to now and demonstrates that there is currently more activity in other fields upon which the history of design can draw than vice versa.

The editors' call for a more comprehensive approach to the study of technology builds on the argument made by some of their predecessors years earlier that an understanding of the social context in which technology has developed would bring unity to the diverse specialized studies.[131] Recently, this argument has been addressed by Cowan in her book *A Social History of Tech-*

nology. Clearly, the book originates in part from her earlier interest in expanding the scope of the field from a study of how devices and machines came into being to an understanding of how these objects fit within the situations of people's lives. As she notes in the introduction:

The history of technology is an effort to recount the history of all those things, those artifacts, that we have produced over the years. The *social* history of technology goes one step further, integrating the history of technology with the rest of human history. It assumes that objects have affected the ways in which people work, govern, cook, transport, communicate: the ways in which they live. It also assumes that the ways in which people live have affected the objects they invent, manufacture, and use.[132]

This openness to consider all forms of aesthetic and technical practice that relate to objects and environments under a single rubric was the premise of a conference, "Re-Visioning Design and Technology: Feminist Perspectives," that was held at the City University of New York Graduate Center in 1995. Technology historian Joan Rothschild, who had attended the CASVA seminar on design history in 1993, justified this elision of design categories in her introduction to the conference proceedings entitled *Design and Feminism:*

Contributing to the separation of disciplines is the distinction made between *design* and *technology,* with the professions being classified accordingly. Thus, because of their association with the arts, architecture and graphic design are known as *design* professions, while engineering and computer electronics, associated with the technical, are called *technology* professions . . . In this book, we seek to use "design" in its broadest sense—to encompass both the aesthetic and the technical.[133]

The relation between design and technology in these proceedings as well as the overlap between Cowan's social history of technology with material that would be suitable for a history of design suggest that at some time in the future, we may see a more broadly constituted history of design that will include engineering and architecture as well as product design and graphic design and maybe even other forms of design as well.

In the April 1997 issue of *Technology and Culture,* the editors published a special section on technology and design. Besides a review of the inaugural exhibition of the Wolfsonian in Miami Beach, along with its catalog, the section included a review essay by design historian Barry Katz in which he argued for a closer relation between the two practices.

In the last analysis, however, it is the designer who domesticates new technology and makes it available for human use. This mutual

156.157

dependency suggests that at the very least the study of design can be deepened by an exposure to the more deeply rooted history of technology, and the study of technology invigorated by the new tendencies in the history and theory of design.[134]

For Katz, an important factor that links the "new scholarship of design" to the "established history and philosophy of technology" is the understanding that "the significance of a technical artifact is not exhausted by its operational characteristics, and that it is suspended in webs of meaning that are multivalent, polysemic, and omnicultural."[135] As with the more recent scholarship in material culture and the decorative arts, the interest in the social context of artifacts to which Katz refers is something that is relatively new in different ways to all these communities of researchers and may ultimately be a means to bring them closer together. **History.** Similar to the shift in American studies from a preoccupation with the characteristics of the "American mind" to a broader investigation of the more concrete and diverse forms of American culture, there has been a related move in the discipline of history since the 1960s from the traditional emphasis on political and military events to the study of ordinary people and everyday life.[136] As a result of this tendency, there was an upsurge of research on the history of women, workers, specific ethnic groups, and others previously marginalized by historians. In some instances, this emphasis on the experience of ordinary people has led scholars to work on material that is close to issues that concern design historians. A number of historians, stimulated by E. P. Thompson's studies of English working-class culture, have studied the cultural factors that shaped the experiences of American workers. Susan Hirsh focused on how independent craftsmen in Newark were transformed into workers doing limited tasks for a wage.[137] As part of her investigation of working-class culture, Lizebeth A. Cohen researched furniture and its arrangements in American working-class homes between 1885 and 1915, a project that was clearly motivated by the new impulses in social and labor history to provide a clearer picture of how American workers lived.[138] Taking a somewhat different approach to the study of workers, Shulamit Volkov looked at the shift from crafts to industrialization in late nineteenth-century Germany in her book, *The Rise of Popular Antimodernism in Germany: The Urban Master Artisans, 1873–1896.*[139] Citing E. P. Thompson's work as an influence, Volkov called her book "an experiment in social history . . . a chapter in the history of a social group."[140] Her research is valuable to design historians for its attention to a group that resisted modernization in Germany, a subject thus far minimized in the design history canon with its emphasis on the Deutscher Werkbund and its ideology of industrial progress. The Werkbund, however, was the focus of Joan Campbell's *The German Werkbund: The Politics of Reform in the Applied Arts,*

which concentrated on the organization's policies and politics rather than on the particular designs or architecture that it produced or supported.[141] And William Morris, a central figure in the design history canon, was discussed by Peter Stansky in *Redesigning the World: William Morris, the 1880s, and the Arts and Crafts*. However, rather than focusing on the particular objects designed by Morris and his colleagues as is evident in much of the design history literature, Stansky, a specialist in modern British history, gave considerable attention to the development of Morris's political views and located him and his work within the social and political events in Britain in the 1880s.[142]

Concentrating on consumers rather than producers, Michael Miller and Rosalind Williams studied the rise of a consumerist ideology and its critique in late nineteenth-century France.[143] Miller's book *The Bon Marché: Bourgeois Culture and the Department Store, 1869–1920* is not a business history but rather an examination of how the Bon Marché, the largest department store in the world before 1914, attempted to reconcile traditional middle-class values with the new age of mass consumption. Rosalind Williams examined the new French consumer lifestyle in her book *Dream Worlds: Mass Consumption in Late Nineteenth-Century France,* but she devoted her primary attention to the emergence of a consumerist critique, which she analyzed through the writings of economists and social thinkers such as Paul Leroy-Beaulieu and Charles Gide. Late nineteenth-century France was also the subject of Deborah Silverman's dissertation at Princeton. Silverman studied art nouveau but concerned herself with the economic issues of craft production as they were discussed within French government circles.[144]

Design-related issues in American history were treated in Roland Marchand's *Advertising the American Dream: Making Way for Modernity, 1920–1940*. Published in 1985, Marchand's book is a monumental study of how advertising images in a twenty-year period embodied values to which Americans were urged to aspire.[145] Based heavily on the analysis of the advertisements themselves, the book demonstrates the growing interest among historians in gathering information from artifacts. Incorporating methods of analyzing advertisements developed by cultural studies researchers such as Judith Williamson and others, it also represents a line of investigation on consumption as a central activity of American capitalist culture.[146] Marchand followed this book with a major study of corporate public relations, *Creating the Corporate Soul: The Rise of Public Relations and Corporate Imagery in American Big Business* that includes, but goes beyond, the artifacts, brochures, and exhibits through which these policies were expressed. Similar to Meikle's interest in the broad cultural history of plastic, Marchand wrote a cultural history of public relations that incorporated design but was not limited to it.[147] Cultural

history was also the framework for Paul Betts, a student of Michael Geyer's at the University of Chicago. Betts's dissertation was entitled "The Pathos of Everyday Objects: West German Industrial Design Culture, 1945–1965."[148]

Business history, a specialized branch of history, is also an area in which issues of design have been discussed. The Center for the History of Business, Technology, and Society at the Hagley Museum and Library in Delaware, near the Winterthur Museum, has given fellowships to scholars such as Meikle and occasionally sponsors a seminar or lecture series on design. In 1991, the center's seminar series focused on industrial design. Of the three programs, one was a panel on design history that included myself and Dianne Pilgrim, director of the Cooper-Hewitt. In early 1999, the British *Journal of Design History* published a special issue, "Design, Commercial Expansion, and Business History," which featured a group of American contributors, among them Glen Porter, the director of the Hagley, who wrote on twentieth-century package design, and historian Sally Clarke writing on Harley Earl and the Art and Color Section at General Motors. In his introduction to the issue, Jeffrey Meikle noted:

Constrained by their own institutional structures and, except for the largest monopolies or oligopolies, enjoined in risky competition with other firms, most businesses that employ design consider it as a necessary but uncertain means of communicating with fickle consumers. At the very least, business history can complicate our understanding of design.[149]

Although studies of designers, producers, promoters, and consumers of goods fall easily within existing fields of historical research as we have seen, the questions about designing that they open up confirm their importance to design history through their intentions to explain much more about products than the evolution of production techniques and forms

DESIGN ARCHIVES The Library of Congress, Smithsonian Institution, and New York Public Library have long-established major archives of printed ephemera, but there have been until recent years few collections of design material that have focused on the twentieth century. The Library of Congress has a major poster collection that includes much twentieth-century material, and the Museum of Modern Art in New York set a precedent for collecting such material with its archive of posters and other graphic ephemera from the modern period. However, few other museums followed this example until about twenty years ago. At that time, some design professionals, librarians, and curators began to recognize the value of design material for research and exhibitions, and a few institutions took a leading role in collecting it.[150] The Library of Congress is now seeking to establish a Center for American Architecture, Design, and Engineer-

ing to publicize and make use of its collections in these areas which number more than five million items. Among these collections is a major archive of material by Charles and Ray Eames.[151] The library joined with the Vitra Design Museum to organize an exhibition based on this archive, *The Work of Charles and Ray Eames*, which opened at the Library in May 1999 and then traveled to the Cooper-Hewitt, National Design Museum, the Saint Louis Art Museum, and the Los Angeles County Museum of Art.[152] A number of academic libraries are also collecting design material, often at the instigation of design teachers. As already mentioned, Syracuse University, prompted by Arthur Pulos, began to assemble the papers of American industrial designers in the early 1960s. At the Rochester Institute of Technology, graphic design professor Roger Remington founded the Graphic Design Archive in 1984. Among its acquisitions, are the complete archives of the American graphic designer Lester Beall, as well as collections of work by other graphic designers such as Alvin Lustig, Will Burtin, Cipe Pineles, William Golden, Ladislav Sutnar, and Alexey Brodovich.[153]

In 1986, the Special Collections Department at the University of Illinois at Chicago Richard J. Daley Library formed the Robert Hunter Middleton Design Printing Collection, which was named after the Chicago typographer mentioned above as a prominent member of the Caxton Club. The Middleton collection initially emphasized design in Chicago, but the university library subsequently obtained the archives of the Aspen Design Conference, which provides a framework for assembling material from across the country.[154] In addition, the Special Collections Department has begun to assemble within the Middleton archive material by African American designers. This began with one large collection of work by Chicago graphic designer and cartoonist Eugene Winslow and has now grown to include work by other designers from Chicago such as Tom Miller, Emmett McBain, Charles Harrison, Richmond Jones, and Don Patton, along with material from designers elsewhere in the United States.

There is also a graphic design archive at the Herb Lubalin Study Center for Design and Typography, founded in 1984 at Lubalin's alma mater, Cooper Union, in New York. The center, which houses Lubalin's archives among others, also includes a study center and a gallery. Its first curator Ellen Lupton brought a background in design, design history, and theory to the planning of exhibitions that emphasized the communicative as well as the aesthetic aspects of graphic design.[155] Under Lupton, these exhibitions varied from retrospectives of work by prominent graphic designers such as Massimo Vignelli, Seymour Chwast, Anton Beeke, and Ikko Tanaka to more theme-oriented shows like *Global Signage: Semiotics and the Language of International Pictures*, *Writing and the Body*, *Period Styles: A History of Punctuation*, and *the abcs of triangle square circle: the bauhaus and design theory*.[156] What differentiated the 160.161

center's approach to design history under Lupton from that of the museums is its interest in examining design as a process of social communication and relating its exhibitions to issues of design teaching and practice.[157]

In 1991, RIT, Cooper Union, and the University of Illinois at Chicago, with a grant from the National Endowment for the Arts, launched a feasibility study for a National Graphic Design Archive, which was to be an electronic database of graphic design images.[158] Although various issues were explored during the grant, the archive never came to fruition. The Lubalin Center, however, has since launched its own graphic design archive on the internet.

Among businesses, the Herman Miller Company has gathered a collection of films, tapes, catalogs, and other items related to its furniture designs, but few other companies seem to have done much with their archival material. Motorola, a leading producer of appliances, hired curator Sharon Darling in 1986 to organize its papers and in 1991 opened a museum that employs films, computers, and exhibits in an interactive format to portray the company's history.[159]

There are also many private collectors of design objects and graphic ephemera though few of them make their collections available to the public. Among the most public-minded is Merrill C. Berman, who has loaned examples from his exceptional collection of more than twenty thousand posters and other graphic ephemera to several museums.[160] In 1985, Darra Goldstein curated *Art for the Masses: Russian Revolutionary Art from the Merrill C. Berman Collection* at the Williams College Museum, and in 1998 the museum joined together with the Cooper-Hewitt, National Design Museum to sponsor *Graphic Design in the Mechanical Age: Selections from the Merrill C. Berman Collection.*[161]

The assemblage of design documentation is necessary to advance design history scholarship, and the availability of archival material is a major determinant in the kinds of research scholars are likely to undertake. Thus far, archivists appear to be broadly interested in all kinds of design collections, not just material by the star designers, and that is a hopeful sign.

DESIGN HISTORY IN THE MUSEUMS The Museum of Modern Art (MOMA) has long had a design collection, and it established a design department in the early 1940s, but this has not been the case for most other American art museums, which have relied instead for their displays of functional objects on curators with expertise in the traditional decorative arts.[162] In the past twenty years or so, major American art museums have devoted increasing attention to design exhibitions, which attract large audiences and receive extensive reviews in the press. These exhibitions for the most part were initially strongly influenced by a decorative arts approach, which reflected the training of the majority of curators, although this is now changing. A decorative arts orientation was particularly evi-

dent in *Design since 1945*, an ambitious survey organized by Kathryn Hiesinger, curator of European decorative arts at the Philadelphia Museum of Art, and presented at the museum between October 1983 and January 1984. Hiesinger confined her selection to domestic objects, the traditional purview of decorative arts historians, and excluded many significant areas of postwar design such as objects for the office, the hospital, and the disabled. The objects were displayed in the catalog according to conventional decorative arts divisions such as ceramics, glass, furniture, metalwork, textiles, and wood, although a new category for plastics had to be added.[163] Hiesinger stated in her catalog essay that functionalism had given way to many new directions, and she sought to demonstrate as much in her exhibition. In 1994, she and Felice Fisher organized a huge exhibition of Japanese design since 1950 in which they sought to characterize Japanese products by focusing on five qualities: craftsmanship, asymmetry, compactness, humor, and simplicity.

However, the product range, unlike the previous exhibition, embraced a panoply of objects that extended from the decorative to the industrial, including cameras, televisions, computers, and automobiles along with kimonos, lacquerware, and teapots.[164]

MOMA continues to sustain the legacy of the modernists and their designated heirs. Its exhibition of Alexander Rodchenko's work in 1998 and its earlier shows of Lilly Reich's and Marcel Breuer's designs are examples, as is its retrospective some years back of work by Italian designer Mario Bellini, who has been admitted to the museum's canon.[165] Unlike MOMA, the Whitney Museum of American Art embraced the new efflorescence of styles in its 1985 exhibition, *High Styles: Twentieth Century American Design*.[166] As a design exhibition, however, this one was particularly troublesome. The century was divided into periods and different curators chose the objects for each period.[167] In the final section, stereo sets from J. C. Penny were mingled with Robert Venturi's pop design chairs for Knoll and art furniture by Scott Burton, which was never intended for use. By parceling out the selections to multiple curators, Lisa Philips, the coordinator, was unable to state a thesis about how American design evolved in the twentieth century.[168]

The history of American design during this period has been better served by several other exhibitions, *Design in America: The Cranbrook Vision, 1925–1950*, first seen at the Detroit Institute of Arts in 1983 and then at the Metropolitan Museum of Art in New York, and *The Machine Age in America, 1918–1941*, which opened at the Brooklyn Museum in 1986.[169] The Cranbrook show gave well-deserved public recognition to the school whose first director was the Finnish architect Eliel Saarinen and from which many important

American designers like Florence Knoll, Charles Eames, Ray Eames, Harry Bertoia, Jack Lenore Larsen, and Eero Saarinen graduated. Cranbrook has been obscured for too long by design historians who continue to emphasize the Bauhaus and other European schools. But the school began in 1925 at the time the Bauhaus was moving to Dessau, and it was a strong force in American design before the Bauhaus émigré teachers arrived.

The organizers of *The Machine Age in America, 1918–1941*, Richard Guy Wilson, Dianne Pilgrim, and Dickran Tasjian, presented a major survey of American design from the 1920s and 1930s but sought to represent cultural

values rather than characteristics of style alone. A similar strategy, featuring examples from the arts and crafts movement in America, was evidenced in the 1987 exhibition, *"The Art That Is Life": The Arts & Crafts Movement in America, 1875–1920*, organized by Wendy Kaplan at the Museum of Fine Arts in Boston.[170]

Design shows have also occurred occasionally at history museums, where the emphasis is on the social aspects of objects rather than their aesthetic value. An approach based more on a material culture methodology could be seen in the exhibition, *Chicago Furniture: Art, Craft, & Industry, 1833–1983*, curated by Sharon Darling at the Chicago Historical Society in 1984.[171] The focus of the show was on the diverse kinds of furniture that were manufactured in Chicago over 150 years, and patent furniture and period revival pieces were mixed with tubular steel kitchen chairs and contemporary art furniture. The exhibition was more historically grounded than most exhibitions of furniture and provided a great deal of information, both in the show and the catalog, about Chicago furniture manufacturers, craftsmen, designers, and labor and economic conditions. Since the exhibit was initiated by a historical society rather than by an art museum, there was less need to justify the displayed objects in terms of a standard of aesthetic quality and more impetus to portray them as evidence of a historical process.

The Henry Ford Museum near Detroit has taken a somewhat different ap-

proach to material culture. Given that Henry Ford himself founded the institution, it is not surprising that it has concentrated on collecting automobiles rather than decorative arts, although it does have an unusually large assemblage of artifacts as well as archives. In 1986, the museum established the Edsel B. Ford Design History Program to encourage scholarly study of industrial design history. The program encompasses exhibits, publications, seminars, and conferences, and its staff collects archives and artifacts that "reveal how designers define problems, identify constraints, formulate solutions, and carry their vision to practical fruition."[172] Also in 1986, the museum opened a major long-term installation, *Streamlining America*, which was intended to show visitors how the concept of streamlining was applied to products in the 1930s in order to produce a sense of optimism during the Depression. This exhibit was followed by a major one on the automobile in 1987 entitled *The Automobile in American Life*, and in 1992 the museum presented *Made in America*, which displayed more than 1,500 artifacts from its collections. Divided into sections, the latter exhibit considered objects from a social history view, emphasizing issues of manufacturing, labor, and consumption.[173] A related approach has been evident in other exhibitions such as *Culture & Comfort: People, Parlors, and Upholstery, 1850–1930*, organized by Katherine C. Grier, which opened in 1988 at the Strong Museum in Rochester, New York. The exhibition grew out of Grier's doctoral research in the program in the history of American civilization at the University of Delaware.[174]

The two government museums devoted to design, the Cooper-Hewitt, National Design Museum in New York and the Renwick Gallery in Washington, D.C., have maintained active exhibition schedules since the late 1970s. The Cooper-Hewitt, which reopened in the renovated Carnegie Mansion on New York's Upper East Side in 1976, was formerly the Cooper Union Museum for the Arts and Decoration. Among the exhibits presented at the Cooper-Hewitt under director Lisa Taylor were *Vienna Moderne: 1898–1918*, *The Oceanliner: Speed, Style, Symbol*, and the large show, *Scandinavian Modern Design, 1880–1980*, organized by David McFadden, curator of decorative arts, in 1982.[175] In addition , the museum offered some more general exhibits such as *Design in the Service of Tea*, *Safe and Secure: A World of Design in Locks and Keys*, and *Bon Voyage: Designs for Travel*. *Milestones: Fifty Years of Goods and Services* featured products recognized as outstanding by the Consumer's Union. Such an exhibit, by emphasizing what consumers themselves have considered valuable, tells us something about the users of design, an element neglected in other exhibitions. In 1991, Dianne Pilgrim, the former

164 . 165

curator of decorative arts at the Brooklyn Museum and one of the organizers of the *Machine Age in America* exhibition, became the director of the Cooper-Hewitt. Her intention was to showcase modern and contemporary design of all kinds, not just celebrated canonical objects. To this end, Pilgrim changed the museum's name to Cooper-Hewitt, National Design Museum and commissioned a new graphic identity for it. She also hired Ellen Lupton from the Cooper Union as the curator of contemporary design. Although the Cooper-Hewitt continued to do conventional exhibitions such as *Czech Cubism: Architecture and Design*, Lupton took a different approach to exhibitions, focusing in several cases on cultural issues rather than the presentation of iconic objects. She brought an awareness of social history to the first exhibition she curated at the museum in 1993, *Mechanical Brides: Women and Machines from Home to Office.*[176] This followed a show that she and J. Abbott Miller had organized at MIT's List Visual Art Center, *The Bathroom, the Kitchen, and the Aesthetics of Waste,* that related changes in product forms to the application of scientific management theories in the domestic sphere.[177]

At the Cooper-Hewitt, Lupton's graphic design shows ranged from *Elaine Lustig Cohen: Modern Graphic Designer* and a display of Cohen's collection of modernist letterheads, *The Avant-Garde Letterhead*, which was displayed at the American Institute of Graphic Arts, to *Mixing Messages: Graphic Design in Contemporary Culture*, a large survey of graphic design in the 1980s. This was a type of exhibition that is rarely presented in a museum since it falls between shows of classic modernist design such as MOMA would present and the annual exhibitions of contemporary work displayed by the design associations and art director clubs.[178]

Pilgrim also aspired to do a series of retrospective exhibitions of the major consultant designers of the 1930s as a way of recognizing America's contribution to design for mass production. In 1994, the museum presented *Packaging the New: Design and the American Consumer, 1925–1975*, which featured work by Donald Deskey, and then three years later it presented a major retrospective of work by the Henry Dreyfuss office, *Henry Dreyfuss Directing Design: The Industrial Designer and His Work, 1929–1972*, which was curated by Russell Flinchum, who wrote his dissertation on Dreyfuss at the City University of New York.[179] The museum has now entered another phase since Pilgrim has left her full-time position and a new director, Paul Warwick Thompson, has been appointed.

Among the shows at the Renwick Gallery since the mid-1970s that related to design history have been several surveys of work by modern designers: *A Modern Consciousness: D. J. De Pree and Florence Knoll, The Designs of Raymond Loewy, The Decorative Designs of Frank Lloyd Wright,* a collection of work

by the Danish architect and designer Arne Jacobsen, *Inspiring Reform: Boston's Arts and Crafts Movement*, and *Easier Living: Russel Wright and the American Modern Style*.[180] The museum also did a larger survey exhibition, *American Art Deco*, which represented the style through the display of sculpture, furniture, textiles, glass, ceramics, and silver, as well as architectural photographs.

The latest gallery to feature exhibitions related to design history is at the Bard Graduate Center. Housed in a rather small space on the ground floor of the townhouse where the Center's offices, classrooms, and library are located, the exhibition program is nonetheless ambitious. Mixed with exhibits on traditional decorative arts themes such as Indian jewelry and objects from Baroque palaces, have been several shows such as *Finnish Modern Design*, and *E. W. Godwin: Aesthetic Movement Architect and Designer*, curated by Susan Soros.[181]

In Chicago, John Zukowsky, the curator of architecture and design at the Art Institute of Chicago, has taken a different tack.[182] Surprisingly for a museum noted for its collection of canonical fine art, Zukowsky has been able to mount several large exhibitions that one might expect to find in a museum of technology, notably *Building for Air Travel: Architecture and Design for Commercial Aviation*, which opened in late 1996.[183] Although much of the exhibition was devoted to airport design, Zukowsky also included the mockup of an airplane interior designed by Teague Associates and considerable information about the design of airline corporate identities. Zukowsky's next exhibition, which opened in early 2001, was entitled *2001: Building for Space Travel*, and another forthcoming exhibition, curated by his associate Martha Thorne, is entitled *Modern Trains and Splendid Stations; Architecture and Design for the 21st Century*. The space travel exhibition was accompanied by an extensive catalog, and Zukowsky published a book on the subject that features the work of John Frassanito & Associates, a firm that has done extensive design work for the space industry.[184]

At the Art Institute, however, the departments concerned with design and decorative arts remain separate. When a major retrospective of Charles Rennie Mackintosh's work, which included both architecture and furniture, came to the museum from Glasgow, it was administered through the department of decorative arts, rather than that of architecture and design. Because Mackintosh's work remains central to the decorative arts canon, this seemed appropriate, particularly since much of Zukowsky's interest centers on more industrial buildings and products such as airports and space shuttles or contemporary architecture and design from all parts of the world.

Perhaps the most widely publicized foray of a museum into the design realm in recent years was the Guggenheim Museum's 1998 exhibition, *The Art of the Motorcycle*, which traced the motorcycle's history from the first models of

the 1860s through the latest versions including one by Philippe Starck. The exhibition treated the motorcycle from an aesthetic point of view rather than a material culture or social history perspective, although in an unusual shift of venues, it moved from the Guggenheim to the Field Museum of Natural History in Chicago, where the staff attempted, through the use of panels, labels, and a concluding video, to introduce a social history element.[185]

The most recent museum of design and decorative arts to open in the United States is the Wolfsonian in Miami Beach, Florida. As I recount in a later essay, the Wolfsonian presented its inaugural exhibition in 1995, *Designing Modernity: The Arts of Reform and Persuasion, 1885–1945*.[186] The museum is still finding its way in terms of an exhibition philosophy but is likely to emphasize the European and American modernist tradition that corresponds to the collecting interests of the museum's founder Mitchell Wolfson. For example, the Wolfsonian recently presented *Leading "The Simple Life": The Arts and Crafts Movement in Britain, 1880–1910* and *Graphic Design in Germany, 1890–1945*, curated by British design historian Jeremy Aynsley, who drew primarily on the Wolfsonian's collection.[187] The Wolfsonian also operates a study center that gives grants to scholars to do research in its collections.

The diversity of design history interests among American museums mirrors the plurality of design history research in the United States. Ranging from the high modern retrospectives of MOMA to shows of less canonical objects presented from a material culture point of view, American museums are open to a variety of approaches. More attention is also being paid in many exhibitions to a critical interpretation of the objects and their social and economic contexts.

CONCLUSION It is evident from the above account that design is the subject of historical investigation from many quarters. If a poll were taken as to whether design history should be a new discipline or simply a site to focus interdisciplinary research, the answers would most likely be the latter. Clearly, the enterprise of design history in the United States is active without any academic support for a new discipline. And because good work is being done outside the framework of such a discipline, the push for change seems even more difficult.

The volume of crossover research we are seeing between design history, material culture, American studies, popular culture, decorative arts, and the history of technology continues to grow. Particularly with the strong emphasis on the social context for understanding objects, there is likely to be more confluence among scholars in different research communities as the social dimension of an object overtakes the distinctions between its mechanical and aesthetic aspects.

The existing research communities will surely sustain themselves, but

the manifestations of crossover interest will most likely appear more frequently in the journals—*Design Issues, Winterthur Portfolio, Technology and Culture, Studies in the Decorative Arts,* or the *Journal of American Culture*—as well as at conferences such as those of the College Art Association, the American Studies Association, the Society for the History of Technology, or the Popular Culture Association. At these events we already see such activity in individual papers and sessions. New books, as well, will give evidence of interdisciplinary awareness, as some have done already, and little by little the edges that separate one research community from another will continue to soften.

While this process may be acceptable and even inevitable to those who believe in laissez-faire pluralism, it leaves unaddressed a number of problems that a more proactive approach to the advancement of design history might address. Most important, it does not relate design history very well to the design community and thus avoids an essential goal of developing the history of a practice, that of contributing to the self-consciousness of the practice itself. American graphic designers and design educators have taken this problem into their own hands and produced much of the research for a history of graphic design themselves. By comparison, little has been done by product designers with the exception of Arthur Pulos's work. In both cases, there is a need for more scholarly engagement to contribute critical writing, documentation, and historical narratives to the field.

The situation has also not generated the kind of debate about narrative issues that is at the core of every field of historical endeavor, whether in art, sociology, or the wider field of history itself. In the United States, as well as in Britain, Scandinavia, and Japan, historians continue to research particular topics in design with no reference to a process of what I will call narrative building. While I neither expect nor advocate the emergence of a master narrative for design history, we do need stronger narrative examples than those we currently have. If one aim of history, as Dennis Doordan put it so well, is to provide "an intelligent rendering of the complexity of past experience,"[188] we need to foreground the narrative problems of how design has developed in a way that has not yet been done either in the United States or elsewhere.

This objective underscores the need for greater attention to design history as a distinct field of expertise. It is neither necessary nor desirable to create new departments of design history, but design history should be given greater emphasis within existing academic structures. I see this happening in three ways. First, an art history program could follow the model of architectural history and hire two or three design historians. This would provide a critical mass for teaching a full program of design history courses to undergraduate and graduate students and would allow the possibility for a graduate student to

complete a strong emphasis on design history within an art history degree program, whether at the MA or doctoral level. A second model would be the Princeton or MIT model of offering a doctoral program in the history, theory, and criticism of architecture to students who have mainly attained prior degrees in practice. This model has worked extremely well and produced some outstanding scholars in architectural history such as Martha Pollak, Deborah Fausch, Mitchell Schwarzer, and Sandy Isenstadt. While there is currently not a sufficiently developed culture of designers and historians in the United States to mount a comparable program, such a model nonetheless remains viable for the future. The third model is to create a strong emphasis on design history within a doctoral program in design. This model follows to some degree that of sociology where some scholars tend to emphasize history and theory or fieldwork but all are trained within a single disciplinary framework.

It is also clear that design history does not only concern designers. As Jeffrey Meikle has noted, "After all, design is the source from which most twentieth-century Americans have had to select the very stuff of their daily lives."[189] Therefore, it will continue to be a subject of interest to scholars in American studies, the history of technology, material culture, and other research communities who consider the products of design to reveal something of significance about human life.

Design, in fact, is everyone's concern. It is the process through which we create the material and immaterial products that influence how we live. Therefore, design history needs to serve different audiences. It is crucial for the practicing designer in order to contribute to the internalization of standards of quality, efficacy, and value. And it is equally important for everyone else, the users of design, who take products into their own spheres of activity and shape their lifeworlds with them. Design history is significant as well for social, political, and commercial leaders who make decisions that affect what does and does not get designed. With the recognition that it can explain so much about how we live and how we might live, it should be recognized as a valuable resource that requires cultivation in its own right.

1 "A Decade of Design History in the United States, 1977–1987" was first presented as a lecture at the tenth anniversary conference of the DHS at Brighton Polytechnic in 1987. It was subsequently published in the founding issue of the society's *Journal of Design History* 1, no. 1 (1988): 51–72. I first learned of the DHS from a colleague, Françoise Jollant, at the International Council of Graphic Design Associations (ICOGRADA) congress in Chicago in 1978. Independently, I had completed as author or editor several trade books on the histories of American turn-of-the-century

posters and World War II propaganda, although I did not think of them at the time as design history. Subsequently, the existence of the DHS was a strong factor in my decision to name design history as the research field for my own PhD, which I completed in 1982.

2 Among them are Cathy Gudis, Carma Gorman, Christina Cogdell, and Rebecca Houze.

3 Letter to the author, August 8, 1987. From the time Danziger began teaching, around 1952, he made reference to various "historical movements, ideas and individuals."

4 Ann Ferebee, *A History of Design from the Victorian Era to the Present* (New York: Van Nostrand Reinhold, 1970). Ten years after its initial publication, the book came out in paperback.

5 Philip B. Meggs, personal communication, October 1987.

6 Philip B. Meggs, *A History of Graphic Design* (New York: Van Nostrand Reinhold, 1983). A second edition, revised and expanded, was published in 1992, and a third edition appeared in 1998.

7 Lloyd Engelbrecht, "The Association of Arts and Industries: Background and Origins of the Bauhaus Movement in Chicago" (Ph.D. diss., University of Chicago, 1973).

8 *Graduate Studies, History of Design,* program brochure, Department of Art History, University of Cincinnati, n.d.

9 I published a drastically revised version of my dissertation as *The Struggle for Utopia: Rodchenko, Lissitzky, Moholy-Nagy, 1917-1946* (Chicago and London: University of Chicago Press, 1997).

10 Caucus status is awarded to various interest groups by the CAA. This entitles them to a session and a business meeting at the annual convention.

11 The name was suggested by Grant Greapentrog, then at Drexel Institute in Philadelphia.

12 Barbara Young, who at the time headed the art department at California Polytechnic State University in San Luis Obispo, produced the first newsletter. Subsequently, occasional newsletters were produced by Richard Martin.

13 American scholars have also published intermittently in the British *Journal of Design History,* which was founded four years after *Design Issues.* See, for example, Eileen Boris, "Craft Shop or Sweatshop? The Uses and Abuses of Craftsmanship in Twentieth Century America," *Journal of Design History* 2, nos. 2-3 (1989): 175-192; Elizabeth Collins Cromley, "Sleeping Around: A History of American Beds and Bedrooms," *Journal of Design History* 3, no. 1 (1990): 1-18; Reed Benhamou, "Imitation in the Decorative Arts of the Eighteenth Century," *Journal of Design History* 4, no. 1 (1991): 1-14; Roann Barris, "*Inga:* A Constructivist Enigma," *Journal of Design History* 6, no. 4 (1993): 263-282; Jeffrey L. Meikle, "Into the Fourth Kingdom: Representations of Plastic Materials, 1920-1950," *Journal of Design History* 5, no. 3 (1992): 173-182; Ellen Mazur Thomson, "Early Graphic Design Periodicals in America," *Journal of Design History* 7, no. 2 (1994): 113-126; Reed Benhamou, "Parallel Walls, Parallel Worlds: The Places of Masters and Servants in the *Maisons de plaisance* of Jacques-François Blondel," *Journal of Design History* 7, no. 1 (1994): 1-12; Richard Martin, "Our Kimono Mind: Reflections on 'Japanese Design: A Survey since 1950,'" *Journal of Design History* 8, no. 3 (1995): 215-224; Sandy Isenstadt, "Visions of Plenty: Refrigerators in America around 1950," *Journal of Design History* 11, no. 4 (1998):

311–322; Nicholas Maffei, "John Cotton Dana and the Politics of Exhibiting Industrial Art in the US, 1909–1929," *Journal of Design History* 13, no. 4 (2000): 301–318; and Sherwin Simmons, "'Hand to Friend, Fist to Foe': The Struggle of Signs in the Weimar Republic," *Journal of Design History* 13, no. 4 (2000): 319–340.

14 See, for example, Tamiko Thiel, "The Design of the Connection Machine," *Design Issues* 10, no. 1 (spring 1994): 5–18; Dennis Doordan, "Simulated Seas: Exhibition Design in Contemporary Aquariums," *Design Issues* 11, no. 2 (summer 1995): 3–10; Barry Katz, "The Arts of War: 'Visual Presentation' and National Intelligence," *Design Issues* 12, no. 2 (summer 1996): 3–21; Sara Schneider, "Body Design, Variable Realisms: The Case of Female Fashion Mannequins," *Design Issues* 13, no. 3 (fall 1997): 5–18; and Michael Punt, "Accidental Machines: The Impact of Popular Participation in Computer Technology," *Design Issues* 14, no. 1 (spring 1998): 54–80. A collection of design history articles from earlier issues of the journal was published as *Design History: An Anthology,* ed. Dennis Doordan (Cambridge: MIT Press, 1995).

15 Ellen Mazur Thomson, *The Origins of Graphic Design in America, 1870–1920* (New Haven and London: Yale University Press, 1997). The section from the book that was published in *Design Issues* was "Alms for Oblivion: The History of Women in Early American Graphic Design," *Design Issues* 10, no. 2 (summer 1994): 27–48.

16 *Design Issues* 11, no. 1 (spring 1995). Scholars contributing to the debate, besides myself and Forty, were Jonathan Woodham, Nigel Whiteley, Alain Findeli, Barbara Stafford, Jeffrey Meikle, and Dennis Doordan.

17 Jonathan Woodham, "Resisting Colonization: Design History Has Its Own Identity," *Design Issues* 11, no. 1 (spring 1995): 22–23.

18 Jeffrey L. Meikle, "Design History for What? Reflections on an Elusive Goal," *Design Issues* 11, no. 1 (spring 1995): 75.

19 Dennis Doordan, "On History," *Design Issues* 11, no. 1 (spring 1995): 81.

20 Alain Findeli, "Design History and Design Studies: Methodological, Epistemological and Pedagogical Inquiry," *Design Issues* 11, no. 1 (spring 1995): 54.

21 Letter to participants from Stephen Mansbach, acting associate dean, CASVA, February 2, 1993.

22 Although the symposium discussions were not recorded, some of the themes found their way into the special number of *Design Issues* on design history.

23 The center has now changed its name to the Bard Graduate Center for Studies in the Decorative Arts, Design, and Culture.

24 *The Bard Graduate Center for Studies in the Decorative Arts: Graduate Degree Programs in the History of the Decorative Arts, Design, and Culture* (New York: Bard Graduate Center for Studies in the Decorative Arts, 1999), 6.

25 Dinitia Smith, "A Private Life, a Public Passion: At Home with Susan Soros," *New York Times,* March 7, 1996, C1, C4.

26 See Pat Kirkham, ed., *Women Designers in the USA, 1900–2000: Diversity and Difference* (New Haven and London: Yale University Press, 2000). Prior to working on the women designers exhibition, Kirkham completed an important book on the Eamses, *Charles and Ray Eames: Designers of the Twentieth Century* (Cambridge: MIT Press, 1995). It is the first to highlight the strong collaborative role of the two rather than feature Charles as had previously been done by Eames scholars.

27 The isolation of graphic design from the rest of design history can be accounted for

by the way that the design professions are segregated from each other. This occurs in the schools, which tend to separate graphic, industrial, and interior design despite the broad interests of designers like Raymond Loewy and Norman Bel Geddes. While someone teaching design history can resist this specialization and offer a survey course that looks at design broadly, history events initiated by the professional associations tend to fall within their own existing boundaries of self-definition. Nonetheless, these events arise from a genuine enthusiasm and usually generate a number of good presentations that evince a passion for the subject as well as draw on untapped documentary material.

28 Condensed versions of some of the presentations from both evenings were later published in the *STA Journal* 1, no. 2 (winter 1980). See Victor Margolin, "Chicago Design," 4–5; Franz Schulze, "The First Wave: Europeanization of American Culture in the 1930's," 6; Joe Hutchcroft, "Walter Paepcke and the Container Design Program," 7–9; and Jay Doblin, "From Bauhaus to Unimark: A Pilgrim's Progress for Design," 10–11.

29 The documentation from the symposium, which consists mainly of some correspondence and audio tapes of the presentations, now resides in the Robert Hunter Middleton Design Printing Collection, Special Collections Department, Richard J. Daley Library, University of Illinois at Chicago.

30 The proceedings were published as *Coming of Age: The First Symposium on the History of Graphic Design* (Rochester: Rochester Institute of Technology, 1985).

31 Massimo Vignelli, "Keynote Address," *Coming of Age,* 11.

32 Dilnot expanded on points made in his two articles on the state of design history, which were published in *Design Issues.* Frances Butler's talk was entitled "Shadow in Popular Visual Arts, Cycles of Imagery," and Hanno Ehses presented "A Semiotic Approach to Design History."

33 Steven Heller, "The History of Graphic Design: Charting a Course," *AIGA Journal of Graphic Design* 3, no. 4 (1985): 1. Among the groups of buffs, one can cite the founders of the Poster Society, an organization that includes designers, dealers, and collectors. The society publishes a journal, and several of its members have been active in publishing and exhibition projects. See Robert K. Brown and Susan Reinhold, *The Poster Art of A. M. Cassandre* (New York: Dutton, 1979). The poster collection of Merrill C. Berman formed the core of the exhibition "The Twentieth-Century Poster: Design of the Avant-Garde" at the Walker Art Center, Minneapolis, in 1984. This show served as an impetus to invite art historians such as Dawn Ades and Alma Law to write scholarly essays on the poster. See the catalog *The 20th Century Poster: Design of the Avant-Garde* (New York: Abbeville, 1984). On a smaller scale, one can cite exhibitions such as *Art Ultra,* an assembly of furniture and decorative arts from 1916 to 1959 at the Hyde Park Art Center in Chicago, which was curated by antique dealer Steve Starr.

A collector was also behind *The Journal of Decorative and Propaganda Arts,* now published in an expensive glossy format by the Wolfsonian in Miami Beach. Including articles by decorative arts scholars such as Gabriel Weisberg, Alastair Duncan, and David Hanks, the journal, which originally stemmed from the collecting interests of Micky Wolfson, is now devoted to the decorative arts and popular material culture in various parts of the world. One thinks, in addition, of journals geared to buffs such as *Automobile Quarterly* and *Art and Antiques,* which often publish well-researched

articles that are useful to the scholar.

34 Heller, "The History of Graphic Design: Charting a Course," 1.

35 Heller is also an active graphic design critic who has written numerous critical reviews of design projects, exhibitions, and designers in *Print*, the British graphic design magazine *Eye*, and elsewhere.

36 Steven Heller and Seymour Chwast, *Graphic Styles: From Victorian to Postmodern* (New York: Harry N. Abrams, 1994); Steven Heller, *Design Literacy: Understanding Graphic Design* (New York: Allworth Press, 1997) and *Design Literacy [Continued]* (New York: Allworth Press, 1999); and Steven Heller and Louise Fili, *Typology: Type Design from the Victorian Era to the Digital Age* (San Francisco: Chronicle Books, 199).

37 Michael Bierut, Jessica Helfand, Steven Heller, and Rick Poynor, eds., *Looking Closer 3: Classic Writings on Graphic Design*, introductions by Steven Heller and Rick Poynor (New York: Allworth Press, 1999). With the exception of Robert Motherwell's *The Dada Painters and Poets: An Anthology* and his editorial involvement with the Documents of Modern Art series, there is no precedent for artistic practitioners taking such an initiative to gather together the important historical documents in their field. Normally this work is done by historians and critics (although Poynor is a critic, the other three editors are working designers or art directors).

38 The Malik Verlag exhibition was held at the Goethe House, New York, in autumn 1984. The Dwiggins show was presented at the New York gallery of the International Typeface Corporation from March 28 to May 16, 1986. It subsequently traveled in a reduced version to the University of Illinois at Chicago, where it was one of the inaugural events for the Robert Hunter Middleton Design Printing Collection.

39 Poster for *Modernism and Eclecticism: The History of American Graphic Design*, 1987.

40 The talk was originally written by Kalman and J. Abbott Miller and then rewritten by Karrie Jacobs before it was presented by Kalman at the symposium. Subsequently it was published in *Print* (March–April 1991) and then in *Tibor Kalman: Perverse Optimist*, ed. Peter Hall and Michael Bierut (London: Booth-Clibborn Editions and New York: Princeton Architectural Press, 1998): 76–81.

41 *Tibor Kalman: Perverse Optimist*, 80.

42 Ibid., 77.

43 In 1993, Meggs curated a retrospective exhibition of work by graphic designer Tomás Gonda at Virginia Commonwealth University's Anderson Gallery. See the catalog written by Meggs, *Tomás Gonda: A Life in Design* (Richmond: Anderson Gallery, 1993).

44 R. Roger Remington and Barbara J. Hodik, *Nine Pioneers in American Graphic Design* (Cambridge and London: MIT Press, 1989); Martha Scotford *Cipe Pineles: A Life in Design* (New York and London: Norton, 1999); R. Roger Remington, *Lester Beall* (New York: Norton, 1996); and Steven Heller, *Paul Rand* (London and New York: Phaidon Press, 1999).

45 Scott has taught graphic design history at the Rhode Island School of Design and at Yale University, where he himself studied. Danziger said of his own lectures, "I was amazed at the hunger that existed for this material, the response to these lectures were [*sic*] unbelievable—clearly there existed a vacuum that needed filling." Letter to the author, August 8, 1987.

46 The series title was Four Decades: The Development of Graphic Design. Besides Yale, the other three participating institutions were Sacred Heart University, the University

of Bridgeport, and the University of Connecticut.

47 *Visible Language* 28, no. 3 (July 1994), part 1: Critiques; *Visible Language* 28, no. 4
 October 1994), part 2: Practices; and *Visible Language* 29, no. 1 (January 1995), part
 3: Interpretations.

48 Andrew Blauvelt, "The Particular Problem of Graphic Design (History)," *Visible Lan-
 guage* 28, no. 3 (July 1994): 211.

49 My contribution to the project, "Narrative Problems of Graphic Design History," is in-
 cluded in this volume in a slightly revised version.

50 This would include books by type designers such as Frederic Goudy, *A Half Century
 of Type Design and Type Making* (New Rochelle: Myriade Press, 1978); Stanley Mori-
 son, *Four Centuries of Fine Printing,* 2d ed. (New York: Farrar, Straus, 1949); and the
 classic study by Daniel Berkeley Updike, *Printing Types, Their History, Forms and
 Use: A Study in Survivals,* 3d ed. (Cambridge: Harvard University Press, 1962).

51 Letter to the author, July 30, 1987. The existence of a collection of William Lescaze
 papers at Syracuse University led architectural and design historian Dennis Doordan,
 then teaching there, to research the design work done by Lescaze for CBS in the
 1930s. This resulted in an exhibition of Lescaze's work at the university's Everson
 Gallery and a symposium entitled "William Lescaze: The Rise of Modem Design in
 America," at which architecture and design historians, including Pulos, came to-
 gether to discuss Lescaze's work. The proceedings were published as a special issue
 of *Syracuse University Library Associates Courrier* 19, no. 1 (spring 1984).

52 Arthur J. Pulos, *American Design Ethic: A History of Industrial Design to 1940* (Cam-
 bridge: MIT Press, 1983) and *American Design Adventure* (Cambridge: MIT Press,
 1988). More recently, another survey of American industrial design, *American De-
 sign in the Twentieth Century: Personality and Performance* (Manchester and New
 York: Manchester University Press, 1998) was published by Gregory Votolato, and
 Jeffrey Meikle is preparing a volume on design in the U.S.A. for the Oxford History of
 Art series.

53 See John Heskett's review in *Design Issues* 1, no. 1 (spring 1984): 79–82.

54 In a letter to the author, January 28, 1985, Deane Richardson, chairman of Worlde-
 sign '85, the ICSID Congress organized in Washington, D.C., by the Industrial De-
 signers Society of America, wrote in response to my proposal for a design history
 session: "The emphasis [of the Congress] is on who we are today and what we need
 to be tomorrow. Even though history is the foundation of 'how we evolved,' the Pro-
 gram Committee cannot muster enough interest and support to include it in this
 Congress."

55 In 1981, historian John Pile launched a design history series in *ID* with an article that
 attempted to define some boundaries for design history in terms of subject matter
 and time span. Pile justified design history, in part, as necessary for cultural literacy.
 "Everyone knows who painted the Mona Lisa," he wrote, "and many people know
 who designed the Guggenheim Museum . . . Awareness of who might have designed
 a particular chair, typewriter, or automobile is much more rare—and try asking any
 stranger to identify Egmont Arens, Eliot Noyes, or Dieter Rams." John Pile, "Design
 History: Interest in Design's Past Shows Designer's Maturity," *ID* 28, no. 5 (Septem-
 ber–October 1981): 22. Michael Kimmelman was listed on the masthead as history
 series editor from January to October 1983, and Arthur Pulos was history editor from

November 1983 to August 1984. The editors called on historians such as Lorraine Wild, Penny Sparke, Catherine L. McDermott, Jeffrey Meikle, Karen Davies, and Richard Horn to write a series of short articles on topics ranging from modern American graphics to Wedgwood pottery. These were popular summaries rather than research pieces.

56 This is a result of the current significance of historical reference in architectural design as well as of opportunities for architects to broaden their commissions to include furniture as well as dinnerware and other decorative objects. Robert Venturi's chairs for Knoll parody historical styles, while Richard Meier made strong reference to a Kazimir Malevich teapot and chairs by Charles Rennie Mackintosh and Josef Hoffmann in some of his designs.

57 Jim Lesko, "Industrial Design at Carnegie Institute of Technology, 1934–1967," *Journal of Design History* 10, no. 3 (1997): 269–292. One of Lesko's discoveries was that the first American to receive a BA in industrial design was a woman, Maud Bowers, who graduated from CIT in 1936.

58 E-mail communication from Kristina Goodrich, IDSA executive director, January 5, 2000.

59 "IDSA's History and Archive Committee," document prepared for a meeting at the Hagley Museum and Library, May 1991.

60 The American Center for Design developed out of the Society of Typographic Arts, which transformed itself in 1989 into the new organization in order to reach a broader range of design professionals.

61 The American Center for Design published a version of Stafford's address as "The New Imagist: Expert without Qualities," *Statements: American Center for Design* 11, no. 2 (1996): 8–12.

62 Ibid., 8.

63 My talk was published as "Teaching Design History," along with Barbara Stafford's essay, in *Statements: American Center for Design* 11, no. 2 (1996): 5–7.

64 An early sign of change in art history can be seen in *Art Journal* 42, no. 4 (winter 1982), a special issue entitled "The Crisis in the Discipline."

65 See, as examples, the articles published in *Art Bulletin* in the late 1980s on the state of research. These include Donald Kuspit, "Conflicting Logics: Twentieth-Century Studies at the Crossroads," *Art Bulletin* 69, no. 1 (March 1987): 117–32; Barbara Stafford, "The Eighteenth Century: Towards an Interdisciplinary Model," *Art Bulletin* 70, no. 1 (March 1988): 6–24; Richard Schiff, "Art History and the Nineteenth Century: Realism and Resistance," *Art Bulletin* 70, no. 1 (March 1988): 25–48; Jack Spector, "The State of Psychoanalytic Research in Art History," *Art Bulletin* 70, no. 1 (March 1988): 49–76; Herbert L. Kessler, "On the State of Medieval Art," *Art Bulletin* 70, no. 2 (June 1988): 166–187; Wanda Korn, "Coming of Age: Historical Scholarship in American Art," *Art Bulletin* 70, no. 2 (June 1988): 188–207; and Marvin Trachtenberg, "Some Observations on Recent Architectural History," *Art Bulletin* 70, no. 2 (June 1988): 208–241.

66 Donald Bush, *The Streamlined Decade* (New York: G. Braziller, 1975).

67 Letter to the author, July 7, 1987.

68 Dolores Hayden, *The Grand Domestic Revolution: A History of Feminist Designs for American Homes, Neighborhoods, and Cities* (Cambridge: MIT Press, 1981).

69 Collins published an article based on his dissertation in *Design Issues* entitled "The Poster as Art; Jules Chéret and the Struggle for the Equality of the Arts in Late Nineteenth-Century France," *Design Issues* 2, no. 1 (spring 1985): 41–50 and reprinted in Doordan, *Design History: An Anthology*, 17–27.

70 Michele H. Bogart, *Artists, Advertising, and the Borders of Art* (Chicago and London: University of Chicago Press, 1995).

71 Frederic J. Schwartz, *The Werkbund: Design Theory & Mass Culture before the First World War* (New Haven and London: Yale University Press, 1996).

72 Edson Armi, *The Art of American Car Design: The Profession and the Personalities* (University Park and London: Penn State University Press, 1988). Armi's previous work had been in medieval art. As far as I know, this was his only foray into design history.

73 See Deborah Dietsch, "Lilly Reich," in the special issue of *Heresies*, "Making Room: Women and Architecture," *Heresies* 11, vol. 3, no. 3 (1981): 73–76; Matilda McQuaid, ed., *Lilly Reich: Designer and Architect* (New York: Museum of Modern Art, 1996); and Esther da Costa Meyer, "Cruel Metonymies: Lilly Reich's Designs for the 1937 World's Fair," *New German Critique* no. 76 (winter 1999): 161–189.

74 See Philip Garner, ed., *The Encyclopedia of Decorative Arts, 1890–1940* (New York: Galahad Books, 1978) and *Contemporary Decorative Arts from 1940 to the Present* (New York: Facts of File, 1980); and Bevis Hillier, *The Decorative Arts of the Forties and Fifties: Austerity Binge* (New York: Clarkson Potter, 1975). I discussed the relation of decorative arts to design in my article, "From the History of Decorative Arts to the History of Design: Some Problems of Documentation," *Art Libraries Journal* 10, no. 4 (winter 1985): 24–36.

75 See the catalog, *At Home in Manhattan: Modern Decorative Arts, 1925 to the Depression* (New Haven: Yale University Art Gallery, 1983).

76 In 1978 the society, in conjunction with the Victorian Society in America, sponsored a symposium on nineteenth-century furniture, which was organized by Kenneth Ames, a material culture historian. The proceedings, entitled "Victorian Furniture: Essays from a Victorian Society Autumn Symposium," were published as a special issue of *Nineteenth Century* 8, nos. 3–4 (1982).

77 Cooper Hewitt, National Design Museum, www.si.edu/ndm/100/resources/masters.htm.

78 Among the articles included in the issue are Ella Howard, "Feminist Writings on Twentieth Century Design History, 1970–1995: Furniture, Interiors, Fashion"; Ann E. Komara, "The Glass Wall: Gendering the American Society of Landscape Architects"; Ashley Brown, "Ilonka Karasz: Rediscovering a Modernist Pioneer"; and Stephanie Iverson, "'Early' Bonnie Cashin, before Bonnie Cashin Designs, Inc."

79 Marcia Pointon, cited in Malcolm Barnard, *Art, Design and Visual Culture* (New York: St. Martin's Press, 1998), 19. The quote is from Pointon's *History of Art: A Student Handbook*, 3d ed. (London: Routledge, 1994).

80 Renée Weber, "Doctoral Research in Printing History, 1970–1984," *Printing History* 7, no. 2 (1985): 17. Only a portion of the topics listed in Weber's survey are concerned with the design and printing of books. Other subjects include the book trade, libraries, and preservation. The listed dissertations were written in various academic departments and professional schools, notably art history, Oriental studies, and

 library science.

81 Susan Otis Thompson, Editorial, *Printing History* 1, no. 1 (1979): 3.

82 Ibid.

83 See, for example, Gordon B. Neavill, "The Modern Library Series: Format and Design,
 1917–1977," *Printing History* 1, no. 1 (1977): 26–37.

84 G. Thomas Tanselle, "Thoughts on Research in Printing History," *Printing History* 9,
 no. 2 (1987): 24.

85 *RHM: Robert Hunter Middleton, the Man and His Letters: Eight Essays on His Life and
 Career* (Chicago: Caxton Club, 1985).

86 *Chicago under Wraps: Dust Jackets from 1920 to 1950. Essay by Victor Margolin*
 (Chicago: Caxton Club, 1999).

87 The term "paradigm drama" was coined by Gene Wise. See his article, "'Paradigm Dra-
 mas' in American Studies: A Cultural and Institutional History of the Movement,"
 American Quarterly 31, no. 3 (1979): 293–320.

88 Ibid., 306–307.

89 Jeffrey L. Meikle, *Twentieth Century Limited: Industrial Design in America, 1925–1939*
 (Philadelphia: Temple University Press, 1979). The book was included in Temple's
 American Civilization series.

90 Jeffrey L. Meikle, letter to the author, June 25, 1987.

91 Unlike other scholars who have done research on design-related topics, Meikle has
 taken an interest in design history's development, even though his academic ap-
 pointment is not as a design historian. He has reviewed books and design exhibi-
 tions for *Design Issues* and the *Design History Society Newsletter*, and his survey
 essay on the literature on American design history and related topics is a useful con-
 tribution to the field. See "American Design History: A Bibliography of Sources and
 Interpretations, *American Studies International* 23, no. 1 (April 1985): 3–40.

92 See Jeffrey L. Meikle, *America Plastics: A Cultural History* (New Brunswick: Rutgers
 University Press, 1995).

93 Jeffrey L. Meikle, "Material Virtues: On the Ideal and the Real in Design History," *Jour-
 nal of Design History* 11, no. 3 (1998): 191–200; and "A Paper Atlantis: Postcards,
 Mass Art, and the American Scene [The Eleventh Rayner Banham Memorial Lecture],"
 Journal of Design History 13, no. 4 (2000): 267–286.

94 Eileen Boris, *Art and Labor: Ruskin, Morris, and the Craftsman Ideal in America*
 (Philadelphia: Temple University Press, 1986). Like *Twentieth Century Limited,* Boris's
 book was also included in Temple's American Civilization series.

95 Boris, *Art and Labor*, xvii.

96 See Alan Trachtenberg, *The Incorporation of America: Culture and Society in the
 Gilded Age* (New York: Hill and Wang, 1982). On modernism, see "Modernist Culture
 in America," a special issue of *American Quarterly* 39, no. 1 (spring 1987). Antimod-
 ernism has been studied by T. J. Jackson Lears in his book *No Place of Grace: Anti-
 modernism and the Transformation of American Culture, 1880–1920* (New York:
 Pantheon, 1981).

97 Jeffrey L. Meikle, "Comments," conference paper presented at the ASA meeting, New
 York, November 22, 1987.

98 Thomas J. Schlereth, "Material Culture and Cultural Research," in Schlereth, ed., *Ma-
 terial Culture: A Research Guide* (Lawrence: University Press of Kansas, 1985).

99 For an exhaustive historical survey of material culture studies, see Thomas J. Schlereth, "Material Culture Studies in America, 1876–1976," in Schlereth, *Material Culture Studies in America*,1–78. The Schlereth essay was the model for my original 1987 survey of American design history.

100 See Simon Bronner, ed., *American Material Culture and Folklife: A Prologue and Dialogue* (Ann Arbor: UMI Research Press, 1985); and Bronner, *Grasping Things: Folk Material Culture and Mass Society in America* (Lexington: University Press of Kentucky, 1986). See also Thomas J. Schlereth, "Social History Scholarship and Material Culture Research," in Schlereth, *Material Culture: A Research Guide*,155–196.

101 Besides training MA and PhD students, the Winterthur Museum offers fellowships and other opportunities for visiting scholars. As well, it organizes regular conferences that consider American furniture and related objects from a material culture perspective.

102 Ames is a good example of how material culture research ties in to American studies as well as popular culture. His essays have appeared in the publications of all three fields. See Kenneth Ames, "The Battle of the Sideboards," *Winterthur Portfolio* 9 (1974): 1–27; "Grand Rapids Furniture at the Time of the Centennial," *Winterthur Portfolio* 10 (1975): 25–50; and "Material Culture and Non-Verbal Communication," *Journal of American Culture* 3, no. 4 (winter 1980): 619–641. Ames has also done an excellent survey of the research on American furniture since 1970. See his essay "The Stuff of Everyday Life: American Decorative Arts and Household Furnishings," in Schlereth, *Material Culture: A Research Guide,* 79–112. A number of his essays have been collected in the volume *Death in the Dining Room and Other Tales of Victorian Culture* (Philadelphia: Temple University Press, 1992).

103 See Michael Ettema, "Technological Innovation and Design Economics in Furniture Manufacture," *Winterthur Portfolio* 16, no. 3 (summer–fall 1981): 197–223.

104 Douglas N. Lantry, "Man in Machine: Apollo-Era Space Suits as Artifacts of Technology and Culture," *Winterthur Portfolio* 30, no. 4 (winter 1995): 203–230. Other twentieth-century articles include Richard Striner's "Art Deco: Polemics and Synthesis," *Winterthur Portfolio* 25, no. 1 (spring 1990).

105 Papers from the 1975 conference were published in Ian M. G. Quimby, ed., *Material Culture and the Study of American Life* (New York: Norton, 1978).

106 Ann Smart Martin and J. Ritchie Garrison, "Shaping the Field: The Multidisciplinary Perspective of Material Culture," in *American Culture: The Shape of the Field*, eds. Ann Smart Martin and J. Ritchie Garrison (Winterthur, Del.: Henry Francis du Pont Winterthur Museum, 1997), 13.

107 See, for example, Regina Lee Blaszcyzk, "The Aesthetic Moment: China Decorators, Consumer Demand, and Technological Change in the American Pottery Industry, 1865–1900," *Winterthur Portfolio* 29, nos. 2–3 (summer–autumn 1994): 103–120; and the special issue "Gendered Spaces and Aesthetics," guest edited by Katherine C. Grier, *Winterthur Portfolio* 31, no. 4 (winter 1996).

108 Katharine Martinez and Kenneth L. Ames, eds., *The Material Culture of Gender: The Gender of Material Culture* (Winterthur, Del.: Henry Francis du Pont Winterthur Museum, 1997).

109 John Michael Vlach, "Studying African American Artifacts," *Winterthur Portfolio* 33, no. 4 (winter 1998): 211. Vlach's essay appeared in a special issue of the journal

entitled "Race and Ethnicity in American Material Life," which also included Jonathan Prown's "The Furniture of Thomas Day: A Reevaluation," and Theodore C. Landsmark's "Comments on African American Contributions to American Material Life."

110 *Winterthur Portfolio* 33, no. 4 (winter 1998): 212.

111 Steven Lubar and W. David Kingery, introduction to *History from Things: Essays on Material Culture,* eds. Steven Lubar and W. David Kingery (Washington and London: Smithsonian Institution Press, 1993), xvii.

112 W. David Kingery edited the volume of conference papers, *Learning from Things: Method and Theory of Material Culture Studies* (Washington, D.C., and London: Smithsonian Institution Press, 1996).

113 Bruce A. Lohof, cited in Donald Dunlop, "Popular Culture and Methodology," *Journal of Popular Culture* 9, no. 2 (fall 1975): 375.

114 See Marshall Fishwick and Ray B. Browne, eds., *Icons of Popular Culture* (Bowling Green: Bowling Green University Popular Press, 1970). In a brief essay on icons, Fishwick stated that "[a] Cadillac and a Volkswagen are both assemblages of steel, glass, and rubber, but they are much more. People who sell, see, and own them know this. They are icons. The very words 'Cadillac' and 'Volkswagen' signify two different lifestyles." See Marshall Fishwick, *Parameters of Popular Culture* (Bowling Green: Bowling Green University Popular Press, 1974), 52. The icon essay was updated and retitled "Eikons" in Fishwick's *Seven Pillars of Popular Culture* (Westport, Conn.: Greenwood Press, 1985), 131–53. See also Bruce G. Vanden Bergh, "Volkswagen as 'Little Man,'" *Journal of American Culture* 15, no. 4 (winter 1992): 95–120.

115 Wise, "'Paradigm Dramas,'" 316.

116 For a history of the popular culture movement, see Ray B. Browne, *Against Academia: The History of the Popular Culture Association/American Culture Association and the Popular Culture Movement, 1967–1988* (Bowling Green: Bowling Green State University Popular Press, 1989).

117 See Diane M. Douglas, "The Machine in the Parlor: A Dialectical Analysis of the Sewing Machine," *Journal of American Culture* 5, no. 1 (spring 1982): 20–29. Douglas's thesis that the sewing machine became a focal point in debates about women's social roles in the nineteenth century can be related to the later discussions about electrical appliances and the transformation of housework in the twentieth century raised by Ruth Schwartz Cowan and other authors in *Technology and Culture.* Additional design-related articles in the *Journal of American Culture* include James J. Best, "The Brandywine School and Magazine Illustration: Harper's, Scribner's and Century, 1906–1910," *Journal of American Culture* 3, no. 1 (spring 1980): 128–144; Bettina Berch "Scientific Management in the Home: The Empress's New Clothes," *Journal of American Culture* 3, no. 3 (fall 1980): 440–445; Jean Gordon and Jan McArthur, "American Women and Domestic Consumption: Four Interpretive Themes," *Journal of American Culture* 8, no. 3 (fall 1985): 35–46; Bridget A. May, "Advice on White: An Anthology of Nineteenth-Century Design Critics' Recommendations," *Journal of American Culture* 16, no. 4 (winter 1993): 19–24; and Richard Martin, "American Chronicle: J. C. Leyendecker's Icons of Time," *Journal of American Culture* 19, no. 1 (spring 1996): 57–86, and "The Great War and the Great Image: J. C. Leyendecker's World War I Covers for *The Saturday Evening Post*," *Journal of American Culture* 20, no. 1 (spring 1997): 55–74.

118 It is no coincidence that many popular culture historians were trained as English professors.

119 See, for example, Ann Uhry Abrams, "From Simplicity to Sensation: Art in American Advertising, 1904–1929," *Journal of Popular Culture* 10, no. 3 (1977): 620–628; Marianne Doezema, "The Clean Machine: Technology in American Magazine Illustration," *Journal of Popular Culture* 11, no. 4 (winter 1988): 78–92; Richard Martin, "Gay Blades: Homoerotic Content in J. C. Leyendecker's Gillette Advertising Images," *Journal of Popular Culture* 18, no. 2 (summer 1995): 75–82; and Thomas Beckman, "Japanese Influences on American Advertising Card Imagery and Design," *Journal of Popular Culture* 19, no. 1 (spring 1996): 7–20.

120 For an account of SHOT's founding, see Melvin Kranzberg and William H. Davenport, "Introduction: At the Start" in *Technology and Culture*, eds. Melvin Kranzberg and William H. Davenport (New York: Schocken Books, 1972), 9–20.

121 See, for example, Michael Brian Schiffer, "Cultural Imperatives and Product Development: The Case of the Shirt-Pocket Radio," *Technology and Culture* 34, no. 1 (January 1993): 98–113; Regina Lee Blaszczyk, "'Reign of the Robots': The Homer Laughlin China Company and Flexible Mass Production," *Technology and Culture* 36, no. 4 (October 1995): 863–912; and David McGee, "From Craftsmanship to Draftsmanship: Naval Architecture and the Three Traditions of Early Modern Design," *Technology and Culture* 40, no. 2 (April 1999): 209–236. See also the review essay by John Staudenmaier and Pamela Walker Lurito Laird, "Advertising History," *Technology and Culture* 30, no. 4 (October 1989): 1031–1036. This essay features Roland Marchand's *Advertising the American Dream: Making Way for Modernity, 1920–1940*, a book also much admired by design historians.

122 Thomas P. Hughes, "Emerging Themes in the History of Technology," *Technology and Culture* 20, no. 4 (October 1979): 707. Hughes envisions the possibility of this concept constraining research as well.

123 See, for example, Robert S. Woodbury, "The Legend of Eli Whitney and Interchangeable Parts," *Technology and Culture* 1, no. 3 (summer 1960): 23–54; and Russell I. Fries, "British Response to the American System: The Case of the Small Arms Industry after 1850," *Technology and Culture* 16, no. 3 (July 1975): 377–403.

124 Merritt Roe Smith, *Harpers Ferry Armory and the New Technology: The Challenge of Change* (Ithaca: Cornell University Press, 1977). The fact that Smith's book was awarded the Fredrick Jackson Turner Prize by the Organization of American Historians was seen by historians of technology as a breakthrough in the scholarly acceptance of their field.

125 Ruth Schwartz Cowan, "The 'Industrial Revolution' in the Home: Household Technology and Social Change in the Twentieth Century," *Technology and Culture* 17, no. 1 (January 1976): 1–23. Cowan's article was also defined by Thomas Schlereth, a historian of American culture, as a progressive example of material culture research that sought to link the study of artifacts with the emerging interest of social historians in the histories of women and the family. Schlereth included it in his anthology, *Material Culture Studies in America* (Nashville: American Association for State and Local History, 1982). In addition, Cowan has published in the women's studies literature, thus linking her research on women and household technology to a larger process of rethinking the study of women in American society. See her article on the effects of

the washing machine on working women, "A Case Study of Technical and Sociological Change" in *Clio's Consciousness Raised: New Perspectives on the History of Women*, eds. Mary S. Hartman and Lois Banner (New York: Octagon Books, 1976): 245–253. Cowan's most comprehensive work on household technology is *More Work for Mother: The Ironies of Household Technology From Open Hearth to the Microwave* (New York: Basic Books, 1983). Another book that deals with household technology and women's role in the home is Susan Strasser, *Never Done: A History of American Housework* (New York: Pantheon, 1982). See also selected articles in Joan Rothschild's *Machina ex Dea: Feminist Perspectives on Technology* (New York and Oxford: Pergamon Press, 1983) and *Dynamos and Virgins Revisited: Women and Technological Change in History*, ed. Martha Moore Trescott (Metuchen, N.J.: Scarecrow Press, 1979).

126 See Joan Vanek, "Household Technology and Social Status: Rising Living Standards and Status and Residence Differences in Housework," *Technology and Culture* 19, no. 3 (July 1978): 361–375; Jane Busch, "Cooking Competition: Technology on the Domestic Market in the 1930s," *Technology and Culture* 24, no. 2 (April 1983): 222–245; and Christine Bose, Philip Bereano, and Mary Malloy, "Household Technology and the Social Construction of Housework," *Technology and Culture* 25, no. 1 (January 1984): 53–82.

127 See John S. Staudenmaier, "What SHOT Hath Wrought and What SHOT Hath Not: Reflections of Twenty-five Years of the History of Technology," *Technology and Culture* 25, no. 4 (October 1984): 707–730. Staudenmaier's article summarizes some of the material in his book-length study of SHOT and its journal, *Technology's Storytellers: Reweaving the Human Fabric* (Cambridge: MIT Press, 1985).

128 Nina E. Lerman, Arwen Palmer Mohun, and Ruth Oldenziel, "Versatile Tools: Gender Analysis and the History of Technology," *Technology and Culture* 38, no. 1 (January 1997): 21.

129 Ibid., 22.

130 Ibid.

131 Besides the previously cited article by Staudenmaier, see Eugene S. Ferguson, "Toward a Discipline of the History of Technology," *Technology and Culture* 15, no. 1 (January 1974): 13–30.

132 Ruth Schwartz Cowan, *A Social History of American Technology* (New York and Oxford: Oxford University Press, 1997), 3.

133 Joan Rothschild, introduction to *Design and Feminism: Re-Visioning Spaces, Places, and Everyday Things*, ed. Joan Rothschild with the assistance of Alethea Chang, Etain Fitzpatrick, Maggie Mahboubian, Francine Monaco, and Victoria Rosner (New Brunswick and London: Rutgers University Press, 1999), 2–3.

134 Barry M. Katz, "Review Essay: Technology and Design—a New Agenda," *Technology and Culture* 38, no. 2 (April 1997): 453. The four books under review were Victor Margolin, ed., *Design Discourse: History Theory Criticism*; Richard Buchanan and Victor Margolin, eds., *Discovering Design: Explorations in Design Studies*; Victor Margolin and Richard Buchanan, eds., *The Idea of Design*; and Dennis Doordan, ed., *Design History: An Anthology*. All except *Discovering Design* were anthologies of articles from *Design Issues*.

135 Katz, "Review Essay," 466.

136 For an account of this turn, see Peter N. Stearns, "The New Social History: An Overview," in *Ordinary People and Everyday Life*, eds. James B. Gardner and George Rollie Adams (Nashville: American Association for State and Local History, 1983), 3–21.

137 Susan E. Hirsch, *Roots of the American Working Class: The Industrialization of Crafts in Newark, 1800–1860* (Philadelphia: University of Pennsylvania Press, 1978).

138 Lizabeth A. Cohen, "Embellishing a Life of Labor: An Interpretation of the Material Culture of American Working-Class Homes, 1885–1915," in Schlereth, *Material Culture Studies in America*, 289–305. Cohen's article originally appeared in the *Journal of American Culture* 3, no. 4 (winter 1980): 752–775. Though it complements the interest of labor historians in American working-class culture, it was first published in a journal that was intended to challenge the dominant approaches in American studies and was then anthologized as an example of material culture research.

139 Shulamit Volkov, *The Rise of Popular Antimodernism in Germany: The Urban Master Artisans, 1873–1896* (Princeton: Princeton University Press, 1978).

140 Volkov, *The Rise of Popular Antimodernism in Germany*, 4.

141 Joan Campbell, *The German Werkbund: The Politics of Reform in the Applied Arts* (Princeton: Princeton University Press, 1978).

142 Peter Stansky, *Redesigning the World: William Morris, the 1880s, and the Arts and Crafts* (Princeton: Princeton University Press, 1985).

143 See Michael B. Miller, *The Bon Marché: Bourgeois Culture and the Department Store, 1869–1920* (Princeton: Princeton University Press, 1981); and Rosalind H. Williams, *Dream Worlds: Mass Consumption in Late 19th Century France* (Berkeley: University of California Press, 1982).

144 See Deborah Silverman, "Nature, Nobility, and Neurology: The Ideological Origins of Art Nouveau in France, 1889–1900" (Ph.D. diss., Princeton University, 1983). The book based on her dissertation, *Art Nouveau in Fin-de-Siècle France: Politics, Psychology, and Style* (Berkeley: University of California Press, 1989), is a welcome antidote to the stylistic studies of art nouveau that have dominated the design history literature for many years.

145 Roland Marchand, *Advertising the American Dream: Making Way for Modernity, 1920–1940* (Berkeley: University of California Press, 1985). See the favorable review of Marchand's book by Jeffrey Meikle in *Design Issues* 3, no. 1 (spring 1986): 85–86. Meikle stated that the book "may be the single most important historical study of American mass culture between the world wars." For an earlier study of how advertising was designed to shape American values, see Stuart Ewen, *Captains of Consciousness: Advertising and the Social Roots of the Consumer Culture* (New York: McGraw-Hill, 1976). See also Stuart and Elizabeth Ewen, *Channels of Desire: Mass Images and the Shaping of American Consciousness* (New York: McGraw-Hill, 1982).

146 The history of consumption is the central topic of the anthology *The Culture of Consumption: Cultural Essays in American History*, eds. Richard Wightman Fox and T. J. Jackson Lears (New York: Pantheon, 1983). The relation of photographic images to consumer attitudes has been discussed by Sally Stein in "The Composite Photographic Image and the Composition of Consumer Ideology," *Art Journal* 41, no. 1 (spring 1981): 39–45.

147 In his chapter on American world's fairs, Marchand devoted considerable attention to

the role of industrial designers such as Walter Dorwin Teague and Norman Bel Geddes in creating corporate exhibits. Two articles based on the research for this chapter appeared in *Design Issues*: Roland Marchand, "Part 1—The Designers Go to the Fair: Walter Dorwin Teague and the Professionalization of Corporate Industrial Exhibits, 1933–1940," *Design Issues* 8, no. 1 (fall 1991): 4–17; and "Part II—The Designers Go to the Fair: Norman Bel Geddes, the General Motors 'Futurama,' and the Visit to the Factory Transformed," *Design Issues* 8, no. 2 (spring 1992): 23–40. Both subsequently appeared in Dennis Doordan, ed., *Design History: An Anthology [A Design Issues Reader]* (Cambridge: MIT Press, 1995).

148 Betts subsequently published some material from his dissertation in a *Design Issues* article, "Science, Semiotics, and Society: The Ulm Hochschule für Gestaltung in Retrospect," *Design Issues* 14, no. 2 (summer 1998): 67–82.

149 Jeffrey L. Meikle, "Introduction," *Journal of Design History* 12, no. 1 (1999): 3.

150 For a discussion of the situation for graphic design, see Allon Schoener, "Are the Documents of Graphic Design Being Saved?" *AIGA Journal of Graphic Design* 3, no. 4 (1985): 2–3, 12.

151 The Library of Congress received a grant of $500,000 from IBM, a principal client of Charles and Ray Eames, to process their material and prepare a catalog for a major exhibition of their work.

152 The Vitra Design Museum organized the exhibition's European venues and the catalog, *The Work of Charles and Ray Eames*, which accompanied showings on both sides of the Atlantic. Before opening in Washington, the exhibition was seen at the Design Museum in London. It was reviewed by Nicholas Maffei in *Design Issues* 15, no. 1 (spring 1999): 75–79. Maffei is a former MA student of Jeffrey Meikle's in American studies at the University of Texas, Austin, and is currently completing a doctorate in design history at the Royal College of Art in London and teaching the history of technology there.

153 Remington has generated a number of projects from the archive including several books; the Graphic Design Archive on Laserdisc, which has 31,000 frames of archival graphic design images; Design Archives Online, composed of two on-line modules that support design history courses at RIT; and 20th Century Information Design, a distance learning course featuring the work of Will Burtin.

154 See Gretchen Lagana, "Collecting Design Resources at the University of Illinois at Chicago," *Design Issues* 3, no. 2 (fall 1986): 37–46.

155 For a collection of essays by Lupton and J. Abbott Miller on critical and historical themes related to graphic design, see Ellen Lupton and J. Abbott Miller, *Design Writing Research: Writings on Graphic Design* (New York: Princeton Architectural Press, 1996).

156 See Lupton's catalogs, *Period Styles: A History of Punctuation* (New York: Herb Lubalin Study Center of Design and Typography, 1988); *Writing & the Body*, Writing/Culture, 3 (New York: Herb Lubalin Study Center of Design and Typography, 1990); and *the abc's of triangle square circle: the bauhaus and design theory* (New York: Herb Lubalin Center of Design and Typography, 1991). To accompany the Bauhaus exhibition, Lupton organized a symposium entitled, "The Bauhaus and Design Culture: Legacies of Modernism," which was held at the Cooper Union on April 20, 1991. Speakers included Maud Lavin, Rosemarie Bletter, Mike Mills, and myself.

157 The exhibition policy has continued under current curator Lawrence Mirsky.

158 William Bevington, *National Graphic Design Archive: An Overview of the NGDA* (New York: Cooper Union, 1994).

159 In 1991, the company opened a Motorola Gallery in Beijing and subsequently created a series of portable photo exhibits. Sharon Darling is currently working on a proposal to reinvent the Motorola Museum as the Global Futures Forum.

160 See Steven Heller's interview, "Merrill C. Berman, Design Collector," *Print* 53, no. 6 (November/December 1999): 40B, 191–192.

161 See the catalog, *Graphic Design in the Mechanical Age: Selections from the Merrill C. Berman Collection with Essays by Maud Lavin, Deborah Rothschild, Ellen Lupton, and Darra Goldstein* (New Haven and London: Yale University Press in conjunction with Williams College Museum of Art, Cooper-Hewitt, National Design Museum; and Smithsonian Institution, 1998).

162 Within the past ten years, a number of museums have hired design curators. Cara McCarty went from the design department of the MOMA to the St. Louis Museum of Art, Craig Miller left the department of decorative arts at the Metropolitan Museum of Art to become the design curator at the Denver Museum of Art, and critic Aaron Betsky was hired as curator of architecture and design at the San Francisco Museum of Modern Art.

163 See Kathryn B. Hiesinger and George Marcus, eds., *Design since 1945* (Philadelphia: Philadelphia Museum of Art, 1983). The decorative arts framework of the exhibition was noted by Charles H. Carpenter Jr. in "The Way We Were: An Exhibition Review," *Winterthur Portfolio* 20, no. 1 (spring 1985): 71–80.

164 See the exhibition's catalog, *Japanese Design: A Survey of Design since 1950,* by Kathryn B. Hiesinger and Felice Fisher (Philadelphia: Philadelphia Museum of Art, 1994). See also the review essay on the exhibition and catalog by Andrew Pekarik in *Design Issues* 11, no. 2 (summer 1995): 71–84.

165 See, for example, the catalogs *Marcel Breuer: Furniture and Interiors* by Christopher Wilk (New York: Museum of Modern Art, 1981); Stewart Wrede, *The Modern Poster* (New York: Museum of Modern Art, 1988); and Magdalena Dabrowski, Leah Dickerman, and Peter Galassi, *Aleksandr Rodchenko,* with essays by Aleksandr Lavrent'ev and Varvara Stepanova (New York: Museum of Modern Art, 1998).

166 See the catalog *High Styles: Twentieth Century American Design* (New York: Whitney Museum of American Art/Summit Books, 1985).

167 The curators were David Hanks (1900–1915), David Gebhard (1915–1930), Rosemarie Haag Bletter (1930–1945), Esther McCoy (1945–1960), Martin Filler (1960–1975), and Lisa Phillips (1975–1985).

168 Curiously enough, while beautiful objects are being celebrated in large, heavily publicized museum shows, many historians and critics of contemporary art, influenced by the continental theories of Roland Barthes, Jean Baudrillard, and others, take a critical view of the role mass-produced objects and images play in contemporary culture. See, for example, Peter D'Agostino and Antonio Muntadas, eds., *The Unnecessary Image* (New York: Tanam Press, 1982) and the exhibition catalog *Damaged Goods: Desire and the Economy of the Object* (New York: New Museum of Contemporary Art, 1986).

169 See the catalogs *Design in America: The Cranbrook Vision, 1925–1950* (New York: Abrams, 1983); and Richard Guy Wilson, Dianne Pilgrim, and Dikran Tasjian, *The*

Machine Age in America, 1918–1941 (New York: Harry N. Abrams, 1986).

170 See the catalog *"The Art That Is Life": The Arts & Crafts Movement in America, 1875–1920*, ed. Wendy Kaplan (Boston: New York Graphic Society, 1987).

171 See the catalog by Sharon Darling, *Chicago Furniture: Art, Craft & Industry, 1833–1983* (New York: Norton, 1984).

172 This quote is taken from the explanatory material on the museum's Web page.

173 For extended reviews of the three exhibits, see Charles K. Hyde, "'The Automobile in American Life,' an Exhibit at the Henry Ford Museum, Dearborn, Michigan," *Technology and Culture* 30, no. 1 (January 1989): 105–111; Jane Webb Smith, "Streamlining with Friction: An Exhibition Review," *Winterthur Portfolio* 25, no. 1 (spring 1990): 55–66; and Larry Lankton, "'Made in America' at the Henry Ford Museum," *Technology and Culture* 35, no. 2 (April 1994): 389–395.

174 See the catalog by Katherine C. Grier, *Culture & Comfort: People, Parlors, and Upholstery, 1850–1930* (Washington: Smithsonian Institution Press, 1988).

175 See the catalogs, *Vienna Moderne, 1898–1918* (Houston: Sarah Campbell Blaffer Gallery, 1978); and David McFadden, ed., *Scandinavian Modern Design, 1880–1980* (New York: Harry N. Abrams, 1982).

176 See the catalog, *Mechanical Brides: Women and Machines from Home to Office* (New York: Cooper-Hewitt, National Design Museum, Smithsonian Institution, and Princeton Architectural Press, 1993) along with the review of the exhibition by Susan Sellers, "Mechanical Brides: The Exhibition," *Design Issues* 10, no. 2 (summer 1994): 69–79 and the review of the catalog by Helen Searing, *Design Issues* 10, no. 2 (summer 1994): 80–83.

177 See the catalog, *The Bathroom, the Kitchen, and the Aesthetics of Waste: A Process of Elimination* (Cambridge: MIT List Visual Art Center, 1992). For an extensive review of the exhibition, see Annmarie Adams, "Waste Not, Want Not: An Exhibition Review," *Winterthur Portfolio* 27, no. 1 (spring 1992): 75–82.

178 See Ellen Lupton and Elaine Lustig Cohen, *Letters from the Avant-Garde: Modern Graphic Design* (New York: Cooper-Hewitt, National Design Museum, Smithsonian Institution, and Princeton Architectural Press, 1996); and *Mixing Messages: Graphic Design in Contemporary Culture* (New York: Cooper-Hewitt, National Design Museum, Smithsonian Institution, and Princeton Architectural Press, 1996).

179 See the catalog by Russell Flinchum, *Henry Dreyfuss; Industrial Designer: The Man in the Brown Suit* (New York: Cooper-Hewitt, National Design Museum, Smithsonian Institution, and Rizzoli, 1997).

180 See the catalog by William J. Hennessey, *Russel Wright: American Designer* (Cambridge: MIT Press, 1983).

181 See the catalogs *Finnish Modern Design: Utopian Ideals and Everyday Realities, 1930–1997* (New York: Graduate Center for Studies in the Decorative Arts; and New Haven and London: Yale University Press, 1998); and Susan Weber Soros, *E. W. Godwin: Aesthetic Movement Architect and Designer* (New York: Bard Graduate Center for Studies in the Decorative Arts and New Haven and London: Yale University Press, 1999).

182 Initially, Zukowsky was curator of architecture, but in 1987, the Art Institute received a grant from the National Endowment for the Arts to explore the possibility of expanding the department to include design. Zukowsky formed a Design Advisory

Committee that included Stephen Bayley, Neil Harris, David Hanks, Dianne Pilgrim, Stanley Tigerman, Peggy Loar, Paulo Polledri, and myself. The committee met twice and as a result of those meetings, the museum decided expand the department of architecture into a department of architecture and design.

183 See the catalog, *Building for Air Travel: Architecture and Design for Commercial Aviation*, ed. John Zukowsky (Munich and New York: Prestel and Art Institute of Chicago, 1996). Zukowsky also published some of the extensive research he did on the design of airplanes and plane interiors as "Design for the Jet Age: Charles Butler and Uwe Schneider," *Design Issues* 13, no. 3 (fall 1997): 66–81.

184 See the catalog edited by Zukowsky, *2001: Building for Space Travel* (New York: Abrams, 2001); and John Zukowsky, *Space Architecture: The Work of John Frassanito & Associates for NASA* (Stuttgart and London: Edition Axel Menges, 1999).

185 The exhibition catalog is *The Art of the Motorcycle*, eds. Thomas Krens and Matthew Drutt (New York: Guggenheim Museum Publications and Harry N. Abrams, 1998).

186 See the catalog, *Designing Modernity: The Arts of Reform and Persuasion, 1885–1945*, ed. Wendy Kaplan (New York and London: Thames & Hudson, 1995).

187 See the catalog written by Jeremy Aynsley, *Graphic Design in Germany, 1890–1945* (London: Thames & Hudson, 2000), and Barry Katz's review "Leading 'The Simple Life': The Arts and Crafts Movement in Britain, 1880–1910," in *Design Issues* 16, no. 2 (summer 2000): 87–89.

188 Doordan, "On History," 76.

189 Jeffrey L. Meikle, "Comments," conference paper presented at the ASA meeting, New York, November 22, 1987.

מי
ימלל
גבורות
ישראל

David Tartakover, "Who Will Utter the Mighty Acts of Israel?" Protest poster published after the massacre of Lebanese refugees by the Israeli army in the Sabra and Shatila refugee camps in Lebanon, September, 1982.

Narrativity becomes a problem only when we wish to give real events the form of a story.

HAYDEN WHITE, "THE VALUE OF NARRATIVITY IN THE REPRODUCTION OF REALITY"

NARRATIVE PROBLEMS OF GRAPHIC DESIGN HISTORY

INTRODUCTION In recent years, scholars have devoted considerable attention to the study of narrative structures in history and fiction.[1] Central to their concerns are several key questions, notably, what constitutes a narrative as opposed to other forms of temporal sequencing of actions and events and how does a narrative make claims to being true or fictive. Regarding the first question, Hayden White has identified three kinds of historical representation: the annals, the chronicle, and history itself. Of these, he argues, only history has the potential to achieve narrative closure.[2] By organizing our accounts of the past into stories, we attempt to "have real events display the coherence, integrity, fullness, and closure of an image of life that is and can only be imaginary."[3] While some theorists like White regard history as a narrative that refers to events outside itself, others, particularly those who define themselves as postmodernists, refuse to make a distinction between fact and fiction and, in effect, treat all history as fiction.[4] That is not the position I will take in this essay, but I mention it to acknowledge a climate in which the idea of history as objective reality is heavily contested.

The distinction that White makes between the messiness of events and the order that historians seek to impose on them is important because it denaturalizes the narrative itself and obliges us to interpret the historian's strategy as a *particular* attempt to order events rather than present the historical work as an objective account of the past. This brings to the fore the necessity of including an analysis of the historian's method in the discussion of a work of history,

whether or not that method has been made explicit by the historian.

The problem of method in the construction of narratives is particularly acute in the field of design history, which, since Nikolaus Pevsner's *Pioneers of the Modern Movement* was first published in 1936, has been highly charged with moral and aesthetic judgments that have conditioned the choices of subject matter and the narrative strategies that historians have employed.[5] Adrian Forty, a prominent architecture and design historian, has claimed that the judgment of quality in design is central to the enterprise of design history.[6]

I do not believe that design quality is the primary concern of the design historian, although it raises necessary questions about how different people give value to products. In truth, the question of what design history is about has rarely been thoroughly addressed or debated. This has resulted in considerable confusion in the field, a situation that the move to establish graphic design as a separate subject area of design history has been unable to escape despite its singular focus.[7]

ISSUES IN GRAPHIC DESIGN HISTORY The first graphic design history to gain widespread attention was Philip Meggs's *A History of Graphic Design* of 1983.[8] It encompasses a wide range of material and has been used extensively as a text in design history courses. In 1988, Enric Satué, a graphic designer in Barcelona, published *El Diseño Gráfico: Desde los Orígenes hasta Nuestros Días* (Graphic Design: From its Origins until Today), which originally appeared as a series of articles in the Spanish design magazine *On*. The most recent books on the topic are Richard Hollis's *Graphic Design: A Concise History* and Paul Jobling and David Crowley's *Graphic Design: Reproduction and Representation since 1800*.[9] In addition, there have been supplementary works such as *Thirty Centuries of Graphic Design: An Illustrated Survey* by James Craig and Bruce Barton, which appeared in 1987, and *The Thames and Hudson Encyclopedia of Graphic Design + Designers* by Alan and Isabella Livingston, published in 1992.[10] Varying numbers of entries on graphic designers and firms have also been included in reference works such as *Contemporary Designers, The Conran Directory of Design,* and *The Thames and Hudson Encyclopedia of 20th Century Design and Designers*. There are as well chronicles and histories of graphic design, in particular, countries such as *Visual Design: 50 Anni di Produzione in Italia,* by Giancarlo Iliprandi, Alberto Marangoni, Franco Origoni, and Anty Pansera and *La Grafica in Italia* by Giorgio Fioravanti, Leonardo Passarelli, and Silvia Sfligiotti; *The Graphic Spirit of Japan* by Richard S. Thornton; *Chinese Graphic Design in the Twentieth Century* by Scott Minick and Jiao Ping; *El Diseño Gráfico en España: Historia de una Forma Comunicativa Nueva* (Graphic Design in Spain: History of a New Form of Communication) by Enric Satué; *A Fine Line:*

A History of Australian Commercial Art by Geoffrey Caban; *Dutch Graphic Design, 1918–1945* by Alston W. Purvis and *Dutch Graphic Design: A Century* by Kees Broos and Paul Hefting; *The Origins of Graphic Design in America, 1870–1920* by Ellen Mazur Thomson, and *Graphic Design in America: A Visual Language History*, the catalog of an exhibition curated by Mildred Friedman at the Walker Art Center in 1989.[11]

While this plethora of publications is commendable for the attention it brings to the subject of graphic design, it has not led to any clarification of how graphic design has been constituted by the respective authors, nor has it marked a satisfactory course for the fuller development of a narrative structure that can begin to explain graphic design as a practice. The term "graphic design" itself as it is applied in most books on the subject remains problematic. W. A. Dwiggins was the first to use it in an essay he wrote for the *Boston Evening Transcript* in 1922.[12] It was subsequently adopted, beginning sometime after World War II, to replace such appellations as "graphic art," "commercial art," and "typographic art."[13]

Some authors have used "graphic design" to account for all attempts since the beginning of human settlements to communicate with graphic devices. Writing in 1985 in a special issue of the *AIGA Journal of Graphic Design* on the topic of graphic design history, Philip Meggs noted the disagreement among experts on the historical scope of the subject:

Some advocate the short-sighted view and believe that graphic design is a new activity, born of the industrial revolution. Others advocate a farsighted view, believing the essence of graphic design is giving visual form to human communications, an activity which has a distinguished ancestry dating to the medieval manuscript and early printers of the Renaissance.[14]

When one considers Meggs's own book, it is clear that he has chosen the "farsighted view" in that he identifies the cave paintings of Lascaux as the beginning of a sequence that ultimately connects with the contemporary posters of April Greiman. Likewise, as Craig and Barton argue in the introduction to their illustrated survey,

Graphic design—or visual communication—began in prehistoric times and has been practiced over the centuries by artisans, scribes, printers, commercial artists, and even fine artists.[15]

Enric Satué takes a similar long view, beginning his own narrative with a chapter entitled "Graphic Design in Antiquity."

The problem with the comprehensive accounts of graphic design history that Meggs, Craig and Barton, and Satué propose is that they assert a continuity among objects and actions that are in reality discontinuous. Corporate identity

programs did not grow out of Renaissance emblem design, nor was the design of books a direct precedent for advertising art direction. Suggesting such connections by locating these different practices in a linear narrative makes it difficult, if not impossible, to disentangle their separate strands and write a more complex account of their relations to one another.

To do so is to begin from a different position than those in the above mentioned texts. It means looking far more closely at the activity of designing as a way of understanding the specific moves by which designers expand the boundaries of practice. This strategy is addressed by Richard Hollis in the introduction to *Graphic Design: A Concise History:*

Visual communication in its widest sense has a long history. . . As a profession, graphic design has existed only since the middle of the twentieth century; until then, advertisers and their agents used the services provided by "commercial artists." These specialists were visualizers (layout artists); typographers who did the detailed planning of the headline and text, and gave instructions for typesetting; illustrators of all kinds, producing anything from mechanical diagrams to fashion sketches; retouchers; lettering artists and others who prepared finished designs for reproduction. Many commercial artists—such as poster designers—combined several of these skills.[16]

Hollis's distinction between the different specialists who produce "commercial art" is helpful because it facilitates the tracing of distinct strands of practice such as typography, illustration, and art direction that sometimes intertwine within a particular professional category. By maintaining the separation between these strands, we can then look more deeply at the particular discourses within each one and understand better how their histories are contextualized and recontextualized into new narratives.[17]

For example, the graphic projects of the poets and artists of the early twentieth-century avant-garde are usually incorporated within the history of graphic design even though they were frequently produced outside the client-practitioner relationship that normally characterizes professional design activity. The innovations of syntax and mixtures of typefaces such as we see in the Futurist poet Filippo Tommaso Marinetti's *Parole in Libertà* (Words in Liberty) were integral components of specific poetic texts that he wrote, just as the visual forms of concrete poems written by others in later years were to be. Similarly, El Lissitzky's small book *Of Two Squares* originated as an argument for a new reading strategy that had implications in Lissitzky's thinking that went far beyond the formal order of the book page.

When Lissitzky's book was assimilated into the discourse of the "new typography" by Jan Tschichold in 1925, it was recontextualized and its original meaning was altered from a new way of thinking about reading to an argument for a modern design formalism. These shifts of intention and context tend to be suppressed when diverse graphic products are drawn together within an assimilationist narrative based on a theme such as modernity or innovation.

Meggs, looking farther into the past than the moment of the modernist avant-garde, describes the visual practices of the Renaissance and Rococo as "graphic design," thus suggesting a continuity between the design activity during those periods and that of contemporary practice. While later designers have engaged in typography, book design, and related forms of visual production that were practiced in much earlier periods, most do so within a significantly different type of professional setting that is not so continuous with earlier activities as Megg's use of terminology suggests.

Another problem is the conflation of graphic design and visual communication as we see in the introduction by Craig and Barton. Graphic design is a specific professional practice, while the term "visual communication" denotes a fundamental activity of visual representation (I would include here coded body language and gestures as well as artifacts) in which everyone engages.[18] Visual communication is a considerably larger category than graphic design, which it includes. A history of visual communication also suggests a completely different narrative strategy from that of a history of graphic design. The former rightly extends back to the cave paintings of Lascaux and Altamira and continues up to the present examples of urban graffiti. The emphasis in a history of visual communication is inherently sociological and does not exclude anyone on professional grounds. While such a history may focus as well on the semantic issues of how words and images visually transmit communicative intentions, its principal subject matter is the act of communication itself.[19]

Andy Kaufmann stencil on a wall in New York's meatpacking district.

Conversely, if we are to adhere more strictly to the meaning of "graphic design" as a description of professional practice that arose at a particular historic moment, we are obliged to consider the way such a practice has been institutionalized in order to include some practitioners and exclude others. This would certainly explain the absence of vernacular material done by nonprofessionals.[20] We would also have to address the ways that different forms of practice have been professionalized. Are typographers, calligraphers, art directors, and illustrators to be considered graphic designers, even when they have their own organizations, exhibitions, publications, and the like?[21] Unless a history of graphic design honors the distinctions among these practices, there is no way

to delineate how the profession has developed socially. Ironically, the cultural identity of the graphic designer will be strengthened more through such an approach than by conflating graphic design with all the other activities that produce visual communication.

Following the latter strategy, the texts by Meggs and Craig and Barton, in particular, result neither in a history of graphic design as a professional activity nor in a history of visual communication as an explanation of human communicative acts. Instead, they minimize the differences between the two and ignore the distinctions among the images they incorporate, which range from Egyptian hieroglyphs to Ohrbach's advertisements.

NARRATIVE STRATEGIES OF GRAPHIC DESIGN HISTORY TEXTS We can now turn to the three major texts by Meggs, Satué, and Hollis to better understand how they tell the story of graphic design.[22] We should first note the different emphases that the authors give to the preindustrial, industrial, and postindustrial periods. Meggs makes the strongest argument for a continuity between these, providing the lengthiest account of the preindustrial era. He establishes analogies between works in earlier and later periods on the basis of characteristics such as formal arrangement, and he unifies communicative activities in different periods by attributing common qualities to them such as "genius" and "expressivity."[23] Satué moves in three brief chapters to the beginning of the nineteenth century while Hollis begins his history in the 1890s with a discussion of the illustrated poster.[24] Regarding the material included for the nineteenth and twentieth centuries, the three authors have much in common, particularly in the sections that begin with the arts and crafts movement and then continue through turn-of-the-century posters, the European avant-gardes, the "new typography" in Germany, wartime propaganda, the émigré designers in America and the subsequent emergence of an American mass communications style, corporate identity, Swiss typography and its revisions, European pictorial posters, and protest design of the 1960s.

All the authors were trained as graphic designers and share similar values about the canon of their profession. This canon has neither developed randomly nor been institutionalized in the manner of an academic literary canon. Rather, it resulted from a selection process that has celebrated noteworthy designs in professional magazines such as *Novum Gebrauchsgraphik, Graphis,* and *Print,* as well as in numerous picture books and occasional museum exhibitions.[25] An important factor in the canonization of graphic design pieces is the visual satisfaction they give to the trained graphic designer. As the three books under discussion show, there is a considerable consensus among the authors regarding the visual quality of the work they include. What is generally

missing, however, are accounts of work by lesser known designers who played important roles in the development of the profession— for example, Fritz Ehmke in Germany or Oswald Cooper in the United States. Ehmke was important because he wanted to preserve design traditions at a moment when Jan Tschichold and others were promoting the new typography. In Chicago, Cooper was the best of the lettering and layout men who preceded the emergence of graphic design in the city as we now know it.

Oswald Cooper studio, Chicago, c. 1922. Cooper is at the drawing board at the back of the room.

One significant difference between Meggs, Satué, and Hollis is the varying amount of attention they give to geographic areas outside the European and American mainstream.[26] Satué, who is from Spain, is considerably more aware than either of the other two authors of how graphic design developed in the Spanish-speaking countries, as well as in Brazil. He devotes almost one hundred pages to this material while Meggs dedicates three pages to "The Third World Poster," a section that mainly refers to Cuban posters of the 1960s with a brief mention of posters in Nicaragua, South Africa, and the Middle East. Hollis, by contrast, devotes a little less than two pages to Cuban posters in a section entitled "Psychedelia, Protest and New Techniques of the Late 1960s." In the texts of Meggs and Hollis, Japanese graphic design is discussed briefly, but the authors refer mainly to postwar activity. When Meggs makes reference to prior work, he mentions early printing in Japan and then later talks about the nineteenth-century ukiyo-e woodblock prints and their influence on Western designers. Satué does not include Japan at all. None of the authors make any reference to modern design in China or other Asian countries nor do they mention graphic design in Africa.[27]

Although Meggs presents typographers such as Baskerville, Fournier, and Bodoni, who worked in the eighteenth century, as geniuses, he merges typography as a practice with other design activities when he reaches the twentieth century, where he neglects, as do the other two authors, some of the most eminent modern typographers such as Victor Hammer, Jan van Krimpen, Giovanni Mardersteig, and Robert Hunter Middleton.[28]

THREE FIGHTING TYPEFACES DRAWN
BY R. HUNTER MIDDLETON
TYPE DESIGNER FOR LUDLOW

Samson
Radiant Heavy
Tempo Black

The three authors' relation to other visual practices such as advertising vary somewhat. According to Hollis,

However effective, such work [i.e., early twentieth-century German posters of Bernhard, Erdt, Gipkins, and Hohlwein] belongs to a history of advertising. Only when advertising has a single visual concept, as it developed in the United States in the 1950s . . . does it have a significant place in the history of graphic design.[29]

Meggs, by contrast, does not even identify these posters as advertising

artifacts. He accounts for them in terms of a formal style, which he calls "pictorial modernism." Satué too treats this work as exemplary of a modern visual style.

Of the three authors, Hollis is most attentive to the differences among visual practices, making reference, for example, to the calligraphic training of Edward Johnston, who designed an alphabet for the London Underground in 1916. He also mentions the contribution that art directors in America made to the emergence of graphic design as a profession. At the same time he removes noteworthy practitioners, firms, and work from the discourses in which their practices were embedded—such as the discourse of advertising—and inserts them into a different narrative. Hence, we encounter the "new advertising," not as a response to the constraints of earlier advertising, but as a contribution to the development of a sophisticated visual sensibility within the graphic design profession.

While none of the authors writes an exclusively connoisseurist history, each is particularly attentive to visual quality. This plays an important role in the construction of their stories, which are propelled along by changes in the look and form of designs as well as by other factors. I make this observation not to instead espouse a social history of graphic design that subordinates discussions of form to arguments about social meaning but to stress that describing *how* artifacts look does not sufficiently address the question of *why* they look as they do.[30]

The latter can only be answered by extracting artifacts from narratives that draw them together for the purpose of creating a tradition of innovation that never existed. The artifacts must be reinserted in the various discourses within which they originated—whether those are related to art, advertising, typography, or printing—and then they need to be related in new ways.

CONCLUSION What then might a history of graphic design that respected the varied discursive locations of visual design activity be like? It would preserve many elements of the narrative sequences established by Meggs, Satué, and Hollis but would be more attentive to a close reading of visual practices in order to discriminate between the different types of work. As a result, we would understand better how graphic design has been shaped by borrowings and appropriations from other practices instead of seeing it as a single strand of activity. By recognizing the many routes into graphic design, we can learn to see it as more differentiated than we have previously acknowledged it to be. This will enable us to better relate emerging fields of endeavor such as information design, interaction design, and environmental graphics to what has come before.

Clearly, the history of graphic design does not follow a neat linear path

that can be characterized by unifying themes such as innovation, excellence, modernity, or postmodernity. Because there have been no shared standards that define professional development nor has there been a common knowledge base to ground a definition of what graphic design is, its development has been largely intuitive and does not conform to a common set of principles shared by all designers.[31] While the scope of what we call graphic design today has considerably expanded from what it once was, it has not done so in any singular way. Frequently individual designers have simply moved into new areas of practice and have then been followed by others.

Not all graphic designers work on the same kinds of projects. Some specialize in posters and function like artists. Others are involved with strategic planning and make use of management skills. And some designers specialize in information graphics, which requires a strong knowledge of social science.[32] A history of graphic design should explain the differentiations between the various activities that fall within the rubric of graphic design. It should acknowledge the tension that arises from the attempt to hold these activities together through a discourse of professional unity while designers continue to move in new directions. A recognition of this tension will ultimately teach us much more about graphic design and its development than would the attempt to create a falsely concordant narrative of graphic design history.

Theater posters, Amsterdam, 1999.

1 The study of narrative forms is a distinct field of research called narratology. A useful introduction to the subject is David Carrier, "On Narratology," in *Philosophy and Literature* 8, no. 1 (April 1984): 32–42. For a full account of the subject, see Mieke Bal, *Narratology: Introduction to the Theory of Narrative,* translated by Christine van Boheemen (Toronto: University of Toronto Press, 1985).

2 Hayden White, "The Value of Narrativity in the Representation of Reality," *Critical Inquiry* 7, no. 1 (fall 1980): 9.

3 Ibid., 27.

4 Linda Hutcheon provides an account of this position in *The Politics of Postmodernism* (London and New York: Routledge, 1989). See particularly the chapter "Re-presenting the Past."

5 Nikolaus Pevsner, *Pioneers of the Modern Movement from William Morris to Walter Gropius* (London: Faber & Faber, 1936). The book was subsequently republished in several revised editions as *Pioneers of Modern Design from William Morris to Walter Gropius.*

6 Adrian Forty, "A Reply to Victor Margolin," *Journal of Design History* 6, no. 2 (1993): 131–132. Forty's comment was part of a response to my article, "Design History or Design Studies: Subject Matter and Methods," which originally appeared in *Design Studies*

13, no. 2 (April 1992): 104–116 and was republished in *Design Issues* II, no. 1 (spring 1995): 4–15. It appears in a revised version in this volume.

7 Arguments for a separate history of graphic design have been voiced for a number of years now. See Steven Heller, "Towards an Historical Perspective," *AIGA Journal of Graphic Design* 2, no. 4 (1984): 5; the special issue of the same publication entitled "The History of Graphic Design: Charting a Course" edited by Steven Heller, *AIGA Journal of Graphic Design* 3, no. 4 (1985); and Steven Heller, "Yes, Virginia, There Is a Graphic Design History," *AIGA Journal of Graphic Design* 10, no. 1 (1992): 4.

8 Philip B. Meggs, *A History of Graphic* Design, 3d ed. (1983; New York: John Wiley & Sons, 1998).

9 Enric Satué, *El Diseño Gráfico: Desde los Orígenes hasta Nuestros Días* (Madrid: Alianza Editorial, 1988); Richard Hollis, *Graphic Design: A Concise History* (London and New York: Thames & Hudson, 1994); and Paul Jobling and David Crowley, *Graphic Design: Reproduction and Representation since 1800* (Manchester and New York: Manchester University Press, 1996). The books by Meggs, Satué, Hollis, and Jobling and Crowley were preceded by several volumes that were essentially visual chronicles such as Karl Gerstner and Marcus Kutter, *Die Neue Graphik* (Teufen: Arthur Niggli, 1959); and Josef Müller-Brockmann, *A History of Visual Communication* (Teufen: Arthur Niggli, 1971). A brief illustrated survey of postwar graphic design is Keith Murgatroyd's *Modern Graphics* (London and New York: Vista/Dutton, 1969).

10 James Craig and Bruce Barton, *Thirty Centuries of Graphic Design: An Illustrated Survey* (New York: Watson-Guptill, 1987); and Alan and Isabella Livingston, *The Thames and Hudson Encyclopedia of Graphic Design and Designers* (London: Thames & Hudson, 1992).

11 Giancarlo Iliprandi, Alberto Marangoni, Franco Origoni, and Anty Panser, *Visual Design: 50 Anni di Produzione in Italia* (Milan: Idealibri, 1984); Giorgio Fioravanti, Leonardo Passarelli, and Silvia Sfligiotti, *La Grafica in Italia* (Milan: Leonardo Arte 1997); Richard S. Thornton, *The Graphic Spirit of Japan* (New York: Van Nostrand, 1991); Scott Minick and Jiao Ping, *Chinese Graphic Design in the Twentieth Century* (London: Thames & Hudson, 1990); Satué, *El Diseño Gráfico en España: Historia de una Forma Comunicativa Nueva* (Madrid: Alianza Editorial, 1997); Geoffrey Caban, *A Fine Line: A History of Australian Commercial Art* (Sydney: Hale & Iremonger, 1983); Alston W. Purvis, *Dutch Graphic Design, 1918–1945* (New York: Van Nostrand Reinhold, 1992); Kees Broos and Paul Hefting, *Dutch Graphic Design: A Century* (Cambridge: MIT Press, 1993); Ellen Mazur Thomson, *The Origins of Graphic Design in America, 1870–1920* (New Haven and London: Yale University Press, 1997); and *Graphic Design in America: A Visual Language History* (Minneapolis: Walker Art Center and New York: Harry N. Abrams, 1989). Shorter accounts of American graphic design history can be found in the fiftieth anniversary issue of *Print* (November–December 1989), edited by Steven Heller with articles on each decade from the 1940s to the 1980s by different authors, and the special issue of *Communication Arts* (March/April 1999), "Forty Years of Creative Excellence."

12 Dwiggins's essay, "New Kind of Printing Calls for New Design," is reprinted in *Looking Closer 3: Classic Writings on Graphic Design*, eds. Michael Bierut, Jessica Helfand, Steven Heller, and Rick Poynor, with introductions by Steven Heller and Rick Poynor (New York: Allworth Press, 1999), 14–18.

13 The first American associations of graphic designers were called, respectively, the American Institute of Graphic Arts, founded in New York in 1914, and the Society of Typographic Arts, established in Chicago in 1927.

14 Philip B. Meggs, "Design History: Discipline or Anarchy?" *AIGA Journal of Graphic Design* 3, no. 4 (1985): 2.

15 Craig and Barton, *Thirty Centuries of Graphic Design: An Illustrated Survey,* 9.

16 Hollis, *Graphic Design: A Concise History,* 7–8.

17 Howard Lethalin provides an excellent model for how separate strands of design practice might be researched in his article "The Archeology of the Art Director? Some Examples of Art Direction in Mid-Nineteenth-Century British Publishing," *Journal of Design History* 6, no. 4 (1993): 229–246.

18 Hollis recognizes this when he includes "the imprint of an animal in the mud" as a form of visual communication in the introduction to *Graphic Design: A Concise History.*

19 An excellent example of a sociological approach to the history of communication is J. L. Aranguren, *Human Communication* (New York and Toronto: McGraw-Hill, 1967). Aranguren discusses both linguistic and visual communication as well as transmission media.

20 This does not preclude designs that adhere to institutional standards of quality being considered within the canon even if their makers are not trained professionals, nor does it prevent designers from appropriating vernacular forms for professional use as Charles Spencer Anderson has done with his "bonehead" design. But it does exclude designs that can be easily defined as vernacular because of their difference from work by professionals. In fact, graphic design is not a profession with a body of technical knowledge that can easily exclude nonprofessionals. If anything, the proliferation of desktop publishing software makes it more and more possible for nonprofessionals to approximate, or at least appear to approximate, professional standards. There has been, however, some debate within the profession about the place of vernacular graphics in design history. The late Tibor Kalman, J. Abbott Miller, and Karrie Jacobs argued in their 1991 manifesto "Good History/Bad History" that graphic design was a medium rather than a profession and therefore its history should include vernacular forms as well. "Graphic design," they wrote, "is the use of words and images on more or less everything, more or less everywhere." *Tibor Kalman: Perverse Optimist*, ed. Peter Hall and Michael Bierut (London: Booth-Clibborn Editions and New York: Princeton Architectural Press, 1998), 77.

21 Specialized histories of these practices were among the building blocks that preceded Meggs's own more comprehensive history. Books by those engaged with typography such as Frederic Goudy's *Typologia,* Daniel Berkeley Updike's *Printing Types: Their History, Forms, and Use,* or Stanley Morison's *A Tally of Types* provide coherent accounts of how typographic design developed and also assert standards of quality. Frank Presbrey's pioneering work, *The History and Development of Advertising* is a history of professional advertising practice that describes the changes that led from selling space to comprehensive campaigns.

22 I have not included Jobling and Crowley's *Graphic Design: Reproduction and Representation since 1800* in this discussion because it does not purport to be a comprehensive history of graphic design.

23 Thus Meggs applies the term "Spanish pictorial expressionism" to Spanish manuscripts

of the tenth century that feature letterforms as pictorial objects, while "American typographic expressionism" refers to New York graphic design of the 1950s and 1960s.

24 The problem with Hollis's strategy of writing a progressive narrative that identifies illustrated posters as precursors for more conceptual design work is that it then makes the posters less accessible for other histories such as a history of illustration, which does not have a similarly progressive character. For a discussion of Hollis's thoughts on graphic design and how they influenced the writing of his book, see Robin Kinross, "Conversation with Richard Hollis on Graphic Design History," *Journal of Design History* 5, no. 1 (1992): 73–90.

25 Martha Scotford discusses the problems of canonization in graphic design history in her article, "Is There a Canon of Graphic Design History?" *AIGA Journal of Graphic Design* 9, no. 2 (1991): 3–5, 13. Among the points she makes is that women are noticeably lacking in the canon. Scotford took steps to rectify this situation with her book *Cipe Pineles: A Life of Design* (New York and London: Norton, 1999).

26 I refer specifically to the United States rather than North America. Although Canada has a rich history of graphic design, including some outstanding designers in the postwar era, none of the authors mention it as a distinct site of graphic design practice. An excellent presentation on the history of graphic design in Canada was made by Peter Bartl at the International Council of Graphic Design Associations (ICOGRADA) congress in Dublin in 1983. For further information on Canadian graphic design, see Michael Large, "The Corporate Identity of the Canadian Government," *Journal of Design History* 4, no. 1 (1991): 31–42, and "Communication among All People, Everywhere: Paul Arthur and the Maturing of Design," *Design Issues* 17, no. 2 (spring 2001); and Brian Donnelly, "Mass Modernism: Graphic Design in Central Canada, 1955–1965 and the Changing Role of Modernism" (MA thesis, Carleton University, 1997).

27 See *Dialogue on Graphic Design Problems in Africa,* ed. Haig David-West (London: ICOGRADA, 1983). This publication reports on a 1982 conference held in Port Harcourt, Nigeria under the sponsorship of ICOGRADA. One of the few Africans to enter the ranks of internationally recognized graphic designers is Chaz Maviyane-Davies of Zimbabwe. See Carol Stevens, "A Designer from Zimbabwe," *Print* 47, no. 5 (September–October 1993): 84–91, 233. Since the end of apartheid, there has also been an upsurge of work by black graphic designers in South Africa.

28 This obscuring of the typographic tradition and the lack of sufficient recognition for twentieth-century typographers was ameliorated to some degree by the publication of Sebastian Carter's *Twentieth Century Type Designers* (London: Trefoil, 1987) and Robin Kinross's excellent *Modern Typography: An Essay in Critical History* (London: Hyphen Press, 1992).

29 Hollis, *Graphic Design: A Concise History,* 31.

30 This is the aim of Jobling and Crowley in *Graphic Design: Reproduction and Representation.* They succeed far better than Meggs, Hollis, or Satué in creating a social context for the work they discuss but, as I noted in a review of their book, "At times the authors appear to be writing social history rather than the history of design in its social context." The review was published in *Eye* 25, no. 7 (summer 1997): 83–84.

31 Some designers and design educators now prefer the term *communication design.*

32 For a critique of graphic design as an art-based profession, see Jorge Frascara,

"Graphic Design: Fine Art or Social Science?" in *The Idea of Design,* eds. Victor Margolin and Richard Buchanan (Cambridge: MIT Press, 1995), 44–55. The article first appeared in *Design Issues* 5, no. 1 (fall 1988): 18–29. Frascara proposes to shift the definition of design quality from the way things look to their effect on the intended audience.

Entrance hall, the Wolfsonian-Florida International University, Miami Beach. Sculpture, *The Wrestler*, 1929. Dudley Baill Talcott (American, 1899–1986). Made by Sculpture House, New York, cast aluminum, 80" x 47" x 30".

MICKY WOLFSON'S CABINET OF WONDERS

Micky Wolfson is one of those larger than life characters who would probably have been more at home in the late nineteenth century than in our current age of dematerialization and electronic communication. He is a man who likes material things and has traveled far and wide to collect them. In 1984 the stocks he inherited from his father, a prominent real estate developer in the Miami area, were sold to an investment firm, and Wolfson realized $84.5 million in cash, a sum that he used to accumulate more than 70,000 objects and 40,000 books and periodicals that now comprise the collection of the Wolfsonian Foundation in Miami Beach, Florida.[1]

Wolfson began to cultivate the collector's instinct as a child when he amassed thousands of keys from hotels and ships' staterooms while traveling with his parents. At Princeton he studied economics and European civilization and then, after graduate studies at Johns Hopkins, he entered the U.S. diplomatic corps. He was the American vice-consul in Genoa, Italy, for five years, resigning in 1971 to begin his life as a full-time collector and man about the world.

To better understand the nature of Wolfson's collecting instinct, we might consider the three categories of collecting devised by museologist Susan Pearce: systematics, fetishism, and souvenir collecting.[2] Systematics, according to her, is an attempt to represent an ideology. As an example, she cites the Pitt-Rivers Museum in Oxford, England, which portrays the natural history of evolution. Fetishism, she says, is the removal of the object from its original historical and cultural context and its recontextualization in terms of the collector's own inter-

ests. A good example would be William Randolph Hearst's accumulation of European decorative arts at San Simeon, his estate in southern California. Souvenir collecting is simply the gathering of objects on which the collector confers the mnemonic power to evoke personal memories of a place or time.

Of the three categories described by Pearce, the Wolfsonian collection most closely resembles the first one, systematics. Wolfson has focused on what he calls "decorative and propaganda arts" in the United States and several European countries—primarily Germany, Italy, England, and the Netherlands—between 1885 and 1945. Over the years he has been outspoken about the purpose of his collection. Referring to a speech he made in 1992 at the Propaganda Ball, an event that was held in Miami as a fundraiser for his foundation, Wolfson noted in a subsequent newspaper interview,

Never doubt that we have a mission and that we are revolutionaries. This foundation is meant to influence the way people think about history and art; we are resolved to make a difference . . . I'm didactic and I'm very interested in analogies. And I don't want to be fashionable—that's why I chose the word propaganda. I am determined to rid the world of oppression, misfortune, and misinformation.[3]

Wolfson focused his collecting passion on an important period in European and American history when the forces of nation-building were coalescing in strong cultural expressions of national identity. The period he bracketed also spans two world wars when the idea of propaganda was defined through massive government-controlled campaigns of persuasion.

The range of objects Wolfson has gathered in more than twenty-five years of intensive collecting follows no existing collection typology. On the one hand, he has a highly cultivated aesthetic sense that has led to his acquisition of some outstanding decorative arts objects that any major museum would covet. On the other, he has accumulated a vast hoard of Nazi and Fascist memorabilia that few, if any, museums would care to be associated with. In between are toys and games, important architectural fragments and details, drawings and maquettes for public murals, posters, and a huge collection of books and periodicals.

Wolfson's attraction to the banners, sculptures, and posters of the Nazis and Fascists is all the more intriguing because he is Jewish. One might have expected him to shun such objects, or at least to ignore them, rather than purchase them. His fascination with these artifacts appears justified, however, because of his missionary zeal to present them as reminders of oppressive political ideologies. Fortunately for him, the market for such objects was somewhat limited during his most active period of collecting, and he was able to accumulate a considerable trove of propaganda examples at a relatively modest cost. There are certainly comparable collections of two-dimensional propa-

ganda material, including posters and leaflets, at major libraries and specialized museums around the world such as the Library of Congress in Washington, D.C., and the Imperial War Museum in London, but no one has heretofore displayed Wolfson's unique kind of collecting judgment, which combines a strong sense of aesthetic value with a keen awareness of an object's historic significance.

Wolfson is known to be a rather private individual, which makes it difficult to analyze too closely the personal reasons for building his collection. Despite his pronouncements of its didactic intent, one also senses that gathering such a gallimaufry of stuff has been great fun for him. "In the early days," he said, "it was sheer self-expression."[4] There are also statements by Wolfson and stories by others that convey the pleasure of the hunt that has animated his searches. "I avoid the things dealers put in the front windows," he noted in an interview. "I like the back rooms and the basements."[5] Of everything that Wolfson has bought, however, his grandest acquisition is the Castle Mackenzie, an historically eclectic mansion in Genoa, Italy, that has somewhere between eighty and one hundred rooms. Wolfson, who purchased it for less than one million dollars but has already spent more than two million on exterior renovations alone, envisioned it as a place to exhibit objects from his collection that were stored in a European warehouse.

Wolfson's passion for things goes well beyond Susan Pearce's definition of systematic collecting and suggests a fire within him that both drives and transcends his didactic intent. Certainly his early collection of keys had no social purpose, and one senses beneath the pronouncements of his current collection's cultural significance, a powerful desire to annex things that appeal to him for highly personal reasons. It is this passion, however, that can easily be lost to public awareness when a personal collection becomes a museum.

For years Wolfson shipped the acquisitions from his peripatetic wanderings, which consumed about ten months of each year, to warehouses in Europe and Miami Beach. Eventually he began to consider how scholars might gain access to this material. In 1987, he hired Peggy Loar from the Smithsonian to create a new institution that would make his collection available to scholars and the public. Its name, the Wolfsonian, was an obvious, if somewhat outrageous, homage to the Smithsonian and signified the grand scale of Wolfson's civic ambitions.

Loar assembled a museum staff, including curator Wendy Kaplan, and supervised the transformation of a Miami Beach Art Deco warehouse into a combined museum, study center, and storage facility.[6] The museum's first exhibition, *The Arts of Reform and Persuasion, 1885–1945*, which opened in November 1995, was curated by Kaplan. Along with a

few borrowed pieces, the exhibition included only three hundred or so objects and publications from Wolfson's vast store. The curator's intent was to construct from the objects that Wolfson had assembled a social narrative that tells the story of how some of the leading nations in the industrialized world attempted to come to terms with the idea of modernity.

The ample catalog edited by Wendy Kaplan, *Designing Modernity: The Arts of Reform and Persuasion, 1885–1945*, which was selected for the 1995 George A. Wittenborn Award by the Art Libraries Society of North America, is beautifully designed and includes numerous photographs, mostly in color.[7] Ten essays by prominent scholars are accompanied by an illustrated checklist of exhibition objects. The foundation invited the scholars to Miami Beach to study the collection and select groups of objects on which to base their essays. The essayists are curators and professors with interests in modern design and the decorative arts. All are known for their writings on topics closely related to the Wolfsonian collection: Wendy Kaplan on the arts and crafts movement in England and America; Laurie Stein on German *Jugendstil*; Elinoor Bergvelt on the work of the Amsterdam school and the artist Jan Toorop; Paul Greenhalgh on worlds fairs and modernism in design; Jeffrey Meikle on American consultant designers and the cultural history of plastics; Irene de Guttry and Maria Paola Maino on Italian decorative arts; Marianne Lamonaca on organic abstraction in twentieth-century decorative arts and design; Dennis Doordan on Italian architecture and design; John Heskett on design in Germany; and Bernard Reilly on American political prints and illustrations.

The catalog is the first attempt to impose a narrative structure on Wolfson's collection. Although Wolfson has continually emphasized the use of his material as a source of social narrative, there are other ways to read it as well. Mieke Bal has argued that collecting itself can be understood as a narrative activity.

I can imagine seeing collecting as a process consisting of a confrontation between objects and subjective agency informed by an attitude. Objects, subjective agency, confrontations as events: such a working definition makes for a narrative, and enables me to discuss and interpret the meaning of collecting in narrative terms.[8]

While Bal's theory of collecting as narrative is extremely useful in suggesting a way of reading the collecting process itself as a story, a means of interpretation invited by the colorful account of Micky Wolfson's collecting career, her focus on fetishism as the basis of collecting limits too severely the types of personal narrative that a collection might represent. Nonetheless, the idea that there could be a meaningful personal story embedded in the process of gathering that resulted in the Wolfsonian is tantalizing when considered as a counterpoint to the social narrative of modernity that the catalog authors relate.

Unlike most museum collections, the Wolfsonian's was assembled by one man and represents his vision. That vision engendered the boundaries of time and typology that determined what Wolfson would collect but it did not lead to his own articulation, other than short polemical statements, of what the collection means. This situation might be contrasted with that of the British architect John Soane, who filled his London townhouse in Lincoln's Inn Fields with models, drawings, prints, and sculptural fragments that both idealized the classical world and served as an inspiration for his own architecture.[9] Soane was both collector and consumer of his collection, which allows

us to examine his motives as a collector in terms of the uses to which he put the objects he assembled. But Wolfson, unlike Soane, has always said that he would leave interpretation to the scholars and, in fact, he made provisions in his plans for the museum to have a study center where scholars could come on a regular basis to use his material. Therefore, the choice of modernity as the central theme of the exhibition and catalog must be seen as an attempt by others to devise a *grand récit* for the collection rather than as an indication of what Wolfson intended the individual pieces to mean collectively as he gathered them.

However, the catalog narrative does not convey a singular vision. It comprises separate approaches to the meaning of modernity by a group of scholars who employ different methods to interpret the material they have selected. The basis of their story is the progressive development from an agrarian to an industrial culture, although the story addresses the reactionary response to industrialization as well as its enthusiastic embrace. In reviewing the catalog, one needs to consider several issues. One is that of narrative and the question of whether or not the essayists collectively tell a coherent story. Another is the issue of methodology and the question of how the essayists make use of Wolfson's objects to develop their arguments.

Wolfson's various statements about his objects repeat the theme that they embody values that are socially significant. This, in essence, is a classic material culture approach. It is reiterated in the opening sentences of the catalog's preface by Peggy Loar:

One of the ways in which a civilization defines itself is in its material culture; its infrastructure, architecture, art, furnishings, tools, technologies, ephemera. Through objects, cultures are recorded, providing us with tangible evidence concerning transformations in values and politics.[10]

This statement is an attempt to position the Wolfsonian Foundation as something other than an art museum. We are asked to view the objects it houses as indices of cultural attitudes rather than as exemplars of superior aesthetic value.

The exhibition and catalog are divided into three sections: Confronting Modernity, Celebrating Modernity, and Manipulating Modernity: Political Persuasion. The essays in the first section begin with the 1890s, and those in the second and third, with the 1920s, but all have 1940 or thereabouts as their closing date. Hence, the divisions are not strictly chronological, but attitudinal. We are not given a rigorously sequential account of the engagement with modernity but rather a comparison of attitudes toward it.

The prevailing theme of the first section is how craft production was incorporated into discourses of national identity. Wendy Kaplan's opening essay on romantic nationalism and design between 1890 and 1930 attempts to provide a broad framework for the more specific national histories that follow. In Russia, pan-Slavic nationalism, a reaction to Westernization, was a powerful discourse for giving meaning to indigenous crafts. The arts and crafts movement in England, she argues, was a response to that country's rapid and extensive industrialization. The movement was highly influential on the continent, but Kaplan notes that it was received there in different ways. For countries such as Norway and Finland, which had been under foreign rule for extensive periods, the crafts became symbols of an independent national identity. Within this argument, items from Wolfson's collection such as the *ryijy* rug designed by the Finnish architect Eliel Saarinen or the prints depicting Saarinen's living room at Hvitträsk, the home and studio he shared with two colleagues outside Helsinki, embody nationalist values.

Kaplan's essay also creates a context within which to incorporate an Irish stationary box and inkstand that exemplify strong Celtic influences, along with one of the masterpieces in Wolfson's collection, the stained glass window depicting scenes from Irish literature, which was made by Harry Clarke for the International Labor Building in Geneva but was never installed. Kaplan closes her essay with a foretaste of the catalog narrative's conclusion, stating that

**only one generation had to pass before some ominous conse-
quences of romantic nationalism would be revealed. As explored in
later essays of this volume, the elevation of earthy, peasant culture
as the only true reflection of the national soul could lead to an in-
tolerance of anyone not considered part of the native society.[11]**

Kaplan's attempt to link the crafts as signs of turn-of-the-century romantic na-
tionalism to their obverse role as signifiers of nationalistic Fascism and Nazism
raises questions about how the catalog scholars defined their relationship to
the Wolfsonian collection. Perhaps Kaplan, as curator of the exhibition, had a
particular predisposition to find coherence in the multiplicity of objects that
Wolfson collected. But the connection she makes at the conclusion of her essay
is debatable. Although Hitler, for example, was interested in peasant culture,
the artifacts that depicted that culture within the discourse of the Nazi regime
were mostly created anew to represent a *myth* of the *volk* rather than an au-
thentic representation of the people's cultural values. Likewise, peasant cul-
tures never became the dominant paradigms in Germany or Italy, where mod-
ern forms of technology and planning, more than the celebration of peasant
life, were required to sustain political power and military strength.

The role of objects in the discourse of national identity is central to Paul
Greenhalgh's essay on English design between 1870 and 1940. Greenhalgh
gives less consideration to the forms of particular objects than do some of the
other essayists and more to the ideological arguments into which objects were
incorporated. As an example of how the British past was mined to produce new
versions of British identity, he cites the reinvention of William Morris, a
renowned socialist, after his death. This was done by Morris's own company,
which was given an entire section at the Franco-British Exhibition of 1898.
Stripped of his politics, Morris was celebrated as "the new Chippendale," and
his subsequent biography, published by his firm, made reference to his ideal-
ism rather than to his socialism. For Greenhalgh, the English compromise was
to rephrase the stereotypical narratives of British life in new forms. Thus Gor-
don Russell's handmade blanket chest of 1927 possessed the simplicity of a
piece of modern furniture, while incorporating the pegged joints and Tudor
hinges of the past.

Other essays in the first section of the catalog include Laurie Stein's on
the question of design and national identity in Germany between 1890 and
1940 and Elinoor Bergvelt's on the decorative arts in Amsterdam between 1890
and 1930. The ways that both authors make use of the Wolfsonian objects rep-
resent more of a decorative arts approach, whereby a close reading of an ob-
ject's appearance and materials is combined with an attempt to address issues
of production and to explain the object's sources and influences. This strategy

differs from that of some other essayists who incorporate the objects more directly into narratives that focus on social or political values. Stein writes authoritatively, particularly about *Jugendstil* furniture by Peter Behrens and Josef Olbrich, and she introduces some new material on the design debates in Germany at the turn of the century. But the story she tells of the Werkbund's formation, the debates at its 1914 exhibition, and the transformation of Henry van de Velde's Weimar school of arts and crafts into the Bauhaus has been frequently repeated, and her version provides no new insights of significance.

The examples of early Dutch modernism that Bergvelt discusses are lesser known, and her essay creates a context for some fascinating objects from Wolfson's collection, particularly books such as the Dutch translation of Walter Crane's *Claims of Decorative Art* and the volume of lectures by William Morris designed by Hendrik de Roos. In her treatment of Dutch furniture, Bergvelt highlights the little-known work of Michel de Klerk, the leading architect of the Amsterdam School. Wolfson, we are informed, has the majority of de Klerk's furniture that still exists, about twenty-five pieces from an original two hundred or so. These pieces, which were unsuitable for industrial production, draw heavily on Orientalist motifs, notably the languid luxury of a pasha's harem. The fact that Wolfson was so attracted to them and accumulated so many (the urge to complete a series being one of the characteristics of a fetishistic collector) may tell us more about his own dreams and fantasies than about the furniture's social significance.

In the lead essay of the catalog's second section, cultural historian Jeffrey Meikle takes the position that modern societies had no singular strategy for coming to terms with change. He contests the argument made by some theorists of the modern such as Marshall Berman that modernity was a break with the past. Instead, he proposes three strategies for what he calls "domesticating" modernity during the interwar years. The first was an evolutionary approach whereby modern life was seen as a seamless and inevitable continuation of the past; the second involved designating discrete zones, notably the modern city, as places where one could experience the modern and then retreat to a more traditional habitus; and the third was to directly appropriate icons of modernity into one's own personal environment as a way of taming their threatening aspects. To illustrate this argument, Meikle found numerous examples amidst Wolfson's collection of prints, posters, plaques, painted panels, and even commercial objects such as toys, souvenirs, and industrial products. As a cultural historian, he is less interested in issues of production, authorship, or style than some of the other essayists and more concerned with creating his own narrative of modernity from Wolfson's vast array of artifacts.

Meikle treats the artifacts as texts that embody representations of cultural attitudes and interprets them largely through iconographic readings. Such an approach is necessarily speculative and achieves its substance from the persuasiveness of the argument. Meikle's three strategies of confronting modernity offer provocative new ways of reading the artifacts of the modern era, but he also cannot resist delving into Freud, a favorite source of methodology for cultural theorists. In one instance, he addresses an image of Henry Dreyfuss's train, the 20th Century Limited, which he finds on a matchbook from King Farouk's collection that was bought in its entirety by Wolfson. Meikle notes the following:

The locomotive's general outline also suggested mixed associations. If its thrusting tubular form, ending in the circular eye of a single headlight, seemed so phallic as to suggest a grand jest, then its broad front, read vertically as a human figure, assumed the form of a vigorous, large-breasted woman whose amply rounded skirt suggested the possibility of a swelling pregnancy. The image promised a rapprochement of the male realm of technology with the female realm of nature—but with no hint of the result.[12]

He goes on to suggest that the miniaturization of the locomotive image on the matchbook cover was one way to make it more familiar and thus tame it. While Meikle gives no hint of being a serious Freudian, his reading of this image does refer us back to the possibility of hidden narratives embedded within Wolfson's own collecting activity.

The other two essays in this section, by Irene de Guttry and Maria Paola Maino and by Marianne Lamonaca, address questions of how design and the decorative arts in Italy changed from the late 1890s to the early 1930s according to the ways craftsmen and designers assimilated modern forms and techniques of production. In their essay on the uses of wrought iron and aluminum, de Guttry and Maino recount the transition from artisanship to industry. Picking up a theme introduced earlier by Kaplan, Stein, and Bergvelt, they discuss the impact of the arts and crafts movement, which in Italy, a less-industrialized country than England, led critics to protest excessive decoration and "eclectic disorder" rather than the factory system. In short, the movement supported the early arguments for rationalism that were to surface again in the 1920s in the architecture of Gruppo 7.

The essay is illustrated with some fascinating and little-known examples of wrought iron decorative objects—a lamp stand, a photograph stand, and a bed—by Alessandro Mazzucotelli, the master of the *stile floreale* or Italian art nouveau. Umberto Bellotto and Carlo Rizzarda are other craftsmen in wrought iron whom the authors bring to our attention.[13] They introduce a political read-

ing of the objects when they explain that aluminum was promoted as a material of choice by the Fascist regime because it could be produced in Italy and came to represent Mussolini's policy of autarky or economic self-sufficiency. In addition to its use for new modern objects such as the office furniture from the Montecatini headquarters designed by Giò Ponti, its promotion also discouraged the employment of iron for decorative objects and, in fact, resulted in the destruction of many wrought iron masterpieces as acts of patriotism.

Lamonaca too addresses issues of eclecticism and aesthetic cohesion in the discourse of Italian decorative arts and design during the interwar years. Her theme is the "return to order," which she argues took multiple forms. There was a renewed emphasis on Italy's past as a source of forms to represent modern national identity. As a counterpart to what she calls "eclectic historicism," the return to classical forms and motifs was intended to embody modern versions of *Romanità* (Romanness) and *Latinità* (Latinness). As an example of this new classical influence, she presents a dinner plate by Gio Ponti which, inspired by Roman and Etruscan art, shows figures in ancient garb in various positions of activity and repose. Making reference to other examples that used designs of the past such as the Rococo-inspired dinner service by Guido Andlovitz and the rustic furniture that stimulated modern versions by Duilio Cambellotti, Lamonaca demonstrates that no singular aesthetic strategy dominated the quest for a modern identity in Italy. Although she marshals objects effectively to represent the interplay between formal values and social ones, the diversity of her choices, ranging from the handcrafted to the mass-produced, mitigates against a cohesive argument about how issues of national identity were played out in the design of goods destined for public consumption. As she notes, "The 'return to order' in Italy was multifaceted and often ambiguous."[14] The mix of mass-produced and one-off objects that she cites represents the contradictions in Wolfson's own collecting strategy. As shown previously, he has argued against being fashionable and for the capacity of his collection to provide social and political enlightenment, yet there is more than one sensibility at work in Wolfson. He is as much attracted to the fine craftsmanship and idiosyncratic iconography of a handmade cabinet as to the generalized political argument of a Nazi plaque. Similar to Lamonaca's essay, these dual attractions to the decorative and the propagandistic are not easily combined in a single narrative.

The essays in the final section, however, focus entirely on the public realm. All are about propaganda rather than decoration, although the question of aesthetics and its relation to national ideology is not ignored. Dennis Doordan, in his study of artifacts in Fascist Italy, defines a new category, political de-

sign, which he says "denotes the total set of objects produced during a particular period that address specifically political themes. The category includes everything from ephemeral works on paper to enduring monuments of architecture."[15] Doordan, who has written a major study of Fascist architecture, is particularly sensitive to the public impact of propaganda art. He finds similar attempts to reinforce the power of the Fascist regime in objects that range from Marcello Piacentini's triumphal arch *Monument to Victory* in Bolzano to a wall

lamp shaped like Roman fasces. Unlike many scholars who study Marinetti's futurist movement as the Italian contribution to the avant-garde, Doordan places it squarely in a political context and links it to Fascist propaganda. Concluding an analysis of Marinetti's early futurist book *Zang Tumb Tuuum* of 1914, Doordan notes that "[m]any elements of this Futurist *ars rhetorica* would later find their way into Fascist political design."[16] His essay, more than many others in this catalog, successfully demonstrates Wolfson's claim that the decorative and the propagandistic can form two sides of the same coin. Wolfson recognizes the power of propaganda in small items such as medallions, in household objects such as the plate painted with the slogan "Fascismo Futurismo" from the Life of Marinetti series, as well as in postcards, posters, and banners. Doordan's acknowledgment of this perception enables him to conclude persuasively that

the diversity of political designs assembled in the Wolfsonian collection requires an alternate model for totalitarian practice, one for which the creation of a mass political culture does not require the same form of expression for every group. Instead, designers are free to select from a set of ideals and symbols and express them in a variety of ways, each one legible and congenial to a different social and political constituency.[17]

Just as Doordan finds narrative continuity between futurism's avant-garde moment and the propaganda of Fascist Italy, so does John Heskett critique those design histories that assert a rupture between the forms of objects in the Weimar Republic and the Nazi period.

Design histories of this period have separated these two phases on a very simplistic basis: the Weimar Republic is depicted as a flowering of modern design that ended when Hitler came to power; the Third Reich is generally ignored.[18]

In his essay, Heskett develops an argument he has made elsewhere that the Nazis were not out-and-out opponents of modern design; they simply picked appropriate forms to suit differing political purposes.[19] As a bridge between the severe geometric aesthetic of the modern movement and the monumental clas-

sicism of Nazi civic architecture, he relies on Julius Posener's earlier conserva-
tive modernism, which recognized the past as the basis for a contemporary
modern style. Heskett describes attempts by Nazi theorists as early as 1922 to
combine revolutionary and conservative ideas. His reference to conservative
modernism fuels his argument that not all Nazi aesthetic ideology was based
on nostalgic visions of *völkisch* simplicity. In fact, some designers working dur-
ing the Nazi period were outright modernists. As examples, Heskett cites Wil-
helm Wagenfeld, represented in the essay by his cubic glass food containers,
and Hermann Gretsch, who designed a wide range of products from cast iron
stoves to plastic housewares.

Like Doordan, Heskett writes about different types of design, but he
does not focus on political iconography as singularly as Doordan does. He is
particularly interested in national design policy and strives to debunk the argu-
ment that all design done in the Nazi period was kitsch.

**The assumption that the Nazi regime engendered only work of little
value is untenable, I would argue, since it completely underesti-
mates two factors. First, designs of high caliber continued to be
produced in the Third Reich: a reprehensible ideology does not nec-
essarily produce inferior design and creativity can flourish in evil
conditions. Second, when used for political ends, artifacts serve
purposes reaching far beyond the forms, functions, and meanings
attributed to them in the processes and practices of design.[20]**

Heskett's claim for continuity between the modern design of the
Weimar Republic and the design standards that operated in select
organizations of the Third Reich challenges the theories of disjunc-
ture between the modernism of the liberal democracies and the tra-
ditionalism of the subsequent repressive Fascist and Nazi regimes.
It also challenges Wendy Kaplan's argument for a connection be-
tween the romantic nationalism of the nineteenth century and the
nefarious use of a preindustrial past by the Fascists and Nazis in the
1930s. Again, Wolfson's two foci of the decorative and propagandis-
tic provide support for Heskett's thesis. A 1936 German postcard
referenced by Heskett shows the lounge deck of the zeppelin, *Hin-
denburg,* whose marble wall and tubular steel furniture recall in a
softer form the starkness of Ludwig Mies van der Rohe's Barcelona
pavilion of 1929, while R. Förster's ceramic figurines of uniformed
Hitler youth are, despite their Nazi reference, firmly embedded in a
long tradition of German popular taste.

Heskett's account of design in the Third Reich derives strongly from his
own distinction between design and decorative art. Design, as Heskett sees it,

is for mass consumption and differs from the singular object in its conditions of creation and conception as well as in its mode of manufacture. His focus on industrial design is more pointed than that of any other essayists and calls particular attention to the differing ways that scholars who wrote for this catalog made use of the Wolfsonian collection.

In the final essay of the catalog, Bernard Reilly casts his lot clearly with issues of representation rather than production by comparing images of workers in German, Italian, and American art of the 1930s. His approach is iconographic as well as historical in that he uses visual analogies between paintings of different cultures to suggest similarities between the three countries instead of assuming that historical circumstances produced differences that make any formal comparisons purely coincidental. Early in his essay he asserts:

This essay will compare a number of such works which address the theme of production. It will show how, and to what extent, the works reflect the economic realities of the era in the three countries and the official policies with regard to industry and labor adopted by the three governments. This comparison will also suggest that despite the profound ideological gulf that separated two militaristic and fascist regimes from a pluralistic, democratic society, a common underlying theme figured in the varying persuasive strategies adopted by all three of them. This theme was the newly assertive role to be taken by the national government in the life and welfare of the individual.[21]

Reilly's argument would seem to reverse those of Doordan and Heskett that the singular ideology of a centrally controlled regime could be manifested in dissimilar forms. While there is surely something to be gained by drawing attention to similar images in different cultures, the attempt to establish political parallels between the images may be misleading. Reilly compares a poster by the Italian artist Marcello Dudovich, a calendar page for the Racial Policy Office of the Nazi Party by Ludwig Hohlwein, and the study for an American post office mural by Frank Shapiro in order to illustrate his observation that all three regimes were concerned with the cohesion of the family. While this may be so, the ideological reasons for promoting the family were sufficiently different in each country and raise questions about the value of comparing them. Had Reilly focused on issues of rhetoric rather than of iconography, he might have better used the imagery to explain how each government constructed distinct arguments for its particular agenda with images that might otherwise appear similar.

As a result of the varied concerns and methods of the ten scholars, the catalog does not offer a singular reading of Wolfson's collection. Some essayists focus more on how the objects function as exemplars of production techniques

and aesthetic judgments, while others eschew these concerns for readings that regard them as signifiers of ideological values. These interpretive approaches are an inevitable result of Wolfson's own complex collecting strategies, which fluctuate between the search for objects that convey significant social and political ideals and the quest for pure visual pleasure. If we acknowledge as well that there are hidden narrative subtexts linked to Wolfson's deepest psychic engagement with the objects he has gathered, we can see that converting a personal collection to a museum is a process that resists a single meaning. This is evident in Wendy Kaplan's catalog, which leaves one with a sense of the narrative possibilities yet to be explored in the Wolfsonian collection rather than a story that closes out further interpretations.

1 For additional information on Wolfson's life, the history of his collecting passion, and the founding of the Wolfsonian, see John Malcom Brinnin, "Mitchell Wolfson, Jr.: The Man and His Mission," *Journal of Decorative and Propaganda Arts* (fall 1988): 80–93; Tom Austin, "A Gentleman and a Scholar," *New Times* (December 30, 1992–January 5, 1993): 11–12, 14, 18, 21–22; and John Dorschner, "What Hath Micky Bought?" *Herald Tropic,* October 29, 1995, 6–16.

2 Pearce's categories are mentioned in John Windsor, "Identity Parades," in *The Culture of Collecting*, eds. John Elsner and Roger Cardinal (Cambridge: Harvard University Press, 1994), 50.

3 Micky Wolfson, quoted in Austin, "A Gentleman and a Scholar," 22.

4 Ibid.

5 Dorschner, "What Hath Micky Bought?" 10.

6 The Wolfsonian has now become part of Florida International University.

7 Wendy Kaplan, ed., *Designing Modernity: The Arts of Reform and Persuasion, 1885–1945* (New York: Thames & Hudson, 1995).

8 Mieke Bal, "Telling Objects: A Narrative Perspective on Collecting," in Elsner and Cardinal, *The Culture of Collecting*, 100.

9 For a critical analysis of Soane as a collector, see John Elsner, "The House and Museum of Sir John Soane," in Elsner and Cardinal, *The Culture of Collecting*, 155–176.

10 Peggy Loar, preface, to Kaplan, *Designing Modernity,* 7.

11 Wendy Kaplan, "Traditions Transformed: Romantic Nationalism in Design, 1890–1920" in Kaplan, *Designing Modernity,* 44.

12 Jeffrey L. Meikle, "Domesticating Modernity: Ambivalence and Appropriation, 1920–1940," in Kaplan, *Designing Modernity,* 165.

13 The extensiveness of Wolfson's holdings in this area, coupled with his fascination for the wedding-cake architecture of the Castle Mackenzie and the Orientalist furniture of de Klerk, hints at a trail that might lead us to a better understanding of Wolfson's own aesthetic proclivities. He showed little inclination to collect the spare tubular steel furniture that best represented modernism in Germany in the 1920s. Instead, he evinced a flair for more colorful and dramatic approaches to form.

14 Marianne Lamonaca, "A 'Return to Order': Issues of the Classical and the Vernacular in Italian Inter-War Design," in Kaplan, *Designing Modernity,* 195.

15 Dennis Doordan, "Political Things: Design in Fascist Italy," in Kaplan, *Designing Modernity,* 226.

16 Ibid., 230.

17 Ibid., 251.

18 John Heskett, "Design in Inter-War Germany," in Kaplan, *Designing Modernity,* 257.

19 See John Heskett, "Modernism and Archaism in Design in the Third Reich," *Block* 3 (1980): 13–24.

20 Heskett, "Design in Inter-War Germany," in Kaplan, *Designing Modernity,* 283.

21 Bernard Reilly, "Emblems of Production: Workers in German, Italian, and American Art during the 1930s," in Kaplan, *Designing Modernity,* 289.

Walter Gropius and Adolph Meyer, model factory, Werkbund exhibition, Cologne, 1914.

DESIGN HISTORY AND DESIGN STUDIES

Design history as an academic subject received its first major impetus in the early 1970s in Great Britain. In 1960, the *First Report* of Britain's National Advisory Council on Art Education (NACAE), known as the Coldstream Report, stipulated that all students in art and design should learn the history of their own subjects. Ten years later, a joint committee of the NACAE and the National Council for Diplomas in Art and Design urged that art and design history courses embody sophisticated historical methods and relate their respective practices to social issues and concerns. The mandates in these reports, however, applied primarily to the polytechnics rather than to the university sector.[1]

Teachers of design history were drafted from other fields such as the history of art and then set to work developing curricula. The new courses established an initial narrative for the field, particularly as course topics were translated into textbooks and publications for a popular audience.

In the introduction to the proceedings of an early design history conference in Brighton, Penny Sparke wrote that

[a]s an academic discipline it [design history] is undoubtedly the child of the art schools, where the increasing number of design students need a historical perspective more relevant to their immediate needs than the one provided by traditional fine art history, and it is largely within their confines that it has blossomed and yielded fruit.[2]

Independent of the teaching activity in Britain, design history courses were also established in the United States, Scandinavia, and elsewhere.[3] Along with these

courses, a loosely knit international community of design historians emerged, abetted by a number of institutional achievements—the founding of the Design History Society in Great Britain in 1977 and the Scandinavian Forum of Design History in 1983, the series of regular conferences and special events organized by these and other groups, several international design history conferences, and the establishment of scholarly journals that have given design historians a place to publish their research.[4]

The importance of design history has been intermittently recognized as well by design professionals. Sessions conducted by historians have been held at national and international design conferences and congresses such as those organized by the International Council of Graphic Design Associations (ICOGRADA) and by the Industrial Designers Society of America (IDSA). ICOGRADA formed a Design History Working Group that communicated by mail for several years in the mid-1980s and produced a design history bibliography.[5] Although the national and international design associations have not developed a sustained involvement with design history, this does not detract from the subject's powerful pedagogical effect on future designers. Through design history courses taught by design historians or studio design teachers, design students in many countries have come to understand the wider cultural context in which designers have worked in the past and in which they continue to work today.

To think of design history as a discipline based on firm assumptions of what design is and how we might study its past is to ignore the dynamic crossings of intellectual boundaries that are occurring elsewhere. For example, researchers outside design history have discovered design to be a rich topic of historical investigation, and some of the best of design history's incipient scholarly accomplishments have come from scholars in other fields such as art history, American studies, and history itself.

When design history first began to emerge in Great Britain, those involved felt it important to mark the subject "design" with boundaries that would shape the development of its historical accounts. In the late 1970s, John Blake, an administrator at the British Design Council, urged that design history become "a kind of coagulation of ideas" that could develop into "a recognizable body of knowledge which can be unequivocally labeled 'design history'—not as an appendage of the history of art, not as an appendage of the history of architecture, not as an appendage of the history of technology or of anything else for that matter though with obvious connections with all these things."[6]

Since that time a body of research has accumulated but, seen in retrospect, this material, which is diverse both in method and in subject matter, does not explain what the framework of investigation is for a design historian. We

have, nonetheless, advanced far beyond the limited boundaries established by scholars who first began to write historical accounts of design activity.

Design history has not developed on the basis of a well-understood subject matter or a set of methods and principles to guide research. Instead, it has grown as a response to the initial literature in the field, first celebrating it and then criticizing it. Among the early texts that framed the terms of later debates, the most influential was Nikolaus Pevsner's *Pioneers of the Modern Movement*, initially published in 1936 and later revised as *Pioneers of Modern Design from William Morris to Walter Gropius*. I want to look more closely at this book for several reasons; first, because it proposed a narrative for design history from which most design historians working today have departed; and second, because it raises the question of what contribution any historical narrative can make to the understanding of design. For my analysis, I have used the revised edition of 1960, which still contains the basic premises that Pevsner stated in 1936. The fact that he did not substantially change his views in the intervening years is a testament to the firm conviction he had about his initial thesis.

Trained in Germany as an art historian, Pevsner was one of a small group of scholars who sought to identify a distinctive quality of modernity in selected art, architecture, and functional objects of their day. Like many of his German predecessors, he infused his narrative with a high sense of morality. He was concerned with establishing firm grounds for aesthetic discrimination, an enterprise that he expanded from its source in connoisseurship to signify a sense of belonging to one's age. For Pevsner, certain objects were modern and others were not. Toward the end of *Pioneers*, we find the following statement, which faces a photograph of the model factory that Walter Gropius and his partner Adolph Meyer designed for the 1914 Werkbund exhibition in Cologne:

It is the creative energy of this world in which we live and work and which we want to master, a world of science and technology, of speed and danger, of hard struggles and no personal security, that is glorified in Gropius's architecture, and as long as this is the world and these are its ambitions and problems, the style of Gropius and the other pioneers will be valid.[7]

To sustain this moral high ground, Pevsner set up a Manichaean dichotomy between virtue, represented by the work of Gropius and the other pioneers he admired, and vice, which he found embodied in the cluttered and hyperornamented style of British goods at the Great Exhibition of 1851. He accounted for the exhibition's horrible state of affairs in the following manner:

Economists and philosophers were blind enough to provide an ideological foundation for the criminal attitude of the employer. Philosophy taught that the unthwarted development of everybody's energy

was the only natural and healthy way of progress. Liberalism ruled unchecked in philosophy as in industry, and implied complete freedom for the manufacturer to produce anything shoddy and hideous, if he could get away with it. And he easily could, because the consumer had no tradition, no education, and no leisure, and was, like the producer, a victim of this vicious circle.[8]

Pevsner's method is a very traditional one in German philosophy. He established a Kantian category for the sublime, which he equated with the style of the modern movement, and then he told the story of a quest to achieve it. The book ends in triumph. Pevsner found the sublime in the work of Gropius and his fellow pioneers and by 1960 still believed that this work embodied the true principles of design.[9]

The examples that Pevsner included in his narrative are united only by his own a priori judgment that they represent stages of a quest for truth. Thus, *Pioneers* does not respond to John Blake's challenge that design history become "a recognizable body of knowledge." The agenda that underlies Pevsner's book excludes most of what we would accept today as appropriate subject matter for design history. Not only did Pevsner establish strict geographic limits to his investigation—its primary focus was Western Europe and Britain—but he also excluded all the objects of daily life that ordinary people use. For Pevsner, the study of design was an act of moral discrimination by which ordinary objects were separated from those which embodied an extraordinary quality.[10] It was this entanglement of morality with subject matter that still makes *Pioneers* problematic.

Pevsner did, however, find support for his values after he moved to England in 1933. British critics such as John Gloag and Herbert Read saw in his method a means to argue for the improvement of British design. In *An Enquiry into Industrial Art in England,* the results of a survey Pevsner conducted of manufacturing in the Midlands, he concluded that "90 percent of British industrial art is devoid of any aesthetic merit."[11]

Given Pevsner's restrictive view of objects worthy of historical investigation, it is no wonder that so many efforts have been made since his book was published to broaden the subject matter of design history. In England, Reyner Banham was one of the first to promote an infatuation with popular culture, particularly that which originated in America. Banham, a member of the Independent Group, a circle of artists, architects, and critics who gathered at the Institute of Contemporary Art in London in the early 1950s, was an important link to Pevsner since he had written his dissertation, later published as *Theory and Design in the First Machine Age,* under Pevsner at the Courtauld Institute of Art.

During the 1950s, Banham was active as a critic of architecture and de-

sign for the *Architectural Review* and other publications. In this capacity he conveyed an enthusiasm, infused with critical intelligence, for mass-produced objects as well as the diverse products of contemporary popular culture.[12] In a now-classic essay, "Who Is This 'Pop'?" he made an important connection between Pevsner's discerning approbation of modern architecture and design and the enthusiasts of popular culture. Distinguishing between a Pop Art connoisseur and a fine art connoisseur, Banham stated that "[t]he opposition is only one of Taste, otherwise the training required to become a connoisseur is the same."[13] Although as a critic he wrote many articles about mass culture, Banham did not associate with the design history movement in England until the early 1970s when he contributed a volume on mechanical services to the Open University course on modern architecture and design and participated in a conference on design and popular culture at Newcastle Polytechnic. For the Newcastle conference, he presented a paper on American cars entitled "Detroit Tin Revisited."[14] In an obituary on Banham, published in the *Journal of Design History,* Penny Sparke stated the importance of this intervention. For her, the paper "served to bring into the context of the newly forming subject, the history of design, the work in the area of mass culture with which he [Banham] had been involved since the mid-1950s."[15] Noting the further significance of Banham's writing, she said that

[n]ot only was it not dated, but it served to introduce into the new discipline an element which did not depend entirely upon either the historical period or theoretical underpinnings of the Modern Movement. This was an important message, the full significance of which has still not been totally grasped, and to which those design historians who are today grappling with such areas as consumption, feminism, taste, and object semantics are still totally indebted.[16]

Sparke is correct in attributing to Banham a seminal role in opening up the subject matter of design history. His work gave younger historians the confidence to explore the history of mass-produced goods of all kinds. But Banham provided no principles for defining design as a subject with defensible boundaries.

Another British design historian, John Heskett, brought a new set of concerns to design history when he wrote about military airplanes, tanks, and armored vehicles in a history of industrial design that was published in 1980. With a particular interest in understanding the conditions for design innovation, Heskett noted that the design of weapons was "heavily conditioned by military attitudes."[17] Opening up a line of inquiry that few design historians have followed since, he declared that "[t]he aesthetics of fear are rarely discussed, or even acknowledged, yet the powerful impersonal forms of military weaponry are

among the most widespread and evocative images of our age."[18]

Yet, despite design history's enlargement to include popular culture and military weaponry, we must also note from a feminist point of view in the 1980s that its subject matter still seemed too narrow. Cheryl Buckley cogently argued in 1986 that

[t]o date, design historians have esteemed more highly and deemed more worthy of analysis the creators of mass-produced objects... To exclude craft from design history is, in effect, to exclude from design history much of what women designed. For many women, craft modes of production were the only means of production available, because they had access neither to the factories of the new industrial system nor to the training offered by the new design schools. Indeed, craft allowed women an opportunity to express their creative and artistic skills outside of the male-dominated design profession.[19]

Embroidery Studio, Royal School of Art Needlework, c. 1905.

What we have seen thus far is a progressive opening up of design history to include topics well beyond what Pevsner would have been willing to recognize as valid. As further material for inclusion we could cite design in Asia, Africa, Latin America, and other regions of the world outside the European and North American orbit. But even having done that, we would still be faced with the nagging problem of whether and how we might establish boundaries for the field. We already have a fragmentation into histories of craft, graphic design, and industrial design. While these divisions serve expedient purposes for the education of students who are preparing for careers in one or another of the craft or design professions, they have no legitimate correspondence to fundamental categories of design activity and are simply stopgap measures to hold off the inevitable problem of trying to define "design" itself.

In the first chapter of his book *Disegno Industriale: Un Riesame* (Industrial Design: A Reexamination) entitled "Definition," Tomás Maldonado made an attempt to define industrial design, which is only one aspect of the larger topic: "By industrial design is meant, normally, the planning of objects fabricated industrially, that is, by machine, and in series."[20] But Maldonado notes that this definition is not quite satisfactory since it fails to distinguish between the activity of the industrial designer and what traditionally belonged to the engineer. It is difficult, he says, to demarcate where in the design of an industrial product the work of one ends and the other begins. Maldonado also finds problems with past attempts to produce a single history of modern design and concludes that "[s]trictly speaking, it is not a question of one history but of multiple histories."[21]

Maldonado is correct in pointing out the difficulty of demarcating distinctions between different kinds of design activity. The definition of what an indus-

trial designer does has changed many times in the past and will continue to change in the future. As evidence of this phenomenon in engineering, Yves Deforge has discussed the nineteenth-century training of the engineer as follows:

During the transition period, which lasted in some cases until the beginning of the twentieth century, the training of engineers still included the knowledge of construction technology or industrial science, as well as *an initiation into the knowledge of styles* and to academic art design. This training let them conceive of interesting ensembles in which the sign function was manifested by forms and decorations inspired by classical styles or by the imitation of architectural effects.[22]

After many years of separation in the twentieth century between education for what Deforge calls the *utility function,* represented by the technical training of engineers, and the *sign function,* exemplified by the more aesthetic education of industrial designers, we now have a few designers who have revived the more comprehensive nineteenth-century practice by obtaining degrees in both engineering and industrial design.

The point I want to make here is that *design* does not signify a class of objects that can be pinned down like butterflies. Designing is an activity that is constantly changing. How, then, can we establish a body of knowledge about something that has no fixed identity? From a nineteenth-century point of view, this is a troubling question. The nineteenth-century mind thrived on classification. During this period, great museums were built to house collections of discrete objects such as flora and fauna, high art, decorative arts, and technology. Boundaries between the natural and the artificial were clearly drawn. Art was also differentiated from craft, and the two were further distinguished from technology. This is the legacy that clearly informed Pevsner's history and it continues to bedevil us today.

But currently in the universities, as in the museum world, powerful intellectual forces are breaking down the boundaries that once seemed to immutably separate fields of knowledge. Let us take art history as an example. Its subject matter has broadened to include such topics as billboards, museum displays, and souvenirs. Design history too has been incorporated within the art historian's purview without anyone batting an eye. And art history's methods have multiplied extensively as scholars have drawn upon critical theories in many other fields and disciplines such as anthropology, sociology, philosophy, and psychoanalysis. At this point, one could even argue that the term "art studies" more effectively accounts for the diverse range of practices that today constitute what is being researched and taught in departments of art history throughout the United States and elsewhere.

In a cogent essay entitled "Blurred Genres: The Reconfiguration of Social Thought," the anthropologist Clifford Geertz states that "the present jumbling of varieties of discourse has grown to the point where it is becoming difficult either to label authors (What is Foucault—historian, philosopher, political theorist? What Thomas Kuhn—historian, philosopher, sociologist of knowledge?) or to classify works (What is George Steiner's *After Babel*—linguistics, criticism, culture history? What William Gass's *On Being Blue*—treatise, causerie, apologetic?)."[23] Geertz continues:

It is a phenomenon general enough and distinctive enough to suggest that what we are seeing is not just another redrawing of the cultural map—the moving of a few disputed borders, the marking of some more picturesque mountain lakes—but an alteration of the principles of mapping.[24]

Seen from Geertz's view of how intellectual discourse is changing, the expansion of design history's subject matter since the mid-1930s when Pevsner published *Pioneers* might be considered to be just another redrawing of the design map. Although this expansion has continued in recent years to include more new topics such as design in regions outside Europe and the United States and the investigation of issues related to consumption, it has not contributed to a radical rethinking of how we reflect on design itself.

When Geertz writes about "an alteration in the principles of mapping," he is referring to the contemporary suspicion of long-standing methods of interpretation in disciplines as diverse as ethnography, philosophy, and even economics.[25] Basic interpretive methods in what were once established disciplines are now being challenged, and in some instances, rejected. This is not simply a temporary phenomenon but a fundamental revolution in the kinds of reflection we want to engage in as human beings, since what we regard as knowledge is simply the codification of our collective experience in the world.[26]

Having begun with such a limited subject matter as Pevsner provided, it is understandable that significant energy would have been expended in broadening the range of topics that design historians might study. Although we have begun to incorporate new material from the less-developed regions of the world, we have also learned from a number of feminist historians that entire categories of objects, regardless of where they were designed or produced, are suspect because of their relation to patriarchal culture, which extends across all geographical regions.

Feminism has provided a powerful critique of design history, although feminist historians are divided among those who have maintained a static definition of "design" and history's relation to it and those who are interested in using history to explore what a new feminist design practice might be like.[27]

Despite these differences, however, feminists have had to break down the distinctions between history, theory, and criticism in order to establish a different vantage point from which to view design and design history.

But even when we look at design from new positions, we must still ask ourselves whether we are studying a specific class of things that are stabilized in categories such as crafts or industrially produced objects or whether the subject matter of design is really much broader. I think the latter is true. The history of design in the twentieth century shows us that designers have not been constrained by a set of principles and rules that proscribed the scope of their work. Rather, they have invented the subject matter of their profession as they have gone along.

Henry Dreyfuss and Norman Bel Geddes, for example, moved from designing products to creating model cities for the New York World's Fair in 1939, while Raymond Loewy designed a Rocketport of the future for the same fair and later went on to work for the National Aeronautics and Space Administration on the interior of the Skylab. In the postwar years, Charles and Ray Eames and many other designers invented entirely new projects that were not imagined by the earlier consultants. In Italy, several generations of designers, which includes Franco Albini, Ettore Sottsass Jr., Mario Bellini, and Andrea Branzi—all trained initially as architects—have continually moved back and forth between design, architecture, and urbanism. And we should not forget R. Buckminster Fuller, whose career as an engineer and designer defies all previous categories of practice.

R. Buckminster Fuller with a model of his Dymaxion House, c. 1927.

Given this process of continual invention that expands our prior understanding of what designers do, it makes more sense to conceive of design as broadly as possible in order to lay the foundation for its study. If we consider design to be the conception and planning of the artificial world, we can recognize the artificial as a mutable category that is changing rapidly as human invention repeatedly challenges its relation to the natural. To grasp the significance of artificial intelligence, genetic engineering, and nanotechnology, we must progressively enlarge our understanding of what design is while we are simultaneously occupied with establishing its historical narratives.

The momentous changes that the world is currently undergoing are forcing us to reconsider how we approach design as a subject of study. I would argue that it is the broad activity of designing, with its multifarious results, that can open up for design historians a range of important new questions that have not been coherently posed before and simultaneously can enable designers to consider new possibilities for practice.

Using an enlarged conception of the artificial as the basis for our

inquiries, we can thus undertake new investigations of what designing is and how it affects the way we organize possibilities for human action. These questions then force us to reconsider how we have previously constituted design's history. Since we cannot isolate a fixed class of products—whether material or immaterial—as the subject for design history and because we need to think instead of designing as an act of continuous invention, it is not realistic to believe that we can mark out a stable terrain that can be claimed by design historians. What I foresee instead is that design can serve as a powerful theme around which the most diverse kinds of inquiries, related to history as well as to the contemporary situation, can be organized.

I therefore want to propose two locations for design history—one in relation to the discourse and particular concerns of its own practitioners and the other in relation to the wider field of design discourse, where it can contribute to the ongoing research about design and its future. Within this wider field, history can play a powerful role that is currently being neglected. Historians bear the knowledge of design's best practice from the past as well as the recognition of design policies and activities that need not be repeated.[28] They are also able to hold up standards based on experience and extrapolate from prior activities possibilities for the future. As the formation of a design research culture intensifies, it will be important to have historians involved in order to engage with the current issues of professional concern and to provide a "long view" that is otherwise lacking.

Until now, few design historians have sought such a role. While it may be argued that design history is a relatively new field and that the historian's energies are best turned to the development of his or her own research community, it can also be propounded that design historians are urgently needed to prevent design discourse from taking too strong a turn toward technique as the dominant topic of research. Historians have the capacity to help shape the consciousness of the design community and to contribute to the articulation of its ideals, principles, and research agendas.

The tension between reflection and technique, which I want to differentiate from the classic theory-practice dichotomy, is marginalized or subdued in many professions. In social work doctoral research, for example, at least as it is conducted in many American universities, there are courses in social work history, which are usually taught by social work academics, but students are strongly encouraged to do quantitative research projects for their dissertations. Such tensions exist in other fields like urban planning, where it is often those engaged with current policy issues who dominate the reflective side of planning education.

A stronger engagement by historians with the burgeoning culture of de-

sign research would not mean the end of the Design History Society or any other group of design historians that convenes to develop design history as a field. It would mean a greater openness on the part of design historians to confront and reflect on issues of current practice and to engage with design researchers who have different interests than their own.

This engagement should work in two directions. First, it can contribute to the wider discourse on design and help to shape design reflection as an activity grounded in historical experience as well as current technique; and second, it can open up the subject matter of design history to new topics that would otherwise be missed. Incorporating design history within a wider field of design studies invites a dialogue with other researchers besides historians. This does not detract from design history's own identity, but it counters the tendency to maintain it as a separate field of activity that has primary relevance to its own practitioners.

In "The Multiple Tasks of Design Studies" below, I present a pluralistic vision of design studies that can encompass very different kinds of knowledge. For my purpose here, I will simply define design studies as the field of inquiry that addresses questions of how we make and use products in our daily lives and how we have done so in the past. These products comprise the domain of the artificial. Design studies addresses issues of product conception and planning, production, form, distribution, and use. It considers these topics in the present as well as in the past. Along with products, it also embraces the web of discourse in which production and use are embedded. Its subject matter includes visual and material culture, as well as the design of processes and systems.

Scholars in different spheres of research are already contributing to a wider discourse about design. In cultural anthropology, for example, Mary Douglas and Baron Isherwood, Grant McCracken, Daniel Miller, and others have written extensively about consumption, although they focus on it as a symbolic act while ignoring questions of how products are designed and made as well as how they are actually incorporated into the daily activities of users. In his important book, *Material Culture and Mass Consumption,* published in 1987, Miller was particularly critical of the kind of design history that is "intended to be a pseudo art history, in which the task is to locate great individuals such as Raymond Loewy or Norman Bel Geddes and portray them as the creators of modern mass culture."[29] Since *Material Culture and Mass Consumption* was published, Miller has participated in several conferences that have been sponsored or cosponsored by the Design History Society in Britain, and his book has been cited by some design historians as being an important work for the field. Miller has focused his attention on the consumer and asserted, along with other

anthropologists, that consumption is not a passive act but a creative project through which people put products to use in ways that were not necessarily intended by those who designed and produced them. He has thus broadened the context within which to study products in contemporary culture.

However, I do not wish to privilege cultural anthropology as the disciplinary base for design studies. It is only one of a number of established disciplines and fields—the philosophy of technology, general systems theory, cultural studies, and cognitive psychology, among them—whose scholars are now beginning to recognize the significance of design in contemporary life. As I reflect on the form that design studies might take in a university setting, I do not envisage a new discipline that will close its boundaries to interventionists from elsewhere. I would follow the lead of Robert Kates who was instrumental in establishing a program on world hunger at Brown University. Instead of focusing on the issue of disciplinary boundaries, Professor Kates emphasized the definition of problems for research:

But we are not a discipline, nor should we be one, despite our proto-theory, scholarly materials, or university courses. We need to be inclusive, not exclusive; we will need new skills and insights as our current inquiries change.[30]

The challenge for those of us who study design at the beginning of the twenty-first century is to establish a central place for it in contemporary life. This requires bold new conceptions and the kind of openness Professor Kates advocates, rather than the more limited thinking that has characterized much of design's study thus far. Historians have a central role to play in this process, and the question of whether they will take up the challenge remains.

1 For this account, I have drawn on a paper by Clive Ashwin, which was presented at a 1977 conference on design history at Brighton Polytechnic. See Ashwin, "Art and Design History: The Parting of the Ways?" *Design History: Fad or Function?* (London: Design Council, 1978): 98–102. See also Jonathan Woodham, "Recent Trends in Design Historical Research in Britain," in Anna Calvera and Miquel Mallol, eds., *Historia desde la periferia: Historia e historias del diseño. Actas de la 1ª Reunión Cientifica Internacional de Historiadores y Estudios del Diseño, Barcelona 1999/Design History Seen from Abroad: History and Histories of Design. Proceedings of the 1st International Conference of Design History and Design Studies, Barcelona 1999*, eds. Anna Calvera and Miguel Mallol (Barcelona: Universitat de Barcelona Publications, 2001), 85–97.

2 Penny Sparke, introduction to *Design History: Fad or Function?* 5.

3 See my essay "Design History in the United States, 1977–2000" in this volume.

4 An international gathering of design historians was organized by Anty Pansera,

Fredrik Wildhagen, and myself in Milan in May 1987. This was followed by another, planned by Paul Greenhalgh, Fredrik Wildhagen, and myself at the Victoria and Albert Museum in London in December 1990. The most recent event, arranged by Anna Calvera and entitled "First International Conference of Design History and Design Studies" (though it was not the first), was held in Barcelona in April 1999 and a follow-up to this event was held in Havana, Cuba, in June 2000. The proceedings of the Milan conference were published as *Tradizione e Modernismo, 1918/1940: Atti del Convegno (*Tradition and Modernism: Design between the Wars, 1918–1940: Congress Minutes), ed. Anty Pansera (Milan: L'Arca Edizioni, 1988). The proceedings of the Barcelona conference, edited by Anna Calvera and Miquel Mallol, were published in 2001 (see note 1 above). The first academic design journal to publish design history articles may have been *Design Issues,* which was founded in 1984. The *Journal of Design History* began publication in Britain in 1988 and the annual *Scandinavian Journal of Design History,* based at the Danish Museum of Decorative Art in Copenhagen, started in 1991. Most recently, the Bard Graduate Center for Studies in the Decorative Arts, Design and Culture established a new scholarly journal, *Studies in the Decorative Arts,* which frequently crosses over into design history. The Catalan journal *Temes de Disseny* also publishes scholarly design history articles on occasion, as does the Brazilian journal *Arcos.*

5 ICOGRADA's initiatives in design history were due to the vision of its then president, Jorge Frascara. He established a working group and found resources to publish the bibliography. See Victor Margolin, *Design History Bibliography* (London: ICOGRADA, 1987).

6 John Blake, "The Context for Design History," in *Design History: Fad or Function?* 56.

7 Nikolaus Pevsner, *Pioneers of Modern Design from William Morris to Walter Gropius* (Harmondsworth: Penguin, 1960), 217.

8 Ibid., 46.

9 Despite this conviction as stated in *Pioneers,* Pevsner had begun to rethink some of his views in the 1950s. See Pauline Madge, "An Enquiry into Pevsner's *Enquiry,*" *Journal of Design History* 1, no. 2 (1988): 122–123. Madge is referring to Pevsner's *An Enquiry into Industrial Art in England,* which was published in 1937.

10 An emphasis on discriminating taste can also be found in one of the major art history survey texts of the postwar years. See Horst Janson, *History of Art,* 2d ed. (New York: Prentice Hall and Harry N. Abrams, 1977).

11 Pevsner, *An Enquiry,* cited in Madge, "An Enquiry into Pevsner's *Enquiry,*" 122.

12 For a discussion of Banham's work as a critic, see Nigel Whiteley, "Olympus and the Marketplace: Reyner Banham and Design Criticism," *Design Issues* 13, no. 2 (summer 1997): 24–35.

13 Reyner Banham, "Who Is This 'Pop'?" in Reyner Banham, *Design by Choice,* ed. Penny Sparke (London: Academy Editions, 1981), 94.

14 Reyner Banham, "Detroit Tin Re-visited," in *Design, 1900—1960: Studies in Design and Popular Culture of the 20th Century,* ed. Thomas Faulkner (Newcastle: Newcastle upon Tyne Polytechnic, 1976): 120–140.

15 Penny Sparke, "Peter Reyner Banham, 1922–1988," *Journal of Design History* 1, no. 2 (1988): 141.

16 Ibid., 142.

17 John Heskett, *Industrial Design* (New York and London: Thames & Hudson, 1980), 190.

18 Ibid.

19 Cheryl Buckley, "Made in Patriarchy: Toward a Feminist Analysis of Women and De-
 sign," in Victor Margolin, ed., *Design Discourse: History Theory Criticism* (Chicago
 and London: University of Chicago Press, 1989), 255. The essay originally appeared
 Design Issues, 3, no. 2 (1986): 3–14. Buckley revisited and expanded her earlier
 views in an article published a decade later, "Made in Patriarchy: Theories of Women
 and Design—A Reworking," in *Design and Feminism: Re-Visioning Spaces, Places,
 and Everyday Things,* ed. Joan Rothschild with the assistance of Alethea Chang, Etain
 Fitzpatrick, Maggie Mahboubian, Francine Monaco, and Victoria Rosner (New
 Brunswick and London: Rutgers University Press, 1999): 109–118.

20 Tomás Maldonado, *Design Industriale: Un Riesame,* rev. and enl. (Milan: Feltrinelli,
 1991), 9. The first edition appeared in 1976.

21 Ibid., 16.

22 Yves Deforge, "Avatars of Design: Design before Design," in Victor Margolin and
 Richard Buchanan, eds., *The Idea of Design: A Design Issues Reader* (Cambridge: MIT
 Press, 1995), 21–28.

23 Clifford Geertz, "Blurred Genres: The Reconfiguration of Social Thought," in Geertz,
 Local Knowledge: Further Essays in Interpretive Anthropology (New York: Basic
 Books, 1983), 20.

24 Ibid.

25 See, for example, John S. Nelson, Allan Megill, and Donald N. McCloskey, eds., *The
 Rhetoric of the Human Sciences: Language and Argument in Public Affairs* (Madison:
 University of Wisconsin Press, 1987); and Donald N. McCloskey, *If You're So Smart:
 The Narrative of Economic Expertise* (Chicago and London: University of Chicago
 Press, 1990).

26 A good example of a design study that cuts across different fields is the catalog
 Household Choices, which was edited by the Household Choices Project in Britain,
 Tim Putnam and Charles Newton, eds., *Household Choices* (n.p: Futures Publications,
 1990). It includes essays by historians, anthropologists, urbanists, and specialists in
 housing and features several photographic sequences as well. John Murdoch, in his
 introduction to the catalog, noted the influence of new methods in art history and
 literary criticism on the study of design:

> The idea that the product, usually at the point of sale, might pass be-
> yond the control of its manufacturer into a realm of variable understand-
> ing, interpretation and use, seemed less familiar than it had recently
> become to art historians, and certainly less familiar than it was to critics of
> written texts. (5)

 Household Choices has brought us a considerable distance from Pevsner's *Pioneers
 of the Modern Movement,* a book with which it can hardly be compared. It does not
 moralize about the quality of products nor does it privilege the artifacts of the modern
 movement as more worthy of our attention than others. Neither does it give primacy
 to the designer's intentions in defining the meaning of a product. It suggests a more
 complex identity for the product than as simply the outcome of a design process. In-
 stead, it is located in a situation, and its meaning is created in part by its users.

27 Prominent in the feminist design history literature are Judy Attfield and Pat Kirkham, eds., *A View from the Interior: Feminism, Women, and Design* (London: Women's Press, 1989); Isabelle Anscombe, *A Woman's Touch: Women in Design from 1860 to the Present Day* (New York: Viking, 1984); Penny Sparke, *As Long as It's Pink: The Sexual Politics of Taste* (London: Pandora, 1995); and Pat Kirkham, ed., *Women Designers in the USA, 1900–2000: Diversity and Difference* (New Haven and London: Yale University Press, 2000). The broader issue of how objects take on a gender identification is addressed in *The Gendered Object,* ed. Pat Kirkham (Manchester and New York: Manchester University Press, 1996). See also Cheryl Buckley, "'The Noblesse of the Banks': Craft Hierarchies, Gender Divisions, and the Roles of Women Paintresses and Designers in the British Pottery Industry, 1890–1939," *Journal of Design History* 2, no. 4 (1989): 257–274; and "Design, Femininity, and Modernism: Interpreting the Work of Susie Cooper," *Journal of Design History* 7, no. 4 (1994): 277–294; as well as Suzette Worden and Jill Seddon, "Women Designers in Britain in the 1920s and 1930s: Defining the Professional and Redefining Design," *Journal of Design History* 8, no. 3 (1995): 177–194.

28 A good example of the latter would be the critique of the British Ministry of Trade's attempt to shape public taste while producing "utility products" during World War II and the subsequent endeavor of the postwar Council of Industrial Design to further this intention. See the excellent set of essays on the subject of utility design in Judy Attfield, ed., *Utility Assessed: The Role of Ethics in the Practice of Design* (Manchester and New York: Manchester University Press, 1999).

29 Daniel Miller, *Material Culture and Mass Consumption* (Oxford: Basil Blackwell, 1987), 142.

30 Robert Kates, "The Great Questions of Science and Society Do Not Fit Neatly into Single Disciplines," *Chronicle of Higher Education* (May 17, 1989): 81.

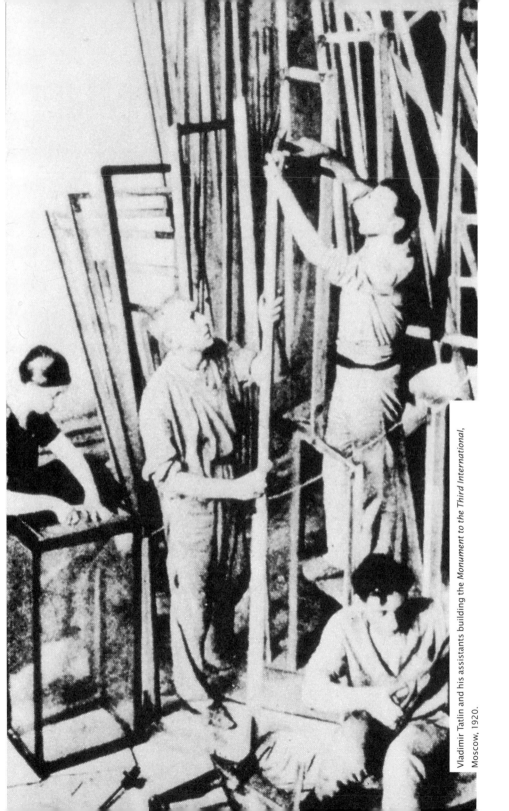

Vladimir Tatlin and his assistants building the *Monument to the Third International*, Moscow, 1920.

THE TWO HERBERTS

From the time Herbert Simon first proposed a "science of design" in 1969, this goal has remained elusive. There have been continuous efforts, particularly among design educators, to ground design in a body of rigorous domain knowledge that they believe constitutes a discipline of design, but there has been no agreement as to what this knowledge consists of. Among those who have actively led these efforts is Nigel Cross, editor of the British journal *Design Studies*. In an editorial of 1996, Cross spoke against inundating design with alien cultures from either science or art, although he recognized the value of borrowing from these cultures where appropriate. His basic concern was with legitimacy. "We have to be able to demonstrate that standards of rigor and relevance in our intellectual culture at least match those of the others," he wrote.[1]

In seeking legitimacy based on standards that exist within other research cultures, Cross echoed a concern of Simon's, that design be conceptualized as to be worthy of university study. In fact, Cross quoted extensively from Simon's essay, "The Science of Design: Creating the Artificial," in his editorial.[2]

Despite frequent citations of Simon's work as a precedent for a design science or discipline, what interpreters frequently miss in the above-mentioned essay is that Simon seeks to legitimize design as a science by reducing the role of intuitive judgment in the design process as much as possible. "In the past," he writes, "much if not most of what we knew about design and about the artificial sciences was intellectually soft, intuitive, informal, and cookbooky."[3] Instead, he defines a science of design as "a body of intellectually tough, analytic,

partly formalizable, partly empirical, teachable doctrine about the design process."[4] Thus, design thinking has to be transferable and verifiable in order to be legitimate.

Let us remember that Simon presented the lectures on which his book is based at the Massachusetts Institute of Technology, one of America's leading technical universities, and he defined his standards and criteria for a new science of design in terms that would be acceptable to a community of engineers. He therefore devoted considerable attention in his chapter on the science of design to forms of logic that would lead to efficient methods of problem-solving. Simon's bias toward a logical rigor that he believes is fundamental to a respectable design science is often overlooked by those who cite his work as a precedent for a new design discipline. Few design educators have sought, as Simon did, to articulate the elements of the design process in such a way that it, or parts of it, might be replicated by a computer—a goal that Simon advanced in "The Science of Design." He denigrates what he calls "cookbook methods," which he believes drove design from the engineering curriculum, and he negates judgment or experience as the bases for design because these cannot be articulated in a language that makes sense to engineers. Instead, he espouses design processes that have been embodied in "running computer programs: optimizing algorithms, search procedures, and special-purpose programs for designing motors, balancing assembly lines, selecting investment portfolios, locating warehouses, designing highways, diagnosing and treating diseases, and so forth."[5]

Simon's theory of design is an operational one. He is interested in strategies of decision-making that are based on mathematically derived procedures. His focus is on method rather than outcome. While he eschews judgment or experience as the basis for design decision-making, he uses precisely these qualities to characterize the *aims* of design, which are just as unsystematically defined in his theory as he might claim methodology to be in someone else's. He defines his examples, whether "cities, or buildings, or economies," as complex systems, thus enabling him to privilege the particular methods of problem-solving he has been espousing as the appropriate ones for designing them. Simon's design projects are simply given and not presented as entities that might be contested from other perspectives.

In the years since *The Sciences of the Artificial* and subsequent editions appeared, there has been little discussion about a science of design as opposed to a discipline, nor have those most concerned with issues of disciplinarity felt constrained by Simon's rejection of judgment and experience. But Simon's essay, with its deceptively catholic definition of design activity ("Everyone designs who devises courses of action aimed at changing existing situations into

preferred ones."), became the impetus for a direction in research activity that has focused more on creating objective models of the design process than on developing a critical theory of practice.

If the term "design science" had achieved wider currency, it would have excluded much of the design research and design activity that are occurring today. Attempting to validate the methods of design practice according to the discourse of science would simply create a hierarchy of activities based on a conception of logical rigor that would become, in my view, an unwelcome reference point for the legitimation of design as an academic subject.

I prefer a much more open conception of design activity that is not preoccupied with justifying a separate sphere of domain knowledge, as the primary purpose of research. I recognize the value of such knowledge but when it is sought or defined in too strict a manner, researchers tend to exclude other valuable perspectives. I instead welcome the multiplicity of discourses that can contribute to a greater understanding of design, both in its practical as well as its theoretical sense.[6]

Until now, the question of whether design should be considered a science, a discipline, or a more pluralistic practice has remained a marginal issue to be debated among theorists. But today the question has a new urgency. There is a growing worldwide movement to establish doctoral programs in design and build a serious academic research culture for the subject.[7] With the advent of such initiatives, it becomes imperative to interrogate the way we constitute design so that we can create the most fruitful conditions for its teaching and investigation. The question of doctoral education is particularly important since it will be through the research done in such programs that important new design knowledge will be created.

For a research community to be respected by researchers in other fields as well as by lay people, there must be some sense that the profession to which it is attached understands how to value and use the types of knowledge the community produces. It is therefore extremely important to frame a debate on the nature of design activity such that it can eventually lead to a greater understanding of what types of design research will be deemed valuable, even if these research tendencies are at odds with each other. I am not speaking here of an academic field that must agree on a single method or goal of research but instead, of one that recognizes and values a plurality of research methods and goals that bear some shared relation to the larger profession to which they relate.

I want to argue here that history, theory, and criticism should play a central role within the diverse field of design research and should be part of the curriculum in every program of doctoral education in design as well as in programs

at the undergraduate and master's level. Of the three subjects, theory has remained the most difficult to characterize and the most open to different interpretations. Design theory, as Herbert Simon defines it, complements the natural science curriculum "in the total training of a professional engineer—or of any professional whose task is to solve problems, to choose, to synthesize, to decide."[8] Simon proposes a theory of operations that includes utility theory, statistical decision theory, theories of hierarchic systems, and theories of logic.[9] The way he has positioned theory in his curriculum for a science of design makes it impossible to bring this subject into relation with history or criticism without challenging the unspoken justification for his own definition of design.

Although Simon is careful to distinguish design science from natural science, he has naturalized the methods of design and embedded them in a technical framework of designing. This framework privileges systems thinking as a means of generating design projects, and efficiency, as a way of judging the effectiveness of design thought.

Simon's definitions of design practice and theory fall within what the late philosopher Herbert Marcuse called "technological rationality." This, Marcuse says is "*a pattern of one-dimensional thought and behavior* in which ideas, aspirations, and objectives that, by their content, transcend the established universe of discourse and action, are either repelled or reduced to the terms of this universe. They are redefined by the rationality of the given system and of its quantitative extension."[10] Clearly, Simon's rejection of judgment and experience as nonquantifiable and nontransferable sources of design thought fit Marcuse's assertion.

Marcuse goes on to argue that closed systems of rationality define the universe in which everyone lives according to the terms of those in control. While I don't wish to argue that design education should have an explicit ideological orientation, I do want to note the relevance of Marcuse's critique to the way we position history, theory, and criticism in design education. What happens at the undergraduate and master's levels is that courses in these subjects are subordinated to the logic of practical training. They provide some form of academic legitimation and modest consciousness-raising but are not expected to interrogate or challenge the rest of the design curriculum. In short, they are incorporated within a system of pedagogical rationality.

The subordinate place of history, theory, and criticism in design education is concomitant with the difficulty most designers have in envisioning forms of practice other than those already given by the culture. And yet, as Richard Buchanan has argued,

The assumption is that design has a fixed or determinate subject matter that is given to the designer in the same way that the subject mat-

ter of nature is given to the scientist. However, the subject matter of design is not given. It is created through the activities of invention and planning, or through whatever other methodology or procedures a designer finds helpful in characterizing his own work.[11]

Buchanan does not foreground a political agenda as Marcuse does, but his characterization of design as indeterminate coincides with Marcuse's concern for critical reflection on the way we create and perpetuate social practices. Although some would claim that the task of the designer is given by the structure of the culture, notably the activity of business enterprises, I have argued in several of the preceding essays that we don't yet know the limits of what might be designed. As Marcuse states,

Every established society . . . tends to prejudge the rationality of *possible* projects to keep them within its framework. At the same time, every established society is confronted with the actuality or possibility of a qualitatively different historical practice which might destroy the existing institutional framework.[12]

If we acknowledge design's indeterminacy and accept Marcuse's explanation of how established society can close out alternative possibilities, we need to then recognize that design theory at its most fundamental ought to be a theory of how design does and might function in society rather than simply a theory of techniques. Marcuse's critique of technological rationalism provides a basis for embedding design thought within the larger activity of social thought rather than isolating design from its social situation and theorizing independently about its processes of invention. By holding design in our vision as a social practice, we are always obliged to consider and evaluate the situations in which it occurs rather than naturalizing design techniques as Simon does.

When we acknowledge our relation to the social as part of our relation to design, we can find in Marcuse's thought a cogent argument for making history, theory, and criticism central to all design education. Marcuse provides the justification for joining them in an integral project of design reflection that can offer a critical understanding of practice and of pedagogy as well.

As an antidote to the one-dimensionality of technological rationalism, Marcuse proposes a dialectical logic that arises from a space outside the dominant system of thought and practice. What embodies dialectical logic is history. Dialectical logic "attains its truth if it has freed itself from the deceptive objectivity which conceals the factors behind the facts—that is, if it understands its world as a *historical* universe, in which the established facts are the work of the historical practice of man."[13]

Historical events exist outside current circumstances, yet they mark the continuity of human experience. Struggles from the past can also become

struggles in the present. Historical experience can offer alternatives to current situations and provide the substance for evaluating the present from a position outside its own logic. Two-dimensional thought for Marcuse is critical thought, which is resisted by the dominant culture.

The given reality has its own logic of contradictions—it favors the modes of thought which sustain the established forms of life and the modes of behavior which reproduce and improve them. The given reality has its own logic and its own truth; the effort to comprehend them as such and to transcend them presupposes a different logic, a contradicting truth.[14]

Marcuse rightly notes that these different logics are nonoperational and may appear weak according to the criteria of the dominant system. This fact is exemplified by the distinctions that some scientists make between hard and soft science, which frequently get played out in the politics of academic promotion and grant getting. It refers us also to the concern Cross expressed in his *Design Studies* editorial regarding his design research colleagues who may have been denied tenure because their work was not seen to be sufficiently rigorous. It points us as well to Simon's preoccupation with logical rigor as a dominant criterion for evaluating design thought.

This is not to say that dialectical thought is not rigorous. But history, and theory, too, can easily be seen as "soft" thought compared with the "hard" logic of science. Thought that conforms to the dominant values of a system will always appear more legitimate than that which arises outside those values. And yet, history can provide us with examples that offer persuasive grounds for a critique of the present.

The practice of William Morris shows us the power of dialectical logic. Morris countered the logic of industrialization, exemplified by the division and mechanization of labor, with the preindustrial practice of craft production. He also sought to employ this thinking strategically in his various enterprises. Although he neither succeeded in changing the industrial system nor in institutionalizing an enduring alternative, his thought and practice kept alive an oppositional critique of what many perceived to be the dehumanizing aspects of industrialization. Morris's ideas have been sustained until now through a distinguished lineage of design thinkers, educators, and practitioners ranging from Walter Gropius to E. F. Schumacher. As a thinker and practitioner, Morris has had a tremendous influence on later designers, educators, and theorists because he so strongly articulated an opposition to the technical rationality of his day. His arguments are still persuasive as we struggle to make sense of the current turbulence of technological innovation.

When history, theory, and criticism are marginalized within design thought, the social conditions of design practice recede in importance. What some educators want to call domain knowledge is primarily operational knowledge rather than knowledge that expands and refines the designer's self-awareness, thus enabling him or her to make more informed judgments about values and goals. However, it is not enough to simply readmit judgment and experience to the design imagination. These qualities require analysis and cultivation. They must be treated as subjects in their own right.

History is our collective experience. The more we know of it, the more we can use it to question the prevailing values of society. To be without a knowledge of history is to give up a space outside the system where one can find alternatives and also empowerment for change. If, indeed, we are to recognize the contingency of design, we should acknowledge the contingency of social systems. It is paradoxical to speak of design's indeterminacy and then frame it in a determined situation of practice. If designers are going to realize the full potential of design thought, then they should also learn to analyze how the situations that frame design practice are themselves constructed.

A reduced model of Tatlin's *Monument to the Third International* being drawn through the streets of Leningrad in a parade, 1926.

Design occurs within a social space, and its very contingency is guided by the values and limits that inform particular projects. Design theory needs to acknowledge the interplay between the techniques of operational activity and their cultural impact and reception. Marcuse notes that "a specific historical practice is measured against its own historical alternatives."[15] This recognition is essential for the critical practitioner. Moving Marcuse's project for the cultivation of critical thought to a more central place in design education and practice is to recognize its importance to the development of self-consciousness and socially aware designers and scholars. They are the ones in the best position to set the design agenda for the next generation.

1　Nigel Cross, editorial, *Design Studies* 17, no. 1 (1996): 1.

2　Although Cross makes reference to Simon in his writings, he is not in agreement with Simon's concept of a "science of design." For Cross, there is a distinction between "design science," a rigorous attempt to extract knowledge from the natural sciences for the designer's use, and his own, as opposed to Simon's, concept of a "science of design," that "attempts to improve our understanding of design through 'scientific' (i.e., systematic, reliable) methods of investigation." Cross states explicitly that "a 'science of design' is not the same as a 'design science,'" something that he opposes. See Nigel Cross, 'Designerly Ways of Knowing: Design Discipline versus Design Science," in Silvia Pizzocaro, Amilton Arruda, and Dijon De Moraes, eds., *Design Plus Research: Proceedings of the Politecnico di Milano Conference May 18–20* (Milan: Politecnico di Milano, PhD Program in Industrial Design, 2000), 45.

3　Herbert Simon, "The Science of Design: Creating the Artificial," in Simon, *The Sciences of the Artificial*, 3d ed. (Cambridge: MIT Press, 1996), 112.

4　Ibid., 113.

5　Ibid., 135.

6　Don Levine provides an intriguing discussion of disciplinarity in his article, "Sociology and the Nation-State in an Era of Shifting Boundaries," *Social Inquiry* 66, no. 3 (August 1996): 253–266. Levine argues for the obsolescence of disciplinary boundaries in the social sciences when he states, "At present few major concepts, methods, or problems belong exclusively to a single social science discipline" (259). He then goes on to compare academic disciplines with nation-states and concludes that disciplines remain valuable as institutions that provide elements of professional identity but he believes that, like nation-states, bounded disciplines have been severely undermined by the emergence of larger forces and tendencies.

7　See Richard Buchanan, Dennis Doordan, Lorraine Justice, and Victor Margolin, eds., *Doctoral Education in Design: Proceedings of the Ohio Conference* (Pittsburgh: School of Design, Carnegie Mellon University, 1999). This was the first conference on the subject. It was attended by approximately seventy-five people from more than seventeen countries. The second conference was held two years later at La Clusaz, France and the papers from that conference were published in David Durling and Ken Friedman, eds., *Foundations for the Future* (Staffordshire: Staffordshire University Press, 2000).

8　Simon, "The Science of Design: Creating the Artificial," 136.

9　Ibid., 134–135.

10　Herbert Marcuse, *One-Dimensional Man* (Boston: Beacon Press, 1964), 12. Marcuse first introduced this term and the concept of social hegemony in a 1941 article, "Some Social Implications of Modern Technology," in Douglas Kellner, ed., *Technology, War, and Fascism: Collected Papers of Herbert Marcuse, Volume 1* (London and New York: Routledge, 1998), 39–66. When the article was expanded to become the basis of *One-Dimensional Man*, the earlier references to Fascism as an embodiment of technological rationality were dropped. Instead, Marcuse focused his critique on the system of global industrial capitalism.

11　Richard Buchanan, "Rhetoric, Humanism, and Design," in *Discovering Design: Explorations in Design Studies*, ed. Richard Buchanan and Victor Margolin (Chicago and London: University of Chicago Press, 1995), 24.

12 Marcuse, *One-Dimensioinal Man*, 219.

13 Ibid., 140.

14 Ibid., 142.

15 Ibid., x.

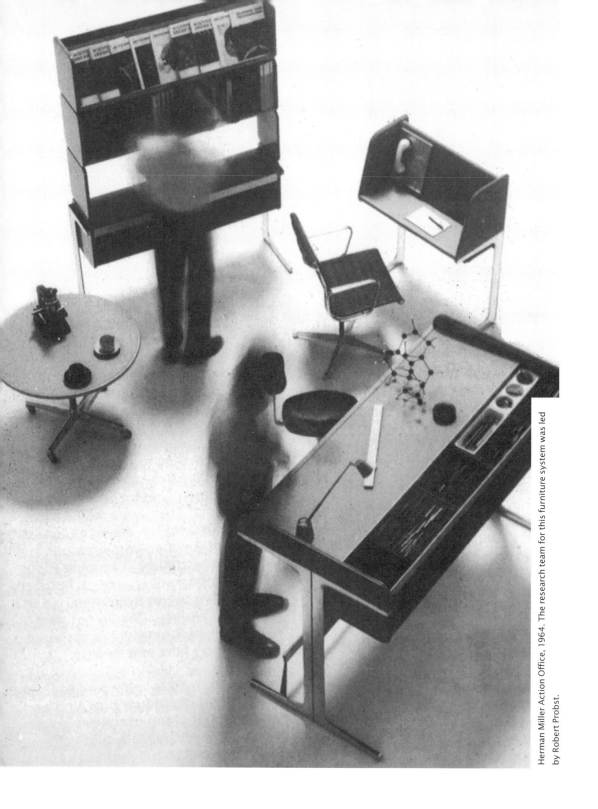

Herman Miller Action Office, 1964. The research team for this furniture system was led by Robert Probst.

THE MULTIPLE TASKS OF DESIGN STUDIES

INTRODUCTION The term "design studies" may have originated in the eponymous title of the journal that was founded in Great Britain in 1979, but it is also used to designate a burgeoning academic field that is constituted more broadly. Interest in this new field has gone hand in hand with the growing attentiveness to design research, an activity with an extremely wide scope whose objectives and methods are just beginning to be articulated.

Some researchers currently work within well-defined communities that relate to their specific interests, while others work alone. Within these communities, there are regular meetings on design history, design management, ecodesign, design thinking research, and artificial intelligence, which are supplemented by listservs and periodic international conferences at which particular research interests are shared. However, recently there have been a number of moves to create broader forums where these diverse interests can be questioned, challenged, and debated with the understanding that what is at stake is the emergence of a single research community related to the subject of design.[1]

One of the big splits among researchers is between those who seek to ground design research in some notion of disciplinarity or domain knowledge that is modeled on the natural or social sciences, and others who prefer a more open and pluralistic approach that includes interpretive methods from the humanities as well.[2] There is also a division between researchers who are focused on pragmatic ends such as design management or design for manufacturing and those for whom design research is a more speculative enterprise.

This lack of a shared community among all design researchers has also been a factor in design education. Unlike most advanced degree programs where students are introduced to the debates and conflicts in their field, no degree program in design at the master's or doctoral level has ever acquainted students with all the existing design research areas; hence, academic programs in design have remained limited in subject matter. With the growing movement to establish more doctoral programs in the field, we face the challenge of creating academic cultures that foster in students a wider understanding of design research. I will make a bold rhetorical move here and propose that "design studies" be the term that embraces the full range of these research efforts and becomes the conceptual location or "topos" where they can be brought into relation with each other.[3] In doing so, I want to build on and improve earlier efforts to accomplish a similar goal.

DESIGN METHODS The most ambitious attempt until now to establish a broad research culture for design was the design methods movement, whose members were primarily active in Great Britain for about twenty years beginning in the early 1960s. Pioneering design methods conferences were held at the Imperial College in London in 1962 and in Birmingham in 1966. The 1967 symposium, hosted by Portsmouth Polytechnic, was, in Geoffrey Broadbent's words, "a watershed in design method studies."[4] At that symposium the organizers set up a confrontation between two groups, one identified as "behaviorists" and the other as "existentialist/phenomenologists." The two extreme positions that these groups represented were characterized, on the one hand, by the quest to find neutral techniques for the measurement of human behavior and, on the other, by an attempt to foster a unique individuality in each person. The polarization raised concerns that led several major figures to leave the movement, as Christopher Alexander did, or to strongly challenge its premises, as did John Chris Jones.[5] According to Alexander, reflecting in 1971 on the design methods movement,

Rationality, originally seen as the means to open up the intuition to aspects of life outside the designer's experience, became, almost overnight, a toolkit of rigid methods that obliged designers and planners to act like machines, deaf to every human cry and incapable of laughter.[6]

And Jones, writing in 1991, had a similar recollection:

We sought to be open minded, to make design processes that would be more sensitive to life than were the professional practices of the time. But the result was rigidity: a fixing of aims and methods to produce designs that everyone now feels to be insensitive to human needs.[7]

Despite these defections, however, conferences on design methods and research continued in England during the 1970s and into the early 1980s. Speaking at a conference of the Design Research Society in 1981, Bruce Archer, an engineer who headed the Department of Design Research at the Royal College of Art for many years and was one of those characterized as a behaviorist at the 1967 Portsmouth symposium, proposed an ambitious agenda for design research that included no less than ten categories. Archer's agenda was based on the belief that a body of pure knowledge could be discovered by dividing design into a series of discrete topics, each of which would yield its own truths. Design taxonomy, for example, was to focus on "the classification of phenomena in the Design area"; design praxiology referred to "the nature of design activity, its organization and its apparatus"; design philosophy was "the study of the logic of discourse on matters of concern in the Design area"; while design epistemology was to be concerned with identifying special designerly ways of knowing, believing, and feeling.[8] Undergirding Archer's delineation of research categories was his assumption that design could be clearly defined and that a set of basic principles could be identified to characterize it.

Today we find few results of Archer's research agenda, which leads us to question why others did not subsequently pursue the broad plan he outlined. Within the design methods movement, there was considerable criticism by a so-called second generation of attempts by first generation theorists such as Archer to liken design to a science. Along with this critique came a call for participatory design, most likely as a response to the democratic political movements of the late 1960s.[9] Both tendencies may have contributed to moving Archer's particular vision of basic design research to the back burner.

For Archer, this subject matter of design embraced principles, thoughts, values, and practices as well as things. It was immaterial as well as material. But, like other first generation theorists, he believed that design knowledge would be deepened if it were grounded in a field of sciencelike inquiry. He favored observation as his fundamental research strategy and presumed that the subject matter of design could be categorized within his ten areas of design knowledge.

Archer's belief in the scientific method was shared by another theorist, S. A. Gregory. Consider his account of design science:

Design science is concerned with the study, investigation and accumulation of knowledge about the design process and its constituent operations. It aims to collect, organize and improve those aspects of thought and information which are available concerning design and to specify and carry out research in those areas of design which are likely to be of value to practical designers and design organizations.[10]

Gregory wanted design practice to be grounded in systematic knowledge as did Archer, but the striving of both men to elevate design research by modeling it on scientific investigation missed the point of how potentially diverse design research might be. Absent from the development of design methods was the recognition that it was one type of discourse among others. Had design methods theorists given greater attention to the plurality of design reflection instead of trying to define design singularly as a science, the movement would not have become as inflexible as its critics found it to be.

Archer, however, later came to rethink the research direction he had initially proposed. Reflecting on the state of design research in a speech to the International Conference on Engineering Design in 1985, he lamented that

[f]ar too much of our work in this field, on the evidence of this conference, remains at too high a level of generality. We still make far too many statements that are supported by a very low level of evidence. We have hardly any well-founded theory.[11]

In retrospect, however, the design methods movement, despite the critiques of its rigidity by Alexander and Jones, posited a valuable and as yet unfulfilled set of aims and purposes. First, it sought to create an autonomous space where designers could reflect on their own practice; and second, it attempted to establish a community of researchers that embraced many forms of practice, from architecture and industrial design to planning, graphic design, and cybernetics.

The movement's openness to make connections between these practices was actually a stimulus to John Chris Jones, who wrote expansively about the future of design in the introduction to the 1981 edition of his seminal book, *Design Methods: Seeds of Human Futures*. There he argued that making a single product was not sufficient. One also had to bring design thinking to bear on the larger situation in which the product would exist. Jones described his comprehensive version of design methods thus:

It is truer to say that design methods are intended for the design of "all-things-together," the total situation as I called it in the original introduction, meaning the functions and uses of things, the "systems" into which they are organized, or the "environments" in which they operate.[12]

He identified these systems as the "operating wholes of which modern life is being formed and made: traffic systems, computer software, educational programs, hypermarkets, etc. This is the scale of design today."[13]

Design methods was predominantly a British movement, but related themes were taken up in the United States as well. Herbert Simon's "science of design" was one example. Such a science was, in Simon's words, "concerned

with how things ought to be, with devising artifacts to attain goals."[14] Simon directed his attention to improving the efficiency of designing, and he advocated as tools design processes that had already been encoded in computer programs. "There is no question," he said, "since these programs exist, of the design process hiding behind the cloak of 'judgment' or 'experience.' Whatever judgment or experience was used in creating the programs must now be incorporated in them and hence be observable."[15]

PROJECT-ORIENTED RESEARCH There was a level of abstraction in the design methods movement and in Simon's "science of design" that most practitioners believe to be too remote from actual design situations. However, the separation of design reflection from what I will call "project-oriented research" is a necessary first step to envisioning design as a more autonomous practice that can occur independently of a market framework. In time, this separation can create new possibilities for thinking about practice, but meanwhile, practitioners have been inclined to develop their own research agendas that are directed to market-oriented forms of production. One area of methodological investigation relates to manufacturing. A number of books on this subject have been written by industrial engineers who are seeking to take control of the product design process. Design for excellence (DFX), design for manufacturability (DFM), total design, and robust design are examples of new manufacturing methods. These are based on the recognition that a pool of shared knowledge, which includes a theoretical conception of the product, is required for successful product development.[16] The aim of researchers in this area, as John Fox notes, is "to broaden the concept of design from the popular idea that it is just a set of drawings or sketches to the wider sequence of where it starts and where it finishes."[17] Such methods emphasize techniques of integrating the different kinds of expertise required to produce a quality product instead of dealing with a general theory that is unrelated to a specific task. They advocate that team members responsible for the development of a product need to understand, respect, and cooperate with each other in order to achieve success.[18] Those involved in product development must also embrace shared values about the level of product quality they are striving to achieve. James Bralla lists no less than fourteen characteristics of quality that range from performance, durability, and cost, to safety, aesthetics, and environmental friendliness.[19] It is important to note that aesthetics, which historically dominated public discourse about design, is only one quality among many within this process.

The growing literature on product quality has been developing primarily within the design engineering community. It is based on a technical knowledge

of assembly line processes and incorporates current research from marketing and management as well as from cognitive and industrial psychology, sociology, and the environmental sciences. The method that has been devised to combine the different types of knowledge needed for integrated product development is "concurrent engineering," which involves a shared stake by the full design team in major decisions that affect the creation of the product.

When a concurrent engineering team functions successfully within a manufacturing enterprise, it provides an example of how theory, research, and practice can be integrated in a design situation. A company manufacturers a particular range of products. It wishes to improve an existing product or produce a new one within its range. This entails rethinking the roles of its employees in the design process. Research is then focused on two objectives: defining the characteristics of the product and devising an appropriate production process. To achieve these objectives, someone has to review the literature on consumer behavior, product quality, and issues of use as well as studies of the learning corporation, design management, and team building. Such research also involves the investigation of new technologies and engineering strategies that can be applied to the production process. Extensive research efforts of this sort are directed to concrete tasks, and their value can be measured in terms of product success or failure in the marketplace. A primary purpose of design research for manufacturing is to develop and justify a conceptual model of the product that can be shared by all those involved in its development. Such research may draw on and integrate knowledge from many different fields in order to define a new product and a process for creating it.

A similar intention to rethink the design process and enlarge its scope can be found in the work of scholars in the field of environmental design who are interested in investigations that can lead to more habitable architecture.[20] The difference between these scholars and those engaged in research for manufacturing is that researchers in environmental design tend to work independently of the architects, developers, and housing authorities who are responsible for most building design and construction. They seek to unite architectural research and practice, which has not been easy to achieve in the past. Environmental design researchers have complained about the reluctance of architects to make use of data on how buildings affect human behavior. They attribute this attitude to the "two culture problem." Architecture remains a culture of artistic theories, while environmental design researchers investigate the physical, social, and psychological effects of buildings on those who inhabit them. Architects are then unwilling to use this research for fear that it will affect their designs.

A related situation is emerging in product design, where there is a growing interest in ethnographic research on product use. However, product design-

ers and manufacturers, unlike many architects, have a strong interest in incorporating the results of this research into their design and manufacturing process. The computer industry has been particularly quick to make use of such research, and manufacturers of other complex products are following suit. Donald Norman, in a recent book, *The Invisible Computer,* has designated ethnographic research as one of six skills within a process of research on user experience that he calls "human-centered development."[21] In fact, social scientists are now joining design firms just as engineers and architects did in the 1930s. Though still within consumer culture, the above-mentioned research tendencies do have the effect of increasing the designer's power. What this means, however, is that designers need to know more about disciplines other than their own. They have to be familiar with literature in related fields such as the social sciences, engineering, and management theory. While they cannot become anthropologists, for example, they do need to understand what kinds of related issues anthropologists address and how knowledge of those issues might be brought to bear on the organization and management of a complex design project. Thus, a principal objective of project-oriented research is to bring knowledge from diverse disciplines to bear on the design of products for use.

DESIGN AS A CULTURAL PRACTICE Project-oriented design research continues to produce effective results, but it is still constrained by the situations where it occurs. Most of it is done within the manufacturing sector of industrialized countries and does not question the fundamental economic and cultural assumptions within which this sector operates.

To consider aspects of design that are different from its operational methods, we need modes of thought that recognize design as a practice within culture and that bring to bear on its study the methods that have been used to understand other cultural practices and their resultant artifacts. While project-oriented research integrates knowledge from diverse fields to improve an end product, the study of design as culture seeks an understanding of design practice in the wider social field where it occurs. It takes in the concerns and interests of the entire community that is engaged with design—designers, users, managers, merchandisers, museum curators, historians, critics, and theorists, to give some examples. The cultural aspect of design studies is rooted firmly in the techniques of the humanities and the social sciences, rather than those in the natural sciences. Like project-oriented research, it brings together investigators from many fields, although its aim is to produce a greater understanding of design as a whole rather than applied knowledge related to project-oriented work.[22] Whereas design history was a peripheral subject for design methods theorists, it is extremely important to this new domain of design studies

because it traces the development of design by linking the history of design thinking and practice to its results in the present.

In an earlier essay in this book, "Design History and Design Studies," I argued for the inclusion of design history within a wider field of design studies because I believe that history, if brought into relation with other disciplines, can contribute much to the study of design in contemporary culture as well as to its role in the culture of the past. While I don't wish to subsume historical research under research for practice, I do believe that it can both inform and be informed by practice if the two are considered more closely. When this is not so, the emphasis on practice tends to be diminished by historians and replaced by a focus on consumption or use.

A good example of how design history and theory can productively inform each other is to be found in sociology, where the history of sociological thought, though a study in its own right, remains a strong force in the formation of practicing sociologists. Sociology has developed in such a way that some scholars do their primary research in the field of history while others make theory or field work their central focus. Yet the sociologist R. Stephen Warner notes the potential relation of these different interests when he states that

[t]he skills of the historian, while requiring practice, are not wholly esoteric, and the nearer in time the object of our explanations the more nearly those skills approximate those of the anthropologist or sociological field researcher.[23]

Warner's example shows us that reflection and practice, while requiring distinct domains for their development, also intersect in particular situations.

To facilitate such intersections, I believe the study of design as culture would be strongest when organized by topics rather than by conventional academic disciplines. This would encourage more interdisciplinary study than if disciplinary training such as history or anthropology were the primary means of preparing design scholars. Within a university setting, design studies might therefore be housed in a flexible interdisciplinary center rather than in a department.

As a prelude to my discussion of topics within the study of design as a cultural practice, I want to note that *design* refers to both an activity and a product; hence, design as culture has relations to disciplines that study human action such as sociology and anthropology and to those that study objects such as art history or material culture. The product itself, whatever its form, is bracketed by its conception, planning, and making on one side, and by its reception on the other. A scholar may emphasize the conception and planning of objects, which could involve research into invention, production, or design policy. Or research could be done on product reception using reception theory or rhetoric.

I propose four core topics or *topoi* for the cultural approach to design stud-

ies: design practice, design products, design discourse and a discrete fourth topos—metadiscourse, which is the reflexive investigation of design studies itself. These four topics embrace the complexity of design culture and the roles that its different actors—designers, managers, theorists, critics, policymakers, curators, and users—play in it. The topics arise from the recognition that design is a dynamic activity whose methods, products, and discourse are interactive and constantly changing.

The study of design practice includes those activities related to the conception, planning, and making of a product, and here I define a product broadly as I have done in some of the earlier essays. Design practice refers to the people, processes, and organizations that are involved in product planning and production as well as those organizations involved with design policies. Design practice belongs to the realm of social action that has traditionally been studied by sociologists, anthropologists, psychologists, and other social scientists. Here I would include books such as Donald Schon's *The Reflective Practitioner*, Lucy Suchman's *Plans and Situated Actions*, and Donald Norman's *The Psychology of Everyday Things*.

The study of design products emphasizes the identity and interpretation of products. Methods germane to this area are, first of all, theories of interpretation such as semiotics and rhetoric, but also aesthetics and methods that may be drawn from structuralism, poststructuralism, or psychoanalysis. The study of products includes the ways that people give meaning to them as objects of reflection as well as function. Links in this area would be made with scholars in art and design history, philosophy, anthropology, cultural studies, material culture, technology studies and related fields. Representative books include *The Meaning of Things* by Mihalyi Czikszentmihalyi and Eugene Rochberg-Halton, *The System of Objects* by Jean Baudrillard, *Doing Cultural Studies: The Story of the Sony Walkman* by a group of colleagues at the Open University and the University of Leicester, and Steve Baker's *Picturing the Beast: Animals, Identity, and Representation*.

The study of design discourse is concerned with the different arguments about what design is and might be as these are embodied in the literature of design. This area is the locus for design philosophy and theory as well as criticism. The literature of design is the record of how reflection on design practice and products has developed historically. It includes works by John Ruskin and William Morris, Siegfried Giedion, Jan Tschichold, Herbert Read, and Reyner Banham, as well as Tomás Maldonado, Gillo Dorfles, and Paul Rand, to name some of the more prominent writers. There has been all too little study of design literature, and more work in this field would help to set standards for future authors.[24] Links to this area might be made with literary theorists, philosophers,

and critics of art and architecture.[25] I consider this topic to be particularly important as it is the one that should provide the frame for contemporary discourse. All too often designers make pronouncements about their practice without a knowledge of how their concerns may form part of a long historical tradition.

The last topic, the metadiscourse of design studies, is the place for reflection on the entire field and how its different components operate in relation to each other. It methodological literature would include historiography, critical theory, and the sociology of knowledge. Examples from one area—design history—would include Clive Dilnot's seminal two-part article "The State of Design History" in *Design Issues* and Cheryl Buckley's critique of design history's patriarchal underpinnings in the same journal.

Besides outlining a range of topics, it is also important to address the questions of how research on design as a cultural practice would fit within existing and future advanced degree programs in design. On the one hand, it should be part of every student's design training, no matter what the level. Currently this role is being played by courses in design history as well as others on topics invented by individual teachers—design ethics, sustainable design, or design for cyberspace. On the other, it could be the theme for a particular doctoral program in design studies that would emphasize design's cultural identity. This provokes the question of who would be attracted to such a doctorate and what someone might do with it. First, a doctorate in design studies with a cultural emphasis would contribute to the creation of an informed and critical practitioner and could even point the way, depending on the student's research, to new forms of practice. Second, such a doctorate would be useful for a design educator who could then bring the relation of reflection and practice into the classroom. This model has been well developed in architecture where it is common for architects or planners to seek doctorates in the history, theory, and criticism of their field. Third, individuals such as design managers, museum curators, or policy makers could use such a degree to explore and refine their understanding of design in order to deepen their own practices. And fourth, this component of design studies could attract historians, anthropologists, sociologists, or political scientists who might study the cultural aspects of design as part of their own doctoral training.

I don't imagine that such specialized design studies programs will pervade academia, but certainly several universities might provide centers where valuable new knowledge could be developed. This knowledge would gradually make its way into design classrooms, studios, publications, and exhibitions and would have the function of raising issues and provoking questions. It is badly needed at this critical moment in design's history when designers are faced with eroding divisions of practice as well as the challenge of new social tasks. Until

now, the richness and complexity of design culture have been all too invisible
to scholars, practitioners, and the public alike. The serious study of design as
culture has the potential to remedy this situation.

DESIGN STUDIES IN THE ACADEMY Let us now return to the larger topic
of design studies and its multifarious strands of research. The time is right to
bring design studies into academia as a research field in the broad sense that I
suggested at the beginning of this essay. [26]At present the traditional bound-
aries in the humanities and social sciences that were established in the nine-
teenth century are collapsing.[27] This situation as it relates to the social sciences
was addressed in an interdisciplinary study that was undertaken in the early
1990s. The report of this effort has much to tell us about how design studies
might be organized within a university setting. The authors of the report, enti-
tled *Open the Social Sciences: Report of the Gulbenkian Commission on the Re-
structuring of the Social Sciences*, note:

**We are at a moment when the existing disciplinary structure has
broken down. We are at a point when it has been questioned and
when competing structures are trying to come into existence.[28]**

The report makes four recommendations that support the type of academic
arrangement that would work for design studies. The authors urge the follow-
ing changes in the structure of doctoral and postdoctoral research: the expan-
sion of institutions that can bring scholars together for short periods of time to
explore specific themes; the establishment of integrated research programs
within universities that cut across traditional lines and have funding for limited
periods of time; the appointment of professors in more than one department;
and the same recommendation for graduate students. Regarding these stu-
dents, the authors ask

**Why not make it mandatory for students seeking a doctorate in a
given discipline to take a certain number of courses, or do a certain
amount of research, that is defined as being within the purview of a
second department? This too would result in an incredible variety
of combinations. Administered in a liberal but serious fashion, it
would transform the present and the future.[29]**

Design studies, as I have argued, badly needs a place where researchers who
are developing its different strands can engage each other. This is crucial if we
are going to provide sensible academic programs at advanced degree levels.
The Gulbenkian Commission report provides an excellent precedent for think-
ing about how a new productive design studies community might be consti-
tuted in academia. It also suggests that such a community should operate out-
side the classroom as well.

We might consider some future association of design studies researchers that could encompass the various specialized design research communities. This is the model that currently exists in well-established disciplines such as sociology, literature, or art history. In the United States, for example, the College Art Association embraces a number of affiliated societies that meet on their own during the larger annual conference although the society members participate in the general conference sessions as well. The College Art Association, as with similar associations of sociologists, anthropologists, or literary scholars, is a place where new issues are introduced and debated.

In the design field, the Design Research Society, established in 1967 and based in Great Britain, probably embraces the widest range of scholars and professionals who are interested in design research. The society has an international network in more than thirty-five countries that is composed of researchers with diverse backgrounds ranging from design and art to engineering, psychology, and computer science. According to the society's promotional literature, its goals include encouraging communication across all design disciplines, supporting the improvement of design performance, and contributing to a coherent body of scholarship and knowledge in design.

The society is now making efforts to broaden its range of interests. This was evident in the promotional literature for its September 2002 conference, "Common Ground," which sought to attract researchers working in a full range of fields from design history and ecodesign to design management and artificial intelligence.

Design is too important to remain as fragmented a subject of study as it currently is. I am not calling for the kind of structural order that design methods theorists like Bruce Archer envisioned as a way of containing design research; rather, I wish to see a pluralistic enterprise that can grow and develop through discussion and debate. Such an enterprise needs different positions and points of view. But I speak here of a pluralism that thrives on engagement rather than isolation. Through such engagement, design studies will intensify the dimension of awareness and reflection that are central to any productive design activity. In this way, it can contribute to the formation of more conscious practitioners while also highlighting design as a component of culture whose study concerns everyone.

1 Among the groups involved in organizing broad-based design research conferences in the past few years are the European Academy of Design, the Japanese Society for the Science of Design, the Korean Society of Design Science, the Assoção de Ensino de Design do Brasil, and the Design Research Society. In May 2000, an international

conference on design research, entitled "Design plus Research," was held at the Politecnico di Milano. Organized by the Politecnico's PhD program in industrial design, the conference raised issues on various points concerning the problems and challenges of building a design research community. See Silvia Pizzocaro, Amilton Arruda, and Dijon De Moraes, eds., *Design plus Research: Proceedings of the Politecnico di Milano Conference, May 18–20, 2000* (Milan: Poltecnico di Milano, PhD Program in Industrial Design, 2000). The most recent initiative has been undertaken by the Design Research Society, which is planning a major international conference for 2002 with the title "Common Ground." The intent of the organizers is to recognize the new maturity of the emerging interdisciplinary design research community.

2 The special issue of *Design Issues* on design research, edited by Alain Findeli, includes a diversity of positions on the subject, though still within a limited range compared with what is possible. See *Design Issues* 15, no. 2 (summer 1999).

3 I am broadening my earlier proposal for "design studies" as "an interpretive practice, rooted firmly in the techniques of the humanities and the social sciences rather than in the natural sciences." That was the definition I put forth in a previous version of this essay, "The Multiple Tasks of Design Research," in *No Guru No Method: Discussion on Art and Design Research,* ed. Pia Strandman (Helsinki: University of Art and Design Helsinki, 1998), 47. The term is likely to be contested as it is already in use by groups with differing conceptions of its meaning.

4 Goeffrey Broadbent, "The Morality of Designing," in *Design: Science: Method: Proceedings of the 1980 Design Research Society Conference,* eds. Robin Jacques and James A. Powell (Guildford: Westbury House, 1981), 309.

5 Geoffrey Broadbent, "Design Methods—13 Years after—A Review," in Jacques and Powell, *Design: Science: Method,* 3.

6 Christopher Alexander, quoted in C. Thomas Mitchell, *Redefining Designing: From Form to Experience* (New York: Van Nostrand Reinhold, 1993), 51.

7 John Chris Jones, "opus one, number two," in Jones, *designing designing* (London: Architecture, Design and Technology Press, 1991), 158–159.

8 Archer's ten points are outlined in his essay, "A View of the Nature of Design Research," in Jacques and Powell, *Design: Science: Method,* 33.

9 See Nigel Cross, ed., *Design Participation: Proceedings of the Design Research Society's Conference, Manchester, September 1971* (London: Academy Editions, 1972).

10 S. A. Gregory, "Design Science," in *The Design Process,* ed. S. A. Gregory (New York: Plenum Press and London: Butterworths, 1966), 323.

11 Bruce Archer, quoted in Bill Hollins and Stuart Pugh, *Successful Product Design* (London: Butterworths, 1990), 10. Hollins and Pugh use Archer's statement to support their claim that little hard research has been done in the area of design management.

12 Ibid., xxvi. In the years since Jones published his original and revised editions of *Design Methods,* his proposal that design go beyond the narrow focus on products to consider a larger situation has moved steadily into the mainstream of design practice.

13 Ibid.

14 Herbert A. Simon, "The Science of Design" in Simon, *The Sciences of the Artificial,* 3d. ed (Cambridge and London: MIT Press, 1996), 114.

15 Ibid., 135.

16 See, for example, James G. Bralla, *Design for Excellence* (New York: McGraw-Hill,

1996); John Fox, *Quality through Design: The Key to Successful Product Delivery* (London: McGraw-Hill, 1993); Bill Hollins and Stuart Pugh, *Successful Product Design: What to Do and When* (London: Butterworths, 1990); and M. Helander and M. Nagamachi, *Design for Manufacturability: A Systems Approach to Concurrent Engineering and Ergonomics* (London: Taylor & Francis, 1992).

17 Fox, *Quality through Design*, ix.

18 Fox points out the huge overlap between the roles of the designer and the engineer in this process. He notes that these roles are not fixed. The role of each on the design team, he argues, is fluid and "depends on the particular bent and choice of the individual."

19 James G. Bralla, *Design for Excellence*, 18–19.

20 For a good introduction to this field, see Gary T. Moore, D. Paul Tuttle, and Sandra C. Howell, eds., *Environmental Design Research Directions* (New York: Praeger, 1985). Although the research of its members is primarily in the field of architecture, the Environmental Planning Association lists all forms of design as being within its purview.

21 Donald A. Norman, *The Invisible Computer: Why Good Products Can Fail, the Personal Computer Is So Complex, and Information Appliances Are the Solution* (Cambridge and London: MIT Press, 1998), 189–191.

22 At a conference entitled "Discovering Design" that Richard Buchanan and I organized at the University of Illinois at Chicago, in November 1990, a small group of scholars and practitioners met to discuss the ways that design might be studied. The participants, who included historians, sociologists, psychologists, political scientists, cultural studies theorists, philosophers, designers, and marketing experts, explored common themes instead of defending disciplinary boundaries. A selection of the conference papers were published as *Discovering Design: Explorations in Design Studies,* eds. Richard Buchanan and Victor Margolin (Chicago: University of Chicago Press, 1995). The "Discovering Design" conference grew out of several prior meetings in Chicago organized by Marco Diani and myself and sponsored by the Center for Interdisciplinary Research in the Arts (CIRA) at Northwestern University. The first meeting, held in February 1988, was entitled "Design, Technology and the Future of Postindustrial Society." The second, "Design at the Crossroads," took place in January 1989. Both events included participants from a number of disciplines and practices. The proceedings of the second meeting were published as *Design at the Crossroads* (Evanston: CIRA Monograph Series, 1989). A French translation appeared in a design journal published at the University of Montreal, *Informel* 3, no. 1 (winter 1989).

23 R. Stephen Warner, 'Sociological Theory and History of Sociology: Autonomy and Interdependence," *Sociological Theory: A Semi-Annual Journal of the American Sociological Association* 3, no. 1 (spring 1985): 22.

24 See, for example, the special issue, "A Critical Condition: Design and Its Criticism," edited by Nigel Whiteley, *Design Issues* 13, no. 2 (summer 1997).

25 The number of books and articles that might be listed here is vast. It should be noted, however, that, unlike the situation in architecture, there has been no history of design reflection, something that is badly needed. For a listing of sources, see my bibliographic essay, "Postwar Design Literature: A Preliminary Mapping," in *Design Discourse: History, Theory, Criticism,* ed. Victor Margolin (Chicago: University of

Chicago Press, 1989), 265–288.

26 An attempt to create an academic research framework was made by Christopher Frayling, rector of the Royal College of Art (RCA) in 1993. Frayling devised three models of design research, which he derived from the British art historian and critic Herbert Read—research *into* art and design, research *through* art and design, and research *for* art and design. Research *into* art and design includes the traditional history, theory, criticism triumvirate but also incorporates aesthetic or perceptual research and research into technical, material, and structural perspectives on art and design. Research *through* art and design, Frayling's second category, is centered on the studio project and relates to what is also known in the UK as practice-led research. As examples, he cites research into the behavior of materials, customizing a piece of technology to accomplish new tasks or documenting a practical studio experiment. In this type of research, documentation of what is done is an essential-component. According to Frayling, the third category, research *for* art and design, is the most difficult to characterize. It is an area where the primary conveyor of research accomplishment is an art or design object or a body of such objects. At the Royal College of Art, he says, research *for* design is not currently an option, although higher or honorary doctorates are given as honors to individuals for distinguished bodies of exhibited or published work. See Christopher Frayling, "Research in Art and Design," *Royal College of Art Research Papers* 1, no. 1 (1993–1994). On the development of pedagogical methods for advanced research degrees at the RCA, see Alex Seago, "Research Methods for MPhil & PhD Students in Art and Design: Contrasts and Conflicts," *Royal College of Art Research Papers* 1, no. 3 (1994–1995).

27 Design studies may be likened to other ways of organizing research that involve multiple disciplines such as area studies (i.e., Slavic studies or Latin American studies), ethnic studies (African American studies or Chicano studies), or period studies (i.e., medieval or Renaissance studies). The formation of programs or centers for multidisciplinary research has occurred in the last thirty years because the research interests of many scholars have outstripped their disciplinary boundaries. Such programs or centers have also made it possible for researchers from different disciplines to talk more easily with each other and often to pursue further investigations based on shared concerns. Besides programs and centers, conferences and publications have also enabled scholars to share ideas and publish their research across disciplinary boundaries.

28 *Open the Social Sciences: Report of the Gulbenkian Commission on the Restructuring of the Social Sciences* (Stanford: Stanford University Press, 1996), 103. The commission, which was chaired by Immanuel Wallerstein, included Calestous Juma, Evelyn Fox Keller, Jürgen Kocka, Dominique Lecourt, V. Y. Mudimbe, Kinhide Mushakoji, Ilya Prigogine, Peter J. Taylor, and Michel-Rolph Trouillot.

29 Ibid., 105.

SOURCES

The chapters in this book, or portions thereof, were presented or published as follows:

1: DESIGN

"Thinking about Design at the End of the Millennium" was originally published with the same title as a conference review in *Design Studies* 13, no. 4 (October 1992): 343–354. Reprinted with permission from Elsevier Science.

"Design at the Crossroads" was first given as a lecture with the same title to the Industrial Designers Society of America, Chicago chapter, in November 1989 and was subsequently presented as "Design at the Crossroads Revisited" at the Conference on Technological Renovation in Design, Curitiba, Brazil, June 1992. It was published with the original title in *Revue Sciences et Techniques de la Conception* [Paris] 1, no. 2 (1992): 153–160.

"The Experience of Products" is a combination of two papers. The first was presented with the title "Products and Experience" at the conference "Design—Pleasure or Responsibility?" University of Art and Design, Helsinki, Finland, June 1994, and was published with the same title in the volume of conference papers *Design—Pleasure or Responsibility?* eds. Päivi Tahkokallio and Susann Vihma (Helsinki: University of Art and Design, 1995), 54–65. The second paper was presented with the title "Experience, Use, and the Design of Products" at the conference "Revision of Use," Bonn, Germany, October 1994, and was published as "Getting to Know the User" in *Design Studies* 18, no. 3 (July 1997): 227–236. Reprinted with permission from Elsevier Science.

"Ken Isaacs: Matrix Designer" began as a lecture with the same title at the Graham

Foundation for Advanced Studies in the Fine Arts, Chicago, November 29, 1995. It was offered again at the Cooper-Hewitt, National Design Museum in New York in October 1996. The essay is being published here for the first time in an extensively rewritten form.

"Expansion or Sustainability: Two Models of Development" was initially given as "Design and the World Situation" at the International Conference on Product Design, London, England, July 7, 1995. It was presented again to the Industrial Designers Society of America, Boston chapter, on February 21, 1996, and then in Spanish to the Fifth International Design Symposium, University of Nuevo Leon, Monterrey, Mexico, March 4, 1996. The paper was published as "Global Equilibrium or Global Expansion: Design and the World Situation" *Design Issues* 12, no. 2 (summer 1996): 22–32. © 1996 by the Massachusetts Institute of Technology. A shortened Spanish version appeared in *tipoGráfica* 10, no. 29 (1996): 10–15; a shortened Italian version in *Stileindustria* 1, no. 4 (December 1995): 12–19; and a similar German version in *form* 157, no. 1(1997). The longer version was republished as "Design and the World Situation," in Tevfik Balcioglu, ed., *The Role of Product Design in Post-Industrial Society* (Ankara: METU Faculty of Architecture Press and Kent Institute of Art & Design, 1998): 15–34.

"Design for a Sustainable World" was presented with the same title at the Internationales Forum für Gestaltung, "Globalisierung und Regionalisierung," Ulm Germany, in September 1997, and then at the fifth Encuentro de Diseño Industrial, Havana, Cuba, June 1998. It was published with the same title in *Design Issues* 14, no. 2 (summer 1998): 83–92. © 1998 by Victor Margolin. A German translation appeared in the IFG proceedings, *Globalisierung/Regionalisierung, kritisches Potential zwischen zwei Polen* (Frankfurt am Main: Anabas, 1998), 190–99; a Portuguese translation in *Arcos* [Rio de Janeiro] 1, no. 1 (October 1998): 40–49, and a Spanish version in *tipoGráfica* no. 38 (1998): 37–40.

"The Politics of the Artificial" was presented with the same title in the lecture series "Technology, Society, and Representation" at the California College of Arts and Crafts, San Francisco, April 1991, and subsequently at the Cooper-Hewitt, National Design Museum; Ohio State University; and the University of Texas at Austin. "The Politics of the Artificial" was published in *Leonardo* 28, no. 5 (1995): 349–356. © 1995 by the International Society for the Arts, Sciences and Technology (SAST). It was reprinted in Richard Roth and Susan King Roth, eds., *Beauty Is Nowhere: Ethical Issues in Art and Design* (Amsterdam: G + B Arts International, 1998), 171–188. A Portuguese translation appeared in *Estudos em Design* [Rio de Janeiro] 5, no. 1 (August 1997), 69–88.

2: DESIGN STUDIES

"Design History in the United States, 1977–2000," which was considerably expanded for this book to bring the narrative up to the present time, was originally presented as "A Decade of Design History in the United States, 1977–1987" at the tenth anniversary conference of the Design History Society, Brighton, England, September 1987. It was published under the same title in the first issue of the *Journal of Design History* 1, no. 1 (1988): 51–72. Published by permission of Oxford University Press.

"Narrative Problems of Graphic Design History" was first published as an essay with the same title in *Visible Language* 28, no. 3 (fall 1994): 233–243.

"Micky Wolfson's Cabinet of Wonders" appeared as a review essay with the title "Micky Wolfson's Cabinet of Wonders: From Private Passion to Public Purpose" in *Design Issues* 13, no. 1 (spring 1997): 67–81. © 1997 by the Massachusetts Institute of Technology.

"Design History and Design Studies" was presented at a conference on design history and historiography, Politecnico di Milano, Milan, Italy, April 1991. It was then published as "Design History or Design Studies: Problems and Methods," in *Design Studies* 13, no. 2 (April 1992): 104–116. Reprinted with permission from Elsevier Science. The essay was reprinted in *Arttu* [Helsinki] 5 (1992) and in *Design Issues* 11, no. 1 (spring 1995): 4–15. An Italian version was included in the proceedings of the Politecnico conference, eds. Vanni Pasca and Francesco Trabucco, *Design: Storia e Storiografia* (Bologna: Progetto Leonardo, 1995), 51–74.

"The Two Herberts" was presented under the title "History, Theory, and Criticism in Doctoral Design Education," at the Conference on Doctoral Education in Design, Ohio State University, October 1998. It was published with the same title in *Doctoral Education in Design: Proceedings of the Ohio Conference, October 8–11, 1998*, eds. Richard Buchanan, Dennis Doordan, Lorraine Justice, and Victor Margolin (Pittsburgh: School of Design, Carnegie Mellon University, 1999) and then republished in *form/work* [Sydney, Australia] 4 (March 2000): 9–18.

"The Multiple Tasks of Design Studies" combines two papers. The first was presented as "Design Research and Design Studies: Why We Need Both" at the "No Guru, No Method?" conference on design research at the University of Art and Design, Helsinki, September 1996. A somewhat different version was given as "The Multiple Tasks of Design Research" at the Third Brazilian Conference on Research and Development in Design, October 1998 in Rio de Janeiro. The original paper was published as "The Multiple Tasks of Design Research" in *No Guru No Method? Discussion on Art and Design Research*, ed. Pia Strandman (Helsinki: University of Art and Design, 1998), 43–47. The second paper, "Design Studies: Proposal for a New Doctorate," was originally presented at the conference "How We Learn What We Learn" in New York City and was published with the same title in Steven Heller, ed., *The Education of a Graphic Designer* (New York: Allworth Press, 1998), 163–170.

Beach structure. Courtesy of Ken Isaacs.

Ken Isaacs sitting in his Superchair. Courtesy of Ken Isaacs.

Microhouse. Courtesy of Ken Isaacs.

Drawing of large Microhouse. Courtesy of Ken Isaacs.

Contemporary Microhouse built by architecture students at the University of Illinois at
Chicago, c. 1998. Photo by the author.

Coffee vendor in East Jerusalem. Photo by the author.

Swatch watches in a store window, Via Manzoni, Milan, 1994. Photo by the author.

Small car in Amsterdam, 1999. Photo by the author.

Telephone pole with the name of the street intersection in Braille, Curitiba, Brazil, 1992.
Photo by the author.

Vernacular kerosene burners, Rio de Janeiro, 1992. Photo by the author.

Evelyn Grumach, logo for Rio '92 Earth Summit. Reproduced by permission of
Evelyn Grumach.

Bicycle transport vehicle, Amsterdam, 1999. Photo by the author.

Bus platform, Curitiba, Brazil, 1992. Photo by the author.

Plastic shells, Curitiba, Brazil, 1992. Photo by the author.

Wooden cart for collecting recyclable materials, Curitiba, Brazil, 1992. Photo by the author.

Market stalls, Curitiba, Brazil, 1992. Photo by the author.

Recycling bins, Bonn, Germany, 1994. Photo by the author.

Man sharpening knives in a public square, Florianopolis, Brazil, 1992. Photo by the author.

Fiberoptics helmet designed by CAE Electronics Ltd. Courtesy of the author.

Cover of University of Cincinnati catalog, n.d. Courtesy of the author.

Design History Forum newsletter, 1984. Courtesy of the author.

Proceedings of the First Symposium on the History of Graphic Design, 1984.

Poster for the first "Modernism and Eclecticism" symposium, 1987. Courtesy of the author.

Design since 1945, an exhibition at the Philadelphia Museum of Art, 1983. Courtesy of
the Philadelphia Museum of Art.

High Styles: Twentieth-Century American Design, an exhibition at the Whitney Museum of
American Art, 1985. Courtesy of the Whitney Museum of American Art.

The Machine Age in America, an exhibition at the Brooklyn Museum, 1986. Courtesy of
the Brooklyn Museum.

The Automobile in American Life, an exhibition at the Henry Ford Museum, Dearborn,
Michigan, 1987. Photo by the author.

Scandinavian Modern Design, 1880–1980, an exhibition at the Cooper-Hewitt, National
Design Museum, 1982. Courtesy of the Cooper-Hewitt, National Design Museum.

David Tartakover, "Who Will Utter the Mighty Acts of Israel?" Poster, September, 1982.
Courtesy of David Tartakover.

Filippo Tommaso Marinetti, *Parole in Libertà*, 1919. Courtesy of the author.

Shepard Fairey, Andy Kaufmann stencil on a wall in New York's meatpacking district,
1999. Photo by the author.

Oswald Cooper studio, Chicago, c. 1922. Cooper is at the drawing board at the back of
the room. Courtesy of the author.

Robert Hunter Middleton, typeface advertisement from Chicago 27 Designers, c. 1942.
Special Collections Department, Richard J. Daley Library, University of Illinois at
Chicago.

Theater posters, Amsterdam, 1999. Photo by the author.

Entrance hall, The Wolfsonian-Florida International University, Miami Beach. Sculpture, *The Wrestler*, 1929. Dudley Vaill Talcott (American, 1899–1986). Made by Sculpture House, New York, cast aluminum, 80" x 47" x 30 3/4". Photo by the author.

The Wolfsonian, originally Washington Storage Company (1927, Robertson & Patterson, architects; addition 1936, Robert M. Little, architect; renovation 1992, Mark Hampton, architect, and William S. Kearns, associate; E. W. Charles Construction Company, contractor). The Wolfsonian-Florida International University, Miami Beach, Florida. Photo by Richard Sexton.

Soane Museum, London. Photo by the author.

Dining chair with armrests, 1915–1916. Designed by Michel de Klerk (Dutch, 1884–1923). Commissioned by F. J. Zeegers for 't Woonhuys (The Dwelling), Amsterdam. Manufactured and retailed by 't Woonhuys, Amsterdam, c. 1917. Mahogany, mohair, velvet upholstery, leather straps, brass. 44 1/2" x 26 5/8" x 22". Photo by Bruce White. The Mitchell Wolfson Jr. Collection, The Wolfsonian-Florida International University, Miami Beach, Florida.

Matchbook cover, The 20th Century Limited, c. 1940. Published by New York Central System, New York. 3 3/4" x 1 1/2". Photo by Bruce White. The Mitchell Wolfson Jr. Collection, The Wolfsonian-Florida International University, Miami Beach, Florida.

Chair from the Montecatini headquarters, Milan, 1938. Designed by Gio Ponti (Italian, 1891–1979). Manufactured by Kardex Italiano, Italy. Aluminum, painted steel, padded leatherette. 30 1/4" x 18 1/2" x 18 1/2". Photo by Bruce White. The Mitchell Wolfson Jr. Collection, The Wolfsonian-Florida International University, Miami Beach, Florida.

Wall lamp, Fascio, c. 1940. Italy. Silver electroplate on copper, glass. 29 1/2" x 12 5/8" x 3 1/2". The Mitchell Wolfson Jr. Collection, The Wolfsonian-Florida International University, Miami Beach, Florida.

Figurines, c. 1937. Designed by Richard Förster (German, dates unknown). Made by Porzellan Manufaktur Allach, Allach and Dachau (Bavaria), Germany. Glazed porcelain. 12" high, tallest. Photo by Bruce White. The Mitchell Wolfson Jr. Collection, The Wolfsonian-Florida International University, Miami Beach, Florida.

Walter Gropius and Adolph Meyer, model factory, Werkbund exhibition, Cologne, 1914. Courtesy of the author.

1950s Cadillac, Los Angeles, California, 1992. Photo by the author.

Embroidery Studio, Royal School of Art Needlework, c. 1905. Courtesy of the author.

R. Buckminster Fuller with a model of his Dymaxion House, c. 1927. Courtesy of the author.

Vladimir Tatlin and his assistants building the *Monument to the Third International*, Moscow, 1920. Courtesy of the author.

Dante Gabriel Rossetti, Sussex chair sold by Morris, Marshall, Faulkner & Co, c. 1865.

A reduced model of Tatlin's *Monument to the Third International* being drawn through the streets of Leningrad in a parade, 1926. Courtesy of the author.

Herman Miller Action Office, 1964. Courtesy of Herman Miller Inc.

Painted wall in Monterrey, Mexico, 1996. Photo by the author.

INDEX

References to figures are indicated by *f*.

Abbe, Dorothy, 137
Ades, Dawn, 173n33
Aicher, Otl, 91
Albini, Franco, 227
Aldersey-Williams, Hugh, 27
Alexander, Christopher, 246
Alexander, James, 129
Allen, Paula Gunn, 113
Ames, Kenneth, 135, 151, 152, 177n76,
 179n102
Anderson, Charles Spencer, 199n20
Andlovitz, Guido, 212
Ansell, Joe, 132
Antonelli, Paola, 142
Aranguren, J. L., 199n19
Archer, Bruce, 247, 256
Arens, Egmont, 140, 175n55
Armi, Edson, 144, 177n72
Aronowitz, Stanley, 109
Ashwin, Clive, 230n1
Augustine, Saint, 2, 9n2
Aynsley, Jeremy, 134, 168

Bailey, Chris, 134
Baker, Steve, 140, 253
Bal, Mieke, 206
Balfour, Alan, 16–17
Banham, Reyner, 222, 253
Barkun, Michael, 14–15, 16–17, 23
Barthes, Roland, 109, 185n168
Bartl, Peter, 200n26
Barton, Bruce, 190, 191, 193, 194
Bass, Saul, 138
Baudrillard, Jean, 19, 109, 111, 116, 117,
 185n168, 253
Bayer, Herbert, 62
Bayley, Stephen, 186n182
Beall, Lester, 139, 161
Beeke, Anton, 161
Behrens, Peter, 210
Bel Geddes, Norman, 30, 149, 173n27,
 183n147, 227, 229
Bellin, Leon, 9n2
Bellini, Mario, 163, 227
Bellotto, Umberto, 211
Bennett, John, 1, 5–6
Bergvelt, Elinoor, 206, 209, 210, 211
Berman, Marshall, 210

266 . 267